Bonnard

Bonnard

Essays by Sarah Whitfield and John Elderfield

Catalogue by Sarah Whitfield

Harry N. Abrams, Inc., Publishers

Published to accompany the exhibition *Bonnard*, organized by the Tate Gallery,
London, in collaboration with The Museum of Modern Art, New York

Tate Gallery 12 February – 17 May 1998
The Museum of Modern Art 17 June – 13 October 1998

Sarah Whitfield is the curator of the original exhibition in London,
in consultation with John Elderfield and David Sylvester.
The exhibition in New York is presented by John Elderfield.

Library of Congress Card Number: 97-43182
ISBN 0-8109-4021-3 (clothbound, Abrams)
ISBN 0-87070-078-2 (paperbound, MoMA)
ISBN 0-8109-2757-8 (paperbound, QPB)

Produced by Tate Gallery Publishing, Ltd., London

Clothbound edition published in 1998 by Harry N. Abrams, Incorporated, New York
All rights reserved. No part of the contents of this book may be reproduced
without the written permission of the publisher

Paperbound edition published by The Museum of Modern Art
11 West 53rd Street, New York, N.Y. 10019

Designed and typeset by Caroline Johnston
Printed and bound in Great Britain by Balding + Mansell, Norwich

Harry N. Abrams, Inc.
100 Fifth Avenue
New York, N.Y. 10011
www.abramsbooks.com

frontispiece:
Peaches and Grapes on a Red Tablecloth
(detail) 1943 (no.89)

Contents

Foreword

This catalogue accompanies a major exhibition of Bonnard's paintings which celebrates the achievements of one of the most enigmatic of the great masters of twentieth-century painting. His observations of daily domestic life and routine have always made him a very accessible artist, yet in the fifty years since his death he has come to be seen increasingly as a profoundly radical painter who broke new ground by taking as his subject the difficult, complex and mysterious nature of sensory awareness. As the works in this selection demonstrate, he devoted a long career to exploring and analysing the processes of seeing and looking, and to translating ways in which visual perceptions interlock with the processes of memory. The present exhibition is intended to show how the independence of Bonnard's vision, embodied in compositions and colour harmonies of an extreme originality and daring, defines him as a painter of our own time.

It is a considerable achievement to have collected together so many of Bonnard's finest paintings, a number of which are very little known, and for this we are indebted to Sarah Whitfield, the curator of the exhibition. She has sought out and selected the paintings and has written a most illuminating essay about the artist and his life and work. As a result of considerable research she has introduced much new material both in the essay and in the captions and comparative photographs that accompany the catalogue plates. Her enthusiasm for the project has been inspiring and infectious from the beginning. We are deeply grateful to her for her energy and commitment. We are extremely grateful, too, to both Antoine and Michel Terrasse for all the help and time they have so generously given to Sarah Whitfield.

We should particularly like to thank the consultants for the exhibition, John Elderfield, whose essay is one of the most original contributions to Bonnard scholarship in recent years, and David Sylvester. Their conversations, advice and support during the preparation of the exhibition have been essential ingredients for the successful realisation of the project.

The exhibition could never have been realised without the support of many collections, both public and private, across the world. Lending to an exhibition inevitably means a long absence and we are deeply grateful to all our lenders for their exceptional generosity in lending works which frequently occupy a central place in their collection.

The exhibition will travel to The Museum of Modern Art, New York, where it will be presented by John Elderfield. We are delighted that this collaboration has been possible and that the exhibition will be seen on both sides of the Atlantic, and we are most grateful to all our colleagues who have worked so hard to ensure its success.

Nicholas Serota, Tate Gallery, London
Glenn D. Lowry, The Museum of Modern Art, New York

Acknowledgements

My thanks, first and foremost, are to the artist's family: to M. Antoine Terrasse for his generosity in making available previously unpublished material from the Bonnard archives, and for his unfailing patience in responding to my queries; to M. Michel Terrasse for sharing his thoughts and perceptions about Bonnard's painting, insights which have proved invaluable in understanding the complex nature of the work. I would also like to thank Mme Pierrette Vernon-Montredon, who has freely shared her knowledge of the life of her great-aunt, Marthe Bonnard.

My thanks also go to MM. Guy-Patrice Dauberville and Michel Dauberville for making available the Bonnard catalogues in the archives of the Galerie Bernheim-Jeune, Paris.

I am particularly indebted to Timothy Hyman, Sargy Mann and Nicholas Watkins for their generosity in sharing their wide and varied knowledge of the artist.

The staff of the following institutions have greatly facilitated my research: in London, the Courtauld Institute of Art Library, the Conway Library, the Imperial War Museum, the Tate Gallery Library, the Wellcome Institute for the History of Medicine Library, and the Witt Library; in Paris, the Bibliothèque Nationale (Réserve des estampes), Musée du Louvre (Cabinet des dessins), Musée d'Orsay (Cabinet des arts graphiques; Service de la Documentation), Musée National d'Art Moderne, Centre Georges Pompidou, Musée Maurice Denis, Saint-Germain-en-Laye (Service de la Documentation); in Chicago, the Art Institute of Chicago, the Ryerson and Burnham Libraries.

I, and everybody associated with the exhibition in both its London and its New York venues, are also indebted, in many different ways, to the following: Julian Bell, Jacques de la Béraudière, Anisabelle Berès, Julia Brown, Christopher Burge, Philippe Cazeau, Melanie Clore, Guy Cogeval, Desmond Corcoran, Sharon Dec, Bernd Dütting, Chantal Duverget, Christopher Eyken, Claire Frèches-Thory, Kate Garmeson, Susan Ginsburg, John Golding, Gloria Groom, Françoise Heilbrun, Fabrice Hergot, Margrit Hahnloser-Ingold, Christel Hollevoet-Force, Ay-Whang Hsia, Caroline Lang, Julianna and Robin Lees, Pierre Levai, Leila Mabilleau, Francis Mann, Lucy Mitchell-Innes, Isabelle Monod-Fontaine, David Nash, Christian Neffe, Richard E. Oldenburg, Angelica Zander Rudenstine, Marc Restellini, Cora Rosevear, James Roundell, Bertha Saunders, Manuel Schmit, Pierre Schneider, Daniel Schulman, Verena Steiner, Michel Strauss, Andrew Strauss, James Taylor, Annette Vaillant, Kirk Varnedoe, Dina Vierny, Caroline Vossen, Philip Ward-Jackson, James Wood and Barbara Wright.

The realisation of an exhibition of this importance makes enormous organisational demands. Ruth Rattenbury with Emmanuelle Lepic and all their colleagues in the Tate Gallery and Celia Clear, Sarah Derry and Tim Holton at Tate Gallery Publishing Ltd have been models of support, and I am immensely grateful to them all.

Lastly, a particular debt of gratitude to the consultants on the exhibition, John Elderfield and David Sylvester. Their experience and wise counsel have been indispensable. In addition, David Sylvester has played a key role in the installation of the London showing.

Sarah Whitfield

Fragments of an Identical World

SARAH WHITFIELD

'You told me that you had seen some of Vermeer's pictures: you must have realized that they're fragments of an identical world, that it's always, however great the genius with which they have been re-created, the same table, the same carpet, the same woman.'

(Marcel Proust, *In Search of Lost Time*, V, *The Captive*)

A private life

The diaries that Bonnard kept during the last twenty years of his life give little away.[1] A typical entry may read 'grey sky', or consist of just a single word, 'fine', 'overcast', scribbled on the page, notations that seem of no importance but were enough, Bonnard said, to remind him of the light 'and of all that had happened on that day'.[2] A number of reflections are jotted down among dozens of pencil sketches, landscapes, nudes, studies for paintings, and self-portraits. Apart from the occasional shopping list and telephone number, there is little evidence of any social contact. The silence of these pages evokes the anonymous self-portrait he once gave a French journal: 'The artist who paints the emotions creates an enclosed world – the picture – which, like a book, has the same interest no matter where it happens to be. Such an artist, we may imagine, spends a great deal of time doing nothing but look, both around him and inside him.'[3]

His early years were spent in Paris, and he continued to keep a studio there even though he later avoided the city, choosing to live in the country, away from other artists. He moved around frequently, dividing his time between the south of France and the north. He exhibited regularly, and his paintings sold easily through a well-established Paris dealer, but by choice he lived simply with few luxuries apart from a modern bathroom and a car. He shunned excess. Visitors to Le Bosquet, the house he bought in a small town above Cannes, were invariably struck by the simplicity of the furnishings and by the small 'impractical and uncomfortable workroom' that was his studio.[4] His nephew Charles Terrasse likened his bedroom to a monastic cell,[5] while the critic Claude Roger-Marx remarked on his 'pronounced taste for discomfort'.[6] That simplicity was carried through in the way he dressed. He was wary of standing out, of being in any way conspicuous, so much so that before setting out on a trans-atlantic voyage he shaved off his moustache in order to look like other passengers.[7] Tall, thin, slightly stooping, short-sighted, and with hands that people noticed were large and often bluish-red, he struck one of his great-nephews as a man who never looked at ease.[8] He once said of himself that when he smoked a pipe he gave himself the disagreeable impression of someone who had settled too comfortably into life.[9]

He hid behind an exterior that was correct, courteous, ironic. Jan Verkade, a painter friend from the early years, considered that Bonnard's youthful manner ('almost frivolous'), which prompted several writers to use words like 'childlike' and 'naïve', was a deliberate ploy to conceal his prodigious talent. Matters that concerned him most he spoke very little about. The reflections noted in his diaries are as carefully honed as aphorisms: 'museums are filled with uprooted works', 'untruth is cutting out a piece of nature and copying it'.[10] One of his first biographers, Thadée Natanson, remembered how carefully he avoided theories and theoreticians, taking no part in the discussions enjoyed by painters who were close friends, such as Maurice Denis or Paul Sérusier; he possibly believed, with Proust, that a work in which the theory is visible is like an object which displays its price-tag.[11] When Denis positioned Bonnard on the edge of the group gathered together in Vollard's gallery in his painting *Homage to Cézanne*, 1900 (fig. 140), he was surely making a point.

By accident or by design, Bonnard left behind few traces apart from his diaries (which are more like sketchbooks), occasional letters,[12] a few interviews. All the bric-à-brac that remains after a death and which is the stuff of biographies either remains to be discovered or has long since disappeared.[13] One way or another, the privacy he valued so highly during his life has been loyally preserved. Yet, from the start, this modest and most discreet of men, this least public of artists made his daily life the subject of his art, observing steadily and calmly everything that was closest to him: his family, his surroundings, his companion, his animals. 'I have all my subjects to hand', he said, 'I go and look at them. I take notes. Then I go home. And before I start painting I reflect, I dream.'[14]

His acceptance of what was 'to hand' is evident from the start. During the 1890s he painted over fifty pictures of his

[9]

family: his maternal grandmother (with whom he lived while a student in Paris), his father, his sister and her husband, their children, and his cousin Berthe Schaedlin (who is said to have refused his offer of marriage).[15] There are few likenesses of his mother. They reflect the peaceful domesticity at Le Clos, the house on the family property of Le Grand-Lemps in the Dauphiné where the family gathered regularly. These are mostly small, sombre canvases, set in quiet, dimly lit interiors from which daylight has been excluded. There are no windows in these rooms, and the doors are shut. There is always a feeling of closeness, of people living together, quietly going about the mundane household tasks, sitting down to meals together. The moments he chooses to paint are the soothing lulls that punctuate a domestic routine. These are intensely private pictures; as Raymond Cogniat observed: 'Bonnard never paints the parts of the house where people work or receive visitors.'[16]

Painted around 1891, *Intimacy* (no.3) shows his sister Andrée, an accomplished pianist, and his brother-in-law Claude Terrasse, a composer and music teacher, seated in the yellow light of an oil-lit living-room. Puffs and trails of smoke from her cigarette, his pipe, and the pipe held by Bonnard's large pink hand in the foreground resting on a knee, mingle with the broken curving lines of the wallpaper pattern to become almost indistinguishable from each other. The three figures are fused in mutual closeness (they could be listening to music), a closeness conveyed through the way the figures are pressed up close to the painter's eyes, to our eyes, so close that it takes a while for our own vision to adjust, for us to be able to read these pressed-flat forms.

In *The Croquet Game* (no.4), Bonnard's masterpiece of the early 1890s, the family scene is set outside, in the garden at Le Grand-Lemps. This landscape, from which the sky is excluded, is seen at the time of day when the light is going and the figures beginning to fade into the dark green of the bushes. The closed-in space has the feel of an interior rather than a landscape. The most ambitious of Bonnard's paintings of the period, it is also the first to express fully the ideas and aims of the group of young painters who gave themselves the Hebrew name 'Nabis' (meaning 'prophets'). They followed the teachings of Gauguin, whom one of their fellow students, Paul Sérusier, had met at Pont-Aven in 1888. Gauguin's radical teaching, his stripping down of art to the essentials of colour, surface and form, his search for an aesthetic outside the Western tradition and his quest for the spiritual, encouraged this group of friends, which included Bonnard, Edouard Vuillard, H.-G. Ibels, Paul Ranson and Maurice Denis, to define their own idea of the purpose of art. One of their associates, Jan Verkade, remembered their call for no more easel paintings, no more superfluous furniture. Painting, he said, had to serve art as a whole, rather than being an end in itself.

The painter's work begins where the architect considers that his is done … We want walls to paint on. We want

nothing to do with perspective. A wall must remain a surface, it must not be breached by the representation of infinite horizons. There are no pictures. There are only decorations.[17]

In *The Croquet Game* Bonnard takes up that challenge. Faithful to one of the Nabis' principal demands, the canvas is first and foremost a surface uninterrupted by perspective and its 'infinite horizons'. Maurice Denis, the theorist of the group, expressed those sentiments with the dryness and precision of a communiqué: 'We should remember that a picture, before it is a battle horse or a naked woman or some sort of narrative, is basically a flat surface covered with paints put together in a certain order.'[18]

The rough texture of *The Croquet Game* (which Robert Rosenblum likens to tweed)[19] reflects the Nabi taste for the sixteenth- and seventeenth-century Flemish tapestries known as '*verdures*' and '*millefleurs*' which they knew from visits to the Musée de Cluny, and to the house of the collector Adam Natanson (the father of their friends Alexandre and Thadée, the founders of *La Revue blanche*). 'The humble subjects of these Cluny decorations', Vuillard wrote in his journal, before describing them as, 'The expression of an intimate feeling on a larger surface, that's all.'[20] Vuillard's genius lay in finding a way to elevate the mundane subjects of domestic life to the level and scale of great decorative art (as in the sumptuous and mysterious panels he painted for Dr Vaquez in 1896). In this respect he was unrivalled, but it was Bonnard who in this strange and mesmerising painting set the pace.

Firmly held together by the flatness of its surface, *The Croquet Game* conforms perfectly to Denis' definition of what a painting should be. The rigid vertical lines of the figures, the pronounced horizontals and verticals in the materials, the straight lines of the three mallets, peg the composition down into a tight formal construction. The control of the surface is reinforced by the concentration of the man crouching down to watch the shot about to be played by the central figure, by the dog waiting to pounce on the ball once it begins its roll towards the hoop, and by the central figure whose gaze plummets in a straight line from her head to her mallet. These invisible lines, stretched across the surface like taut wires, are an essential part of Bonnard's pictorial structure (e.g. the 'line' created by the two cats eyeing each other across the room in no.26, or the 'line' connecting the plate of fruit with its reflection in no.64). Making the subject an integral part of the formal structure sets Bonnard apart from his fellow Nabis, a point that can be made very clearly by comparing *The Croquet Game* with Denis' *Easter Mystery* (fig.1), an equally ambitious painting of the previous year.

Denis, whose painting is a confirmation of his strongly-held Catholic faith, combines the narrative simplicity of the early Italians with the Symbolist vocabulary of his own time. The mood of the painting evolves from the dark figure of Christ at the bottom of the picture, announcing his resurrec-

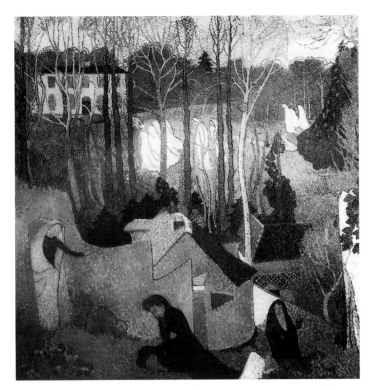

fig.1 Maurice Denis, *Easter Mystery* 1891, oil on canvas 104 × 102 (41 × 40⅛) *Private Collection*

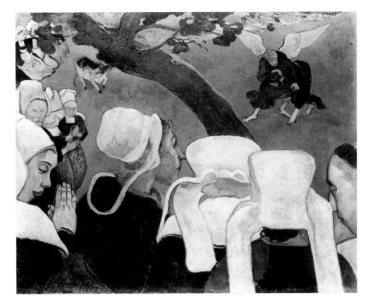

fig.2 Paul Gauguin, *The Vision after the Sermon or Jacob Wrestling with the Angel* 1888, oil on canvas 73 × 92 (28¾ × 36¼) *National Gallery of Scotland*

tion to Mary Magdalen, to the white figures at the top, souls to whom Christ has held out the promise of resurrection and eternal life. It is a painting of immense solemnity, but it is a solemnity that hangs on the painting like Proust's 'price-tag'. Bonnard, on the other hand, constructing his narrative around nothing more momentous than a croquet game, creates a work of extraordinary resonance and mystery. The main figures are locked in a moment of concentration that clamps the picture together, while off to one side, in complete contrast to the frozen poses of the croquet players, five young girls are joined in some high-spirited game. Dressed in white and utterly carefree, they are like a tongue-in-cheek response to Denis' solemn virgins. As Antoine Terrasse has pointed out, the structure of this painting, the way in which it joins together the real and the imaginary, was directly inspired by Gauguin's *The Vision after the Sermon or Jacob Wrestling with the Angel* (fig.2).[21] There, the peasant women, their imaginations fired by the sermon they have just been listening to, are confronted by a vision of Jacob's moral struggle. Denis' painting, too, owes much to Gauguin's, which both painters could have seen at a Paris art gallery where it had been deposited by Gauguin towards the end of 1888, the year it was painted.

In a photograph of the studio at Le Bosquet (fig.3), taken towards the end of Bonnard's life, a postcard of *The Vision after the Sermon* is pinned to the wall. It's impossible to tell whether it had been there long, or whether it was merely a recent addition to the other postcards and reproductions. What is certain is that from a very early date this painting became a talisman for Bonnard, providing him with a model

fig.3 Pierre Bonnard's studio at Le Cannet photographed by Cartier-Bresson in 1944. There are postcards of works by Vermeer, Monet, Gauguin, Seurat and Bonnard (*The Window* 1925), a reproduction of a Picasso (from a recent album published by Editions du Chêne), and a small painting by Renoir.

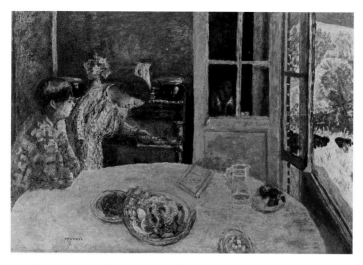

fig.4 Pierre Bonnard, *The Dining Room, Vernonnet* 1925, oil on canvas 126 × 184 (49⅝ × 72½) *Ny Carlsberg Glyptotek, Copenhagen*

to which he kept returning.[22] *The Dining Room in the Country* (no.26) was painted just over twenty years after *The Croquet Game*. The setting is Bonnard's house at Vernonnet, in the Seine valley. The French windows in the dining room open on to a garden with a view dropping away to water and distant blue hills. The contrast between the coolness of the interior and the summer heat of the garden is made more intense by the diagonal thrust of the thick piece of wood supporting the balcony overhead and the dark vertical slab of the doorjamb. The solidity of these architectural elements at the centre of the picture plays the same role as the massive tree-trunk does in Gauguin's painting. They serve as barriers between the familiarity of the dining room and the unexplored territory that lies outside. In many of the dining room pictures the garden is seen as a luscious haven of colour and warmth, a glistening memory of the garden of Bonnard's childhood at Le Grand-Lemps. The same process is at work in *The Open Window* (no.42). There, the barrier is the drawn-up blind, a dark slashing shape signalling the separation of the domestic world from the trees outside and the limitless blue of the sky.

In many of the dining room pictures, the contrast between the interior and the garden is registered by a sudden raising of the temperature, a device that Gauguin had used when he placed the imaginary figures of Jacob and the angel on a field of fiery red. In *The Dining Room, Vernonnet*, 1925 (fig.4), the cool colours of the tablecloth – pinky-beige, blue, mauve, aquamarine – move first towards yellow, then a stronger blue, before colliding with the ringing tones of the violet and blue under the window. The temperature continues to rise as the image moves through gold, red and yellow to the shrill acid greens and yellows of the garden beyond. The steady progression across one space to another is seen in Bonnard's play on the empty surface of the table against the vertical bands which describe the wall, the dresser, the door, the window, a progression which leads the eye away from the room and out into the world beyond.

In still later works, that world outside becomes more densely planted, greener, lusher, as though it has been transfigured by the heat and languor of Gauguin's South Pacific. In *Dining Room Overlooking the Garden*, 1930–1 (no.62), the landscape crowding the space outside the window reaches back to a small gate, the other side of which, just beyond our range of vision, are specks of life, possibly figures. Miniaturised by the distance and the abundance of nature, these visual hints draw the eye back into a space that invites the same lengthy contemplation as the plates and dishes laid out on the table. A similar effect occurs in a still life painted around the same time, *Still Life in Front of the Window* (no.63), in which Bonnard picks up the motif he had used years before in *The Croquet Game*. In this still life, the image of an undiscovered world is conveyed by the flecks of red and black vanishing into the background beyond the stone balustrade. There is a vast distance between the bowl of peaches in the foreground and the scene outside, a distance made more dramatic and intense by the resonance of the sunlight, deep as shadow. The time of day is in no doubt. The light-soaked fruit, orange-red spheres stroked with violet, are a reminder of a description by Bonnard of peaches lying in a dish: 'They are so intense and soft, and some of them resemble the setting sun.' The description of a day coming to its end expressed in the deep burnished red of the interior, made more intense by the gradual blackening of the window-frame, prepares the way for Bonnard's larger theme. The slow passage of time expressed in the ripeness and maturity of the peaches (contrasting with the sprig-like shapes of children playing outside) extends into the garden beyond which, as so often in Bonnard's later works, appears as a distant and unattainable paradise.

Reinstating the vague

Bonnard's early work was created in a climate of Symbolist thought. The reaction of the Nabis against what they saw as the materialism of their teachers led them, as Maurice Denis said, 'to seek for beauty outside nature'.[23] One of their leaders in this respect was Stéphane Mallarmé, whose writings appeared in *La Revue blanche* and whose poems were read aloud at gatherings of the Nabis. Bonnard admired Mallarmé profoundly, as a poet and as a man. As Thadée Natanson observed: 'Mallarmé is the one faithful companion whom he enjoys meeting every day as much as he enjoys his daily walks.'[24] To understand Bonnard's strong attachment to Mallarmé it is enough to compare, say, *Still Life in Front of the Window* (no.63) with the famous passage from Jules Huret's interview with the poet in 1891:

The contemplation of objects, the images and flights of fancy arising from this contemplation – these constitute the song … To name an object is to destroy three-quarters of the pleasure we take in the poem, which is

derived from the enjoyment of guessing by degrees; of suggesting it. That is our dream.

Symbolism is the perfect way to approach this mystery: one gradually conjures up an object so as to demonstrate a state of mind, or, conversely, one chooses an object which, when gradually deciphered, reveals a state of mind.[25]

When Bonnard described his method of working as looking, taking notes, reflecting and dreaming (by which he means, perhaps, allowing his imagination to take possession of the motif), he was describing a process which is analogous to that followed by Mallarmé. The peaches are contemplated rather than observed, and painting them becomes a means of extracting from nature a meaning and a value that goes beyond representation. The process is more marked in the later paintings because by then Bonnard had a much greater mastery of colour as a means of describing the experience of looking. Nonetheless, it is a process which is there almost from the start. In the small *intimiste* paintings of the mid-1890s (e.g. no.7), as much as in a mature work such as *The Table* (no.50), he uses the expanse of a tablecloth in the same way as Mallarmé uses the expanse of a verbal space to suggest an emptiness occupied by a floating succession of impressions and memories.[26] When Bonnard made a note to himself in his 1939 diary 'that the inner feeling of beauty be at one with nature, that is the point',[27] he was keeping faith with the Symbolist credo of his youth.

Writing about Mallarmé, the poet Yves Bonnefoy has pointed out that as the myriad facets of a single perception cannot be contained in a single line of verse, the first duty of the poet is to preserve what Bonnefoy calls 'the rhythmical play of his gaze', which is to say he must leave plenty of room for 'the restlessness of words: words he barely discerns, just as his eye catches a vague glimpse of one thing as it follows another, words dismissed at the time but nevertheless retained, suspended in memory…'.[28] Keeping the same words, the same images in a continual state of flux has its parallels both in the way Bonnard retains his small vocabulary of objects and in the way he paints them. The same pots, carafes, chairs, vases, the same blue cigarette box, the same oval wicker basket, the same interiors, the same woman appear and reappear over a period of nearly fifty years.

Mallarmé's reluctance to weaken the mystery of an object by naming it finds its equivalent in Bonnard's understanding that at times the precision of naming takes away from the uniqueness of seeing. An early example of this is *The Pears, or Lunch at Le Grand-Lemps* (no.14). Here Bonnard pushes the table-top back into the picture. The objects placed on the tablecloth are noticed, but only casually. The carafe of water, for instance, is lightly drawn in black with four or five strokes of white and a dab of pink at its centre. The carafe of wine, the coffee pot, the plates of fruit are each observed as though hovering at the edge of his vision. Some of the objects are more in focus than others. Those on the right-hand side of

the picture are so lightly washed in with white, a few strokes of pink and blue giving them the merest suggestion of form, that it seems as though they have passed across the painter's field of vision virtually unnoticed and unrecognised.

That unevenness of looking is recorded in the process. Very often, Bonnard begins with a base of very liquid paint diluted with so much turpentine that it covers the canvas like a vapour. From this he gradually builds up the paint in layers, sometimes to a thick and crusty finish. In *The Lunch*, 1899 (Bührle Collection, Zürich), the top paint is very different from that seen in no.14; it is thick and almost roughly applied, especially in the sticky black of the tray and the intense green paint in the chair-backs, while the dress of the young child standing on the right is so thickly painted that Bonnard is able to indent a long vertical line down one side by scraping through the paint with the pointed end of his brush. In other parts of the canvas the liquid underpaint remains visible, as do the pencil lines sketching in the composition. In no.14, Bonnard pins down the objects with accents of black, on the blade of the knife, on the cup at the top right edge of the table and on the silvery grey of the coffee pot. Here the shape of the young girl is blurred, a sudden movement forward suggested by the hazy penumbra following the line of her back. A very similar process is at work in the late still lifes of the 1940s. In *Still Life with Bottle of Red Wine* (no.85), the apricot white of the tablecloth is both rough and luminous with narrow areas of the canvas so thinly painted that the weave of the canvas shows through. These become little halos of light around the dish of fruit, the wine bottle at the back of the composition and the jar in the foreground. Bonnard paints objects as though he has no prior knowledge of their forms, as though he has watched them take their shape from the light. However familiar the object, its appearance is never fixed.

Hans Hahnloser remarked on Bonnard's habit of including in his paintings 'a cloudy and indistinct shape'.[29] This is usually a piece of loose material such as a towel or a curtain whose soft form inflating into the space acts as a foil to the rigid armature of a naked body, the frame of a door or a window. The formlessness of the sheets, towels and clothes scattered around the bedroom in *Man and Woman* (no.16) contradicts both the solid vertical of the folded screen and the angularity of the male nude. In *The Bathroom* (no.24), the transparency of the curtains and the flimsiness of the material covering the divan set up a counterpoint to the sculptural figure of the nude. A more extreme example is *Nude Standing by the Bath*, 1931 (fig.5), in which the emptiness of the bath, the billowing white curtain and the clothes thrown over a chair create a scene in which everything, except the nude, becomes a heaving mass of unformed possibilities. Moreover, as Bonnard once said, he liked to construct a painting around an empty space.[30] His ingenuity in finding flat or hollow forms that provide that empty space, and which nonetheless appear natural and unforced, manifests itself from a very early date, in the mattress of no.15, for instance, or in the

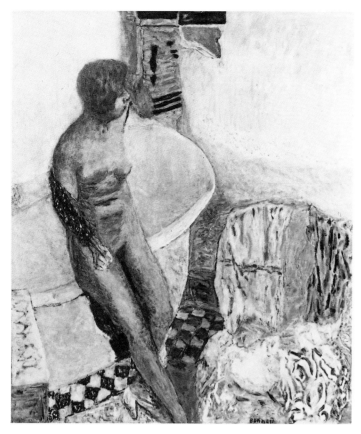

fig.5 Pierre Bonnard, *Nude Standing by the Bath* 1931, oil on canvas 120 × 110
(47¼ × 43¼) *Musée National d'Art Moderne*

table top in no.14. It is a device that becomes as characteristic
as a signature: spaces that in the early pictures tend to be flat
and square in shape, later become round or oval receptacles,
such as a tub (no.34), a bath (no.48), a basket or bowl (no.69).
These 'holes' or 'hollows' are invariably placed at the centre
of the picture. Sometimes, in the dining room pictures and
the still lifes especially, Bonnard keeps this sense of empti-
ness in play through the objects themselves. The white space
of the tablecloth in no.50, for instance, is laid with plates and
dishes of fruit, but some of these objects, like the four white
plates, and the half-empty bottle placed at the centre of the
composition, as well as the grey-blue seeping patches of
shadow, are spaces that fill the emptiness of the table, but
which by being left unfilled themselves reinforce a percep-
tion of absence. John Berger, writing about *Indolence*,
observed 'how the painting is pulling towards a very different
image: the image of the imprint of a woman on an *empty*
bed'.[31]

Bonnard is a painter who, as Patrick Heron pointed out in
1972, knows 'how to make a virtue of emptiness, how to keep
a great expanse of the picture surface intensely meaningful
without any resort to picture-filling incident'.[32] The other
side of this is that Bonnard also makes a virtue of excess.
Whereas emptiness in his paintings is often associated with
the house and the things that are found in the house, excess
is associated with the untidiness of nature, above all with
the riotous disorder of an overgrown garden. Bonnard's

sympathy for the unpredictability and anarchy of nature is
nowhere more evident than in *The Garden* (no.76), where the
tangled density of late summer growth is imitated in the way
the painter himself seems to rebel against the strict mar-
shalling of the surface found in the interiors, in, say, *Nude
with Chair* (no.79). Right at the end of his life, he noted down
a sentence from Delacroix's Journal, 'one never paints
violently enough'.[33] Combining, or reconciling, violence and
order in a painting is at the heart of the many contradictions
found in Bonnard's work between the subject and the paint.
The meditative stillness of *The Vigil* (no.41) or *Nude in the
Bath* (no.75), for instance, is expressed with an astonishing,
and unexpected, vehemence of colour.

Bonnard's acceptance that vagueness and incompleteness
are an essential part of consciousness has many parallels in
the literature of his own time, in the writings of Henry
James, of Proust as well as Mallarmé (James's brother, the
philosopher William James, was another prominent figure
who stressed the importance of what he called 'the reinstate-
ment of the vague to its proper place in our mental life').[34]
Proust was attracted to those painters of his own day who
prized the suggestiveness of uncertainty – Whistler, for
instance, as well as Vuillard. Here he is describing the
impression made on him by a collection of paintings by the
fictional painter Elstir belonging to the Duc de Guermantes:

> Among these pictures, some of those that seemed most
> absurd to people in fashionable society interested me
> more than the rest because they recreated those optical
> illusions which prove to us that we should never succeed
> in identifying objects if we did not bring some process of
> reasoning to bear on them … Surfaces and volumes are in
> reality independent of the names of objects which our
> memory imposes on them after we have recognized them.
> Elstir sought to wrest from what he had just felt what he
> already knew; he had often been at pains to break up that
> medley of impressions which we call vision.[35]

The gap that exists between seeing an object and recognising
it comes across very strongly in the way certain objects in a
Bonnard painting remain utterly mysterious. It is as though
the painter, in seeing them, has either forgotten what they are
or failed to recognise them.[36] One can only guess at the iden-
tity of the shape protruding into the picture from the right in
Dining Room Overlooking the Garden (no.62), while the
blurred shape by the table in *The Mantelpiece* (no.111) or the
merging patches of brown and yellows in *Nude with Green
Slipper* (no.55) become coherent only after long and careful
study. And how is one to read the shapes centre top of fig.5?
The acceptance of abstract shapes in a figurative world is
found in the Japanese prints Bonnard admired (and bought),
but it is also worth noting that in the late 1880s parallels
between Japanese prints and Symbolist literature were being
made by critics like Renan, who was surprised to find in
Hokusai 'the plastic realisation of these dreams of the
beyond, of these nostalgic musings that the most advanced

literary schools in England and France have thought them-selves alone in sighting'.[37]

Bonnard makes us aware of the way in which conscious-ness is made up of a flow of haphazard perceptions, but he also makes us aware that the principal subject for the painter must be the surface which, as he says, 'has its colour, its laws over and above those of objects'.[38] Compare Matisse in his 1908 *Notes of a Painter*: 'the work of art must carry within itself its complete significance and impose that on the beholder even before he recognises the subject matter.'[39]

Stuck to life

Bonnard said he had all his subjects to hand. One was Maria Boursin, whom he met when he was twenty-six.

She was born in 1869 at Saint-Amand-Montrond, a small town south of Bourges, the capital of the Department of the Cher, one of five children of Amable Boursin (1830–?), a car-penter, and Honorine Méténier (1830–1927).[40] By the time she met Bonnard on a Paris street in 1893, she had left home, moved to Paris, found a job and changed her name to Marthe de Méligny.[41] She had so effectively erased her past that not even Bonnard learnt her real name until their marriage in 1925, nearly thirty years after they began living together.[42] Her reason for breaking off all contact with her parents and with most of the other members of her family is unknown. However, she remained in touch with her younger sister Adèle, who had also moved to Paris (where she met her future husband, Adolphe Bowers).[43] According to Pierrette Vernon, Marthe's great-niece, Marthe and Adèle met regularly in Paris up to around 1920, although it appears that neither Bonnard nor Adolphe Bowers were aware of these meetings; nor did Adèle know the identity of the artist with whom her sister was living.[44] A handful of postcards received from one of her four nieces, Gabrielle Bowers, shows that she remained sporadically in touch with her sister's family up to the end of the First World War.[45] Although her mother was still alive at the time of the Bonnards' marriage, Marthe claimed otherwise.[46] The truth may be that she had no wish to find out. Hédy Hahnloser, a close friend of Bonnard's and a loyal collector of his work, gave evidence on behalf of the Bonnard heirs in 1952 at one of the hearings in the long drawn-out dispute with the Bowers family over the Bonnard estate. She told the court that she had heard Marthe say a thousand times that there had been no one to care for her during her childhood: 'without her beloved grandmother she would have been completely abandoned. Never once, not a single time, did she say anything about a sister, or even a niece.'[47] Thadée Natanson, another witness for the Bonnard family at the 1952 hearing, said that Marthe always claimed that her only family was her grandmother.[48] It is not hard to understand how someone who claimed to have no family, no ties of any sort, and whose past was a blank would have appealed to Bonnard's love of solitude and privacy.

When, at the age of twenty-six, Bonnard decided to make his life with Marthe, he was defying the respectability of his family's solid middle-class background. His friends from the professional classes who maintained an easy balance between convention and nonconformity, families such as the Bernheim-Jeunes, the Natansons, and later the Hahnlosers, accepted Marthe as Bonnard's companion and were unfail-ingly kind and hospitable to her. And, so it appears, were Bonnard's own family. A photograph (fig.146) taken at Le Grand-Lemps in 1913 shows Bonnard's family seated around a table in the garden with himself and Marthe. None the less, certain conventions were observed. Bonnard's nephew Charles Terrasse only learnt about Marthe when he was seventeen: 'So we did know that our uncle was living with a woman, but this was something the family didn't discuss in front of the children.'[49] It is also the case that Bonnard chose to keep his marriage a secret (his family only found out about it after his death).[50]

Gradually, from 1893, Marthe's presence slides into the work. She is the girl pulling on a black stocking (no.6), lying fully clothed on a divan (no.21), pulling a chemise over her head (no.18). Her round face, small, slightly-built body with narrow hips and long legs, make her an instantly recognisable model, and Bonnard made many drawings of her for two important sets of illustrations, Peter Nansen's *Marie* and Verlaine's *Parallèlement*. The drawings for *Marie* (fig.42) were used later as studies for paintings, while the drowsy nudes he did for the Verlaine poems relate to a group of major paintings executed between 1898 and 1900 (nos.15–17).

One of these is *Indolence*, a painting of a young girl stretched out naked on a bed. One arm is thrown across her breast, the other supports her head. Her right leg dangles over the edge of the mattress, the other is drawn up at right angles to it, the big toe arched as it lightly scratches the inside of the right thigh. The bedcovers, which have been pushed down to the end of the mattress, form a loose shadowy mass down the right-hand edge of the canvas and wash back into the picture like dark foam. The young girl looks out at the viewer, who in turn looks down at her from the height of someone standing by the bed. The scene is lit by the artificial light of an oil lamp, which turns the white sheet covering the mattress faintly yellow and the covers the colour of wet seaweed. The uneven lines of shadow oozing over the sheet reinforce the sense of liquefaction. (There is a strong affinity here with Maillol's *The Wave*, particularly with the woodcut he made of the image in 1895–8.)

There are two versions of *Indolence*: no.15, which Bonnard kept for himself; and the one now belonging to the Musée d'Orsay, dated 1899, which belonged to Thadée Natanson. In both, the presence of an unseen male companion is subtly introduced, in the first version, no.15, by the clay pipe which can just be seen lying on the edge of a table at the top of the picture; in the second, by a small cloud of smoke suspended above the area between the woman's pubis and her left ankle, as though exhaled by a figure standing over the naked body.

Bonnard was at this time a habitual smoker of clay pipes (see no.3).[51]

The image of *Indolence* has often been compared to Manet's *Olympia*. But whereas Manet's work was a very public painting, *Indolence* was a painting to be enjoyed privately.[52] It has the intimacy of a bedroom scene by Fragonard.[53] The great slab of mattress filling most of the canvas becomes a vast space, as large, as grand and as solemn as the bed once imagined by Mallarmé: 'as big as a sacristy' ('grand comme une sacristie').[54] It makes this an image of profound repose, a sinking into sleep, maybe, or a drowsy awakening, a liquid melting painting which evokes Mallarmé's perception of woman as a state of deliquescence, as in his poem *Tristesse d'Eté*:[55] *Siesta* (no.17), the other great bed painting of this period, could well have been inspired by lines from the monologue spoken by Mallarmé's Faun: 'Non, ces closes/Paupières et mon corps de plaisir alourdi/Succombent à la sieste antique de midi./Dormons.'[56]

The way in which these paintings reveal a sensibility so close to Mallarmé's suggests that they may have been a conscious homage to the poet, whose death on 9 September 1898 would have been felt particularly keenly by Bonnard.[57]

The subject of *Indolence* and *Siesta* takes the idea that art should be faithful to life to an extreme that other Nabi painters would not have contemplated. It is a deliberate – even pointed – rejection of the chaste subject-matter favoured by Maurice Denis and his circle, as well as by Signac and the Neo-Impressionists. The bed in these paintings is Bonnard's (fig.6), the nude his lover. He wants us to look at her as he himself looks at her: closely, affectionately, wonderingly. This realism is so close to the bone, and so foreign to other contemporary painting in France, that it has prompted comparisons with the harder, grittier realism of Munch and Ibsen, both of whom were taken up by the Natanson brothers in their literary magazine *La Revue blanche*.[58]

But the differences between Munch and Bonnard are far greater than the similarities. *The Day After*, painted in 1894–5, is the Munch painting most often compared to *Indolence*.[59] (Bonnard would certainly have known it as a drypoint of the image was published in 1895.) It is a painting about sickness, physical and spiritual, and the story it tells is clear enough: a young girl, perhaps a prostitute, her bodice undone, lies insensible on a bed. The bottle and two glasses on the bedside table suggest that she has been abandoned after a night of casual sex and alcohol. The image is harshly realistic, but it is fiction. Bonnard's art was stuck to life. And nowhere is this made clearer than in another intimate picture of his own bedroom, *Man and Woman* (no.16), which includes a full-length naked self-portrait. Standing in front of a mirror in which he can see Marthe, also naked, seated on the bed playing with two cats, her skin illuminated by the pale yellow of artificial light, Bonnard appears as a tall, bony, shadowy figure divided from her by a folding screen, a severe vertical division that accentuates the separateness of the two figures, rather as the Tree of Knowledge separates Adam and Eve.[60] Here, the play between intimacy and distance (one of Bonnard's chief characteristics) is given a particularly fine edge.

Yet it would probably be misleading to read too much drama into Bonnard's use of the diptych:[61] his preoccupation with his own separateness is by no means confined to this work. *Man and Woman* is the first of several paintings in which he appears with Marthe, but the only one in which he

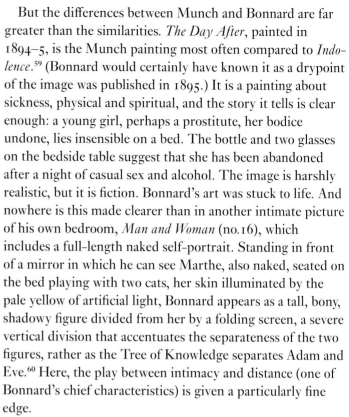

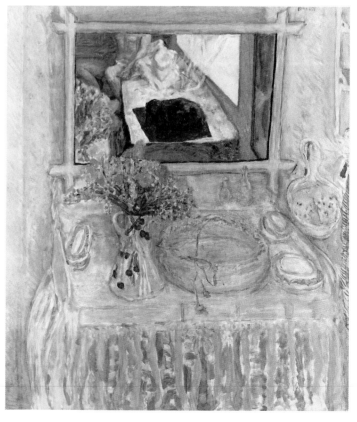

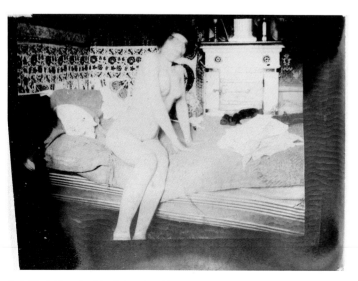

fig.6 Maria Boursin (Marthe), *c.*1899. Photograph by Bonnard. *Musée d'Orsay*

fig.7 Pierre Bonnard, *Dressing Table and Mirror c.*1913, oil on canvas 124.1 × 116.7 (48⅞ × 46) *The Museum of Fine Arts, Houston*

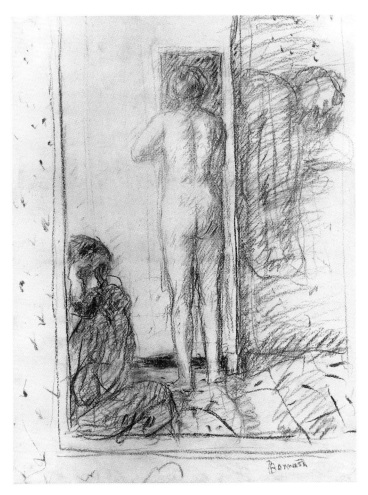

fig.8 Pierre Bonnard, *Standing Nude with Head of the Artist* 1930, charcoal on paper 60.3 × 45.7 (23¾ × 18) *Private Collection*

is fully visible. Usually he makes his presence known by revealing just a part of himself, a headless body (fig.7), a knee (no.46), an anonymous profile (no.47), his hands (nos.3 and 65), a distant head (no.73). In many of these images he is the only one of the couple who is seen to *look*. Marthe rarely looks out of a picture, her head is often bowed, turned away, and if she does look straight ahead her stare is blank rather than alert. In *Man and Woman* Bonnard is both looking out of the picture and back into it through the mirror, as he does in a later drawing (fig.8). His face is mostly in shadow, muffling his gaze, which nonetheless shows him to be alert and watchful, while Marthe, distracted by the cats, is enclosed in a world of her own. Even when his face cannot be seen, as in *Nude in the Bath*, *c*.1925 (no.47), Bonnard's unwavering attention is conveyed by the purposefulness of the upright figure moving into the picture from the left, a pose that contrasts dramatically with the passivity of Marthe lying inert in the water. (The position of Bonnard's hands in this painting suggests that he may be drawing himself in the bathroom mirror.) Sometimes his attentiveness catches us off guard, as in *The Dining Room, Vernonnet* (fig.4), where the painter conceals himself behind one of the panes in the door. His face is smudged against the glass as he stares into the room. The two women, seemingly unaware of this strange silent pres-

ence, focus their attention on the Bonnards' German basset, Ubu, whose muzzle is just visible above the table.

Another 'hidden' self-portrait is found in *The Earthly Paradise* (no.36), one of the four decorations Bonnard made for the Bernheim-Jeune family between 1916 and 1920. The figure of Adam gazing at the landscape stretching back to distant blue hills is surely the painter himself, while the sleeping Eve stretched out on the ground may be an allusion to Marthe. The painting itself can be read as a reworking of *Man and Woman*, particularly since one of the sketches for that early work (fig.35), in which a naked male holds out his arm as though to receive an offering, suggests that at that time Bonnard may have been thinking of Adam and Eve as a possible theme, a theme that might easily have been inspired by the photographs he and Marthe took of each other naked in the garden.[62]

Marthe is almost always seen in her own domestic surroundings, and as an integral part of those surroundings. In some paintings she is so much a part of the room that she is barely noticed, as in *White Interior* (no.68), where she bends down to feed the cat, her head and back describing a smooth feline arc against the vertical lines of the radiator and the French windows. In *The Open Window* she is glimpsed in a chair on the right-hand side of the picture, her face almost rubbed out by the light filling the room, and in *The Breakfast Table* (no.73), seen as an almost transparent profile, she fixes her attention on the table, oblivious to the watchful attention of her husband whose reflection is seen in the mirror just beyond the crown of her head. (These profile views of Marthe are reminders of the enigmatic and translucent profiles in the paintings of Odilon Redon, a painter that Bonnard, along with his fellow Nabis, admired unreservedly.)[63] In a sense many of these works are variations on the theme of the artist and his model as well as on the double portrait. This is the case even when Bonnard is not visible. In the last bath paintings (nos.75, 80, 94), the viewpoint is that of someone standing looking down at the figure lying in the water, a return to the viewpoint in *Indolence* which, as we have seen, is that of someone looking down at the figure on the bed. We are always made acutely aware that whatever the subject of the painting – a nude, a still life, a landscape – what we are being asked to witness (and to participate in) is the process of looking. But it is in the paintings of Marthe above all that we find Bonnard portraying himself as the ever-attentive, watchful presence.

In a conversation Bonnard had towards the end of his life with some friends who were visiting him at Le Cannet, one of them quoted Balzac: 'A curse on the man who keeps silent in the middle of the desert, believing that there is no one to listen to him.'[64] Bonnard, after asking him to repeat the sentence, paused for a long time before replying, 'Speaking, when you have something to say, is like looking. But who looks? If people could see, and see properly, and see whole, they would all be painters. And it's because people have no idea how to look that they hardly ever understand.'[65]

Towards the end of his life Bonnard told a fellow painter, 'There was a time when, under pressure from my dealers, I let them have canvases that I ought to have kept, either to do more work on, or to forget about and return to later. This is why a number of them – at least half – need further work, or should even be destroyed.'[66] He may have been making a general point, but his remark has a particular relevance to the years between 1906, when he was given the first of his many one-man shows at the Bernheim-Jeune gallery, and the First World War when the art market went quiet. In those eight years he exhibited over two hundred new works. At a time when he was working his way out of the *intimisme* of the 1890s without having found a clear direction, when his painting was beginning to look a bit too much at ease with itself (especially in comparison with what else was happening in Paris), his willingness to settle into a steady rhythm of production for the art market, to allow too many works out of the studio, left him dangerously exposed.[67]

He had also been left exposed by the success of his Nabi pictures. By the early 1900s, the rich seam of autobiography that had carried him through from *The Croquet Game* to *Indolence* and *Siesta*, and which had given him a very strong artistic identity, closed down. A new restlessness and uncertainty creeps into the work as he moves away from the *intimiste* interior, widening his subject-matter and tackling larger, more demanding canvases. Two particularly fine works from this period, both views of the Place Clichy (Dauberville nos.409 and 410), show a new element of complication being introduced into the street scenes of the 1890s (no.8) as he combines the *intimisme* of the Nabi paintings and the realism of Impressionism (which he discovered surprisingly late)[68] with the large scale of the decorative panel. As he told Ingrid Rydbeck in 1937, like others of his generation he had wanted to take Impressionism further, particularly with regard to composition,[69] but the new directions European art took in the 1900s and 1910s, and the speed with which critics took up new positions, left them, as he put it, suspended in mid-air.[70]

He now started to travel, visiting museums in Holland, Spain, Belgium and England in the company of friends such as Vuillard and Roussel. He went back to painting from the model,[71] at the same time pursuing the contemporary fashion for pastoral fantasies in works such as *The Faun or the Rape of the Nymph* (no.22). It was around this period too that he established a pattern of dividing his time between the city and the countryside.

The pastoral subjects look back to the nudes of *c.*1900 in that they have a strong erotic content as well as containing the occasional self-portrait (ironic depictions of himself as a lecherous satyr or Pan, in homage perhaps to Mallarmé for whom the faun was a symbol of the artist).[72] But the pastoral theme, so popular in French art of the time, did not fit Bonnard as easily as it did, say, his friend Ker-Xavier Roussel,

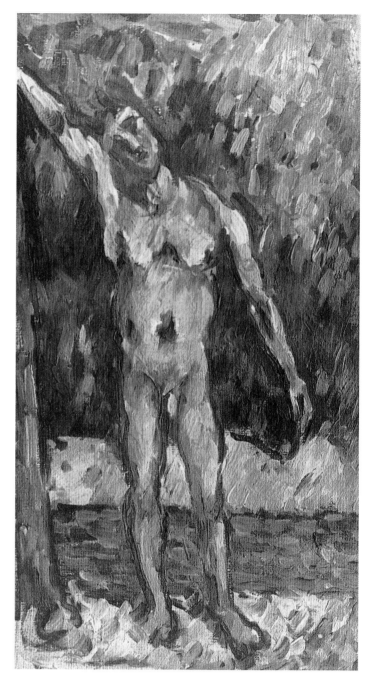

fig.9 Paul Cézanne, *Nude Bather c.*1876, oil on canvas 24 × 14 (9½ × 5½)
Private Collection

whose lightness of touch made him ideally suited to painting southern landscapes heavy with sun and pink blossom and populated with dancing nymphs and satyrs. The series of 156 lithographs Bonnard made as illustrations for *Daphnis et Chloé* in 1902 is his masterpiece in this genre, possibly because of the intimate scale, but chiefly because these works show a style of drawing, both dense and airy, which created the perfect graphic style for Impressionism.

The composition of *The Faun or the Rape of the Nymph* is the first sign of Bonnard's interest in Cézanne as a great figure painter (it was painted the year after Cézanne's death). His response to the challenge Cézanne's bathers posed to virtually every young artist around 1905–10 is very different from that of, say, Derain, Braque or Picasso. Ignoring the

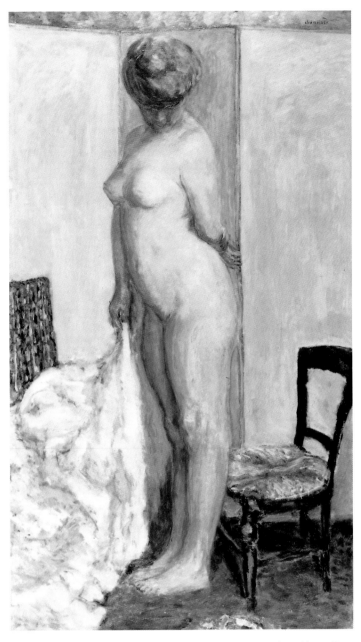

fig.10 Pierre Bonnard, *Standing Nude c.*1905, oil on canvas 140 × 80 (54¼ × 31½)
Private Collection

problems that interested those painters – the problem, for instance, of inventing a new iconography for the nude (which Picasso mastered in *Les Demoiselles d'Avignon*) – Bonnard chose a different route (his own invention of a new iconography for the nude was to come later). *The Faun or the Rape of the Nymph* suggests that the Cézannes he looked at most closely were the erotic paintings of the 1870s, such as *The Abduction* or *The Battle of Love*. Cézanne made three versions of the latter; an oil owned by Pissarro,[73] one believed to have been given by the artist to Renoir,[74] and a watercolour owned by the writer Octave Mirbeau (fig.47). It's hard to believe that Bonnard was not familiar with one or other of these versions, especially as Mirbeau, for instance, was someone he had known well since the days of *La Revue blanche*. *The Battle of Love* comes straight out of Greek mythology, as does *The Amorous Shepherd*, another of Cézanne's paintings inspired

by pastoral themes which Bonnard could also have known at first hand as it belonged to his dealer Josse Bernheim.[75] Bonnard takes his cue from Cézanne's own ambiguous treatment of these erotic themes. Figures seen from a distance are either grappling with each other or fiercely embracing. He returns the subject to its classical roots by turning the male into Pan, the embodiment of desire – and, typically, moves in close to the figures relishing their physical proximity. This is made clearer still in the pleasure he seems to take in accentuating the softness of the faun's furry pelt, just as he did in *Fauns*, the pastoral landscape of 1905 he gave Arthur and Hédy Hahnloser some years later, in which the faun is seen lying on his back being tickled into a small pink erection by one of the nymphs.[76]

The Faun or the Rape of the Nymph is situated between the classical idiom of Cézanne's bathers and the pastoral ideal and humour of Roussel's mythological decorations. The nonchalance and effervescence of Roussel's brushwork may appear totally opposed to the densely packed, rhythmical marks of Cézanne, but as Denis pointed out, it was Cézanne's example that taught his generation 'to turn sensory perceptions into art'.[77] The Nabi preoccupation with surface, while fed by many different sources, owed much to Cézanne's exquisite use of the sable brush. But it was Cézanne's effortless fusion of the figure with its surroundings, the way in which his bathers fit into a landscape as naturally as rocks, slopes and trees, that finds its equivalent in Bonnard's nudes, figures which fit into an interior like a post in the floor or as a door into a wall. And if the poses of some of Cézanne's bathers call to mind – perhaps fortuitously – those adopted by Bonnard (the bathers of 1890–2 in the Musée d'Orsay, is a case in point), it is because Bonnard, like Cézanne, was looking to the human figure to provide a paradigm of balance. His acquisition sometime before 1910 of a small Cézanne oil,[78] *Nude Bather* of *c.*1876 (fig.9), is significant in that it is one of a series in which Cézanne works out a pose that is an expression of perfect equilibrium. In *The Bathroom* (no.24), the figure is placed at the centre of the picture, her body weighing down the soft ripples of the curtains and the divan and balancing the verticals of the window and walls. The rounded curves of her head, breast and buttocks echo the three round forms receding into the picture – the tub, the basin and the chair which carry the eye back to the nude in her mirrored image. The highly structured organisation of the surface and the way in which the nude fits into it is completely different from, say, an equally large and ambitious painting, *Standing Nude* (fig.10), painted around the same time or a little later. There the nude is a professional model and the painting has the look of a study done from life.[79] It is an uncomfortable work, with little going on between the figure and the background, or indeed between the artist and the model. Bonnard's own discomfort is palpable and one understands why he found the presence of the model or the object 'very disturbing' ('très gênante').[80]

If he was ill at ease with the model, he was hardly more

comfortable with those who sat to him for their portraits, even though they were usually friends or acquaintances. Leila Mabilleau, for example, the daughter of Bonnard's friend Claude Anet, remembered how her portrait proceeded slowly and painfully through ten sittings in his Paris studio, and even then gave him very little satisfaction.[81] More often than not, Bonnard worked on a portrait in the absence of the sitter. Henry Dauberville recalled how Bonnard would place himself in front of the subject with a sketchbook, after which he would make drawings on large sheets of Ingres paper, then 'six months later he would summon you to the studio and you would find the painting completely finished.'[82]

Bonnard found it extremely difficult to paint in front of a static motif, just as he found it almost impossible to paint the unfamiliar. At the end of his life, when he was living alone at Le Cannet, he accepted Maillol's 'loan' of his model Dina Vierny. When she arrived he asked her not to pose but to move around the studio: 'He didn't want me to keep still. What he needed was movement: he asked me to "live" in front of him, and try to forget him.' And she added, 'He wanted both presence and absence.'[83] Around the same time, he confessed to a young painter, Kostia Terechkovitch, that he saw every new object as a source of intimidation (unlike Vuillard, he said). 'For fifty years I have kept coming back to the same subjects. I find it very difficult even to introduce a new object into my still lifes.'[84]

These were some of the inhibitions Bonnard had to deal with when he turned away from Gauguin's highly stylised synthetic art to immerse himself in the freshness and informality of Impressionism. One of the most revealing passages in a conversation he had with Angèle Lamotte (in 1943) is one in which he talks about Renoir, Cézanne and Monet.[85] These were painters, he says, who were able to work from the motif because they knew how to defend themselves in front of nature. His insistence on this point is interesting precisely because it indicates how concerned he was by his own reaction in front of the motif. He observed that Cézanne was able to hang on to his original idea by being extraordinarily patient in front of nature: 'he used to remain there, lizard-like, warming himself in the sun, not even touching a brush. He would wait until things had once again become as they were when he conceived them.'[86] Renoir defended himself by embellishing, Pissarro by arranging nature into a system, and Monet by never spending more than ten minutes in front of the motif: 'He didn't give things time to take possession of him.'[87] And he goes on to say that a comparison between the paintings by Titian and Velázquez in the Prado is a comparison between an artist who knows how to defend himself and one who does not.

Titian had a total defence against the motif; all his pictures bear the hallmark of Titian, they were conceived according to his initial idea of them. Whereas with Velázquez there are great differences in the quality of the motifs that he found seductive: his portraits of infantas,

and his big academic compositions in which all we can recognize are the models themselves, the objects themselves, in which there is no perceptible original inspiration.[88]

It was, he said, all a matter of the force of the initial 'seduction', the initial idea; if that failed, then all that was left was the motif, and from that moment the painter was no longer in control. 'With some painters – Titian for instance – this seduction is so great that it never leaves them, even if they are in direct contact with the object for a very long time.'[89] And he ends with the admission, 'Personally, I am very weak, it is difficult for me to control myself in front of the object.'[90]

The achievement of the earlier canvases, of *The Croquet Game* and *Indolence* in particular, is in the way the subject and paint mesh together. The croquet players merge and re-emerge from their green carpet as though woven out of the same material, and the nude in both versions of *Indolence* dissolves into the whiteness of the bed to the point where the body and sheet are one. However, this perfect fusion of subject and paint which is the hallmark of Bonnard's greatest paintings seems to have eluded him when he painted from the model or the motif.

Those masterpieces among the early works were composed in the studio. *Man and Woman* was preceded by at least two oil studies, (no.11 and fig.40), while in the case of *Siesta*, the nude was taken directly from an antique sculpture, the *Hermaphrodite* in the Louvre (fig.43).[91] A photograph of a number of life studies of nudes painted around 1904 shows small easel paintings which, in comparison with what had gone before, look tentative and unresolved. It's as though there is no collaboration between Bonnard and the model, as though he is stuck in the limbo of what John Berger has called 'a copying distance'.[92] Above all, there is no sign of the sudden and mysterious seduction by the motif, the trigger Bonnard depended upon to release the 'initial idea'.

Once again, there is a close parallel with Proust. In *Time Regained* the narrator experiences a very similar difficulty in dealing with the immediacy of the motif which he describes as follows:

So often, in the course of my life, reality had disappointed me because at the instant when my senses perceived it my imagination, which was the only organ that I possessed for the enjoyment of beauty, could not apply itself to it, in virtue of that ineluctable law which ordains that we can only imagine what is absent.

Reality, or the motif, stands for the intellect that, as Proust said, supplies the artist with pretexts for evading instinct.[93]

The solution to what one suspects had become an agonising dilemma was found around 1908–9, in no.24, for instance, or in *Woman in the Bathroom*, 1909 (fig.11). In these paintings, Bonnard returns to an idea first tested in *Siesta*

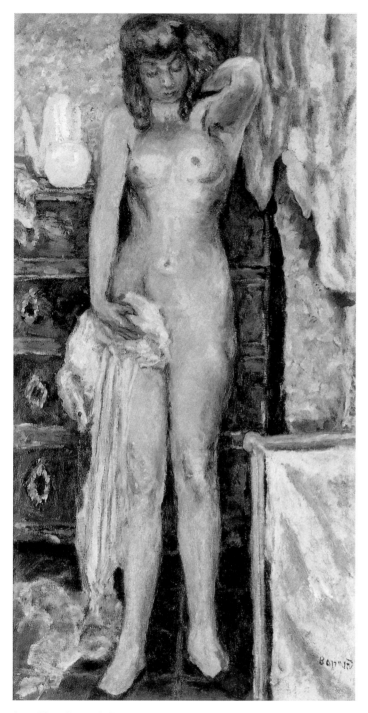

fig.11 Pierre Bonnard, *Woman in the Bathroom* 1909, oil on canvas 109 × 57 (42⅞ × 22½) *Private Collection*

Next to the postcard of Gauguin's *The Vision after the Sermon* pinned to the wall of Bonnard's studio was another of his 'talismans', Seurat's *Bathers at Asnières*. Seurat's ambition had been to portray his contemporaries in the same way as the sculptures of the Parthenon frieze publicly portrayed the contemporaries of Phidias,[94] and critics of the time – Félix Fénéon, for instance – saw him as 'being in the tradition of the Greek sculptors'.[95] An early flower piece, *Daffodils in a Green Pot* (no.1), suggests that Bonnard was very aware of Seurat from the start, and that awareness can only have been heightened by the retrospective of Seurat's work organised by the Salon des Indépendants in 1905, and by the major exhibition put on by Bonnard's dealers, Bernheim-Jeune, in 1909. (It may have been around this time that Bonnard acquired a drawing for Seurat's *The Models*, probably from Félix Fénéon.)[96] The way in which a nude, such as the young girl seen in Seurat's small oil (fig.12), combines the solidity of sculpture with the pliancy of flesh, is surely reflected in the

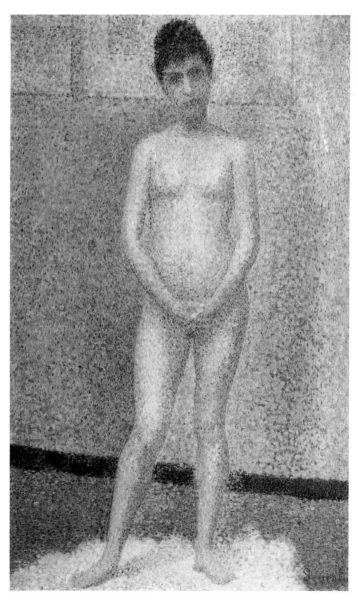

fig.12 Georges Seurat, *Standing Model* 1887, oil on ?wood 25 × 16 (9¾ × 6¼) *Musée d'Orsay*

and in *Woman with Black Stockings* (no.19), that of bringing together the historical and the contemporary by redoing a figure from the Antique in a modern idiom. By presenting the nude full-length and frontally, as in fig.11, Bonnard makes her resemble a standing sculpture, not unlike the small nudes he had made around 1906, in a short-lived experiment with modelling in the round. That experience of working in plaster shows that Bonnard was thinking of the nude in terms of sculpture, and this in turn helped him find in painting the weight and density appropriate to the human figure without having to work from a model.

nude seen in fig.11, painted the same year as the Bernheim-Jeune exhibition.

There is no doubt that Bonnard shared Seurat's desire to invest the human figure with the dignity and grandeur of classical art. In 1970 Antoine Terrasse drew attention to the way in which the poses of Bonnard's nudes reflect those of antique sculptures,[97] while in 1984 Sasha Newman pointed out a number of specific sources in addition to the *Hermaphrodite* in the Louvre: *The Dying Niobid* (fig.69),[98] for instance, and the Egyptian bronze, *Lady Takushit*, also in the Louvre (*Nude, Lit by a Lamp*, 1911), and the quotation from the Medici *Venus* in the nude reflected in the mirror of *The Bathroom*, 1908 (no.23). The arm raised behind the head is a gesture Bonnard seems to have borrowed as early as 1909 (fig.11), while the arm of *Lady Takushit* reappears as the left arm of Reine Natanson in *Marthe with Red Blouse*, c.1928 (Musée National d'Art Moderne, Paris).

Bonnard's borrowings from sculpture were wide-ranging, but the one piece that seems to have preoccupied him the most is *The Dying Niobid*. The top half of this celebrated statue is borrowed for no.31, while the lower half provides the position of the legs of the nude in no.34. Other figures of nudes in tubs or baths also seem to carry echoes of this sculpture (see no.30), but none of them, not even those that quote from it most directly, give any indication of the tragic origin of the pose, which is that of a woman, mortally wounded, sinking to her knees. The seated nude pulling on her stockings in no.19 is based on the *Spinario* (as is the seated figure in Seurat's *The Models*).[99] The standing figure in *Large Yellow Nude* is surely a back view of *The Medici Venus*, while the nude in *The Bath Mitten* is also a reminder of a classical Venus (see fig.105 and no.87), and *Nude Crouching in the Bath* is obviously based on the *Crouching Aphrodite* in the Louvre (see fig.121). The austere profile of a standing nude has the stillness of an archaic kouros (see fig.78), while the relationship between the seated woman and the attendant child in *The Sewing Lesson* (no.52) evokes the relationship between the figures on a Greek stele. Not all the sculptural sources are taken from Antiquity: the upright figure of Adam gazing into the distance in *The Earthly Paradise* (no.36) – one of Bonnard's few male nudes – brings to mind the gothic saints gazing down from the portals of French cathedrals, while *Grey Nude in Profile* looks as if it could have been inspired by a side view of Rodin's *The Age of Bronze* (fig.112). Nor are the sources always specific: a bronze statue from Angkor (fig.13) acquired by the Musée Guimet – a museum that Bonnard was in the habit of visiting – suggests that a sculpture such as this may have been the source for the carved verticals and horizontals of the legs that support many of his nudes, for example in *The Bathroom* (no.66), and *Nude in the Bath* (no.75). Many of these sculptures Bonnard knew extremely well. Antoine Terrasse has said that when Bonnard used to have lunch with his niece Renée Terrasse in the rue des Saints-Pères (where she worked), he invariably arrived at her office after a visit to the Louvre where, more often than

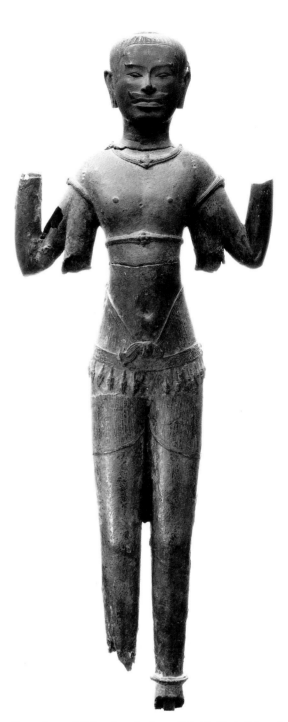

fig.13 Bronze figure of Vishnu from Angkor, H.88 (34¾) *Musée Guimet, Paris*

not, he had spent the morning looking at the collection of antiquities rather than visiting the paintings which 'he knew by heart'.[100]

Bonnard has no difficulty in making the gestures and poses of classical sculpture appear both natural and of his own time. Moreover, he emphasises the modern by following Degas' lead in domesticating the traditional subject of the bather by bringing her indoors.[101]

At the same time as the nudes reveal their sculptural pedigrees we recognise them instantly as living images of Marthe Bonnard. We do so not because her features are familiar to us – the poses Bonnard chooses invariably conceal her face – but because her body is one we come to know

extremely well. Even in *The Bathroom* (no.66), where what we mostly see is the top of her head, and her legs, we identify the round helmet of hair and the long narrow legs with the same ease as we recognise the essence of Madame Cézanne in the perfect Dutch doll oval of her face.

The way Bonnard draws on classical sculpture is to be expected from someone who, as his nephew Charles Terrasse remarked, 'felt a fascination for Greek thought which has not left him'.[102] Maurice Denis wrote about Racine that he used 'a limited vocabulary of elevated, thoroughly familiar words, just as Puvis de Chavannes uses simple gestures, white drapery and a blue sky'. Classic art, Denis goes on to say, 'contains nothing out of the ordinary, nothing unusual, its elements are known to everyone, they are banal'. He could be describing a Bonnard painting. At the same time, Bonnard's profound admiration for the art of Antiquity explains why he is one of the few major twentieth-century painters to have found no use for tribal art. This bias (if that is the right word) is perhaps one of the reasons why influential critics like Christian Zervos refused to see Bonnard as a significant modern artist, a judgement that has had profound consequences for his reputation.[103]

The way in which Bonnard is never tempted by a precise physical description that might distract from the unity of the whole can also be seen as tying in with his respect for the rules of classical art. The faces of the nudes, particularly those of the later years, are erased or blurred, even made invisible, their features scumbled over with a thick residue, rather like the accumulation of mineral deposits that encrust the surface of old marble. For example, the profile of the face of the nude in *Grey Nude in Profile* (no.74), which is heavily outlined in a deep terracotta; or *Standing Nude* (no.56). There, the golden brown paint describing the hair is painted in patches revealing green under-painting; it is as though part of a crusty surface has flaked off. Painting heads against a strong light is also an effective way of obliterating detail and playing down identity (e.g. no.96). Hands are often hidden and feet disappear into shoes or slippers. Objects are chosen for their form not for their particularities. This process happens very early on. The faces of Bonnard's family in *The Croquet Game* are either in profile, lowered, or turned away. In *Man and Woman* the nude's face is directed downward towards the cats playing on the bed, and in *Siesta* her face is half hidden. And it seems to be broadly true that, although the features of Marthe are recognisable in many of the domestic scenes in which she figures, they are more often than not effaced or concealed when she is portrayed as a nude. The unity of the composition is further reinforced by what Bonnard called the 'aesthetic of movement and gesture'.[104] The nude acts as a support, a pole on which the composition rests, and Bonnard is extremely careful not to let her line or form conflict with the simple geometry of the interior. As he said, 'there has to be a stop mechanism, something to lean on.'[105] Again, the example of Cézanne's bathers comes to mind.

Bonnard's discomfort in the presence of the model made working at an easel very uncomfortable. He preferred the mobility and variability of vision that comes from watching a figure moving about, or from moving around himself observing objects from different angles and different heights. (The tyranny of the single viewpoint may also explain why he gave up photography.) One of his cryptic diary notes reads: 'The eye's judgement – different, walking, standing, sitting'.[106] A prime example of this vision which takes into account the swivelling motion of the eye and the different positions from which an object is seen is *Corner of a Table* (no.72). This painting, which is more or less square, looks as if it has been turned on its side half way through its execution. That is to say, the table top and the chair look as though they could have been painted when the canvas was positioned in such a way that its bottom edge was what is now the right-hand side. But it is not always the painter who moves or changes his viewpoint. A number of the paintings require us to position ourselves at an angle to the canvas rather than dead centre. *The Spring or Nude in the Bath* (no.32), is a case in point. By moving to the right of the picture and looking at the composition on the diagonal (as though standing at the end of the bath), the viewer suddenly perceives the nude as round and solid, like a piece of sculpture.

Bonnard's instruction to Dina Vierny not to pose, but to live in front of him, brings us back to the early work. The figures in those works – his lover, various members of his family – had not modelled for Bonnard. They had arranged themselves by accident into certain poses which Bonnard had either remembered or recorded in sketches. His way out of the impasse of working from the motif that held him up, so to speak, for at least four or five years, was to return to that mixture of formal composition and improvisation.

Against the wall

In 1941, a visitor to Le Cannet remembered Bonnard telling him, 'it is enough for the painter if windows are sufficiently large to allow the full radiance of daylight to penetrate, like lightning, so that all its nuances can strike everything it happens to encounter.'[107] The first major painting in which light appears as the protagonist is *The Dining Room in the Country*, 1913 (no.26).

It is a large painting, the largest he had attempted since the triptych and decorative panels he had painted a few years earlier for the Russian collector Ivan Morosov. It was shown at the 1913 Salon d'Automne, where it was noticed by Guillaume Apollinaire who declared it to be 'pleasantly Vuillardian in mood', before saying that he much preferred the canvas by Matisse hanging in the same room (*Portrait of Mme Matisse*).[108] But, as has been pointed out by others,[109] it may have been precisely Matisse whom Bonnard had in mind when he began painting it.

The past five years had been triumphant ones for Matisse.

In 1911 he had completed four majestic interiors, *The Pink Studio*, *The Painter's Family*, *Interior with Aubergines* and *The Red Studio*. The year before that his two major decorative panels, *Dance II* and *Music*, had attracted a lot of attention, and in 1908, he had been honoured by a retrospective exhibition at the Salon d'Automne.

Comparisons have been made between *The Dining Room in the Country* and Matisse's *La Desserte* (*Harmony in Red*), 1908, but comparing Bonnard's picture with *Interior with Aubergines* (fig.14) is perhaps more telling. Both pictures have an underlying tripartite structure which is conceived in terms of layering. In the Matisse a decorative panel is placed against a screen which is placed against a canvas, which in turn is placed against the wall. In the Bonnard the layers are transparent; thus the glass panels in the door reveal a gauze-like curtain which reveals the wall. Both paintings introduce a similar device in the long shutter running down the side of the window pierced down the left-hand side. Matisse uses these holes to reveal the darkness of the wallpaper, Bonnard the brightness of the outside light. Matisse is already demonstrating the principles of cut-out shapes laid one on top of the other, whereas Bonnard demonstrates his affinity with Japanese prints and the way in which interior and exterior spaces unfold like screens. Matisse uses the window as an area of pattern to be fitted into a patterned whole (it is not the source of light). Bonnard sees the wide open window and door as conduits of the light that is at the core of the picture's drama. Both paintings are conceived as a series of linked, carefully articulated spaces for the eye to travel through. This is what makes *Interior with Aubergines* a very different painting from Matisse's earlier *La Desserte* in which the spaces demand to be understood simultaneously and instantaneously. In order to look at Matisse's great interiors of 1911 it is necessary to get inside them, to explore their space, and it is this sense of moving through a painting that in turn becomes so crucial for Bonnard.

Take *The Bathroom* of 1932 (no.66). The setting is the bathroom at Le Bosquet, a setting that is by now extremely familiar. The nude is familiar too, but neutralised into a smooth sculptural form. She is seen against a sheet of yellow-gold striped through with purples and red, a passage of glowing heat which is picked up in the soft brightness of the pink pubis. Between those two warm areas is the cool marble white of the nude's right breast reflecting off the scalding whiteness of the stool. The passage between the bath and the nude is a closely plotted course through the abstract patterns made by the heavily grouted bathroom tiles, the horizontal slats of the blind, and the grid created by the lozenge pattern of the linoleum floor (a successor to the checked blouses of the 1890s and the red chequered tablecloths of the 1910s). The eye is encouraged to pass over the painting's surface from left to right, as though following the light as it moves across the porcelain coolness of the bath and the damp blue tiles to the warmth of the nude's skin and the burnished coat of the dog. The measured pace of the colour here, and the

fig.14 Henri Matisse, *Interior with Aubergines* 1911, oil on canvas 212 × 246 (83½ × 96¾) *Musée de Grenoble*

way each mark is knitted into the structure of the composition, give the painting its weighty stillness. The clock, its hands pointing at five in the afternoon, quietly signals an arrest of time.

The drama of *The Bathroom* is in the behaviour of light, as it is in *The Dining Room in the Country*. Entering through the door and the window, the light hits the tablecloth with such brilliance that the white is changed into a piercing azure blue. This electrifying intensity is seen in *Nude with Green Slipper* (no.55) in which the blue in the bath mats and the blue lozenge-shaped tiles shines out with the unwavering brilliance of a neon tube. Bonnard once told his friends the Hahnlosers that all his life he had been trying to understand the secret of white.[110] The white porcelain baths and sinks, white curtains and tablecloths, white radiators and bathroom tiles that he returns to time and again are evidence of this passionate investigation into the way this colour acts as a receptacle for light. In *The Dining Room in the Country* he paints a blue that is so luminous, so electrically charged from within, that we know instantly that the white material of the tablecloth he was looking at has been transfigured by light. Blue, normally a cool colour, becomes a source of glaring heat. The light in that painting is daylight. The light in *The Table* (no.50) is artificial, but this in no way softens the dazzle emitted by the whiteness of the tablecloth, a whiteness that activates the spaces between the plates and dishes, exerting the presence of the cloth which seems to mimic through its shape and colour a piece of sized canvas. The analogy made here between a white tablecloth and a blank canvas, or a blank sheet of paper (it is surely a play on the traditional conceit of a painting within a painting) is not confined to this painting; it can also be seen in works as far away from each other in time as nos.14 and 85. Bonnard uses white as a transmitter, to

relay colour, but he also uses it as the colour of contemplation, stillness and emptiness. In *The Bath* (no.48) the wall of white enamel running the length of the painting with its barely perceptible modulations of colour moving very slowly and softly across the surface evokes the limitlessness of a sky, and the notion of the beyond. In the image of the bath, as in the image of the tablecloth, Bonnard makes us aware of what Gaston Bachelard has called 'the infinite quality of the intimate dimension'.[111] But it is his affinity with Mallarmé that is once more reaffirmed. In the prose poem 'Le Nénuphar blanc', the poet picks a water lily which encloses 'in the hollow whiteness a nothing, made of intact dreams, of a happiness which will not take place'.[112]

Increasingly, Bonnard's paintings are about the intimacy of contact; the contact made by the eye and the hand, the contact of light as it catches or brushes a surface, the intimacy of the contact between the painter and the paint. It is revealing, for example, how susceptible Bonnard was to the surfaces of antique marble sculpture: as he told Tériade in 1942, 'the beauty of an antique piece of marble lies in a whole series of movements indispensable to the fingers.'[113] Bonnard sustained that same intimacy with his own materials. When drawing, he used what George Besson described as 'an indescribably blunt pencil that was so short that a landscape or a nude seemed to spring from the ends of his fingers compressed around an invisible point.'[114] In other words, as he drew, his fingers travelled with the pencil, feeling their way across the surface of the paper. When painting, he sought a similar intimacy with the canvas, which led to his unorthodox way of working.

Just when he decided to tack his canvas to the wall instead of placing it on the easel is not easy to say, but it probably happened gradually rather than suddenly. Early photographs taken of him in his studio show an easel, and he obviously continued to make use of it during the early 1900s when he was working from the model, and occasionally later when he painted portraits. Nonetheless, in an early work such as *Intimacy*, Bonnard is already using the device of framing the composition by painting a line around it – something he was to do as a matter of course later on when beginning work on a piece of canvas cut from a roll and pinned to the wall.[115] In this way he gave himself the option of staying within the 'frame' or moving outside it. The line of paint that frames the small intimate scene of no.3 (the canvas, 38 × 36 cm, is not a standard format), suggests that this could be a very early example of Bonnard pinning the unstretched canvas to a hard surface, a board perhaps, or the wall.[116] It is also possible that his myopia was a factor, that is to say, it was easier for him not to be distracted by the sort of peripheral vision that affects short-sighted people when they look at objects outside their natural focus. Painting against the wall Bonnard would only see the canvas and therefore would not be subjected to looking at objects he could not focus on.

There was, however, another advantage to the wall. Its hard surface invites the pressure of the hand on the canvas,

pressing with fingers or rubbing with a cloth. This was important in that Bonnard wanted his paintings to impart the idea that every inch of the surface has been touched. This is an idea that carries a moral as well as aesthetic significance. In his conversation with Tériade he describes a painting as 'A series of patches that merge, and finally form the object', and then goes on to criticise painters in the past he describes as 'virtuosos' who achieved a unity of the surface by means that were, as he says, 'not always honest'.[117] The integrity of the surface lay in making the process of painting every inch of it visible.

Bonnard's concern with the surface is there from the start, in *The Croquet Game*, painted in 1892, the year he confided to Vuillard that he was just beginning to understand something about oil painting.[118] As we have seen, the Nabis rebelled against easel painting, seeking ways of bringing art closer to the decorative arts, especially through their contribution to the revival of mural painting in France in the 1890s. The surface was all-important, and Bonnard's preference for painting against the wall may well have its origins in his sympathies with a widespread reaction against easel painting. Bonnard's experiments early on with supports other than canvas, such as panel and paper, and his preoccupation with graphic work may well have something to do with his ambivalence towards oils at that time, and with what appears to have been a profound aversion to the slack feel of the stretched canvas. By substituting the wall for the easel Bonnard kept the painting in contact with a hard surface, a contact that is transmitted through the paint. Looked at closely, his canvases sometimes reveal a light coat of 'frottage' where charcoal has been rubbed into the canvas allowing the surface of the wall to show through (e.g. no.65, *The Large Yellow Nude*, and no.74, *Grey Nude in Profile*). In *The Dining Room, Vernonnet*, 1925 (fig.4), the uneven surface of the wall against which Bonnard worked is transmitted in the 'frottaged' areas of blue paint in the right-hand edge of the table.

The texture of many Bonnard paintings is not unlike the matt surface of a distempered wall (the same is true of Vuillard). Puvis de Chavannes's experiments with waxes and pastel added to pigments in order to enhance the chalky surface that would make his painting 'hang like a veil upon the surface', as he put it, had offered the Nabis valuable lessons in how to get away from the 'hollow' polish of virtuoso painting. At the same time, Bonnard varied the textures of his surfaces enormously, using them to bolster the subject of the painting, such as in the bath paintings, for instance, where the paint imitates a steamy dampness. A note beside a sketch in Bonnard's diary for *Nude Standing by the Bath* (fig.5) – one of Bonnard's 'wettest' paintings – reads 'rainy' ('*pluvieux*'), an example of how the weather of a particular day finds its way into the paint itself.[119] Dabs of colour, the shape of small paw marks, blur at the edges as they evaporate and sink into the canvas, like ink soaking into blotting paper (e.g. *Grey Nude in Profile* and *The Bathroom*). Two of the tiles on the right-hand side of *Nude in the Bath and Small Dog*

(no.94) are 'dripping' with paint, while underneath the bath, to the left, is a slippery patch of green. As he said, 'the climate of the work transcends all else.'[120] In others, the surface is rough and abrasive. Take *The Large Bath, Nude* (no.80). In many places the surface is like the surface of unglazed pottery, especially in the thick chalky area at the top of the canvas. Elsewhere there are heavy marks like patches of rough plaster, scuffed-up whites and sudden patches of dryness, as in the lower rim of the bath, imitating the uneven texture of a plastered wall. At the same time, from a distance the effect of the surface is as unified as Puvis' 'veil', only here it is a sort of liquid unity. The same is true of *Nude with Green Slipper*. There the leg on the stool is modelled so thickly along the shin that it looks as solid as plaster. The smoothness of the surface is further disrupted by areas of the sized canvas showing through. Yet, from a distance, the illusion is of everything in the room being touched by light and surrounded by air. There is a sort of marvellous contradiction between the way the paint is laid on the canvas and the way it is perceived.

These layered and complex surfaces, which are especially evident in the works of the 1930s and 40s, were built up over months, sometimes years, which is why many of the late works are difficult to date. *The Large Bath, Nude*, was underway by 1937, but in 1939, Bonnard asked Raymond Escholier, who had been instrumental in buying *Nude in the Bath* of 1936 for the Musée Moderne de la Ville de Paris (as it was then known) to allow him to borrow the painting back. Antoine Terrasse is surely correct in thinking that he did so in order to be able to have it by him as he continued to work on the second version.[121] There are various stories about the lengths Bonnard was prepared to go to in order to retouch a painting, using friends to distract guards in museums, or turning up at collectors' houses with a small paint-box in his pocket. Following the public showing of a painting that belonged to his friends the Hahnlosers, *A Sea Outing*, in 1924, the year it was painted, Bonnard considerably reworked the canvas. Later still, he made further corrections to the painting by drawing in pencil on a photograph.[122] Recently, it has emerged that this is no isolated case. The photograph reproduced as fig.108, a painting which had been bought by an American collector, has touches of white gouache and black ink in the small area around the dog. According to Antoine Terrasse, a number of other works are known to have been 'revised' in this manner.[123]

Lost paradises

Between 1923 and 1924 three people who had been extremely close to Bonnard died; his sister Andrée, her husband, Claude Terrasse, and in the last months of 1924 Bonnard's lover, Renée Monchaty. At the same time, the health of his companion Marthe had for some years been giving cause for concern. There are a number of pictures in the early 1920s which show Marthe alone and sunk in her own thoughts, such as *The Vigil* (no.41), and these are particularly touching in that they suggest the isolation of a woman who has withdrawn into herself. This new intimacy – the closest Bonnard comes to the first person narrative since nos.15–17 – is taken to an extreme in no.43, the painting that is an open confession of his affair with Monchaty which ended with her suicide. It is difficult to know whether this unusually explicit scene was begun while she was still alive, or whether it commemorates the role she briefly played in Bonnard's life (he reworked it in the mid-1940s). In any case, it is a picture of terrible poignancy. The mistress, surrounded in a glow of warm golden colour, is seated in a garden looking out at the painter, smiling, one cheek supported by the palm of her hand, her round blonde head set against the flatness of a tablecloth rhymed with a plate of ripe fruit, while, divided from her by the back of a chair (which looks like a large wheel) and almost edged out of the picture, is the shadowed profile of Marthe.

The earliest descriptions of Marthe by those friends of Bonnard's who had known her for many years are found in Thadée Natanson's 1951 monograph, *Le Bonnard que je propose*; the essays by Henry and Jean Dauberville in the *catalogue raisonné*; the book written in 1966 by Natanson's niece, Annette Vaillant; and in several articles by Bonnard's close friend, the publisher George Besson. Natanson's description of her appearance, her way of walking, her habit of taking baths, her hoarse voice, finds echoes in almost every book that has been published on Bonnard:

> She already had the resemblance to a bird which she never lost; the startled look, the liking for water and for taking baths, the weightless walk that comes from wings, her slender high heels as spindly as a bird's feet, and even something of a bird's gaudy plumage. But her voice croaked rather than sang, and was often hoarse and breathless. Slight and delicate, her health had always given cause for alarm both to herself and to other people; nevertheless she still had fifty years to live, which gave the lie to the doctors who had condemned her from the start.[124]

Each of these witnesses comments on her reclusive behaviour, which they say became increasingly marked as she grew older. She is said to have become timid and suspicious, even of Bonnard's close friends. One of Bonnard's great-nephews, Antoine Terrasse, tells how, on the occasions when Bonnard persuaded her to accompany him on one of his regular walks, it was evident that the umbrella she carried was not to protect her from the sun but to shield herself from others. 'It sometimes happened, especially in former days, that when Marthe was dressed in particularly colourful clothes she would complain that people were staring at her, and sometimes in an unpleasant way.'[125] It is surely no accident that there are few photographs in which Marthe's features are plainly visible. Those Bonnard took of her (apart from the

early ones of her posing nude on a bed) are from a distance. One taken by Thadée Natanson at the market in Vernon shows her wrapped in a huge fur coat looking apprehensively at Bonnard, whose attention is elsewhere (fig.15). Her slow retreat into complete isolation makes pitiful reading. 'Her end was rather sad; she was stricken with some sort of cerebral disorder, which lasted a few weeks and made life extremely difficult for those close to her.'[126] As Annette Vaillant put it: 'At the end of her life Marthe could hardly bear herself any more.'[127]

The nature of Marthe's illness is only vaguely hinted at or passed over in silence. Those close to Bonnard, as Michel Terrasse has pointed out, 'adopted the painter's discretion and reserve in matters concerning her, although everyone knew what lay behind the visits to the spas and changes of air which were constantly prescribed for her was a Marthe who had for years withdrawn into the narrow limits of herself.' Natanson, who says that she died after at least fifty years of ill-health, 'which gave her very little peace of mind, and which finally robbed her of what little she still had,[128] writes about her 'diseased lungs' ('*bronches malades*'), and Annette Vaillant remembered her 'as always staving off some illness or other – she had a weak chest, or perhaps tubercular laryngitis – and a hoarse, breathless voice … as she gruffly declared to my mother that she was "ravaged", her speech was weirdly savage and harsh.'[129] Michel Terrasse, in his recent book on the artist, tentatively suggests that she suffered from asthma.[130] George Besson, however, who met Bonnard in 1909 and became one of his closest friends, was unequivocal about her illness. Writing in 1948, he described her as suffering from tuberculosis for thirty years and from some nervous disorder for at least half that time.[131]

Whether Marthe suffered from a lingering form of tuberculosis, as seems likely, or asthma, or some other bronchial illness, by the end of the First World War her state of health had become a source of permanent concern.[132] Bonnard organised his life to accommodate her needs, a fact noted by Hédy Hahnloser among others.[133] The way he and Marthe lived did not conflict with his needs as a painter (he was extremely protective of those needs), but did impose certain restrictions. Those who knew Bonnard well have hinted at what those restrictions were, but in the only letter known to the author in which Bonnard speaks openly about Marthe's condition they are plainly stated. (The letter is one he wrote to George Besson during a six month stay at Arcachon in the winter of 1930–1.) 'For quite some time now I have been living a very secluded life as Marthe has become completely antisocial [Marthe étant devenue d'une sauvagerie complète] and I am obliged to avoid all contact with other people. I have hopes though that this state of affairs will change for the better but it is rather painful.' It is well known that in the 1920s and 1930s Bonnard and Marthe regularly visited French spas for the sake of Marthe's health, but those bleak words addressed to Besson suggest that Bonnard's habit of staying in secluded rented villas was primarily in order to protect

fig.15 Pierre and Marthe Bonnard at the market in Vernon in 1926.

Marthe from the social contacts that had become so hard for her to bear.

The house they took at Arcachon, the Villa Castellamare, was located in the part of the town known as the Ville d'Hiver, a famous 'ville sanatorium' founded in the 1860s. *Dining Room Overlooking the Garden* (no.62), one of the masterpieces of the early 1930s, shows the interior of the Villa Castellamare, and the garden in front of the house which looks onto a large public park (the house and park are still there). In the light of Bonnard's letter to Besson, and his self-imposed isolation, it is perhaps worth taking a harder look at the main subject of this painting, which is the window. The viewpoint is that of someone standing in front of the table, gazing out into the garden, and once it is understood that it is the painter who has taken up that position, who is looking through the window and out across the green of the trees and the grass, the more the window appears as a glass barrier closing off the world outside, making secure everything that is inside. The idea of the window as an inpenetrable opening is reinforced here by the solid wooden slats dividing the panes like bars, and the stone balustrade blocking the other side of the glass. The garden, tantalisingly out of reach, now seems as unattainable as ever, and its thunderous luminosity (very reminiscent of the light in Fragonard's landscapes) is heavy with suggestion, so much so that the painting seems as close as Bonnard gets to painting 'not the thing itself', as Mallarmé said, 'but the effect it produces'. It does not take much imagination to see this work as a profound distillation of his recent isolation, as closely bound up with the painter's private life as *Man and Woman* had been thirty years earlier.

The letter to Besson also makes it clear that Marthe was by this time suffering from more than a physically debilitating illness, but before assuming that her fragile state took the form of some neurotic compulsion to wash, it is worth

remembering that in an age when hydrotherapy was one of the most popular treatments for a whole range of ailments, and when frequent warm baths and showers were widely accepted as standard treatments, Marthe's meticulous attention to hygiene could equally well fit the pattern of someone carefully following popular medical advice of the day. In *Tuberculose est curable: Moyens de la reconnaître et de la guérir. Instructions à l'usage des familles* (Paris 1901), for instance, Dr Elisée Ribard told her readers: 'Perfect cleanliness is a prerequisite. The whole body should be soaped daily, in favourable conditions, after which it should be massaged quite energetically. This has never done any harm, not even to patients confined to bed.'[127] Whatever the reasons that lay behind Marthe's baths, the ceramic tiles, the patterned linoleum and the plain enamel tubs of the modern bathroom offered Bonnard a setting for the twentieth-century nude so dauntingly banal that few others would have dared to appropriate it.

Bonnard began painting pictures of Marthe washing early on (from the 1900s), rather in the manner of Degas who had made the subject of feminine hygiene his own. The subject of the nude washing herself in a round zinc tub was one Bonnard treated at least a dozen times in the period between 1914 and 1917. Works such as nos. 30 and 34, for instance, are concerned above all with composition, combining Bonnard's favourite device of creating a painting around an empty space, preferably a round void (for which the tub provided the best possible pretext) with his attachment to classical sculpture (the nude crouching in the tub is surely a series of variations on the theme of the *Crouching Aphrodite* in the Louvre).

The first paintings in which the nude is seen lying full length in the bath, *Nude in the Bath* (no. 47) and *The Bath* (no. 48), date from 1925. Marthe was then in her mid-fifties, but, as many have observed, these works show a young woman in her mid-twenties, the age she was when she first met Bonnard. In no. 48, only the legs are visible, but in no. 49, the head and body are Marthe's; in both, the body, or what can be seen of it, is made to look so relaxed that it is almost lifeless. The wall and the rim of white porcelain encasing the body in *The Bath* seem to play deliberately on the similarity between the shape of a sarcophagus and the shape of a bath tub, and so reinforce the painting's death-like stillness, its sense of *présence-absence*. The body, tilted slightly towards us and made light and transparent by the greenish hue of the water, invites a prolonged contemplation which in turn invites a sense of finality. The horizontal format, and the way this is echoed in the symmetry of the composition, is an essential part of this inducement to look at the painting as one might look at a recumbent figure on a tomb. The calmness of the image and the transparency of the colour encourages a sinking into the painting which is like sinking into the quiet emptiness of a Rothko.[135]

It is difficult to see this very silent painting as anything other than a mute expression of sorrow for Marthe's plight.

At the same time, just as Bonnard denies the ageing process in all the later paintings of his companion, he also counters the elegiac mood of the late paintings with bursts of exuberance, outpourings of pleasure that appear to affirm the very opposite. *The Vigil* is a case in point. Marthe's isolation is emphasised by the repetition of empty spaces around her, the table tops, the floor, the back of the chair in which she is resting. She seems engulfed by emptiness. The mood of the painting is one of profound reverie, but it is a mood that is violently contradicted by the spectacular clash of the red and gold palette. The whole room looks as though it has been caught in the dying blaze of a sensational sunset. Two notes in Bonnard's diaries, written fourteen years apart, read: 'What is beautiful in nature is not always beautiful in painting',[136] and, 'Nature sets traps for us with her themes.'[137] By taking a sunset out of its context and placing it indoors (as he does again in his choice of fruit in *Still Life in Front of the Window*), he both draws attention to and avoids the obvious trap, turning weary cliché into a powerful and surprising metaphor.

The landscapes and the still lifes through which he celebrates nature's endless renewal of life are another means of countering the elegiac. The evocation of the garden recurs again and again in Bonnard's work, as a place of countless summers, unchanging and, above all, unthreatened. The sense of longing that permeates *The Earthly Paradise*, for example, in which the figure of Adam is inserted into the landscape like a hidden self-portrait – a metaphor for the isolation of the artist, for his deeply-rooted attachment to nature, for his contemplation of the true paradises (which, as Proust says, are the ones we have lost)[138] – is accompanied by a joyous depiction of the myriad forms of life that populate the earth. The garden, as it appears in no. 76, a tangle of branches, stems and leaves, is an expression of nature at her wildest and most explosive.[139] The blazing emerald greens, lemon yellows, aquamarines and shrill pinks are the colours he admired in the Japanese *ukiyoe* prints he collected as a student, and in the Persian miniatures he and Matisse admired, both types of art devoted to the expression of physical and spiritual pleasure. Monet's late paintings of his garden (which Bonnard would have seen on his visits to the painter's studio at Giverny) offered another paradigm of renewal, and of ripeness.

When James Thrall Soby visited the house at Le Cannet after Bonnard's death, the housekeeper, Antoinette Isnard, told him that Bonnard never painted the flowers she picked for him straight away: 'He let the flowers wilt and then he started painting; he said that way they would have more presence.'[140] The passage between ripeness and decay, 'the rapid, surprising action of time', as Bonnard put it, is one of the major themes of the last years (although in the case of Marthe, as we have seen, the passage of time is denied). This is as true of a still life such as no. 61, in which the irises and marigolds are caught between flowering and fading, as it is of the peaches which reminded him of the setting sun.[141]

Bonnard's fruit verges on over-ripeness. The deep shadow in *Bowl of Fruit*, 1933 (no.69), is cast by the bowl lit by an electric bulb above the table, and that darkness is echoed in the surfaces of the fruit, parts of which blacken in the light, giving them the succulent weight of ripeness. As a fruit rots, it softens, shrivels, begins to seep, eventually becoming liquid colour, like paint. Watching the gradual disintegration of a peach, a fig or a grape, taking in the deepening colours and damp textures of decay would be second nature to someone as permanently attentive as Bonnard, so it is not surprising that some of his marks, the ones that are round and smudged at the edges, suggest the organic softness of pulp, or the stains left on a surface by an over-ripe fruit. At the time of the exhibition of the late paintings in Paris in 1984, the painter Miquel Barceló remarked: 'What is perverse in Bonnard is the blend of happiness … with a sort of decomposition, a sort of overdose.' These are strong words, but certain of the pictures have an organic structure that is so 'ripe' that it teeters on the edge of disintegration. The pale amber grapes in *Corner of a Table* (no.72), for instance, have reached the peak of their maturity, and this ripeness, this delight in nature's excesses which Barceló calls 'overdosing', is reinforced by the vertiginous instability of the composition. In other table paintings Bonnard places a patch, or hole of dark near the centre of the cloth, cavities which anchor the composition by making the eye focus on one spot: the lozenge-shaped box in the foreground of *Coffee* (no.29) is one example, the wine bottles in *Still Life with Bottle of Red Wine* (no.85) another. Here, however, there is nothing to anchor the objects to the mottled white emptiness of the cloth. Instead the eye is made to shoot off at an improbable angle to the back of a small chair stuck in the top left corner. This is a painting which shows Bonnard at his most extreme, but it is only taking to an extreme his view that each painting is the result of a continuous organic process: 'it has to ripen like and apple', he said of *Café 'Au Petit Poucet'* (no.57). He turns the same attentive eye on himself, stoically observing the destructive effects of age. In one of the last self-portraits, the transparency of the paper-thin flesh drawn over the painter's cold and emaciated chest suggests impending death (no.96), in another, the eyes, caved in, have become dark absorbing holes from which no light is reflected back into the outside world (no.95).

The steady passage of time is not a subject confined to the late work. The family groups of the 1890s depicting the old (Bonnard's grandmother) and the very young (his nephews and nieces) are typical of the scenes that surrounded him when the family gathered at Le Grand-Lemps, but the way in which he dwells on the extremes of youth and age reveals a more reflective side to his choice of subjects than is generally supposed. One way of looking at the frozen image of the family group that makes up *The Croquet Game* is to see in those stiff and rigid figures a denial that moments of childhood happiness and tranquillity are transitory (perhaps Bonnard's habit of clinging to the same objects, to the things associated with the ritual of meal times and the comfort of domestic routine, is also a defence against the transitory). One way of looking at the bathroom paintings of the last twenty years, at the unchanging figure of Marthe, is to see how he embalms an image in memory while keeping it alive and in the present by emphasising the organic nature of the paint. There is no contradiction here, just the 'subtle balance between lies and truth' that Bonnard speaks of.[143]

In the three late bath paintings (nos.75, 80, 94), the bodies sunk in their white porcelain tombs made incandescent by the gold and violet light reflecting off the surfaces of the tiles and the water are suspended between being and non-being. These pictures are about more than just the passage of time or the consolation of memory. They are, like so many of Bonnard's images, about the acceptance that everything in nature surrenders to time. The contemplation of loss, which is prefigured in the meditative stillness of *The Bath*, 1925, is made more absolute in these three late masterpieces in which colour accumulates in a rich and jewel-like brightness evoking the splendours of ancient tombs and Early Christian mosaics. Here the longing has ceased to be for a person, for a life that has been slowly erased by illness, for a time that has long since passed. The longing is now for a death that comes as a release. These works crystallise what has always been Bonnard's primary mood, that of elegy. He has often been described as a painter of pleasure, but he is not a painter of pleasure. He is a painter of the effervescence of pleasure and the disappearance of pleasure. His celebration of life is one side of a coin, the other side of which is always present – a lament for transience.

Notes

1. Twenty diaries with four days to a page, 1927–1946, are preserved in the 'Réserve des estampes' in the Bibliothèque Nationale, Paris. They are pocket diaries, mostly 'Agenda Bijou', measuring 13.4 × 6.7 cm.

2. These weather notes cease at the end of June 1942.

3. 'Le peintre du sentiment produit un monde clos, le tableau, qui est un livre et transporte son intérêt partout où il est placé. Cet artiste, on l'imagine, passant beaucoup de temps à ne rien faire qu'à regarder autour de lui et en lui.' 'Pierre Bonnard nous écrit', *Comœdia*, 10 April 1943 (Bonnard had been asked to write a few lines on 'la peinture française d'aujourd'hui'.)

4. James Thrall Soby, 'Bonnard' in Alexander Liberman, *The Artist in his Studio*, New York 1960, p.18.

5. Preface to catalogue of *Exposition Rétrospective Bonnard*, Galerie Bernheim-Jeune, Paris, May–July 1950, p.11.

6. 'Un Grand Peintre est mort', *Littéraire*, 1 February 1947.

7. Thadée Natanson, *Le Bonnard que je propose*, Geneva 1951, p.88. In 1926 Bonnard had been invited to Pittsburgh as a member of the Carnegie International Jury. Photographs of him taken after his arrival, however, show him with a moustache which means that either Natanson's story is apocryphal, or Bonnard allowed his moustache to grow back during the sea voyage. I am grateful to John Elderfield for drawing my attention to this anomaly.

8. Sargy Mann, 'Let it be felt that the painter was there', *Drawings by Bonnard* (touring exhibition organised by the Arts Council of Great Britain in association with Nottingham Castle Museum), 1984, p.10.

9. 'Quand je fume une bonne pipe, je me donne à moi-même, quelquefois, l'impression d'être trop confortablement installé dans la vie. Et ça, je ne le veux pas!' [anon.] *7 jours*, 11 January 1942, p.16.

10. Bonnard made a selection of the notes in his diaries under the heading 'Observations sur la peinture'. These were published with a short explanatory text by Antoine Terrasse in *Bonnard*, Centre Georges Pompidou, Paris, 1984. They are given in English translation in *Bonnard*, New York 1984 (published on the occasion of the exhibition at the Phillips Collection, Washington and the Dallas Museum of Art).

11. 'A work in which there are theories is like an object which still has its price tag on it.' Marcel Proust, *In Search of Lost Time*, VI, *Time Regained*, Vintage, London 1996, p.236.

12. A number of letters from Bonnard to Maurice Denis have been deposited in the Musée Maurice Denis, Saint-Germain-en-Laye.

13. According to Pierrette Vernon, the great-niece of Marthe Bonnard, letters belonging to her great-aunt were handed over at the time of the legal battle over the Bonnard estate.

14. 'J'ai tous mes sujets sous la main. Je vais les voir. Je prends des notes. Et puis je rentre chez moi. Et avant de peindre je réfléchis, je rêve.' [anon.] *7 jours*, 11 January 1942, p.16.

15. Michel Terrasse, *Bonnard: Du dessin au tableau*, Paris 1996, p.24.

16. 'Dialogue between Raymond Cogniat and Jean Cassou' in Annette Vaillant, *Bonnard*, 1966, p.20.

17. 'Le travail du peintre commence là ou l'architecte considère que cesse le sien … Nous voulons les murs à peindre. Loin de nous la perspective. Le mur doit rester une surface et ne pas être troué par la représentation d'horizons infinis. Il n'y a pas de tableaux, il n'y a que des décorations.' Dom Willibrod Verkade, *Le Tourment de Dieu*, Paris 1926, p.94.

18. 'Se rappeler qu'un tableau, avant d'être un cheval de bataille, une femme nue, ou quelconque anecdote, est essentiellement une surface plane recouverte de couleurs en un certain ordre assemblées.' Maurice Denis, *Théories, 1890–1910: Du symbolisme et de Gauguin vers un nouvel ordre classique*, Paris 1913, p.1.

19. *Les Peintures du Musée d'Orsay*, Paris 1989, p.592.

20. 'Sujets humbles de ces décorations de Cluny. Expression d'un *sentiment intime* sur une plus grande surface, voilà tout.' Journal, 16 July 1894, carnet 2, MS. 5396. I am grateful to Timothy Hyman for allowing me to read the proofs of his forthcoming book on Bonnard published by Thames and Hudson in the World of Art series, in which he draws attention to the 'millefleurs' tapestries.

21. See Nicholas Watkins, *Bonnard*, 1994, pp.21–2.

22. David Sylvester pointed out Gauguin's continuing importance for Bonnard in 'Bonnard's "The Table"', first published in the *Listener*, 15 March 1962, reprinted in *About Modern Art: Critical Essays 1948–96*, 1996, p.108.

23. 'Le Salon d'Automne de 1905', *L'Ermitage*, 15 November 1905.

24. 'Mallarmé seul est un compagnon fidèle qu'il retrouve chaque jour avec le même plaisir que ses promenades et qui lui donne l'équivalent.' Natanson 1951, p.91.

25. 'La contemplation des objets, l'image s'envolant des rêveries suscitées par eux, sont le chant: … *Nommer* un objet, c'est supprimer les trois quarts de la jouissance du poème qui est faite du bonheur de deviner peu à peu; le suggérer, voilà le rêve./ C'est le parfait usage de ce mystère qui constitue le symbolisme: évoquer petit à petit un objet pour montrer un état d'âme, ou, inversement, choisir un objet et en dégager un état d'âme par une série de déchiffrements.' Jules Huret, 'Enquête sur l'évolution littéraire' in *L'Echo de Paris*, 14 March, 1891, p.2. Reprinted in *Les Interviews de Mallarmé* (ed. Dieter Schwarz) Neuchâtel 1995, pp.30–1.

26. In his preface to Stéphane Mallarmé, *Poésies*, Paris 1992, p.xii, Yves Bonnefoy describes *Hérodiade* as 'un grand espace verbal'.

27. 'Que le sentiment intérieur de beauté se rencontre avec la nature, c'est là le point.' Diary entry for 18 January 1939.

28. Preface to Stéphane Mallarmé, *Poésies*, Paris 1992, p.xxxi.

29. 'A Memoir by Hans R. Hahnloser' in Vaillant 1966, p.181.

30. 'Pour commencer un tableau, il faut toujours qu'il y ait un vide au milieu'; quoted in *Bonnard*, Musée National d'Art Moderne, Centre Georges Pompidou, Paris 1984, p.32.

31. 'The Nudes of Pierre Bonnard', *New Society*, 20 January 1966.

32. 'Colour and Abstraction in the Drawings of Bonnard' in *Bonnard: Drawings from 1893–1946*, American Federation of Arts, New York (touring exhibition), 1972.

33. Entry in Bonnard's diary for 1946.

34. Cited in Richard Poirier, 'In Praise of Vagueness', *New York Review of Books*, 14 December 1995.

35. Marcel Proust, *Remembrance of Things Past*, II, *The Guermantes Way*, Harmondsworth, p.435.

36. On this subject James Thrall Soby quoted Paul Valéry, 'To see is to forget the names of the things one sees.' See Soby's essay 'Monet' in Alexander Liberman, *The Artist in his Studio*, New York 1960, p.17.

37. 'La réalisation plastique de ces rêves d'au-delà, de ces songes nostalgiques que l'école la plus avancée de la littérature anglaise et française a cru seul entrevoir.' A. Renan, 'La Marque de Hokusai', *Le Japon artistique*, Documents d'art et d'industrie réunies par S. Bing, Paris 1888, pp.110–11.

38. 'Le principal sujet, c'est la surface qui a sa couleur, ses lois, par-dessus les objets.' Diary entry, 2 December 1935.

39. 'Une œuvre doit porter en elle-même sa signification entière et l'imposer au spectateur avant même qu'il en connaisse le sujet.'

40. The other children were Adèle (1871–1945), Amable (d.1901), Aline and Esperance (no dates known).

41. According to Pierrette Vernon, Méligny is the name of a small village in the Cher.

42. In 1909 Bonnard made a will leaving everything to 'Marthe de Méligny'. See *Le Procès de la succession Bonnet et Le droit des artistes*, speech for the defence given by Maurice Garçon, avocat à la Cours de Paris, 10 November 1952, p.14.

43. The marriage between Adèle Boursin and Adolphe Bowers took place on 12 May 1898.

44. Conversation with the author, May 1997.

45. Garçon 1952, p.14 . The postcards are addressed to 'Boursin-Méligny, Poste restante, Saint-Tropez'.

46. Garçon 1952, p.15.

47. 'Pendant ces trente années d'amitié intime, Marthe m'a mille fois assuré qu'elle n'avait, dans sa jeunesse, personne qui s'intéressait à elle. Sans son adorée grand-maman, elle aurait vécu sa vie dans un abandon complet. Elle n'a pas raconté une seule fois, une unique fois, quelque chose en relation avec une soeur, non plus qu'une nièce.' Garçon 1952, p.19.

48. Garçon 1952, p.17.

49. Garçon 1952, p.48.

50. The marriage took place in Paris on 13 August 1925 at the Town Hall in the 18th *arrondissement*. The witnesses were Louisa Poilard, the concierge, and her husband, Joseph Tanson, a bank employee. Garçon 1952, p.15.

51. See also Maurice Denis' likeness of Bonnard in his large group portrait *Homage to Cézanne*, 1900 (fig.139).

52. Thadée Natanson sold this version to his brother Alexandre, who hung it in his bedroom.

53. See Antoine Terrasse, *Pierre Bonnard*, Paris 1967, p.54; Guy Cogeval in *Bonnard*, Paris 1993, p.72. The Fragonard painting it compares with most closely is *La Gimblette. Jeune fille faisant danser son chien sur son lit*, c.1768, of which there are several versions.

54. Stéphane Mallarmé, *Poésies*, Paris 1992, p.156.

55. Bonnefoy describes this poem as 'a strange mixture of love and laments, a river of long tresses, tear-stained make-up'. See *Poésies 1992*, p.195.

56. *Monologue d'un faune*, lines 101–3. See *Poésies 1992*, p.210.

57. A photograph of Bonnard, taken at Le Relais, the Natanson family house, the day after Mallarmé's burial at Valvins on 10 September 1898, is reproduced as fig.138.

58. In October 1895, Thadée Natanson visited Christiana (now Oslo) where he saw the major Munch exhibition at the Galerie Blomquist which he wrote about for his magazine. In June the following year, Munch had his first one-man show in Paris at Samuel Bing's La Maison d'Art Nouveau, which was also written up for *La Revue blanche*, this time by Strindberg.

59. Cogeval 1993, p.28; Sasha Newman, 'Nudes and landscapes' in *Pierre Bonnard: The Graphic Art*, Metropolitan Museum of Art, New York 1989, p.190.

60. I am grateful to Robert Rosenblum for pointing out this connection.

61. *pace* Guy Cogeval, who sees the screen in this painting as 'une séparation existentielle entre les deux sexes'. See Cogeval 1993, p.74.

62. See Françoise Heilbrun and Philippe Néagu, *Bonnard photographe*, Paris 1987.

63. See Pierre Bonnard , 'Hommage à Redon', *La Vie*, 30 November 1912. See also Maurice Denis, *Théories* 1913, p.254.

64. 'Malheur à qui garderait le silence au milieu du désert en croyant n'être entendu de personne.'

65. 'Parler pour dire quelque chose, c'est comme regarder. Mais qui regarde? Si les gens pouvaient voir, et bien voir, voir pleinement, ils feraient de la peinture tous. Et c'est parceque les gens ne savent pas du tout regarder qu'ils ne la comprennent presque jamais.' André Beuder, 'Pierre Bonnard', *La Nouvelle Revue française*, no.358, November 1982.

66. 'Il fut une époque ou pressé par les marchands je me laissai aller à céder des toiles que j'aurais du garder, les travailler plus, les oublier pour les reprendre ensuite. C'est ainsi qu'un certain nombre seraient à revoir, la moitié au moins, et même détruire.' Jules Joëts, 'Deux grands peintres au Cannet', *Arts-Documents*, no.29, February 1953, pp.8–9.

67. This problem was compounded after the artist's death. In 1963, following the settlement of the long-running dispute over Bonnard's estate, hundreds of works were released into the public domain. The critic Claude Roger-Marx expressed his fears at the time that a large number of these were works which had been abandoned by the artist and which he had never intended to allow out of the studio. 'Prière de respecter Bonnard', *Le Figaro littéraire*, 30 March 1963.

68. See Raymond Cogniat, *Bonnard*, Paris 1969, p.207, note 78.

69. See Antoine Terrasse, *Pierre Bonnard*, Paris 1967, p.94.

70. 'Hos Bonnard i Deauville', *Konstrevy*, no.4, Stockholm, 1937.

71. Maurice Denis recalled that while Bonnard was a student at the Académie Julian he 'painted grey and copied the model scrupulously'. 'Pierre Bonnard', *Le Point*, 1943, p.4. During his career Bonnard used many different models, some of whom he shared with artists such as Vallotton (in the 1900s and 1910s), and later with Henri Lebasque (at Le Cannet). See also Watkins 1994, p.181.

72. Newman 1984, p.12. See also *Faune ou Le Dieu Pan et les nymphes*, c.1899 (Dauberville 221) and *La Fête du Vin*, 1900 (Dauberville 223).

73. Venturi 379.

74. Venturi 380.

75. *Cézanne*, 1996, no.65, p.205.

76. Bonnard gave this painting to the Hahnlosers as a replacement for the large pastoral landscape, *Summer* (Dauberville 538) which they had commissioned for the Villa Flora but subsequently returned because it was too large for the space.

77. *Théories* 1913, p.254.

78. John Rewald, *The Paintings of Paul Cézanne: A Catalogue Raisonné*, no.252, vol.1, pp.174–5. Bonnard made a lithograph after the oil which is reproduced in *Album Cézanne*, Bernheim-Jeune, Paris 1914, p.3, as 'Le baigneur de Cézanne'. The painting is listed in the catalogue of the sale 'Collection Bonnard' at the Galerie Charpentier, Paris, 23 February 1954, as 'Nu de jeune baigneur, 24 × 14'. He lent it to the Cézanne exhibition at the Galerie Bernheim-Jeune, 10–22 January 1910.

79. According to Michel Terrasse, Bonnard painted ninety-six nudes from life, fifty-two of which were painted between 1903 and 1910. See Terrasse 1996, p.65 (footnote).

80. 'Propos de Pierre Bonnard à Tériade (Le Cannet 1942)', 'Couleur de Bonnard', *Verve*, vol.5, nos.17–18, August 1947 (special issue).

81. Leila Mabilleau in conversation with the author, 1995. The portrait is Dauberville 1458. There is also an oil sketch, Dauberville 1457.

82 See also George Besson's account of sitting to Bonnard in 1909, which is recorded in Vaillant 1966, pp.109–10.

83 'Il ne voulait pas que je reste tranquille. Ce qu'il désirait, c'était le mouvement; il me demandait de "vivre" devant lui en essayant de l'oublier.' 'Il voulait à la fois la vie et l'absence.' Annie Pérez, 'Entretiens avec Dina Vierny', Hommage à Bonnard, Galerie des Beaux-Arts, Bordeaux 1986, p.136.

84 'Depuis cinquante ans je reviens toujours aux mêmes sujets. Il m'est très difficile même d'introduire un nouvel objet dans mes natures mortes.' 'Quand je brossais le portrait de Bonnard', Opera: l'hebdomadaire du théâtre, du cinéma, des lettres et des arts, Paris, 5 February 1947.

85 'Le Bouquet de roses: Propos de Pierre Bonnard recueillis en 1943', 'Couleur de Bonnard', Verve, vol.5, nos.17–18, August 1947 (special issue).

86 'Il lui arrivait souvent de rester là, de faire le lézard, de se chauffer au soleil, sans même toucher un pinceau. Il pouvait attendre que les choses redeviennent telles qu'elles entraient dans sa conception.'

87 'Il ne laissait pas aux choses le temps de le prendre.'

88 'Titien avait une défense totale devant le motif, tous les tableaux portent la marque du Titien, ils avaient été conçus suivant l'idée initiale qu'il s'en faisait. Tandis que pour Vélasquez, il y a de grandes différences de qualité entre les motifs qui l'ont séduit, ses portraits d'infantes, et ses grandes compositions académiques où l'on ne retrouve que les modèles mêmes, les objets mêmes, sans que soit sensible aucune inspiration première.'

89 'Chez certain peintres – Le Titien – cette séduction est tellement forte, qu'elle ne les abandonne jamais, même s'ils restent très longtemps en contact direct avec l'objet.'

90 'Moi je suis très faible, il m'est difficile de me contrôler devant l'objet.'

91 Newman 1984, p.110.

92 John Berger, 'Steps towards a small theory of the visible', Tate, no.11, Spring 1997, p.41.

93 Marcel Proust, Time Regained, pp.229, 233.

94 'Je veux faire ambuler ainsi que sur les frises les modernes, en ce qu'ils ont d'essentiel, les placer dans les toiles arrangées en harmonies de couleurs, par les directions de tons, en harmonie de lignes par la direction, la ligne et la couleur disposées l'une par l'autre.' Gustave Kahn, 'Puvis de Chavannes', La Revue indépendante, January 1888, pp.142–3.

95 L'Art moderne, 10 July 1887, cited in Richard Thomson, Seurat, Oxford 1985, p.141.

96 Still-Life with Hat, Umbrella and Clothes on a Chair (de Hauke 663). This drawing is now in the Metropolitan Museum of Art, New York. The catalogue of 'Collection Bonnard' at the Galerie Charpentier, 23 February 1954, lists it as 'L'ombrelle 31 × 23 cm (dessin pour Poseuses)'. He had acquired it by 1926, as the catalogue of Les Dessins de Georges Seurat, Galerie Bernheim-Jeune, Paris, 29 November–24 December 1926, lists the lender of no.113, one of four drawings for The Models, as 'P.B.'.

97 Antoine Terrasse, Bonnard Nues, Paris 1970.

98 Newman 1984, p.16.

99 The Spinario was one of the most common borrowings from the Antique: see John Leighton and Richard Thomson, Seurat and the Bathers, 1997, p.148. Bonnard returned to this source in Femme à sa Toilette: Le Peignoir, c.1923 (Dauberville 1218).

100 In conversation with the author, May 1997.

101 See Anthea Callen, The Spectacular Body: Science, Method and Meaning in the Work of Degas, New Haven and London 1995, p.145.

102 '… Eut pour la pensée grecque un attrait qu'il garde toujours.' Charles Terrasse, Bonnard, Paris 1927, p.17.

103 Zervos's dismissal of Bonnard in the article he wrote shortly after the painter's death, 'Pierre Bonnard est-il un grand peintre?', Cahiers d'art, 22, 1947, pp.1–6, had a profound effect on Bonnard's reputation.

104 'Esthétique du mouvement et des gestes. Il faut qu'il ait un arrêt, un appui.' Diary entry, 4 December 1935.

105 Ibid.

106 'Jugement des yeux – différent. marchant, debout, assis.' The page on which this is written is reproduced in facsimile in Antoine Terrasse, 'Les Notes de Bonnard' in Bonnard, Centre Georges Pompidou, Paris 1984, p.180.

107 'Au peintre il suffit que les fenêtres soient larges afin que pénètre, telle la foudre, l'éclat du jour, qu'il frappe avec toutes ses subtilités tout ce qu'il peut rencontrer.' Maurice Rheims, 'Bonnard et sa palette de lumière', Le Figaro, 31 October 1988.

108 L'Intransigeant, 14 November 1913. Reprinted in Apollinaire on Art: Essays and Reviews 1902–1918 (ed. Leroy C. Breunig), New York 1988, p.242.

109 See Nicholas Watkins, Bonnard, 1994, pp.137–8.

110 Conversation with Verena Steiner, Villa Flora, Winterthur, April 1997.

111 The Poetics of Space, Boston 1994, p.86. First published in French in 1958 under the title La Poétique de l'espace.

112 Published in L'Art et la Mode, 22 August 1885. Cited in Virginia Spate, The Colour of Time: Claude Monet, London 1994, p.190.

113 'La beauté d'un morceau de marbre antique réside dans toute une série de mouvements indispensables aux doigts.' 'Propos de Pierre Bonnard, à Tériade (Le Cannet 1942)', 'Couleur de Bonnard', Verve, vol.5, nos.17–18, August 1947 (special issue).

114 Cited in Sargy Mann, 'Let it be felt that the painter was there …', Drawings by Bonnard, Arts Council of Great Britain (touring exhibition), 1984, p.8.

115 Another early example of Bonnard enclosing the image within a painted frame is A Bourgeois Afternoon, 1900, Musée d'Orsay.

116 Bonnard told Pierre Courthion 'Voyez-vous, j'ai en horreur les dimensions donnés d'avance, ces formats tout faits. Travailler dans les mesures composées me parait intolérable.' 'Pierre Bonnard', Les Nouvelles littéraires, vol.24, June 1933.

117 'Une suite de taches qui se lient entre elles et finissent par former l'objet.' 'Propos de Pierre Bonnard à Tériade (Le Cannet 1942)', 'Couleur de Bonnard', Verve, vol.5, nos.17–18, August 1947 (special issue).

118 Terrasse 1996, p.27.

119 Dairy entry, 17 February 1931.

120 'Au-dessus de tout plane le climat de l'oeuvre'. Extract from an entry in Bonnard's diary, 14 February 1939.

121 Antoine Terrasse in conversation with the author, August 1997.

122 Margrit Hahnloser-Ingold, '"Promenade en mer" – image and portrait', Bonnard, London 1984, p.82.

123 Antoine Terrasse in conversation with the author, August 1997. Photographs of Dauberville nos.1218, 1415, 1503, 1516, 1554 were also retouched by the artist.

124 'Elle avait déjà, d'un oiseau, gardera toujours, l'air effarouché, le goût de l'eau, de se baigner, la démarche sans poids, qui vient des ailes, les talons hauts et minces aussi grêles que des pattes et jusqu'au plumage vif. Mais la voix caquette plus qu'elle ne chante et souvent un enrouement l'assourdit. Menue, délicate, alarmant depuis toujours les autres et soi-même sur sa santé, elle en a pour cinquante ans encore à faire mentir les médecins qui l'ont depuis toujours condamnée.' Natanson 1951, pp.23–4.

125 'Il arrivait, surtout autrefois, que, lorsque Marthe était habillé de façon particulièrement voyante, elle se plaignait d'être trop regardée même avec malveillance.'

126 'Sa fin fut assez triste; elle fut prise d'une sorte de dérangement cérébral, qui dura quelques semaines et rendit la vie extrêmement pénible autour d'elle. Son mari la soigna avec un très grand dévouement.' Garçon 1952, p.20.

127 Vaillant 1966, p.135.

128 Ibid., p.36.

129 Ibid., p.78.

130 Bonnard: Du dessin au tableau, Paris 1996, p.155.

131 'Tuberculose depuis trente ans et, pour le moins névropathe depuis quinze', 'Billet à la Provinciale', Arts de France, no.19–20, 1948. See also George Besson, 'Il y a cinq ans mourait Pierre Bonnard', Tous les arts, 24 January 1952. I am grateful to Chantal Duverget, who has recently submitted her thesis 'George Besson, critique d'art et collectioneur 1882–1971 to the Université de Rennes 2 – Haute Bretagne, for bringing the Besson-Bonnard correspondence to my attention. N o cause of death is given on Marthe's death certificate.

132 In the light of letters Bonnard addressed to Besson, of Besson's statement, and of accounts of Marthe's behaviour towards Bonnard's friends, it is worth noting the following description of what was known as 'La folie tuberculose': 'Alternatives de dépression et d'excitation, de manie et de mélancolie, une irritabilité extrême, un caractère ombrageux, irascible, des idées vagues de persécution.' Isabelle and Caroline Kruse, Histoire de la tuberculose: Les fièvres de l'âme 1800–1940, Paris 1983, p.281.

133 'L'état de santé et les dépressions de Marthe durant les années vingt contraignaient Bonnard à une vie tranquille et retirée': cited in exhibition catalogue Bonnard, Centre Georges Pompidou, Paris 1984, p.209.

134 'La première indication à remplir est une propreté irréprochable. Un savonnage quotidien de tout le corps, pratiqués dans de bonnes conditions et suivi d'une friction un peu énergique, n'a jamais fait de mal à personne, même aux malades alités.'

135 The comparison between Bonnard and Rothko has been made several times. See Jean Clair, 'The Adventures of the Optic Nerve' in Bonnard, New York 1984, p.40. Also, Bonnard Rothko: Colour and Light at Pace Wildenstein, New York, February–March 1997 (catalogue essay by Bernice Rose).

136 'Ce qui est beau dans la nature ne l'est pas toujours dans la peinture.' 13 May 1932.

137 'La nature nous tend des pièges avec ses thèmes'. Extract from 1946.

138 In Search of Lost Time, VI, Time Regained, 1996, p.222.

139 Bonnard's own garden at Le Cannet was described by James Thrall Soby as 'dense and thick; patterns of trees, shrubs, flowers, bushes intermingled, pierced with windowlike openings through which she escaped into a panorama of sky, mountains, sea and distant Cannes.' 'Bonnard' in Alexander Liberman, The Artist in his Studio, New York 1960, p.18.

140 Ibid., p.18. Bonnard noted down the name and address 'Antoinette Isoardi, Serra Capeau, Le Cannet' in his diary for 1936, the year she presumably started working at Le Bosquet. Soby records her surname as 'Isnard'.

141 According to Hédy Hahnloser, who gave Bonnard the flowers seen in no.61 ('two dark lilac-coloured irises and a mass of orange or sulphur-yellow marigolds'), 'to see them perish and almost disappear, the stalks drying up, the twigs lose their leaves, was a profound experience.' 'A Memoir by Hans Hahnloser' in Vaillant 1966, p.184.

142 'La perversité chez Bonnard c'est le mélange de bonheur … avec ce pourrissement, cette overdose.'

143 Entry in Bonnard's diary, 1945, reads: 'Il y a une formule qui convient parfaitement à la peinture: beaucoup de petits mensonges pour une grande vérité.'

fig.16 The wall of Pierre Bonnard's studio at Le Cannet, where the painter lived and worked from 1925 until his death in 1947. Photograph taken by Alexander Liberman in 1955.

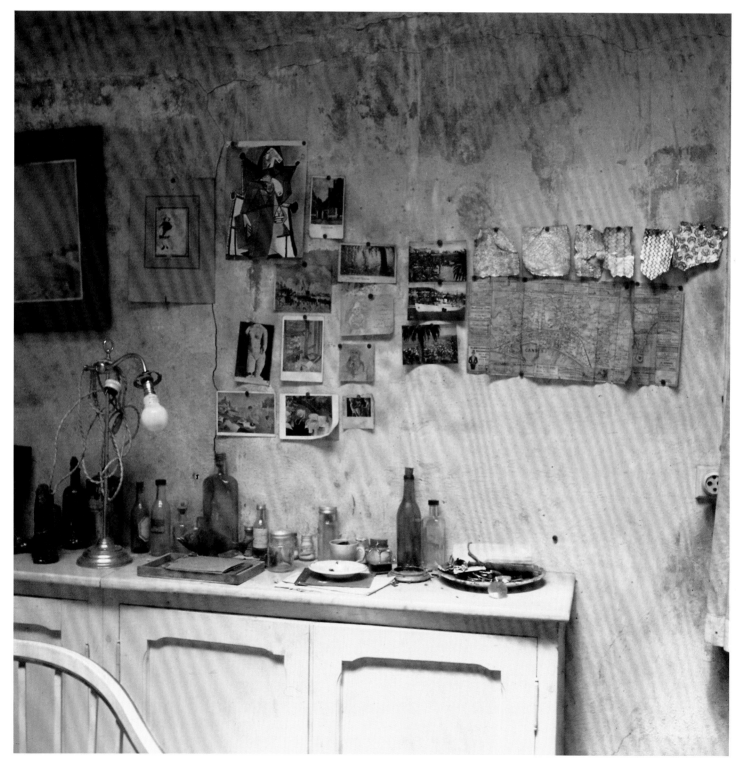

Seeing Bonnard

JOHN ELDERFIELD

Bonnard famously observed that painting was 'the transcription of the adventures of the optic nerve',[1] but criticism has been slow to acknowledge why a painting by Bonnard might usefully be thought of not as a representation of substance but as a representation of the perception of substance.[2]

As early as 1893, Roger-Marx wrote that Bonnard 'catches fleeting poses, steals unconscious gestures, crystallizes the most transient expressions',[3] an acknowledgement that the artist was representing snatched moments of perception. Such an interpretation was supported by the self-consciously 'Impressionist' paintings – paintings of momentary perceptions – that Bonnard made in the years after 1900, when the tradition of his perceptual as well as temperamental ingenuousness was consolidated.[4] However, the more complex works, spatially, compositionally, and colouristically, which began to appear around 1912, led to the suggestion that Bonnard was representing an extended process of perception rather than just a single moment. Of such works, Leon Werth observed in 1919 that 'Bonnard looks at the world the same way that a young animal or an infant move their eyes about. He witnesses the sudden and miraculous birth of objects and characters.'[5] The conventional early modernist reference to 'innocent' vision notwithstanding,[6] Werth noticed that the mobile and suddenly revelatory processes of perception are represented in Bonnard's paintings.

But how, precisely, might a painting by Bonnard be thought a representation not of substance but of the perception of substance? And why might it be useful to think of it in this way? Although Bonnard himself explained the processes of his vision in Charles Terrasse's 1927 monograph on him, on which he collaborated,[7] he did so elliptically and epigrammatically, and this subject did not gain much attention in the artist's lifetime. Neither was it revived until the reaction against Bonnard as merely a hedonistic and traditional painter, always a current within the critical archive but a torrent immediately after his death in 1947, had sufficiently subsided.[8] Once Bonnard's 'adventures of the optic nerve' began to attract renewed critical attention in the 1960s, however, they increasingly came to be thought of central importance to an understanding both of his art and of his status as a modern artist.

In 1962 David Sylvester wondered whether Bonnard was 're-creating the process of seeing', noticing how looking at his paintings seemed, effectively, to reproduce both the sensation of loss of acuity at the periphery of the visual field and the creation of a scanpath of eye movements between focal points, fixated for varying durations and, consequently, with varying attentive interest. But, knowing that Bonnard painted from memory, Sylvester also wondered whether the process is 'really rather more like the process of recalling than it is like the process of looking at something which is actually there.'[9] Ten years later, in 1972, Pierre Schneider was in no doubt about the answer: Bonnard frequently placed the most important objects on the periphery of a picture, which shows that he had substituted decentred, multi-focused vision for traditional, hierarchical, centrally-focused compositions.[10] This, in effect, was the mark of Bonnard's radicalism, the defence against those who might think him a conservative.

Such an interpretation was made explicit by Jean Clair in 1984, in the fullest treatment of this subject ever to appear.[11] Referring to Bonnard's statement that he sought 'to show what one sees when one enters a room all of a sudden',[12] Clair supposed that Bonnard sought 'to paint the feeling of "visual entirety" that one experiences on entering a room, before one has recognized, distinguished, brought into focus and identified the various details ...'. Thus,

> the revolution in painting brought about by Bonnard was that, for the first time, a painter attempted to translate onto canvas the data of a vision that is physiologically 'real' ... He was the first artist to have attempted to portray on canvas the integrality of the field of vision and so bring nearer to the eye what classical perspective had kept at a distance.

Bonnard replaced 'artificial perspective' by the record of 'natural vision'.

I begin with this brief foray into the critical archive so that two facts may be established from the start: that the physiological processes of vision were long known to be germane to the appearance of Bonnard's paintings, with the artist himself corroborating the connection; and that attention to this subject from critics, long a minor theme in the literature, grew to its present prominence in support of the claim that Bonnard was a revolutionary painter. The first fact leads to the conclusion that this subject is, indeed, important to an

understanding of his paintings. The second also leads to this conclusion, but additionally tells us that this subject may not have been treated carefully enough.

A glamorisation of modern art as revolutionary runs the risks, first, of neglecting what modern art may share with the past and, second, of promoting the myth of alienation from the past as an explanation of modernist fragmentation and destabilised order.[13] In Bonnard's case, his debt to the past is considerable in so far as the perceptual effects he creates in his paintings are traceable even to the Rococo: 'Ingres, Boucher – the first modern craftsmen', he noted in his diary.[14] As for alienation, fragmentation and destabilisation, however, these qualities are the last to be found mentioned in the critical archive. Effectively, Bonnard's 'revolution' is seen to be that of a modern empirical realist who has finally discovered the way to record 'natural vision'. It is unquestionable, I think, that a quiet vision of the actual (to borrow a description of the work of the eighteenth-century poet John Clare) is the base of Bonnard's art.[15] But doesn't it go without saying that his art cannot be thought to reveal some final, true picture of the actual, only his own vision of what he believes to be actual?

This vision, it does need saying, is more complex than often supposed, both in its operation and in what it represents, which is, I shall argue, the restless flux found in a moment of experience that will be intense as well as optimistic, threatened as well as pleasuring, and as unembarrassed by genuine sentiment as by showing the struggle of the experience meant to be shared. What follows offers one account of what Bonnard's representation of perception comprises and what it represents, thought here to be as much a waking dream of fact as a record of it; therefore, a vision both of life and of absence. (A model, Dina Vierny, wrote that Bonnard 'asked me to "live" in front of him, trying to forget him. At once he wanted life and absence.')[16]

The headings of the sections that follow are all quotations from Bonnard.

The demands and the pleasures of seeing, and its rewards. Crude seeing and intelligent seeing [17]

Simply to say that a painting by Bonnard may be thought of not as a representation of substance but as a representation of the perception of substance will not alone do much to distinguish what is individual to Bonnard's paintings – certainly not what is modern in them. For this may be said of any representation by any artist that admits the accidental nature of vision, be it the illusion of foreshortening or the way in which colours change in different lights.

Michael Baxandall has argued that the systematisation, in the eighteenth century, of means of representation that do not admit the accidental nature of vision – namely styles of geometric technical drawing that may be considered 'means of registering visually the substance of objects as opposed to

their sensational visual character' – made it impossible for the painter's kind of representation, in contrast, to be thought to be simply a representation of substance, thus ending 'the old Renaissance simplicity of depicting "Nature"'.[18] This is to imply that, before the eighteenth century, painters, however knowing they were, could not knowingly make paintings that may be thought to depict perception, although they did make them, and that, in and after the eighteenth century, all knowing painters made such paintings knowingly unless they chose not to. Let us presume that Bonnard did choose to do so. What evidence is there in his paintings to show that he did? To begin to address this question, it may be as well to offer a brief example of the kind of difficulty opened by the suggestion that a painting by Bonnard comprises a representation of perception, and David Sylvester's remarks relating to the loss of acuity in peripheral vision will serve.

'Towards the edges [of Bonnard's paintings]', Sylvester writes, 'things get muzzy, as they do in reality at the periphery of our field of vision, and I'm no more aware of exactly where the rectangle of the canvas is than I am of exactly where my field of vision ends.'[19] Let us take it, although Sylvester does not say this, that he is imagining the pictorial field as a representation of the centralised field of vision of a single fixation of the eyes, decreasing in acuity from centre to periphery, or possibly of a few clustered fixations. (Optical acuity is greatest, we need to remember, only within a tiny area of less than two degrees around the centre of the gaze; that is, only when the image is 'foveated' – when the light that comprises the image is caused to fall through the pupil on to the tiny area of the fovea at the opposite side of the retina. Outside 'foveal' vision, optical acuity is fairly good in 'parafoveal' vision, for some twenty degrees each side of the centre of the gaze, but thereafter rapidly deteriorates in 'peripheral' vision.)[20]

But do peripherally placed things 'get muzzy' in Bonnard's paintings because Bonnard has actually *painted* things on the periphery in a muzzy way? Or are things on the periphery simply *perceived* in a muzzy way? E.H. Gombrich's explanation of a similar case tells us that if the artist had painted them in a muzzy way, as compared to how he had painted things at the centre, when the eye is fixated at the centre of the canvas, they will be perceived as *doubly* muzzy; therefore, inaccurate representations of the workings of visual perception.[21] If he has not painted them indistinctly, and they look muzzy, then they look muzzy simply because things seen in peripheral vision do look muzzy under normal conditions. Bonnard has not contrived that. He has not represented the workings of visual perception, merely *relied* upon them. This second argument would seem to prevail because Bonnard does not, generally, paint peripheral things indistinctly as compared to things at the centre of a picture.

Of course, it may be argued that Bonnard has represented the optical fact of centralised acuity, by contriving to make the beholder look at the centre of the pictorial field, which,

under normal conditions, causes peripheral things to look blurred. But this is a weak argument because making the beholder look at the centre is what painters had been doing for a very long time without the implication that they were representing perception. And in so far as Bonnard does contrive it that the eyes of the beholder do, to begin with, look at or near the centre – or, more precisely, move reiteratively around a primary scanpath at or near the centre – he cannot prevent the eyes from then making forays into the outer boroughs, even to peripheral edges that, when reached and foveated, will not look any more muzzy than any other parts of the picture that have been foveated. Indeed, Bonnard counts on the eyes doing just that, on their moving over paintings under precisely the same conditions as they move over other kinds of visual fields.[22]

This tells us, first, that Bonnard cannot be said to have reproduced the effect of a single fixation of the eyes or of a few clustered fixations, and, second, that it would have been unnecessary for him to do so because we see the visual field of a painting under the same conditions as we see other visual fields. If, in fact, he sought the forementioned effect, he did not need to represent it but to rely upon it. And if he relied upon it, he could rely upon it applying to multiple fixations across every part of the visual field. Thus, it would seem to suffice that painting, rather than seeking to represent the varying distinctness of foveal, parafoveal and peripheral vision, should, in Baxandall's words, 'instead register the field of vision offered within the frame with equal distinctness so that the eye can operate in its normal scanning way'.[23]

Perhaps Bonnard's painting does. Perhaps he registers the field with (relatively) equal distinctness, then creates for the eyes major stimuli close to the centre, sufficient to effect a primary scanpath there, then minor stimuli in more peripheral regions of the field. If this is the case, though, it is not enough simply to say that Bonnard does not represent but relies upon the workings of visual perception, for he thus manipulates these workings to cause particular, intended effects to be represented.

Discussing Matisse, Lawrence Gowing seemed exasperated when wondering whether this question of representing perception belongs to 'a whole epoch of subtle confusion, at root, perhaps, a semantic confusion, springing from ideas like Mallarmé's – to paint not the object but the effect it produces'. He concluded, with Baxandall: 'If the effect of nature had been the aim, why not have painted the object and let it produce its own.' However, he went on to say of Matisse's painting that it 'did not depend on the dwindling effects of effects; it could generate its own lively brightness … [in the artist's words, by not] "considering colour as warm and cool" in the Impressionist manner … [but rather] "seeking light through the opposition of colors".'[24] It deserves notice, then, that Bonnard's great revision of his art in the years around 1912, owing, he said, to his dissatisfaction with the inability of his rediscovered Impressionism to attend to form, led not only to what he himself stressed, new attention being paid to drawing and composition, but also to far more oppositional colour than before.[25]

Effectively, Matisse (and then Bonnard) realised that contrasted (complementary) hues at high intensity, when juxtaposed, seem to generate rather than to imitate light because such contrasts produce after-images and, with each eye movement, after-images left by the previous view will 'moire', introducing a visible movement into the scene. As Julian Hochberg has explained, although this effect is actually the result of the shifting and trembling of the viewer's gaze, it can serve to simulate the experience of being dazzled by more than one can grasp; or trying to grasp a scene as a whole with a defocusing gaze and not regarding any part specifically; or of being afforded only a single momentary glimpse of something.[26] But the question this raises is whether the optical vibration is to be thought purely the effect of the painting, of its own sensational visual character, or also the effect of substance represented as vibrating in the painting, which would make the vibration still the effect of an effect and the painting still the representation of perception of substance. In this example, Matisse and Bonnard do not only cause intended workings of visual perception to be represented for the beholder, they also cause them to serve a representational purpose. But they are able to do this only because they allow the painting's own sensational visual character to be noticed.

We must go back before Mallarmé for guidance out of this quagmire, to a famous eighteenth-century critical text, Diderot's *Notes on Painting* of 1765, which distinguishes two kinds of painting.[27] The first kind is uniformly articulated in scrupulous detail at a close distance, therefore losing definition to the extent that the beholder backs away. No artists are mentioned, but the mode broadly corresponds to what Svetlana Alpers, writing of Dutch seventeenth-century painting, calls an 'art of describing', a map-like, hyper-realist art of the expanded, more-or-less evenly filled surface that is indifferent to the beholder's position, unlike an Albertian perspectival art which requires a situated, monocular viewer.[28] Indeed, owing to its uniformly detailed articulation, Diderot's first kind of painting will appear to be veridical at every single part of the surface that is foveated. Thus, Diderot can say: 'My relation to such a picture is like my relation to the nature that was the painter's model.'

Diderot's second kind of painting, in contrast, imitates a scene perfectly only from the vantage point the painter actually took, and only those details visible from that vantage point. Like the first kind, it loses definition to the extent that the beholder backs away, but it also loses definition as the beholder comes nearer to the painting than the painter was to the scene. The first kind of painting obeys what Diderot calls 'the law of universal finish'. The second kind does not. It cannot be said, obviously, to obey some law of universal *unfinish* because it depicts some things in more detail than others, according to their distance from the point of view of the painter either across his field of vision or in depth.

Rembrandt is Diderot's example of the second kind of painting. (It deserves noting, in passing, that Albertian perspective is not thought worthy of mention in 1765, which, of course, makes problematical the suggestion that it was Bonnard's revolution to have replaced it.)[29] Whereas a painting of the first kind is veridical at every part of the surface foveated, a painting of the second kind is veridical only in the relatively few focal regions treated in detail. As Hochberg has demonstrated, a painting of this second kind therefore exploits the differences between central and peripheral vision in so far as when the beholder's gaze is directed at a focal region, the painting can be made indistinguishable from one of the first kind that is uniformly detailed throughout, as well as from the represented scene itself, because, under such a condition, both foveal and peripheral vision seem normal.[30]

Bonnard aligns himself with Diderot's first kind of painting when he writes, 'I try to give the picture more layers, more unity … the picture must be supported … there must not be any holes in it.'[31] His paintings are relatively uniformly articulated in their level of detail, and the whole field is thoroughly developed and painted in its every part, including every margin and corner, whether with brush or rag, whether thickly or thinly, having been worked from close-up (as photographs demonstrate) into a continuous membrane. But nothing is scrupulously detailed as if seen close-up. Therefore, no part of the surface seems veridical when foveated. This distinguishes his painting from Diderot's first kind – and also from Diderot's second kind, which is veridical when a focal region is foveated. In contrast to both, any part of a Bonnard painting will only be veridical when it is *not* foveated, that is to say, when it is seen in parafoveal or peripheral vision, or at a distance.

Because the eye, wherever it is directed in a painting by Bonnard, meets patches too large to be within the resolving power of foveal vision, there is nowhere for the fovea to pick up fine detail. But as the fovea moves away from an array of patches, they will form into continuous colours and edges, owing to the lower resolving power of parafoveal and peripheral vision. Like Diderot's second kind of painting, Bonnard's exploits the differences between central and peripheral vision, only in an opposite direction. The answer, therefore, to the questions posed by Sylvester's remarks is: Bonnard's paintings are only muzzy at the edges *when you look at the edges* – when the centre, in contrast, *sharpens* as it is reclaimed by parafoveal or peripheral vision; conversely, if you move your gaze away from the edges, they will sharpen as the fovea leaves them.[32]

The pictorial field of a Bonnard, then, may be thought to represent not 'natural vision', decreasing in acuity from fovea to periphery, but the very obverse of that, an increase in acuity from fovea to periphery. At the risk of over-simplification, it may be said that Bonnard obeys the law of universal unfinish, which is to say, he impossibly combines the uniform articulation of Diderot's first, close-up kind of painting with the diminished detail of the second, distant kind. This is an impossible combination because, other than from close-up, the painter cannot see objects with an equal distinctiveness either across the field of vision or in depth. This is another argument against Bonnard representing natural vision. Indeed, it is an argument against Bonnard representing the perception of substance, for he could never have seen-and-painted substance as it appears in his paintings. And, of course, he did not; he did most of the work of painting from memory.[33]

The impossibility of combining uniform articulation with diminished detail is removed if one removes the painter from his distant viewpoint and imagines, instead, the painter scanning all parts of a scene separately from the same distance, and remembering them together in the painting, or remembering the scene, however scanned, in the form of separate parts to be put together as if at the same distance in the painting. To imagine either of these things is to acknowledge the separation of looking and painting in Bonnard's practice.

In summary: (1) A painting by Bonnard cannot be thought to represent the perception of substance on the part of a painter-beholder in a fixed position before that substance because we know it was mainly painted from memory. (2) Neither can the painting be thought to represent a memory of the foregoing perception subsequently painted by the beholder because the painting is, in either case, inaccurate to that perception. (3) It may be thought to represent a memory of the perception of substance on the part of a beholder who was not in a fixed position before that substance, presented to other beholders who are necessarily more or less fixed in position before the representation. A wonderful conceit: Bonnard painted (from memory) close-up as if painting (from reality) at a distance but still able to see uniformly across the visual field, which would have been impossible when painting from reality but not when painting from memory. He does not simply represent his (memory of his) perception of substance but causes his (memory of his) perception of substance to be represented in the perception of other beholders, each one of whom might say, with Diderot: 'My relation to such a picture is like my relation to the nature that was the painter's model.'

This is, effectively, an idea of painting not as a representation given over to the beholder but, rather, as a stimulus for a representation to be created by the beholder. This was a reason why a painting should contain enough oppositional colour so that it would 'generate its own lively effects', as Gowing has it, so that it would as much seem to generate light like nature as to represent light like a picture of nature. Movements of the eyes across Bonnard's paintings create a vibration suggestive of daylight illumination as patches of paint form and unform continuous colours and edges. Too much illumination, though, especially when formed by too purely oppositional colour, risked dazzling and blinding, therefore stopping the beholder, already confused to find that things can be more clearly seen by not looking at them. That would happen at times, most especially with the late bathtub

paintings. But if the beholder was to be expected fully to create the representation, there had to be enough time allocated for the creation.

To show what one sees when one enters a room all of a sudden[34]

Let me describe what actually happens when I suddenly enter a room. The first two of the following things will happen simultaneously; the third may happen, almost immediately afterwards. (1) The occluding edge of the doorframe expands to uncover or 'unwipe' the new visual array, then recedes and contracts behind me to wipe out the old one and is itself wiped out.[35] (2) A shearing of optical texture occurs at the peripheral borders of the array because (as we have learned) the acuity of the eye quickly diminishes outside central, foveal vision. I find it impossible, in fact, clearly to see the entire room all of a sudden in this stage of 'global' pre-attentive vision before any purposive scanning has taken place; all but the smallest part of the scene that falls on my fovea is devoid of detail. (3) However, two ninety-degree turns of my head to left and right will encompass the whole room (for the field of view of the head is roughly hemispherical), during which turns my eyes will also be in movement, both in compensatory movement for that of my head and in exploratory movement across and around the hemispherical field of my head, and will 'accommodate', change shape as they hunt for the optimum state of focus on objects in differing depths.[36]

Since accommodation cannot, of course, easily be induced by a painter working on a plane surface, it must be the lateral exploratory movements of my eyes that mainly interest us here; more precisely, the conjunctive movements that change the direction of the gaze of the two eyes.[37] These can either be smooth, because under cognitive control, or occur in pre-programmed ballistic jumps, or saccades, from one foveal fixation to the next, elicited by parafoveal or peripheral stimuli.

When Bonnard speaks of wanting to show what one sees when one enters a room all of a sudden, he can hardly be referring to global pre-attentive vision before any purposive scanning has taken place, although, as we have learned, some of his recent commentators suggest as much.[38] For, in so far as we can see his paintings thus, they are no different from any other visual fields and, in so far as we do move on purposively to scan his paintings, we do not see them thus, as is the case with any visual field. Bonnard's representation of perception (as I shall continue to call it, despite the growing number of qualifications) is a representation of what happens in the third, voluntary stage described above.

Sasha M. Newman effectively acknowledges this when she says of Bonnard's *The Open Window* of 1921 (no.42):

The viewer feels as if he has walked into a room, been drawn to the sublime landscape glimpsed through the window, and has accidentally noticed the sleeping woman [identifiable as Marthe de Méligny, Bonnard's lover since 1893 and wife from 1925, and his principal model][39] out of the corner of his eye which was originally trained elsewhere.[40]

Remembering the first stage mentioned above, however, surely the beholder feels as if stopped *in front of* a rectangular opening on to a room, for while the doorframe has been wiped out, the occluding edge of the painting substitutes for it, as if a doorframe itself.[41] And yet, the subsequent part of Newman's description (I give only a part of it) seems true to experience of the painting (to mine, in any event). It follows, therefore, that the painting may be said to record what one sees when one enters a room all of a sudden, but as if from a position outside the room. Perhaps it records, outside the room, a memory of what was seen entering it.

In this account, Bonnard's representation of the delays and successivities of perception,[42] at the third stage, describes the temporal dimension of perception, as much contemporary criticism claims it does. Only, the description appears to be made for the purpose of showing a deferral that connotes the withdrawal, and thus the unavailability, of an image lost to a memory that seeks to recover and thus to retain it.[43]

But how, precisely, are these delays and successivities generated? They depend upon the fact that vision, as Bonnard puts it, is mobile and variable.[44] Vision is variable, in brief, in so far as the acuity of the viewing eye decreases in intensity from fovea to periphery because, among the light-receptor cells at the back of the retina, the closely-packed 'cones', sensitive both to hue and to fine detail under conditions of high illumination (thus providing daylight, photopic vision), give way to the ever more sparely distributed 'rods', less sensitive to detail and blind to hue but which provide monochrome (or scotopic) vision in dim light.[45] This is why, under conditions of low illumination, we see things more distinctly if we don't look directly at them (the so-called Arago phenomenon),[46] which tells us that, if we fixate near the centre of any painting, peripherally placed elements will come into attention as the light fades.

In *Dining Room Overlooking the Garden* of 1930–1, (no.62) Bonnard helps along this phenomenon by having concealed the figure of Marthe in the left margin within a mauve zone of paint adjacent to the yellows and oranges of the painting's centre. ('A figure should be a part of the background against which it is placed', he wrote.)[47] Only a tiny percentage of the foveal cones are responsive to short-wave colours like mauve and blue and are overwhelmingly responsive to the long-wave yellows and reds which compose daylight. Thus, as the light fades, and vision shifts from the foveal cones to the peripheral rods (the so-called Purkinje shift),[48] short-wave colours increase in brightness and, therefore, visibility relative to long-wave colours.

The relative distribution, and function, of cones and rods also explains why I say that the figure of Marthe, revealed in scotopic vision, is represented as concealed by Bonnard in photopic vision. The two ends of the spectrum cannot be concurrently focused by the eye. It normally focuses for the yellow light so abundant in the world, an effect Bonnard enhances by loading this picture with yellow, as he so often did. ('One can't have too much,' he would say.)[49] Thus, short-wave light is permanently out of focus under daylight conditions; therefore, substances indicated in mauves and blues beside or within areas of long-wave colours will seem distanced and remote in photopic vision, as frail Marthe does in this painting and as her water-glazed body does in the great bathtub paintings which commemorate the scenes where his remote and reclusive wife lived so many of her hours. Bonnard, we know, loved what he called *'l'heure bleue'*.[50] Perhaps it was because in scotopic vision at twilight these spectral figures emerge.

What Bonnard calls the variability of vision is accompanied by what he calls its mobility. Vision is mobile, in brief, in so far as the viewing eye constantly, restlessly changes its direction so as to redirect its acuity within the visual field to cause an image to fall in the fovea, the retina's tiny central area of maximum acuity under conditions of bright illumination.[51] As we have learned, these conjunctive eye movements may either be smooth, when the eye is turned wilfully according to the demands of attention, or saccadic, when the eye turns automatically in fixation reflexes that respond to the stimuli of parafoveal and peripheral information. It is important to add, though, that the direction of central, foveal vision by cognitive demands for information about objects can be overridden by the more quickly and automatically operating system stimulated by parafoveal and peripheral vision. This has a crucial bearing on the painter's attentional direction and the beholder's temporal experience of a painting.

W.J.T. Mitchell observes, of the tradition of denying the dimension of time in the visual arts, that the claim that a painting must be scanned in some temporal interval is usually met with the counter-argument that this temporal process is not determined or constrained by the object itself; that we can perform the scanning in more or less any order we wish; and that we know throughout the process that we are the ones who are moving in time while the 'object itself' remains stable and static. Moreover, the passage of time must be inferred in a painting from a single spatialised scene; it cannot be directly represented by the medium in the way that spatial objects can.[52] To learn, however, that our wilful scanning of a painting can be overridden by an automatically operating system – which can be controlled by the painter who understands the system – means that the temporal process of scanning of a painting may, in fact, be determined or constrained by the object itself.[53] We may continue to believe that we are the ones moving in time; but knowing that we are moving in symmetry with the object can, if not actual-

ly suspend the difference between subject and object, make us conscious, perhaps, that the object is a transformational object, in Christopher Bollas's sense of an object 'pursued in order to surrender to it as a medium that alters the self'.[54]

To move in symmetry with the object is to acknowledge that temporality is, in fact, as directly represented by the medium of Bonnard's painting as spatiality, in so far as the same medium that forms the scene as spatialised also forms it as temporalised, the experiences of spatiality and temporality being inseparable for the beholder. Bonnard thus sponsors the pacing of our experience of spatiality, leading us along reiterative paths then prompting us into exploration, delaying us in a ruminativeness then sending us off inquisitively to the next place, and experience of the varying rhythms of the pace is integral to experience of its varying locations.

In *Dining Room Overlooking the Garden*, Bonnard delays perception of the image of Marthe by placing it within a blurry area of short-wave coloration to reduce the amount of information it offers when compared to other images. He may be said to represent the temporal event of Marthe (eventually) suddenly appearing in the scene. This narrative of appearance, effected by Bonnard arranging things so that the beholder will eventually move his eyes to foveate the left border of the painting, is no more inferred from the painting than is knowledge of the spatial position of Marthe in the scene, which is provided simultaneously with her temporal appearance. In the case of a painting showing a scene from a narrative, temporality would not be given directly by its signs but have to be inferred; for example, from the signs standing for limbs in spatial movement. It seems suggestive, therefore, to note that, with rare exceptions, Bonnard purges his paintings of gestural or propulsive movements, shifting movement from the depiction to the perception of the depiction, creating a narrative of attention for the attentive beholder. The plotting, or pacing, of this narrative of attention is what is experienced as rhythm, which requires a background of enhancing stillness to be heard.[55]

Another, and related, reason for Bonnard avoiding the depiction of violent movement would seem to be that the principal trigger of automatic fixation choices among peripheral stimuli is actual movement. Therefore, images of and in which movement might, in reality, be expected will be high on the list of those that catch the eye. Bonnard will very carefully ration their use – for instance, by tending to camouflage faces[56] – and depictions of extravagant movement will be reserved for *tours de force*. Two astonishing, very different examples are *Stepping out of the Bath* of 1926–30 (fig.17) and *The Boxer* of 1931 (no.61). In the former, Marthe is discovered leaving the bath not unlike Thetis slithering over Jupiter's body in the great painting by Ingres, 'a creature of prodigal fluidity appropriate to her watery origins', in Robert Rosenblum's words,[57] and everything around her collapses as if in amazement in a retinal blur. In the latter, the artist's own impotently flailing arms are caught in the process of beating at the surface of the painting that simulates a mirror, there-

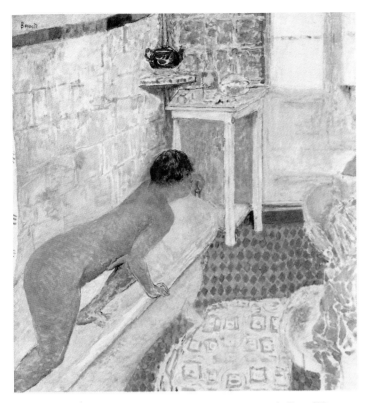

fig.17 *Stepping out of the Bath* 1926–30, oil on canvas 129 × 123 (50¾ × 48⅜)
Private Collection

fore suggesting that his frustration is seeking both admission and escape; this time it is the centre, within these arms, that blurs – the face contorting in distress, the pupils of the eyes contracting almost to blindness, at the weakness of the self-exposure – falling away.

These examples demonstrate how the eye will move over what is (represented as) stopped, to stop on what is (represented as) moving, which is why a basic stillness is necessary to Bonnard's mobilising exercise. The direction and speed of the mobility will mainly be affected by the simple perceptual rule that automatic fixation choices are generally confined to areas of high information, identifiable by significant differences within the field of vision. This is, of course, the basic principle of camouflage, which Bonnard adopts when he smoothes differences between figure and ground to defer fixation choices – for example, by giving them a similar coloration, as with the figure of Marthe in *Dining Room Overlooking the Garden* (no.62) and *The Open Window* (no.42).[58] Related to this principle is the fact that tonal contrasts are recognised more quickly and with fewer errors by peripheral vision, and attract its attention more, than tonal similarities, as do eccentric more than even contours, sharp more than soft accents. This is why, for example, the contrasted, eccentric and sharp drawing of the top of the bread-basket (if that is what it is)[59] in the lower right corner of the former work attracts such inordinate attention. It helps to distract my attention from Marthe across the painting.

These factors do not explain, however, why not only Marthe but also the cat beside her in *The Open Window* is slow to appear to my perception, since it is both strongly contrasted in colour against the ground and described in eccentric contours to which my eye will move to fixate more quickly than to predictable or redundantly repeated ones. In this case the answer must be, in part, because it is difficult to detect the true colour of a small area through peripheral vision;[60] thus, vision centrally fixated on the painting might miss this one. A more important reason, though, which may also explain Bonnard's attraction to broad framing devices, could be a cultural rather than a strictly perceptual one. Given the conventional function of the frame to dignify the centre, it is understood that elements within a framing area are not meant to be examined individually but only to be sensed marginally, and the broader the framing area the more the orientation to the centre and the less *übersichtlich*, visually easy to grasp, becomes whatever is placed in the framing area itself.[61]

Such a phenomenon will be affected, though, by the number and character of marginal elements. When there are few peripheral targets for fixation, they will be recognised accurately, but when the number of these targets is increased, especially by those that do not admit of easy recognition, the visual field will constrict in a tunnel vision to prevent an overloading of the system.[62] This may be thought to occur in the case of *The Open Window*, *Dining Room Overlooking the Garden*, and other works, similarly loaded with incident around the periphery. My overstimulated eye retreats to the centre – until attracted by peripheral incident again.

There is frequently a retinal blur at or near the centre of Bonnard's paintings, depicting either a too-far-to-focus distance, as with the view through the window of *The Open Window*, or a too-near-to-focus proximity, as with the head of the model in *Nude in the Tub* of *c*.1916 (no.30). (Perhaps this is what the artist meant when he said, sounding a little like the psychoanalyst Jacques Lacan, that 'to begin a picture, there must be a void in the middle.')[63] In the visual perception of the world, retinal blur stimulates the eye to accommodate.[64] A depiction of retinal blur will, therefore, puzzle the eye which, having been stimulated into unproductive accommodation, will first continue to accommodate (like searching for something under obscure circumstances, something distant from the eye, or in shadow, or irradiating, or disintegrating …) until search for signification in the 'void' overloads or frustrates the perceptual system and, in a reversal of tunnel vision, turns attention to the periphery, being egged on by sight of (previously occluded) peripheral elements. Then the centre will call for attention again …

Since I have had reason to criticise Jean Clair's account of Bonnard's representation of perception, I am pleased to be able to acknowledge a great insight this account contains. He noticed how Bonnard achieves a 'double victory' when he expands the pictorial surface to the broad field of binocular vision but also gives equal value to the centre and the periphery; and when he expands the chromatic range to its extremities (violets and blues at one end, oranges and reds at the other) but also unifies the chromatic field with the

equalising effect of an evenly shimmering fabric.[65] Bonnard's carrying the eye backward and forward between centre and periphery may be thought, like these double victories, a way of expanding and contracting the painting as if it were pulmonary. This is the largest, 'global' rhythm of his paintings.[66]

'The strict cropping of the visual field nearly always produces something false', Bonnard wrote in his diary. 'The second stage of composition consists of bringing back certain elements which lie outside the rectangle.'[67] The frame of a Bonnard, like the occluding edge of a photograph,[68] announces that between what it encloses and what it excludes there is a difference, a rupture, that cuts across the world of representation. But the painted border inside the frame tells of what is absent from the rectangle because things are hidden in the border as if they were absent from the rectangle. Thus, revealing things to be there in the border is, effectively, to bring back into the rectangle things that were outside. Additionally, and even more importantly, the veridical scene will also be outside of the rectangle, only in the external world, until the rectangle is seen peripherally and veridical reality 'returns' in the vividness of painterly illusion.

In *The Provençal Jug* of 1930 (no.59), for example, my perception of the hand in the right margin is delayed, but delayed less than is perception of the arm beneath it, owing to its greater contrast against the ground and to the even darker and sharper zigzag design inscribed on the cuff of the blouse, which invites fixation. To accept its invitation (Bonnard thus forces me to) is to discover that the patches of paint, which describe the eponymous pot and its immediate environment only flatly and summarily when they are directly foveated, sharpen into a coherent illusion of volume and spatial depth as they are reclaimed by my parafoveal and peripheral vision. What is more, not only does the interior of the painting transform in the mobility of my looking, its occluding edges are wiped out by it, as if I had suddenly entered a room.

A related example. Closed polygonal forms are known to be identified more quickly and accurately than histoforms (e.g. bar graphs and bar codes) throughout the visual field, but with an increase in eccentricity (the angle away from the fovea) of more than fifty degrees the surface of a form becomes the more salient dimension than the shape, solidly toned (silhouetted) forms being more quickly and accurately identified than outlined forms.[69] The lower part of *Table in Front of the Window* of 1934–5 (no.71) effectively comprises solid and outlined polygons disposed over a histoform, and the latter proves extremely difficult to foveate owing to the greater attraction of the former. But the looming presence of the solid, coarsely fragmented histoform in the upper part of the painting calls for my attention even at the expense of everything beneath it. Its being strongly contrasted to the ground helps, but so does (once again) the fact that it contains sharp, eccentric contours that call for deciphering, in this case as a chair in front of the window. To fixate on that area (once again) transforms the painting. I see that my very

gaze is being overlooked by that of the figure of Marthe, who was previously hidden in the right-hand orange border, and with this confirmation that my gaze might usefully be held at that point, the table slides toward me under *the projection of my gaze*; at least, *as long as I can hold it there*.

The projection of my gaze: because the saccade throws my sight into the visual array, which fractures upon the entry of what is, effectively, my performative act.

As long as I can hold it there: because with steady fixation, owing to a mechanism known as Troxler's effect, small objects in the periphery begin disturbingly to disappear. Fixation leads ultimately to blindness; if I managed to eliminate all head and eye movements relative to the visual array so that it remained fixed on my retina, within a few seconds virtually the whole visual world would disappear.[70] (The immobile, eternally fixated eye of perspective diagrams would not, in fact, see anything.) My optical immobility would mean my blindness, then. Blindness, Freud tells us, symbolically means impotence.[71] (Immobility means impotence means blindness, *The Boxer* tells us.) Movement will mean not only sight but also desire.

Importance of an unexpected impression [72]

The foregoing examples were largely examples of delays, of Bonnard delaying perception of elements situated in parafoveal and peripheral vision. This meant, in the main, his delaying the perception of elements situated in the actual periphery of his paintings. Self-evidently, though, the perceptual mechanism applies to elements seen peripherally (or parafoveally) wherever they happen to be placed; this is demonstrated by the example of *The Provençal Jug*, where Bonnard delays representation of the centrally placed incident as veridical until we fixate on peripherally placed incident and, consequently, see the centre in peripheral vision. In this instance (and in many more), the eye will eventually repeat the journey backward and forward between the centre and the periphery of the canvas in cognitive search for the enjoyment of re-experiencing sight of the painting transform – or of re-enacting the pulmonary rhythms of the transformations. Initially, though, the successivity is the result of conjunctive eye movements that are saccadic (not under cognitive control) and of the fact that such eye movements are, to a significant extent, reiterative.

The foregoing example confirmed something we learned earlier: with paintings, like Bonnard's, composed of broad colour patches, areas claimed by parafoveal or peripheral vision are sharper and clearer than those claimed by foveal vision. It is normal to vision, however, that we turn the eye to place an area of attention in the fovea: not because of any actual tie of attentional and foveal stimulation but simply because it is normal. This normal correlation between attention and the fovea occurs as a result of an also normal demand for high acuity.[73] In Bonnard's paintings, the normal

correlation will disappoint the normal demand; to place an area of attention in the fovea results in loss of acuity. The result is a restlessness of vision that is even greater than the, again, normal restlessness of reiterative patterns of perception.

Bonnard's paintings may be said to offer three patterns of reiterative eye movements: backward and forward between the centre and periphery; across and around the surface; and across and around small sections of the surface. Having considered examples of the first kind, which I have characterised as pulmonary and global, in the foregoing discussion of delays, I shall in this section offer examples of the second kind after we learn a little more about reiterative eye movements.[74] (The third kind will be considered in the next section.)

Saccadic eye movements, whether or not operating in reiterative patterns, are so fast (taking around 160 milliseconds to programme internally, and occurring at the rate of around three per second) that they occupy only some ten per cent of viewing time.[75] (Speed is important because, during saccades, the eyes' threshold for taking in information is raised.)[76] Some thirty per cent of viewing time is thought to be occupied by reiterative saccadic eye movements and the (typically) ten fixations that punctuate them to compose a scanpath of a duration of three to five seconds, the remainder of the viewing time being occupied with less regular eye movements, both saccadic and cognitively driven. And it is from the reiterations of a scanpath that what has been called a feature ring or network is formed, a sequence of sensory and motor memory traces that alternatively record a feature of the object and the eye movement required to reach the next feature on the ring.[77] In effect, a very large proportion of viewing time concentrates on a very small number of targets. (No wonder that features can remain undetected for so long.) The smallness of the number of targets on a scanpath appears to be attributable to the fact that short-term (immediate) memory can only store between five and nine independent items.[78] And the creation of a scanpath, then a feature network, is literally and specifically the creation of a memory. As J.J. Gibson writes: 'The essence of memory as traditionally conceived is that it applies to the past, in contradistinction to sense perception, which applies to the present. But this distinction is wholly introspective.'[79] The obvious conclusion to be drawn from this is that Bonnard paints from memory paintings that, representing perception, represent the creation of memory.

Thus far, in addressing the visual appearance of these works, I have stressed the continuity and relative uniformity of the painted membrane and the discontinuity and relative diversity of the depicted incident. What has not yet been remarked is the discontinuity and diversity in painterly detail itself that may be discovered by scanning across the membrane. 'A brush in one hand, a rag in another', as he himself said,[80] Bonnard is a painter of the articulated touch.

Let me notice just a few areas of *Nude in the Bath and*

Small Dog of 1941–6 (no.94). In the lower right corner, the area immediately to the right of the bath still seems wet with aqueous pigment; beneath it, I see that short runs of a thinned green have dripped down the surface and, in one case, followed the contours of a squarish lozenge block of paint, the prototypical Bonnard form.[81] The area of the side of the bath above the dog (that touching emblem of his fidelity after Marthe's death; she died in 1942), and of the mauve and pink tiles above the bath, are dense with paint so dosed with medium that it is as translucent as encaustic. Aided undoubtedly by that association, I see that the huge slabs at right of centre, each smeared horizontally with paint that is very dry (for a bathroom), have the look of a map by Jasper Johns, at once pasted on like a decal and of enormous weight. The curtain at the left (if that is what it is) is also drily painted, but seems to have been stabbed at in a way that seems done nervously, and is nervous-making. The right margin blurs, having been feathered with a late addition of paint that gives way to bare canvas near the base. And within all of this, the woman-in-water surrounded by enamel is the creation of smeared and stroked marks that taper to the paint-encrusted head, part jewellery, part putrefaction, which I cannot bring into focus except by looking at it from a greater distance than needed to focus what surrounds it, or peripherally, as if its decadent beauty literally repelled me.[82]

In offering this partial description, I show that I have savoured the diversity of the paint handling. It affords savouring. Yet, I think that it would be mistaken to say that its intended function is the disinterested provision of pleasure – or expression of the autographic self or of the qualities of the painterly medium itself in order to provide pleasure. The painting is diverse because it composes a picture, an intentionally articulated illusion conveyed through the varied reflections of light off the intentionally various painted surface. Seen other than very close-up, variety of handling of painterly substance transforms into worldly substance itself transformed by quantities and qualities of irradiating (and disintegrating) light. Bonnard's successivities are effectively the product of a plotted field of varied illumination. Like Chardin, whom he deeply admired (and as whom he imagined himself in a famous self-portrait),[83] Bonnard 'keeps the beholder on his toes by teasing him between one point of fixation and another'.[84]

Bonnard, to use Hogarth's famous words, through 'intricacy in form … leads the eye a wanton kind of chase' across the painting.[85] A classic, early eighteenth-century demonstration of this was known as 'Titian's bunch of grapes'. In Roger de Piles's words: 'the grapes, being separated, would have each its light and shade equally, and thus dividing the sight into many rays, would cause confusion; but when collected into one bunch, and becoming thus but one mass of light and one of shade, the eye embraces them as a single object.'[86] In 1924, the critic Roger Allard must have been thinking of de Piles when he noticed that Bonnard avoided the 'canon of the pyramid upon which early 18th-century connoisseurs based

their judgments.'[87] Bonnard's own paintings with grapes and other fruit court 'confusion' by showing closed silhouetted forms (often with closed silhouetted forms inside them; *Corner of a Table* (no.72) of *c*.1935 is one obvious example) disposed in extrafoveal arrangements – the kinds of forms that, as we have learned, attract fixation reflexes in the kind of arrangements that creates competition among these reflexes. The result is a restless movement of vision. And such a result will be encouraged whenever similarly strongly legible forms are dispersed beyond the reach of a single foveation. Thus, in *White Interior* of 1932 (no.68), a bright white door swung open at the centre of the picture is opposed to a dark multicoloured view beyond a door swung open at the right; and a brown-orange chairback at the left of the white door, with an inclined plane (unexplained) to its left, is opposed to a similar yellow shape just beyond the open door, with an inclined plane (explained as an open door) to its left. And just in case I have missed the point, flowers at top left oppose flowers at bottom right.

These chasing rhythmic movements forward and backward across and around the surface are different from the larger, global rhythms that carry forward and backward between the surface's centre and edges. While the global rhythms have a pulsatile aspect owing to the regular bounce provided by the edge, which rebounds the gaze, the chasing rhythms have a more spasmodic aspect owing to the more extended and irregular scanpaths they follow. And while the global rhythms thus regularly mark the limits of the representation, the occluding edges which substitute for a doorframe, the chasing rhythms are oblivious to these limits, close-circuited manufacturers of representation of what I see when I enter a room. The former is a technique of interruption in so far as it shows me both what cuts through the representation and, from that outside position, the representation clarifying as I look back inside. The latter is a technique of continuation in so far as it carries me between thematically associated elements, and continues to carry me, making a single representation stretch out temporally as it repeats.[88]

These two techniques, and rhythms, cannot entirely be separated in the experience of a painting by Bonnard. But they can be separately identified, and it is fair to say that, of these two, the chasing rhythms affording continuity are the ones that predominate. With these chasing rhythms, the ballistic aspect of the saccade is not thematised to the dramatic extent that it is with global rhythms, where vision will be thrown back into the centre from outside. Still, they too have performative connotations, being the product of dodging, restless, wavering trajectories which pass things in and out of our notice like an oversolicitous provider.

Following Bonnard's own lead, some commentators have stressed the purely optical aspect of these chasing rhythms. Thus, it has been claimed that the artist shows us the 'natural', curvilinear, concave space that the eyes see in such panoramas.[89] In fact, since the eyes' threshold for taking in information is raised as they dart around in saccadic move-

ment, as compared to their moments of fixation, the eyes can hardly perceive spatial curvature. For the same reason, awareness of the succession of temporary retinal impressions is absent from the perceptual experience. However, in so far as visual perception acknowledges, with every move of the head, the difference between the visual world, stable but unbounded, and the visual field, bounded but unstable, it carries a vague sense of the retinal mosaic, and a clear sense that movements of the head (not of the eyes) make possible the sense of 'looking around' the inside of a concave volume, while movements of the eyes (not of the head) make possible 'looking at' whatever attracts them. In effect, it is bodily movement that registers spatial curvature and makes possible (to a lesser extent) awareness of the retinal mosaic.[90] If Bonnard paints either spatial curvature or the retinal mosaic, he is representing perception not by simply transcribing the adventures of the optic nerve but transcribing the adventures of the body that carries the optic nerve.

When he says he is doing the former, it follows, he is forgetting that his adventures are performative, or believing that his eyes alone can be performative, able to insert embodiment into the optical field. In fact, when he explained that, while 'the vision of distant things is a flat vision … it is the near planes which give the universe as the human eye sees it, of a universe that is rolling, or convex, or concave…',[91] he was distantly echoing the old statement of Berkeley that 'visual appearances are altogether flat', and it is only through transference of the sense of touch to the eye that one negotiates around proximate objects.[92] And when he said that 'a painting is a series of patches [*taches*] that join together to form the object, the fragment [*morceau*] over which the eye can travel without limitation', thus equating it with the retinal grid, he added immediately: 'The beauty of a fragment of antique marble resides in the whole of a series of indispensable movements of the fingers.'[93] Every fixation point, every tessera on the retinal grid, is effectively conceived as a touch of the eye.

The corollary of the proposition that foveating and touching are equated is that not touching may be inferred when foveating is frustrated or unproductive or when a target is missed or delayed because camouflaged.

Let me consider *Young Women in the Garden* (no.43), painted in 1923 then reworked and completed in 1945–6. We learned earlier that closed polygonal forms are more quickly and accurately perceived than histoforms. In this instance, though, the dazzling contrast across the orange-and-blue tablecloth with yellow surround produces an after-image with each shift in focus, which, superimposed on the subsequent fixation, makes it difficult to gain the image of the blonde woman's face. It is like looking into glare; being dazzled by more than I can absorb; afforded only a momentary glimpse of somebody; not being able to know where to reach somebody. The distracting, contrasting darks in the periphery make the matter worse, until, foveating the cluster in the bottom right corner, which turns out to represent

Marthe, I see the blonde woman peripherally from Marthe's point of view. And I see her clearly from that point of view, for reasons we already know. From Marthe's point of view, if that could precisely be occupied, I could reach over and touch her, as I could not from a position in front of her, looking at her directly.

Yet, I cannot solely adopt Marthe's point of view because my eye turns normally to the blonde woman to place that area of attention in the fovea. (At this moment, I can imagine two views on the blonde woman, Marthe's and mine, converging.) But, again, the image of her face cannot be gained. My eyes may return to Marthe, but more likely, because the chasing rhythms supersede the global rhythms, they will move nervously between the face of the blonde woman and the analogously shaped, very fluid, almost melting prospect of fruit, which I can foveate, because it is as bright as its surround, and therefore can reach to and extract from its surround. But in order to do that, I have to reach past and push aside the other, unseeable and untouchable prospect for which it is a surrogate. (At this moment, I can imagine two views – Marthe's view on the blonde woman and my view on the surrogate – that do not converge but cross each other. My view, of course, was first taken by the first beholder, the artist.)

After this little dramatisation of the attentional narrative,[94] it is only fair to say that the blonde woman is known to be a young model named Renée Monchaty, who was Bonnard's lover, and apparently his fiancée, for the few years before she committed suicide in 1923, the year this painting was temporarily completed. Two years later, Bonnard finally, impulsively married Marthe, after whose death in 1942 the painting was completed by gilding the area of the garden. (Bonnard was partial, he said, to the gilded backgrounds of early Renaissance paintings; their artificiality reminded him of collages.)[95]

Whether or not one believes the story that Renée was found dead in her bath,[96] it is a fact that, in the year of her death, Bonnard, having flirted earlier with Degas's theme of the solitary domestic bather, began his own great series of bathtub paintings which comprises his single greatest achievement. In these, it is Marthe now who, at first proximate even to the point of claustrophobia, becomes inexorably more and more distant because less available to foveating sight. At the end, the woman-in-water is outlined in enamel in the shape, ironically, of a binocular panorama, only she has receded into a blur. Around her, the bathroom becomes, in Julian Bell's careful phrase, 'a glittering jewel chamber'.[97] But it is not only a lively surrogate possession, it is also a lurid picturesque, what happens when the meanings of things decay and they can be viewed purely aesthetically. And it is also the means of blurring the woman-in-water. The chamber scintillates, provoking the pupil to contract in order to reduce the light level to which the sensitive retina is exposed. Blink reflexes may even occur, reflexive closings of the eye, such as may be induced by sudden noise and puffs of air as well as by bright lights.[98] This is all more than can be comfortably looked at, only it invites looking. This is all unavailable to be touched, only it remembers touching, as if the more dazzling the looking, the more scintillating the touch.

In this sense, too, the woman-in-water is found a surrogate. This is not a place in the solid, tactile world, not a terrestrial array, where light and shade change places slowly in one direction. The bathroom tiles form a screen that reflects and projects an aquatic array, a liquid wavy surface where light and shade interchange rapidly in both directions, and oscillates in an iridescence that is glittering, sparkling, *brillant*.

… everything sparkles and the whole painting vibrates [99]

Famous photographs by Brassaï and Henri Cartier-Bresson of Bonnard's studio wall at Le Bosquet, taken around 1946, show a slightly changing array of postcard reproductions of works of art, among them Seurat's *Bathers at Asnières*, Gauguin's *Vision after the Sermon*, and a *Seated Woman* by Picasso, plus a few picture postcards.[100] Such is the attraction of art-historical sources that the right-hand side of these photographs is often cropped, for it only shows an old creased map of Cannes and a half dozen even older, small sheets of silver paper, some patterned. It would seem that only one visitor, Pierre Courthion, had the sense or the curiosity to ask what 'those papers with shimmering colours' were there for. Bonnard's reply was: 'It helps me to find my sparkles [*mes brillants*].' And then he turned the conversation by offering Courthion a drink.[101]

The high degree of reflectivity of such papers, like that of aquatic arrays, is attributable to the speed of the successive simultaneous contrasts produced by the rapid interchange of light and shade, which effectively reverses the experiences of distinction and separation normally produced by contrasts, causing light and shade or figure and ground to 'assimilate', to seem to shift toward each other as if mixing.[102]

One form of assimilation is lustre, the vacillating effect created on (or, seemingly, over) a surface by the forming and unforming of continuous colours and edges when colour patches are seen at the distance, whether frontal or peripheral, just before complete optical mixture occurs.[103] Since lustre is the product of distance from the object of attention, it is, therefore, the product of what I have called global rhythms in Bonnard's art.

A second form of assimilation is the scintillation created by multiple contrasts: the optical restlessness produced when different continuities struggle for dominion, as in chequer-board patterns and other densely repeated arrays that can produce *moiré* effects,[104] and in situations where confusion is possible between shadow and body colour (because tonality will subjectively lighten when perceived as the former rather than latter).[105] Since this kind of scintillation is the product

of reiteratively scanning the object of attention, it is, there-
fore, the product of what I have called chasing rhythms in
Bonnard's art.

The third form of assimilation, generated by silver paper
and aquatic arrays – and in Bonnard's art by closely packed,
contrasted stimuli that replicate their mobile effects – is a
more extreme manifestation of the second form, and is
potentially the fullest, most complete form of all three,
capable of producing the highest 'albedo' or whiteness of
substance,[106] which results from the almost continuous
oscillation of the eyes. Closely packed, contrasted stimuli,
especially when in densely repeated arrays, require longer
fixations and shorter saccades.[107] However, there is no
absolute distinction between saccades (and other kinds of eye
movements) and fixations: the eye is never literally fixed, but
moves constantly in small tremors, drifts from fixation, and
microsaccadic movements that jerk the eye back to the
fixation point, as well as in various compensatory movements
as the position of the head changes.[108] Therefore, closely
packed, contrasted stimuli minimise the difference between
saccades and fixations, and their respectively higher and
lower thresholds for taking in information. The assimilation,
the blur of the oscillation of the eyes, is the blurring of the
distinction not only between light and dark, and figure and
ground, but also between (saccadic) not seeing and (fixated)
seeing. Yet the assimilation, the blur, is not a melding of these
opposites but, rather, their rapid alternation. This is most
evident in the characteristic physical response to this extreme
form of assimilation, the blinking of the eyes.

Papillotage, the blinking of the eyes,[109] was the name by
which assimilation was known to the art criticism of the eigh-
teenth century. It was associated with the Rococo style of the
first half of that century, especially of Boucher, a style which
Diderot called '*le genre heurté*' ('the jerky style') because its
flickerings of light and colour on the surface (one thinks
particularly of the electric treatment of fabrics) produced
rapid movements of the eye and, therefore, distracted the
beholder by reminding him of the presence of the surface.[110]
Consequently, in the words of a modern critic, *papillotage*
'expresses both the gaze, the acceptance of the object seen,
and the blink which cuts off the eye from contact with the
world and, in so doing, brings the self back to self'.[111]

Bonnard came to artistic maturity in a period of
enthusiasm for the Rococo, which he admired and with
which his own art has been associated.[112] Thematically, he
may be thought to combine the eroticised, displayed body
of a Boucher with the body's performative relationship to
its environment of a Chardin, and thus the spectacular
consumerism of Boucher with the placid utopianism of
Chardin.[113] Optically, he may be thought to combine the
quick *papillotage* of a Boucher with the slower, more
prolonged exchanges of a Chardin, where a fully and evenly
filled surface image is similarly adjusted to the space of the
beholder, but this time by markedly varying its legibility with
the beholder's distance from the array. Such an effect is

analogous to *papillotage* in making the beholder conscious
that the optical creation of the image is his own.

What I have called Bonnard's global rhythms, in so far as
they are rhythms of distance, control the relative legibility of
the image. The enhanced legibility of the image that we have
noticed with achievement of lateral distance from it also
occurs, naturally, with achievement of retreating distance
from it. Our understanding of *papillotage* will be aided
by knowledge of what, in this analogous condition, the
beholder's consciousness comprises.

Diderot wrote of Chardin's *La Raie*: 'Come closer,
everything becomes blurred, flattens, disappears; step back,
everything comes back together and is recreated.'[114]
Effectively, the eye is an active agent in the production of
meaning, of different and contradictory kinds of meaning
which ebb and flow through the pictorial object according to
the spatial relationship of the beholding subject to it. Step-
ping back (or looking in from the side), the eye recreates the
representation; the beholder is rejoined to the world of the
representation. Approaching (and looking head on), the
representation disappears (or transforms) into its own
means; the beholder is re-separated from contact with the
represented world.

For Diderot, the recreation of the represented world pro-
duced by stepping back allows the beholder to imagine that
he might enter the space of that world; it takes shape around
him and, as if in a reverie, he feels a part of it. If the beholder
is thus imaginatively within the painting, this means, Michael
Fried has argued, 'that according to that fiction the beholder
is removed from in front of the painting just as surely as if his
presence there were negated or neutralised, indeed just as
surely as if he did not exist.'[115] This suggests that when the
eye approaches it also recreates: it recreates the beholder who
has been negated, neutralised in stepping back. The beholder
is thus (re-)represented before the picture, from which
position he had 'disappeared' when the picture was perceived
(at a distance) as a representation. And the beholder is thus
recreated as a representation precisely when the picture, in
contrast, is perceived (close-up) to have 'disappeared' as a
representation.

This means that the beholder's representation and the
world's representation, the visibility of subject and of object,
are mutually inhibitory, the former being associable with
proximity (and frontal views) and the latter with distance
(and peripheral views). In Bonnard's self-portraits where the
mirror is coterminous with almost the entire canvas surface,
the artist is placed in front of the canvas-mirror, looking at it,
and he sees only a virtual image of himself 'inside'. In his
paintings of Marthe immersed in bathing, the body that is
sought in memory gains the status of an unapproachable cult
image, the 'unique apparition of a distance' riven from the
traces that inscribe her, and the presence of the artist, on the
proximate surface.[116]

It is important, though, to distinguish between what
bathing (for hours on end) may have meant for Marthe in her

actual and historical existence, and for the culture to which she belonged, and the function it assumes in Bonnard's paintings of Marthe bathing.[117] And it is also important to distinguish, in the paintings, the activities surrounding bathing from immersed bathing itself. The former align Bonnard with Chardin, the latter with Boucher.

The activities that surround bathing show Marthe engaged in steady, rhythmic and repetitive acts relatable to the body and its care – washing, scrubbing, drying – which place such emphasis on the dexterity of the hands that the figural poses are almost entirely determined by it.[118] Often, a hand will reach to a foot to tie the body into a giant Möbius strip, a solipsistic knot of self-absorption that is charged with the tactile quality of bodily contact and frank in the invitation to intimacy.[119] The self-absorption is, of course, an apartness. But the prolonged, extended, unhurried activity only apparently excludes the beholder, who waits and watches and can imagine a closeness amounting to an identification with the never-ageing, painted woman. ('He looked after her, feared her, put up with her, loved her', a common friend wrote: 'her identity almost merged with his in the constant anxiety she caused him.')[120] Not just looked at but looked after, Marthe is supported in these paintings, which are among Bonnard's slowest, their slowness bespeaking the tactile solicitude of the gaze.[121]

The late paintings of immersed bathing are faster, mobilised by the whirr of the *papillotage*. Within them, the body is a floating, dissolving, numb thing, lost in water as if suspended in the non-seeing darkness within vision that alternates with seeing and light in the assimilating whirr.

There is the continuum, and there is the repetition of disjunction, which forms it. The continuum captures a greater range and intensity of illumination than normally is available to pigment.[122] It may, therefore, be thought a way of brightening the representation emotionally, too.[123] If it does that, it does so wishfully. The continuum also unifies the chromatic field, stretched to the distant, opposite ends of the spectrum, as a single shimmering fabric.[124] This may also be thought wishfully optimistic, for the pulsatile rhythms that vibrate the field allow of the interpretation that tactile contact with the represented object is utterly denied in the dazzling 'space of light' that is created.[125]

The disjunction which, when repeated, forms the continuum is a technique of interruption, like the pulsatile global rhythms discussed earlier. But whereas those rhythms interrupt by showing the edge and with it the representation, *papillotage* is an interruption of and in vision itself, a splitting of vision by the duration of the blink in the process of gaining the representation.

We have heard that Bonnard associated gilded grounds, creators of *papillotage*, with the technique of collage. He said that both reminded him of the artificiality of painting. Collage did so, he said, by 'taking bits and pieces of the outside world and incorporating them into pictures'.[126] *Papillotage* offers the outside world as bits and pieces, and composes them like a collage, by accretion, as Bonnard's paintings do. Between each bit and piece is a space during which the seen outside world is absent. But in the repetitive alternation of present pieces and absent spaces the distinction between the two is blurred; they assimilate. The repetition of disjunction, of interruption, forms the continuum, which hides the difference …

The hiding that takes place in Bonnard's paintings admits of two contrary, but not mutually irreconcilable explanations. It may be thought to connote protection and preservation on the analogy of camouflage or chromatic mimicry. On this analogy, when orientation fails to produce detection – when the alignment of attention with a source of sensory input is unproductive because the stimulus has not reached a reportable level[127] – it is to hold the stimulus intact from detection. This explanation works well for visual *masking*, the reduction of visibility relative to the ground, such as occurs with the peripherally hidden images in Bonnard's paintings. It may be thought to confirm the Chardin element in Bonnard, the placidly utopian element, in so far as the hiding merely delays the finding, and leads to the pleasurable shock of surprise that marks the moment of detection: The beholder can learn from this how to use Bonnard's paintings imaginatively to represent the anticipation of a simultaneity between pleasure and surprise, which is to say, to represent a hedonism that rescues pleasure from every surprise.[128]

The foregoing, protective mimicry model does not work so well, however, with visual *veiling*, when a stimulus is unreportable owing to glare, as happens in *papillotage*. In this instance, an image cannot be said to be protected from detection (then rescued from its protection), for the image is effaced in the glare. An alternative model is required, which acknowledges how sensory input blends and merges across the field, not merely camouflaging but erasing distinctions between figure and ground. Writing in 1935 on animal mimicry, Roger Caillois proposed an analogy with schizophrenia, where space is a devouring force which slackens the contours of bodily integrity so that the body seems to assimilate to its surroundings, desolidifying in space,[129] or perhaps we should say in the present context, washing away.

This explanation may be thought to confirm the Boucher element in Bonnard, the spectacular consumerism of an utterly mesmerising art of a surface that is spatially illegible, in which bodily 'depersonalisation by assimilation to space' attracts an erotic, even a pornographic interest.[130] Unless one's thinking is utterly hostile to the nature of pornography, this element may be enjoyed both for itself and as a reminder of what is intrinsic to visually mesmerising images. To say, as I do now, that the effect of bodily assimilation also serves another, less sensational purpose should not be thought a denial of, or excuse for, an amiable visual sponsorship of sexual enjoyment. But it does serve another, indeed an opposite purpose, which pertains not to the proximity of the image but to its distance.

Proximity and distance connote finding and losing.

Marthe, when immersed in her bath, is pictured as an Aphrodite who, instead of rising from her shell to bring desire and pleasure into the world, retreats into her shell in denial of *aphrodisia*, is lost in herself in her self-immersion.[131] The avoidance of love, the retreat of desire, the elusiveness and unavailability of women:[132] these associations that attach to Bonnard's poignantly pessimistic works have in common the motif of hiding. Things cannot be found, are lost, because the experiences of distinction and separation are cancelled, causing figure and ground to assimilate, hiding figure in ground. In the blink of the *papillotage*, the world is hidden momentarily from the beholder, bringing the self back to self, an experience that is represented and re-represented in Bonnard's paintings: represented in the subject of Marthe's self-immersion and re-represented in Bonnard's means of depicting that subject, in the blink of the *papillotage* when Marthe disappears.

It would be unnecessarily literal to see these images as actually representing (and re-representing) Marthe's reclusive illness, even if we knew precisely what it was.[133] What is worth considering, though, is whether Bonnard's paintings might be thought to represent (and re-represent) to Bonnard himself his sight, his view, of the symptoms of that illness. (Marthe was apparently prone to different forms of protective delusional behaviour, from delusions of persecution to agoraphobia, with which the obsessional bathing may have been thought to be associated – whether reasonably or unreasonably is of no import.)

Hiding and blurring in bathing, which is how Bonnard represents Marthe, associates her separation with the aqueous medium in which she is self-immersed. Self-evidently, this forges an association with painting, but with painting as a medium of covering rather than as a medium of revealing. Marthe is lost in the paint as in water, and in both as in darkness rather than in light. Discussing 'depersonalization by assimilation to space' in schizophrenia, Caillois writes that 'while light space is eliminated by the materiality of objects, darkness is "filled," it touches the individual directly, envelops him, penetrates him, and even passes through him …'[134] Bonnard's representation of Marthe as enveloped may be thought a representation of his view of her splitting and disintegration in her defensiveness and her depersonalisation.[135]

However, owing to the very association of the media of bathing and painting, might not painting wishfully challenge whether it is to be accepted that Marthe is lost to darkness? Put simply, in so far as the compulsion to repeat replaces the ability to remember when a content of memory is not available to consciousness, and may take on a ceremonial aspect, can Bonnard's own repetitive acts of making images from memory of such ceremonies – images that themselves cause compulsive repetitions of the eyes over them – be thought to be wishfully therapeutic, as well as, obviously, resignedly commemorative?

An image that is both wishfully therapeutic and resignedly commemorative would be one that inscribes the wished-for desire for what has been lost, or the means of recovering it, upon the sadly diminished reality of the present experience. We have noticed how the shape of the woman-in-water looks blurred when directly foveated but sharpens and hardens when looked back upon in peripheral vision. The effect is comparable to that of an anamorphic ghost. So we need to ask, with Lacan: 'How is it that nobody has ever thought of connecting this with … the effect of an erection?'[136]

What is more, how is it that nobody has ever thought of connecting both of these things with Bonnard's practice of painting on unstretched canvases tacked to the wall, canvases that were stretched and tightened afterwards? Once taut as a drum, a canvas's optical vibration gained a patent, visible motivation: was it not the canvas itself in what Lacan would call its developed form that was beating in desire, finding and losing the object in the vacillation?[137]

Those willing to consider this question will be predisposed to ponder the following curious coincidence.

Lacan's *The Four Fundamental Concepts of Psycho-Analysis*, which discusses Caillois on mimicry and the meaning of anamorphic ghosts, suggests that discontinuity, in which something is manifested as a vacillation, is the essential form in which the unconscious appears.[138] One of his examples, taken from Maurice Merleau-Ponty's *The Visible and the Invisible*, is of a man who dreams that he is a butterfly (*papillon*), which Merleau-Ponty had associated (and Lacan agrees with him) with the butterfly which inspires with phobic terror the subject of Freud's 'From the History of an Infantile Neurosis'. This subject, the so-called Wolf Man, recognises (in Lacan's words) 'that the beating of little wings is not very far from the beating of causation, of the primal stripe marking his being for the first time with the grid of desire.'[139]

Trusting that the etymological association of *papillon* and *papillotage* has been made, I direct your notice to the final words from Bonnard's diary that have been published: 'I hope that my painting will endure without craquelure [that is, with a tautly unbroken surface]. I should like to present myself to the young painters of the year 2000 with the wings of a butterfly.'[140]

The work of art: a stopping of time[141]

In conclusion, the art-historical argument underlying all of this can be summarised as follows.

Charles Morice's 'Enquête sur les tendances actuelles des arts plastiques', published in *Mercure de France* in August and September of 1905, recorded a consensus that Impressionism was finished.[142] This may now be thought to be surprising, for the creation of the art-historical category called Post-Impressionism has led to the view that Impressionism was already finished in the 1880s.[143] What is revealed by Morice's survey, however, and by contemporaneous artists'

statements and interviews, is that it was only in the early years of the twentieth century that unease in avant-garde circles about three related conventions of Impressionist painting, broadly conceived, reached such a pitch that repudiation of these principles was seen to be necessary to the creation of a truly original new art. These conventions were the fictive instantaneousness of the creation, the record, and the perception of a painting.[144]

In order to sustain the belief that a painting records a stopped moment in time, it should be possible to sustain the belief that it was *created* in a moment, like a photograph, say. Since that is impossible to painting, the belief that it records a moment in time might be sustained, instead, by sustaining the belief that it can be *perceived* in a moment, even if it is made also to be savoured at length later.[145] But a painting is made over time and seen over time; in either case, a subject engages perceptually, intellectually and emotionally at length with an object. In order to sustain in good faith the belief that a painting records the *perception* of anything at all, it cannot be honest to offer the incredible impression that it was created or can be perceived in a moment. The only reason to pretend that a painting records a moment in time is if a painting is thought to *remember* a moment in time.

As Matisse demonstrated, though, to remember a momentary perception is not necessarily to record a moment in time. His particular dissatisfaction with Impressionism led him to conceive of painting as a temporal process of extracting, from a momentary perception of something, the essential property of it that stayed in the memory and, therefore, survived its merely temporary manifestation at any particular moment. Matisse's deep and growing suspicion of the sensational record, of painting that may be thought of as a representation of the perception of substance, is evident in the development of his art and his art theory in the years after 1906, years when Bonnard had 'returned' to Impressionism.[146]

That Picasso's Cubism also, and almost simultaneously, evidenced scepticism of the sensational record hardly needs saying, except to encourage other than stylistic interpretation of what commonality of interest and intent meant in those years. What does need saying, therefore, is that Picasso's phenomenological probing of the uncertain veracity of the perceived did not offer the same out-and-out escape from mere appearances that Matisse's mnemic approach did. It was only in 1912, in fact, in his deployment of collage, that Picasso suddenly achieved that escape, in the multiplicatory play of individual arbitrary signs that seem to shift their spatial positions and are only provisionally in stasis.[147] By that same year, Matisse was making a kind of painting that, in its own, different way, also comprised a simultaneous order of separate parts that could be perceived to be mobile.[148] That was the year that Bonnard, having been out of step with avant-garde art in his period of rediscovered Impressionism, took stock of where he was, did not like what he saw, and changed his direction.

It is not my intention here to urge influences, although

unquestionably that would be possible, but rather to suggest that, in or around 1912, Bonnard woke up to what had been happening between 1906 and 1912 in the most exciting painting in Paris, which then meant anywhere. In Baxandall's concise summary, it was 'an abrupt internalization of a represented narrative matter into the representational medium of forms and colours visually perceived'.[149] The narrative component of a painting had been allocated to its performative representation in the perception of the beholder.

But Bonnard continued to proclaim: 'The work of art: a stopping of time'.[150] How is that possible?

It was not only possible; it was necessary. The only reason to pretend that a painting records a stopped moment in time, we have learned, is if a painting is thought to remember a momentary perception. Bonnard needed to remember the original 'seductive vision' – or the 'original thought' or the 'initial idea' – of the object, he said, lest 'the inconsistent, fleeting world of the object' take over and swamp him in the mere appearances of things 'just as they are'.[151]

In saying this, he sounds rather like Matisse.[152] Unlike Matisse, though, Bonnard has an explicitly adversarial relationship with the perceived world. Knowing that he is too weak and will succumb to mere appearances, he wants to be 'armed', 'shielded' and 'successfully protected … against nature', which is why he will not look at the object while he is working.[153] (The object, we have noticed, will often be armed, shielded, protected against him; an interesting symmetry.)

If the original seductive vision (or idea or thought) is found in the first, momentary perception, then a painting that represents it must offer a representation of that temporal site in which it was found, must be interpretable as a record of a momentary perception, one gained entering a room all of a sudden, for example. Bonnard is representing a tiny, enclosed world of a trapped time. But the aim of recalling that temporal site is so that the painting may be used by the beholder to recover from it the original seductive vision (or thought or idea) trapped in the world at that time. This is how Bonnard's and Matisse's attitudes to memory may be seen to differ: Matisse extracts something memorable from momentary perception and offers it to the mind; Bonnard remembers extracting something memorable and offers that to the mind. Matisse wants the image to create an intense, immediate impression so that it will fully enter the beholder's mind immediately, where that first impression will go on resonating even as the beholder continues to contemplate the image; indeed, even after he has ceased to contemplate it. For Bonnard, the image is more important as a present experience than it is for Matisse, which is why his paintings are the more difficult to remember.[154]

Bonnard would say that, first and foremost, he sought to paint the savour of things, to recover their savour.[155] This is his Chardin side. He requires that a painting be slowly absorbed, be savoured, so that its surprises well up, one after another, into the field of perception and thereby articulate

the original seductive vision in its performative representation by the beholder. However, the inventorising required from the beholder acknowledges that the moment that produced the original seductive vision was itself temporal. 'There is a duration to the blink,' Jacques Derrida reminds us, 'and it closes the eye', allowing temporality and with it history, which is always waiting, to rush in.[156] Bonnard's expression of the almost instantaneous alternation of the present and the non-present is his Boucher side, the side of erotic display and melancholic absence assimilated in the same image. The beholder is taken to this side slowly through the inventorising, as in the structure of the present essay. Chardin offers the mediatory narrative, which leads to the hoped-for rapture promised by Boucher, the quiet vision of fact that translates into the wishful dream in which life and absence are indivisible in the *papillotage*.[157]

But, finally, why should Bonnard seek to protect himself from someone protected against him? It must be, as he says, because he would otherwise be too weak to retain the first wish of her, and the dream actuality would disappear. So was it, then, a selfish dream, which was itself responsible for submerging and concealing the ageing Marthe in the interests of a fantasy? Or can it be thought, in any sense, a shared vision of actuality? And is the vision sharable? We learned, near the beginning of this essay, that Bonnard proposed to the model Dina Vierny that she 'try to forget him' so that she would be able 'to "live" in front of him'.[158] Could he propose to Marthe anything less?

It is an attractive idea, that Bonnard's paintings can be used in order to learn that sharing is bound to a mutual acknowledgement of separateness. I think that they can be used in this way, for they do refuse to dominate. The difficulty, I know, is that they are themselves so dominated, so painfully submitting to what they show, an acknowledgement of Marthe's forgetfulness of everything except herself and what is materially contingent to her separate existence. This aspect has been thought to mark Bonnard's paintings with a frustrated anger as well as with a tenderness, their success being judged by the artist's capacity to balance these opposing tensions.[159] But do we wish to use these images in this way, to be judging what tensions might be thought artistically productive in a domestic relationship? If we want to be so practical, far better, surely, to use them to learn not to elicit reciprocity.

If Bonnard's paintings are to be thought exemplary, though, it should be in consequence of a larger scene that they allow to be enacted. It is one that Stanley Cavell calls 'the uncanniness of the ordinary'.[160] The pact that Bonnard's paintings make with us, in this account, is that if ordinary, commonly held, everyday things can be seen to be extraordinary because puzzlingly, uncannily unreadable – because returned to us by Bonnard to look unfamiliar to our first bewildered then delighted eyes – then they may be used to support ordinary, everyday efforts to step back from everyday thinking, and take pleasure without a concept, which is where explanation ends.

Still, an obvious, but necessary conclusion is that, by returning the familiar looking unfamiliar, Bonnard's paintings may also be used to show where (their own) criticism should aim to begin.

Notes

1 'La Peinture ou la transcription des aventures du nerf optique'. Diary note for 1 February, 1934, in *Bonnard*, exh. cat., Centre Georges Pompidou, Paris 1984, p.190, trans. *Bonnard*, exh. cat., Washington and Dallas 1984, p.69.

2 I take this way of stating the problem from Michael Baxandall, *Patterns of Intention. On the Historical Explanation of Pictures*, New Haven and London 1985, p.81, in a discussion of perceptual issues relating to the work of Chardin, pp.74–104, which has been influential on what follows. So has been the same author's 'Fixation and Distraction: The Nail in Braque's *Violin and Pitcher* (1910)', in John Onions, ed., *Sight and Insight. Essays on Art and Culture in Honour of E.H. Gombrich at 85*, London 1994, pp.399–415.

 Among the general works on the psychology of perception, which lay out the mechanisms of acuity, attention, colour vision and so on in more detail than I can possibly give or am competent to provide, I have found most useful: J.J. Gibson, *The Senses Considered as Perceptual Systems*, Boston 1966; J.J. Gibson, *The Ecological Approach to Visual Perception*, Boston 1979; Richard L. Gregory, *Eye and Brain. The Psychology of Seeing*, 4th ed., Princeton 1990; R.N. Haber and M. Hershenson, *The Psychology of Visual Perception*, New York 1973; Julian E. Hochberg, *Perception*, 2nd ed., Englewood Cliffs, N.J. 1978; Julian E. Hochberg, 'Some of the Things that Paintings Are', in Calvin F. Nodine and Dennis F. Fisher, eds., *Perception and Pictorial Representation*, New York 1979, pp.17–41; Trevor Lamb and Janine Bourriau, eds., *Colour: Art and Science*, Cambridge 1995; M.H. Pirenne, *Optics, Painting, and Photography*, Cambridge 1970; Irvin Rock, ed., *The Perceptual World*, New York 1990.

 Further notes give both specific references to some of these works and cite more specialised literature. I am pleased to acknowledge here the research support of Christel Hollevoet in collecting these materials, aiding the preparation of the endnotes, and in opening subjects of enquiry.

3 'Le talent de Bonnard est parmi les plus primesautiers, les plus franchement novateurs. Il surprend les poses d'un instant, dérobe les gestes inconscients, fixe les expressions les plus fugitives.' Roger-Marx, *Le Voltaire* (1894), quoted in 'Quelques opinions sur Bonnard', in Claude Roger-Marx, *Pierre Bonnard. Les peintres français nouveaux, no.19*, Paris 1924, p.12.

4 The temperamental ingenuousness of Bonnard's painting was noted by Guillaume Apollinaire: 'I do not know why, it invariably makes me think of a little girl with a sweet tooth. [...] I willingly abandon myself to the charms of M. Bonnard's cultivated and appealing manner. [...] M. Bonnard is full of fantasy and ingenuousness.' *L'Intransigeant*, 10 March, 1910, in Leroy C. Breunig, ed., *Apollinaire on Art: Essays and Reviews 1902–1918*, New York 1972, p.61. Bonnard's perceptual, Impressionist ingenuousness was noted by François Fosca: 'L'ingénuité de Bonnard est au contraire parfaitement naturelle, elle ne s'embarasse d'aucun système. Comme le disait Debussy de Moussorgsky, il semble découvrir la peinture à mesure qu'il peint. [...] Bonnard est la victime de cet impressionnisme qui fait à la fois sa force et sa faiblesse. Esclave de sa sensibilité, incapable de choix, d'ordonnance, il se sauve par un goût inné, qui tient du prodige.' François Fosca, *Bonnard*, Geneva 1919, pp.56, 61, quoted in Roger-Marx 1924 (as note 3), p.13.

5 'Le regard que Bonnard porte sur le monde est semblable à celui dont nous suivons les mouvements d'un jeune animal et d'un petit enfant.[...] Il assiste à [...] la naissance soudaine et miraculeuse des objets et des personnages.' Leon Werth, *Bonnard*, Paris 1919, 1923, pp.20, 33, quoted in Roger-Marx 1924 (as note 3), p.13.

6 Jonathan Crary, *Techniques of the Observer. On Vision and Modernity in the Nineteenth Century*, Cambridge, Mass. and London 1992, pp.95–6, discusses the association of modernity and the originality of 'innocent' vision.

7 Charles Terrasse, *Pierre Bonnard*, Paris 1927. This is an appropriate place to explain why the account of Bonnard's perceptual effects, which occupies so much space in this essay, does not include reference to contemporaneous scientific discoveries in the structure of perception. I can think of no more lucid explanation than that given by Jonathan Crary in his 'Seurat's Modernity', in Ellen Wardwell Lee, *Seurat at Gravelines. The Last Landscapes*, Indianapolis 1990, p.61:

 we are often led to think in terms of relatively secure and stable categories – of artists making something called art and scientists doing something called science in some other area of activity. Seurat is often seen as someone who in various ways 'used' or borrowed scientific ideas or theories in order to make his paintings [and such a view could be interestingly offered of

Bonnard, although I am not competent to offer it], but this tends to obscure the ways in which the fundamental aims of art and science often overlap and intermingle. The 1880s [and the decades that followed, too] were a time when thinkers and researchers from a wide variety of fields were probing the structure of perception, the relation between mind and sensation, and how the external world could be most usefully represented [...] It was a period when the earlier certainties of positivism and realism about the reliability of perception and of realist forms of perception were being profoundly questioned.

In so far as I will, later, associate aspects of Bonnard's perceptual probings with eighteenth-century models, I will do so because I think that it illuminates his practice; not because I think that an association with contemporaneous models would not.

8 The Bonnard literature from 1943 to 1985 is usefully summarised in Phillipe Le Leyzour, ed., 'Sur Bonnard. Propos et critiques, 1943–1985', *Hommage à Bonnard*, exh. cat., Bordeaux 1986, pp.27–36.

9 David Sylvester, 'Bonnard's *The Table*', *The Listener*, 15 March 1962, reprinted in his *About Modern Art. Critical Essays, 1948–96*, London 1996, pp.104–10, where another important, 1966 essay on Bonnard is also reprinted, pp.136–9. The quotations given appear on p.109; the technical language of the paraphrase is entirely mine.

10 Pierre Schneider's introduction for the catalogue of a Bonnard exhibition at the Galerie Claude Bernard, 1972 is referred to in Le Leyzour 1986 (as note 8), p.33.

11 Jean Clair, 'Les Aventures du nerf optique', Paris 1984 (as note 1), pp.16–37 (pp.20, 24, for the quotations from Clair that follow); trans. Washington and London 1984, pp.29–50 (pp.32, 36, for the quotations).

12 'Parfois [...] il cherche "à montrer ce qu'on voit quand on pénètre soudain dans une pièce d'un seul coup".' Marcel Arland and Jean Leymarie, *Bonnard dans sa lumière*, Paris 1978, p.21. This statement is also quoted in Jean Clair, 'Les Aventures du nerf optique', Paris 1984 (as note 1), p.19, trans. Washington and London 1984, p.32, where the sentence is said to be a diary note.

13 See Leo Bersani and Ulysse Dutoit, *The Forms of Violence. Narrative in Assyrian Art and Modern Culture*, New York 1985, pp.vii–viii.

14 Bonnard's diary note, 'Boucher, Ingres, premiers artisans modernes', appears in Tériade, ed., *Verve*, vol.5, nos.17–18, 1947, n.p., trans. Michel Anthonioz, ed., *Verve: The Ultimate Review of Art and Literature (1937–1960)*, New York 1988, p.170.

15 My analogy to Clare, and some of its language, is indebted to Robert Wells, 'The Waking Dream of Fact', *The Times Literary Supplement*, 13 June 1997, no.4915, pp.3–4.

16 '[Bonnard] ne voulait pas que je reste tranquille. Ce qui l'intéressait, c'était le mouvement; il me demandait de "vivre" devant lui en essayant de l'oublier. Il voulait à la fois la vie et une absence.' Annie Pérez, 'Entretien avec Dina Vierny', *Beaux-Arts*, 1984, quoted in Bordeaux 1986 (as note 8), p.136, cat.72.

17 Bonnard, diary note for 13 June 1930: 'Les exigences et les plaisirs de la vision et les satisfactions. Vision brute et vision intelligente', in Paris 1984 (as note 1), p.183, trans. Washington and London 1984, p.69.

18 Baxandall 1985 (as note 2), p.97.

19 Sylvester 1996 (as note 9), p.107.

20 This description will be refined and elaborated, as needed, in subsequent parts of the text. In fairness to David Sylvester, I should say now that he cannot possibly have been imagining the pictorial field as a representation of the centralised field of vision, for reasons the reader is invited to deduce and which I will give later. I need to take the liberty of interpreting it in this way for two reasons. (And I take the liberty because Sylvester's text does not explicitly disallow it.) First, in order to explain the very crucial issue of the relationship between how peripheral vision works and how things placed peripherally in a painting are perceived, I want to dispose of some consequences of confusing the two. Second, in order to afford a sense of how Bonnard delays knowledge of things in his paintings, using the forementioned relationship, I want to offer a somewhat analogous experience for the reader.

21 E.H. Gombrich observes that, if an artist were to reproduce, say, the doubling of images of proximate objects caused by taking a distant focus above them, if the beholder were then to take a distant focus above them in the representation, a double image of the double images would appear. As he explains, this is the phenomenon referred to by J.J. Gibson as the Greco Fallacy: if it were true (it obvi-

ously isn't) that El Greco elongated his figures because his astigmatism thus distorted them, he would have seen his painted figures (doubly) distorted. Only a correctly proportioned painted figure would have been seen as a (singly) distorted figure. (See E.H. Gombrich, 'Mirror and Map: Theories of Pictorial Representation', in his *The Image and the Eye. Further Studies in the Psychology of Pictorial Representation*, [Ithaca 1982], pp.181–2.) I hesitate before disagreeing with Gombrich on the subject of visual perception, but what he argues is not true under all conditions, and may not be true under any conditions. It is certainly not true for Bonnard's paintings, as we shall learn. (The impatient reader may turn to note 32.)

22 How the eyes scan visual fields is considered in: Gibson 1966 (as note 2), ch.12, pp.250–65; David Marr, *Vision. A Computational Investigation into the Human Representation and Processing of Visual Information*, San Francisco 1982; David Noton and Lawrence Stark, 'Eye Movements and Visual Perception', *Scientific American*, vol.224, no.6, June 1971, pp.34–43; the same authors' 'Scanpaths in Saccadic Eye Movements while Viewing and Recognizing Patterns', *Vision Research*, vol.11, no.8, August 1971, pp.929–41; Alfred L. Yarbus, *Eye Movements and Vision*, New York 1967, pp.171–96.

23 Baxandall 1985 (as note 2), p.93.

24 Lawrence Gowing, *Matisse*, London 1979, p.51. Matisse is quoted from the notes of his teaching recorded by Sarah Stein. For the full quotation, see Jack Flam, *Matisse on Art*, Berkeley and Los Angeles 1995, p.52.

25 In 1937 Bonnard wrote: 'When my friends and I attempted to carry on, even go beyond the work of the Impressionists we tried to surpass them in their naturalistic vision of colour. Art is not nature. We were more rigorous in our compositions, and found there was much more to be got out of colour.' Quoted in *Bonnard*, exh. cat., Galerie Salis, Salzburg; J.P.L. Fine Arts, London 1991, n.p. See Steven A. Nash, 'De Quelques Sources dans l'oeuvre tardive de Bonnard', Paris 1984 (as note 1), pp.41–3; trans. Washington and London 1984, pp.20–3; Julian Bell, *Bonnard*, London 1994, p.17.

26 Hochberg 1979 (as note 2), pp.34–5.

27 'Notes on Painting. To serve as an Appendix to the Salon of 1765', in *Diderot on Art*, ed. and trans. John Goodman, New Haven and London 1995, I, pp.191–240, specifically pp.208–9.

28 Svetlana Alpers, *The Art of Describing: Dutch Art in the Seventeenth Century*, Chicago 1983, p.44, for a summary of effects. See also a useful commentary, relating an art of describing to modern art: Martin Jay, 'Scopic Regimes of Modernity', in Hal Foster, ed., *Vision and Visuality. Dia Art Foundation Discussions in Contemporary Culture, 2*, Seattle 1988, pp.3–27.

29 See the comments by Clair quoted earlier, which suffer from equalising culture and nature in the antithesis of 'artificial perspective' and 'natural vision'. Since every depictive system is artificial (and to some extent natural), even if Bonnard could be said to record 'natural vision', the record will be as 'artificial' as any classical, geometrical perspective system, which is itself 'natural' in the sense of recording a retinal image, as well as artificial in so far as the eye can never 'see' the retinal image. A useful account of 'Transformations in Rococo Space', is the chapter of that title in Norman Bryson, *Word and Image. French Painting of the Ancien Régime*, Cambridge 1981, pp.89–122.

30 Julian E. Hochberg, ch.10: 'Art and Perception', in Edward C. Carterette and Morton P. Friedman, *Handbook of Perception*, x, *Perceptual Ecology*, New York, San Francisco and London 1978, pp.231–2; Hochberg 1979 (as note 2), pp.27–9. Both accounts, which compare a painting by Rembrandt to Impressionist paintings, have been deeply influential on my description of how Bonnard exploits the differences between central and peripheral vision.

31 'Voyez, fait-il, je cherche maintenant à donner plus d'assise au tableau, et plus d'unité. J'ai cru longtemps qu'il suffisait de faire chanter un ton un peu vif dans une gamme éteinte. C'était une expérience. Mais il faut que tout le tableau soit soutenu, vous comprenez. Il ne doit pas y avoir de *trous*. A ce point de vue, le Cubisme et les peintres de la nouvelle génération ont fait du bon travail. Mais ils sont durs, les jeunes!.' Quoted in Pierre Courthion, 'Quand Bonnard vivait encore', in his *L'Art indépendant: Panorama international de 1900 à nos jours*, Paris 1958, p.41.

 Jean Cassou wrote about the 'insolent principle of equality' in Bonnard's works, noting that 'Un compotier vaut un visage [...] tout divertit et cependant rien ne tire l'oeil exagérément', and spoke of an 'harmonieux ensemble là où nous n'avions vu tout d'abord qu'une promenade de

sensations en sensations'. (Jean Cassou, 'Le Lyrisme de Bonnard', *Formes*, no.9 [November 1930], pp.3–5.)

32 The mechanism is explained, with reference to views on Impressionist paintings from varying distances, in the publications by Hochberg cited in note 30. The flaw in Gombrich's argument, given in note 21, is as follows. If an artist mimetically represents a blurry double image of something seen that way in peripheral vision, it is conceivable that the beholder of the image will see a double image of the double image if he looks at it in peripheral vision. It is by no means certain that he would see a redoubled image because peripheral vision may not have the acuity to distinguish between doubled and redoubled images. But it is very certain that he would not see a redoubled image – indeed, that he would not see a doubled image – if the painter had composed the blurry double image by imperfectly combining patches of paint. On the contrary, the image would become sharper, more veridical, as Hochberg explains and as experience of Bonnard's paintings demonstrates. While a visual field organised in imitation of veridical visual experience will produce a *non-veridical* experience when the field is viewed peripherally, a visual field organised in imitation of non-veridical visual experience, like a Bonnard, will produce a *veridical* experience when the field is viewed peripherally.

Two things need adding to this. First, here the term *veridical* means more veridical than what is non-veridical, and the term *non-veridical* means less veridical than what is veridical; these are not absolute terms, obviously. Second, a peripheral *view on* a field should not be confused with the peripheral *placement* of something *within* a field. Thus, Bonnard sometimes does paint peripherally-placed things in especially non-veridical ways as compared to other parts of a painting; these become more veridical when viewed peripherally with respect to their placement, i.e. from the centre of the painting as well as from a peripheral position in relation to the painting.

33 It is often simply said that Bonnard painted from memory. He gave that impression at times, and it is clear that most of the work of painting was done from memory; see, for example, an account of the way Bonnard worked by the Mexican artist Angel Zarraga in James Elliott, 'Bonnard and His Environment', in *Bonnard and his Environment*, exh. cat., New York, Los Angeles and Chicago 1964, pp.24–5; also quoted in Bell 1994 (as note 25), p.20 (see p.22 for painting from memory). However, he did work from drawings, and sometimes watercolours and pastels (see Antoine Terrasse, 'Bonnard the Draftsman', *Bonnard: Drawings from 1893–1946*, exh. cat., The American Federation of Arts, New York 1972, n.p.; Sargy Mann, '"Let it Be Felt that the Painter was There …"', *Drawings by Bonnard*, exh. cat., Arts Council of Great Britain in association with Nottingham Castle Museum, 1984, pp.7–16; and photographs (see note 68). And he would sometimes begin painting from a model, only to feel forced to leave it (see Bonnard to Angèle Lamotte in *Verve* 1947 [as note 14], n.p.; partial trans. *Verve* 1988, pp.170–1 [as note 14], and see note 151, and the final section of this essay).

With respect to the contrast of close-up and distant viewing discussed in the text, Bonnard was conscious of the difference. 'L'exécution se fait le nez sur la toile ou sur le papier,' he noted. 'Il est nécessaire de connaître d'avance l'effet des lignes, des volumes, des couleurs qui seront vus à distance, ce qui en restera comme puissance […] Ce qui, à distance, ne porte plus, ou au contraire s'exaspère: Dans une peinture moyenne, le changement se produit à partir de 5 mètres environ. La répartition des taches se transforme si les valeurs ne sont pas justes.' ('Notes de Bonnard', in Arland and Leymarie 1978 [as note 12], p.26, 27.)

34 As note 12.

35 Gibson 1966 (as note 2), pp.203–8. Gibson 1979 (as note 2), pp.82–3, repudiated the metaphor of wiping to talk of deletion and accretion, but I retain it here for its greater descriptive force.

36 On accommodation, see Haber and Hershenson 1973 (as note 2), p.21. The metaphor of hunting appears in Gibson 1966 (as note 2), p.258. Accommodation is an automatic reflex, triggered by retinal blur, a fact which is significant for perception of Bonnard's paintings, as we will discover later.

37 Conjunctive movements are to be contrasted with disjunctive movements, which change the relative directions of the gaze of the two eyes (making them more convergent or more divergent) while leaving their average direction of gaze unchanged, thus helping the focus of the accommodation of individual eyes. Disjunctive movements are always smooth and under continuous control based upon feedback about disparity between current and desired vergence angles. See Marr 1982 (as note 22), pp.363–4.

38 Clair's description, quoted earlier, of Bonnard's providing 'a feeling of "visual entirety"' implies that Bonnard is painting global pre-attentive vision before any purposive

attentive scanning has taken place. The attraction of this erroneous idea, which has been repeated by other writers, is associable with the early modernist attraction to the idea of an originary, 'innocent' vision; see note 6.

39 On Marthe de Méligny, née Maria Boursin, see Maurice Garçon, *Le Procès de la succession Bonnard et le droit des artistes*, Paris 1952, pp.9–20; Belinda Thomson, 'Pierre Bonnard: Private Life, Public Reputation', in *Bonnard at Le Bosquet*, exh. cat., The South Bank Centre, London 1994, pp.17–19; Sasha Newman, 'Nudes and Landscapes', in *Bonnard: The Graphic Work*, exh. cat., The Metropolitan Museum of Art, New York 1989, pp.145–91, especially pp.158 ff.

40 Paris 1984 (as note 1), p.82 (cat.17); trans. Washington and London 1984, p.146, cat.20.

41 It is sometimes held that Bonnard's representation of perception extends to his representing the 'unbounded' appearance of the visual field; even, in the case of his horizontal paintings, the effect of a binocular panorama (see, for example, Clair's remarks in Paris 1984 [as note 1], pp.30–32; trans. Washington and London 1984, pp.42–4). I find more convincing Sylvester's suggestion that Bonnard chooses not to relate forms in a painting to the geometry of its edges but, rather, to geometries within the painting in order to control the design of the painting from the middle outward (Sylvester 1996 [as note 9], pp.107–8). If Bonnard had truly wanted to overcome the limitations of a framed painting in conveying the effect of an expanded panorama, there were lots of ways he could have gone about doing this: for example, actual panoramas, dioramas, ridged painted surfaces delivering two disparate arrays, stereoscopes, and motion pictures (cf. Gibson 1966 [as note 6], pp.233–4).

The idea that Bonnard wanted to overcome the limitations of a framed painting undoubtedly owes something to his practice of working on unstretched canvases tacked to the wall. However, Bonnard's own statements on this practice stress the possibility of making alterations to and, therefore, making more precise the dimensions of the canvas; that is to say, to make the framing edges more exact, not to escape from their constraints. (Typical statements by Bonnard on this subject appear in Courthion 1958 [as note 31], p.40; Pierre Courthion, 'Impromptus Pierre Bonnard', *Les Nouvelles littéraires*, vol.12, no.558 [24 June 1933], p.10; Arland and Leymarie 1978 [as note 12], p.21; Salzburg and London 1991 [as note 25], n.p.)

42 I take the terms, delays and successivities, from Bell 1994 (as note 25), p.27.

43 My allusion here is, of course, to both Walter Benjamin's concept of the 'aura' and Marcel Proust's '*mémoire involontaire*', which Benjamin associates in 'On Some Motifs in Baudelaire': 'To perceive the aura of an object we look at means to invest it with the ability to look at us in return. This experience corresponds to the data of the *mémoire involontaire*. (These data, incidentally, are unique: they are lost to the memory that seeks to retain them. Thus they lend support to a concept of the aura that comprises the "unique manifestation of a distance." […])' (Walter Benjamin, *Illuminations*, ed. Hannah Arendt; trans. Harry Zohn [New York 1973], p.190).

44 'The eye of the painter gives a human dimension to all objects and reproduces them as they are seen by the human eye. But this vision is mobile, and this vision can change.' Bonnard, 1927, quoted in Salzburg and London 1991 (as note 25), n.p.

45 Summary accounts of the composition of the retina may be found in Gregory 1990 (as note 2), pp.68–72. Fuller accounts, with differing emphases, appear in Malcolm Longair, 'Light and Colour', Denis Baylor, 'Colour Mechanisms of the Eye', and John Mollon, 'Seeing Colour', in Lamb and Bourriau 1995 (as note 2), pp.65–102, 103–26, 127–50; Edwin H. Land, 'The Retinex Theory of Color Vision', in Rock 1990 (as note 2), pp.39–62.

46 See the reference to this phenomenon in the discussion of the gaze in Jacques Lacan, *The Four Fundamental Concepts of Psycho-Analysis*, trans. Alan Sheridan, New York 1977, p.102

47 Quoted in Washington and London 1984 (as note 1), p.198, cat.46.

48 A useful account of this topic and other aspects of the perception of colour is Peter Parks, 'Colour in Nature', in Lamb and Bourriau 1995 (as note 2), pp.151–74. I am grateful to Bridget Riley for having introduced me to this excellent anthology, in which her own, lucid 'Colour for the Painter' appears, pp.31–64. A fascinating consideration of the Purkinje shift in relation to Giotto's paintings appears in Julia Kristeva, 'Giotto's Joy', in Norman Bryson, ed., *Calligram. Essays in New Art History from France*, Cambridge 1988, pp.27–52, especially pp.41–2.

49 Quoted in Annette Vaillant, *Bonnard ou le bonheur de voir*, Neuchâtel 1965, p.150; trans. David Britt as *Bonnard*, London and Greenwich, Conn. 1966, p.146.

50 See Nicholas Watkins, *Bonnard*, London 1994, p.140. In stressing the increased visibility, because brightness, of short-wave over long-range coloration at twilight, I am not claiming an increased compositional importance, and therefore visibility, of the area of the coloration itself. Bonnard himself reminds us of this, writing to Matisse of the latter's *L'Asie* which Matisse had lent him: 'the red there is wonderful late in the afternoon. By day it is the blue that takes the lead. What an intense life the colors have, and how they vary with the light.' (Antoine Terrasse, ed., *Bonnard/Matisse. Letters between Friends*, trans. Richard Howard, New York 1992, p.126).

51 For accounts of eye movements and vision, see the references in note 22.

52 W.J.T. Mitchell, *Iconology. Image, Text, Ideology*, Chicago and London 1986, p.100.

53 This fact is, I realise, one that a belief in free will makes difficult to accept, as I learned from a colleague when I argued for Matisse's manipulation of the beholder's attention in *Pleasuring Painting. Matisse's Feminine Representations*, London 1995, pp.18–22 and *passim*.

54 Christopher Bollas, *The Shadow of the Object. Psychoanalysis of the Unknown Thought*, New York 1987, pp.13–30, p.14 for the quotation.

55 In a relevant discussion of rhythm in narrative in Mieke Bal, *Narratology. Introduction to the Theory of Narrative*, trans. Christine van Boheemen, Toronto 1985, pp.68–76, we are reminded that pause has a retarding effect. Bollas 1987 (as note 54), p.13, stresses the 'enhancing stillness' of the atavistic facilitating environment provided by a transformational object and the rhythmic movements and sounds that, set against this stillness, 'continuously negotiate intersubjective experience that coheres around the rituals of psychomatic need'. Rosalind E. Krauss, *The Optical Unconscious*, Cambridge, Mass. and London 1993, p.217, refers to Jean-François Lyotard's discussion of Cézanne's stillness and passivity which 'permits the body's own density to well up into the field of perception and to carry along with it [an] unconscious […] that is the object of repression'. It is of note that Bonnard's own account of his inability to paint directly from nature stresses Cézanne's silence and passivity before nature as his way of discovering the original 'seductive vision' or 'original thought' or 'initial idea' of the subject; see note 151.

56 Yarbus 1967 (as note 22), p.191, notes that faces are particularly attractive to fixation, especially their potentially most mobile elements, eyes, lips, and then noses. The following more recent study confirms this: Calvin F. Nodine, Dennis P. Carmody and Harold L. Kundel, 'Searching for Nina', in John W. Senders, Dennis F. Fisher and Richard A. Monty, eds., *Eye Movements and the Higher Psychological Functions*, Hillsdale, N.J. 1978.

57 Robert Rosenblum, *Ingres*, New York 1972, p.84.

58 In the former work, we have learned, Bonnard concealed the figure in an area of short-range coloration with the result that it becomes more visible at twilight because that area is brighter then. In the latter, he conceals it in an area of long-range coloration such as occupies most of the interior, whereas the exterior is an area of short-wave coloration. Thanks to Charles Moffett, Director of the Phillips Collection, I have had the opportunity to see this work in fading light. The effect is, naturalistically, of an interior in which the light fades as compared to the more brightly illuminated exterior. The small area of bluish mauve above Marthe's becomes the brightest part of the room.

59 Put crudely, the visual process is a three-link chain in which *orientation* (alignment of visual attention with a stimulus) leads to *detection* (the stimulus reaches a reportable level) to *identification* (the report on the stimulus recognises what it is). I have been interested in describing the gap between orientation and detection in Bonnard's paintings. For reasons of space, I have omitted a discussion of the gap between detection and identification. But there is always a gap in so far as vision can deliver an internal description of shape even when an object is not recognised in the conventional sense of understanding its use and purpose, because representation of the shape of an object is stored separately from representation of its use and purpose. (See Marr 1982 [as note 22], p.35; Anne Triesman, 'Features and Objects in Visual Processing', Rock 1990 [as note 2], pp.97–110.) This topic opens large questions, which I regretfully must postpone for a future publication.

60 Peter Parks, 'Colour in Nature', in Lamb and Bourriau 1995 (as note 2), p.153.

61 See E.H. Gombrich, *The Sense of Order. A Study in the Psychology of Decorative Art*, 2nd ed., London 1984, pp.156–7.

62 N.H. Mackworth, 'Visual Noise Causes Tunnel Vision', *Psychonomic Science*, vol.3, 1965, pp.67–8; Haber and Hershenson 1973 (as note 2), p.211–12.

63 'Pour commencer un tableau, il faut toujours qu'il y ait un vide au milieu.' Bonnard, quoted in Arland and Leymarie

1978 (as note 12), p.21. Also quoted in Paris 1984 (as note 1), p.32; trans. Washington and London 1984, p.44. 'In every picture, this central field cannot but be absent, and replaced by a hole – a reflection, in short, of the pupil behind which is situated the gaze.' Lacan 1977 (as note 46), p.108.

64 Haber and Hershenson 1973 (as note 2), p.21.

65 Paris 1984 (as note 1), p.32; trans. Washington and London 1984, p.44.

66 I take the term, global rhythm, from Bal 1985 (as note 55), p.69.

67 Diary note for 12 October 1935: 'La découpure stricte dans la vision donne presque toujours quelque chose de faux. La composition au second degré consiste à faire rentrer certains éléments qui sont en dehors de ce rectangle.' Quoted in Paris 1984 (as note 1), p.191; trans. Washington and London 1984, p.69.

68 For Bonnard's own very matter-of-fact photographs, see Françoise Heilbrun and Philippe Néagu, Bonnard photographe, Paris 1987, trans. as Pierre Bonnard: Photographs and Paintings, New York 1988; Jean-François Chevrier, 'Bonnard et la photographie', Paris 1984 (as note 1), pp.218–39; trans. Washington and London 1984, pp.83–104; and Newman 1989 (as note 39), pp.177–82.

69 George W. Menzer and John B. Thurmond, 'Form Identification in Peripheral Vision', Perception and Psychophysics, vol.8, no.4, October 1970, pp.205–9, especially p.205.

70 Russell L. de Valois and Karen K. de Valois, Spatial Vision, Oxford Psychology Series, XIV, New York and Oxford 1988, pp.161–2; Gregory 1990 (as note 2), pp.66–7.

71 More precisely, the blinding of Oedipus is associated with castration, on which subject the immense psychoanalytical literature is best approached through J. Laplanche and J.-B. Pontalis, The Language of Psycho-Analysis, trans. Donald Nicholson-Smith, New York 1973, pp.56–9.

72 Verve 1947 (as note 14), n.p.; trans. Verve 1988 (as note 14), p.170.

73 Michael I. Posner, 'Orienting of Attention', Quarterly Journal of Experimental Psychology, vol.32, no.1, February 1980, p.9.

74 The following account of reiterative eye movements is mainly drawn from Yarbus 1967 (as note 22), Noton and Stark, June 1971 (as note 22), and Nodine, Carmody and Kundel 1978 (as note 56). The mechanisms of attraction and distraction, of attention and deferral of attention, that have already been discussed in the context of eye movements between centre and periphery of the surface naturally apply to eye movements within and around the surface as well. I, therefore, offer no further explanations of these.

75 Marr 1982 (as note 22), p.366; Noton and Stark June 1971 (as note 22), p.38; Hochberg 1978 (as note 2), p.163.

76 Posner 1980 (as note 73), p.10. It is an exaggeration, then, to say that the eyes are actually blind during saccades, as some accounts have it.

77 Noton and Stark, June 1971 (as note 22), pp.38–9.

78 Hochberg 1978 (as note 2), p.163.

79 Gibson 1966 (as note 2), pp.275–6.

80 Verve 1947 (as note 14), n.p.; trans. Verve 1988 (as note 14), p.170.

81 Patrick Heron, 'Pierre Bonnard and Abstraction', in his The Changing Forms of Art, New York 1958, p.123.

82 See 'Medusa's Head', in Sigmund Freud, Sexuality and the Psychology of Love, ed. Philip Rieff, New York 1963, pp.202–3. In Freud's interpretation, the apotropaic, paralysing head of Medusa not only provokes castration anxiety but denies it, in part because the stiffening of the petrification replaces the erection. This has bearing on what happens when the object in this painting is viewed at a distance or peripherally, a topic I return to later.

83 The association of Bonnard's Portrait de l'artiste par lui-même of 1930 (private collection), and Chardin's Autoportrait au chevalet (Louvre), was made by Antoine Terrasse in Paris 1984 (as note 1), pp.122–3, cat.37; trans. Washington and London 1984, pp.188–9, cat.41.

84 Baxandall 1985 (as note 2), p.101, on Chardin.

85 Gombrich 1984 (as note 61), p.96.

86 Roger de Piles, Cours de peinture par principes, Paris 1708, excerpted from a 1743 translation in Elizabeth G. Holt, ed. A Documentary History of Art, II, Garden City, N.Y. 1958, p.182. This text is discussed by Gombrich 1984 (as note 61), pp.99–100, and Baxandall 1985 (as note 2), p.91.

87 La Revue universelle, April 1924, quoted in Roger-Marx 1924 (as note 3), p.13. In 1912 an anonymous reviewer in The Times, quoted by Watkins 1994 (as note 50), p.124, complained that a painting by Bonnard 'bewilders the eye instead of guiding it'.

88 The action of carrying us over is metaphoric, in so far as the jumps of the saccadic movements reproduce a reality based on the resemblance of parts not necessarily in contact with each other and, therefore, metaphorical. (See Claude Gandelman, Reading Pictures, Viewing Texts [Bloomington and Indianapolis 1991], p.10.) But this is also a derealising

technique: in so far as we are led to make analogies between the forms, we do not take them literally but, rather, project expectations aroused by one feature onto the next. (See Michael Podro, The Manifold in Perception. Theories of Art from Kant to Hildebrand [Oxford 1972], p.86.)

89 See note 11.

90 For these aspects, see Gibson 1966 (as note 2), pp.252–6; Gibson 1979 (as note 2), pp.209–12.

91 Quoted in Bell 1994 (as note 25), p.80.

92 This statement is discussed in Gandelman 1991 (as note 88), p.6.

93 'Le tableau est une suite de taches qui se lient entre elles et finissent par former l'objet, le morceau sur lequel l'oeil se promène sans aucun accroc. La beauté d'un morceau de marbre antique réside dans toute une série de mouvements indispensables aux doigts.' Published as: 'Propos de Pierre Bonnard à Tériade, Le Cannet, 1942', Verve 1947 (as note 14), n.p.[p.59]; trans. Verve 1988 (as note 14), p.174.

94 I do not pretend, of course, that the narrative is necessarily viewed in the order that I have given. What I do hope to have demonstrated, though, is that the two rhythms of the viewing – the global rhythms and the chasing rhythms – that I have differentiated are, in fact, differentiable in the viewing, which produces the chiastic form of the two views that overlay the surface.

95 See Verve 1947 (as note 14), n.p.[p.59]; trans. Verve 1988 (as note 14), p.174.

96 Her suicide in a bath is stated as a fact in Newman 1989 (as note 39), p.190, and has been repeated by a number of other writers. However, this is denied in a letter from Michel Terrasse to Belinda Thomson dated 22 November 1993, according to whom she committed suicide with a gun; where precisely this happened is not stated (Thomson 1994 [as note 39], p.18, note 20).

97 Bell 1994 (as note 25), p.98.

98 Effectively, the photoreceptors are swamped with intense light during dazzle effects and seek to reduce the stimuli. (See Gibson 1979 [as note 2], pp.217–18.) Normally, blinking occurs with no external stimulus. (See Gregory 1990 [as note 2], p.68.) The distinction between terrestrial arrays and aquatic arrays, made below, derives from Gibson 1979, p.92.

99 'tout s'éclaire et la peinture est en pleine vibration', note of 1946, quoted in Paris 1984 (as note 1), p.203; trans. Washington and London 1984, p.70.

100 Among the sources that reproduce these photographs are: Antoine Terrasse, Pierre Bonnard, Paris 1967, discussed p.170, reproduced p.171 (Brassaï); Michel Terrasse, Bonnard et Le Cannet, Paris 1987, p.112 (Henri Cartier-Bresson); Jean Clair, ed., Pierre Bonnard, Milan 1988, p.192 (Cartier-Bresson); London 1994 (as note 39), pp.24–5 (Cartier-Bresson).

101 Pierre Courthion, Bonnard: Peintre du merveilleux, Paris 1945, pp.30–1. See also Alexander Liberman, The Artist in his Studio, rev. ed., New York 1988, p.34, where these 'strangest souvenirs of all' are described as 'silver chocolate wrappings'. Liberman seems to offer his own opinion when he adds that 'the crumpled, glistening tinfoil was a constant reminder of the master of all art, light. On some of the tinfoil there was a stamped pattern. It seemed to hold light captive. All his life Bonnard was fascinated by pattern'. It is possible, none the less, that he is paraphrasing what Bonnard told him.

102 On reflectivity, or more precisely reflectance – the proportion of the incident light that is reflected back by the substance instead of being absorbed – see Gibson 1966 (as note 2), pp.208–10. Assimilation is known technically as the von Bezold spreading effect, for the spreading together of background and pattern. See Dorothea Jameson and Leo M. Hurvich, 'From Contrast to Assimilation: In Art and in the Eye', Leonardo, vol.8, no.2, Spring 1975, pp.125–31; Valois 1988 (as note 70), p.163.

103 Lustre is a well-known phenomenon of Neo-Impressionist paintings, like the Seurat in the postcard on Bonnard's wall. See William Innes Homer, Seurat and the Science of Painting, Cambridge, Mass. 1964, pp.142–3, 159, 171–5. The reason for lustre is that, outside the fovea, the enhancing effects of simultaneous contrast appear to extend over a greater distance. (See Hochberg 1979 [as note 2], p.30.) Minor eye movements will cause borders to change, thereby producing successive simultaneous contrasts (which Helmholtz discussed in 1881 as way of overcoming the limitation of pigment to create brightness; see Homer 1964, p.31).

104 See Gombrich 1984 (as note 61), pp.131–6; also the technical papers, Olga E. Favreau and Michael C. Corballis, 'Negative Aftereffects in Visual Perception', and Vilayanur S. Ramachandran and Stuart M. Antis, 'The Perception of Apparent Motion', in Rock 1990 (as note 2), pp.25–38, 139–51.

105 This is demonstrated for a Cubist painting, by means of a shaded reversible figure, in Baxandall 1994 (as note 2),

p.412. The figure is reproduced after Richard Gregory, 'Space of Pictures', in Perception and Pictorial Representation, ed. Calvin F. Nodine and Dennis F. Fisher, New York 1979, fig.12.1, p.233.

106 Gibson 1966 (as note 2), pp.208–10.

107 Conversely, fixations of a short duration, fulfilling a survey function, are known to result from long saccades. See Nodine, Carmody and Kundel 1978 (as note 56). Given the constancy of speed of reiterative saccadic eye movements, the more closely packed the stimuli that compose a scanpath, the quicker and the shorter it runs.

108 Haber and Hershenson 1973 (as note 2), pp.22–3; Gibson 1979 (as note 2), p.212.

109 'Papillotage: Action de papilloter. Mouvement continuel et involontaire des yeux. Fatigue produite sur la vue par un objet trop brillant ou de couleurs trop vives.' [Continual and involuntary movement of the eyes. Tiring effect an overly shiny object or overly bright colours have on one's vision.]
 'Papilloter: Se dit d'un mouvement continuel des paupières, qui empêche les yeux de se fixer sur un objet. En peinture: avoir des reflets trop éclatants qui fatiguent les yeux: cette teinte papillote.' [Is said of a constant motion of the eyelids, preventing the eyes from focusing on a specific object. Can be said of a painting that has an overly vivid glitter which tires the eye.] Claude and Paul Augé, Nouveau Petit Larousse illustré, 86th ed., Paris 1955, p.736.

110 I was alerted to the subject of papillotage by its mention, in the context of a discussion of viewing distance, in David Carrier, High Art. Charles Baudelaire and the Origins of Modernist Painting, University Park, Pa. 1996, pp.40–6. A useful discussion of eighteenth-century papillotage can be found in Marion Hobson, The Object of Art: The Theory of Illusion in Eighteenth-Century France, Cambridge 1982, pp.52–61, which discusses Diderot's dislike of Rococo painting and alludes to the Salon of 1765 when he refers to 'le genre heurté'. (See also note 114.) On Diderot and papillotage, see also Ian J. Lochhead, The Spectator and the Landscape in the Art Criticism of Diderot and his Contemporaries, Ann Arbor 1982.
 On scintillating effects in Chardin, see Baxandall 1985 (as note 2), p.101. Diderot disliked papillotage because he disliked art which called attention to the spectator's presence, a subject extensively explored in Michael Fried, Absorption and Theatricality. Painting and Beholder in the Age of Diderot, Chicago 1980. An important, very different account of these effects, with particular reference to Hyacinthe Rigaud, appears in Bryson 1981 (as note 29), pp.100–2, in a chapter on Rococo space, pp.89–121, which is relevant to the present subject of discussion. Rococo papillotage might be usefully compared to Christine Buci-Glucksmann's anachronistic concept of 'baroque vision' as dazzling, disorienting and ecstatic in her La Raison baroque: De Baudelaire à Benjamin, Paris 1984 and La Folie du voir: De l'esthétique baroque, Paris 1986, discussed in Jay 1988 (as note 28), pp.3–27, especially pp.16–18.

111 Hobson 1982 (as note 110), p.52.

112 Newman 1989 (as note 39), pp.146, 203 note 9. Bonnard's Rococo connotations comprise a familiar theme in the critical literature. For example, writing in L'Intransigeant on 22 June 1912, Guillaume Apollinaire observed: 'We find in his works the mysterious joy that characterizes the eighteenth century for us.' Breuning 1972 (as note 4), p.242. Newman 1989, pp.173–5, observes that Bonnard's art was associated with Pierre-Paul Prud'hon's and herself adds to the association.

113 Bryson 1981 (as note 29), pp.115–20 discusses what is there called the 'operative' relationship of the figure and environment in Chardin.

114 'The Salon of 1763', in Denis Diderot, Salons de 1759–1761–1763, edited by J. Seznec, Paris 1967, pp.139–40, quoted after Carrier 1996 (as note 110), pp.44, 188, but in a modified translation. In 'The Salon of 1765', Diderot compared the changes from proximate to distant viewings of Chardin's work to the effects of the 'manière heurtée' (Goodman 1995 [as note 27], I, p.64). However, by the time of 'The Salon of 1767', he said that moving backward and forward made no difference at all in the perception of Chardin's art (Goodman 1995, II, p.86). As Bryson 1981 (as note 29), p.120, observes, Diderot was obviously fascinated by varying effects of the image at different viewing distances – a fascination that continues in the Goncourts, Baudelaire and into the twentieth century. However, he must eventually have realised that to admit to that fascination ran counter to his belief that the viewer should always be removed from before the image, as noted below.

115 Fried 1980 (as note 110), p.131, within a broad discussion of this subject, pp.122–32.

116 See notes 43 and 157.

117 Three broad actual and historical possibilities may be entertained as explanations for Marthe's obsessive bathing.

First, it may be thought a requirement of some unknown physical illness which demanded either great cleanliness or the warm (or cold) comfort of immersion, or of some unusual sensual requirement which demanded one or the other, or both, of these things for its satisfaction. However, even if evidence of such an illness or sensual requirement were discovered, this would not preclude the second or third possibilities.

Second, it may be thought a psychological disorder of unknown origin, either an obsessional neurosis, if the repetitive immersions mattered most (see Laplanche and Pontalis 1973 [as note 71], pp.281–2), or a paranoia, if the cleanliness mattered most (ibid., pp.296–7), or both; in either and both cases, a disorder associable with schizophrenia (ibid., pp.408–9). What has been reported of Marthe's other forms of anomalous behaviour (delusions of persecution, agoraphobia; see note 39) offers support for this view.

Third, it may be thought to have had a social cause in that cleanliness was, at the turn of century, when Marthe and Pierre met, one of the signs which distinguished the élite from the populace. (See Alain Corbin, 'Intimate Relations', in Michelle Perrot, ed., *A History of Private Life*, IV, *From the Fires of Revolution to the Great War*, Cambridge, Mass. and London 1990, pp.482–6.) Marthe has been said probably to have been a seamstress or errand girl (Newman 1989 [as note 39], p.158) or a shopgirl (Thomson 1994 [as note 39], p.17); in the court case which settled the Bonnard's estate, she was described as having been a seller of artificial flowers and a model (see Garçon 1952 [as note 39], p.10–11). She was certainly a social climber who had changed her name from Maria Boursin to the aristocratic-sounding Marthe de Méligny, a name associable with the class of *demimondaines* (see Newman 1989, p.158), and hid her past name from Pierre for thirty-two years until they were married. The very form of the name-change is telling: from Boursin (*bourse* = purse, money) to Méligny (*mélange* = mingling, crossing). In any event, it is clear that, isolated from her sources, she was not accepted by Pierre's *haute bourgeoise* society (as well as, and because of, symbolising Pierre's declaration of independence from *embourgeoisement*), and courted isolation – which returns to the second possibility.

The question of which possibility Bonnard's paintings allow the beholder to entertain is addressed in the text which follows.

118 Cf. Bryson 1991 (as note 29), pp.116–17, on Chardin.

119 Earlier, Bonnard had used the familiar hand-to-head motif of self-absorption, which he took from Degas. His subsequent, persistent use of the hand-to-foot motif is very much his own. Interestingly, its source in his own art appears to be *Man and Woman* of 1900. Although the cat in this painting may be thought to attract the gesture, this does not alter how the gesture is an important sign of the woman's separateness, which is reinforced, of course, by the screen that separates man and woman. I presume that it was the male image in this painting that motivated Bonnard's purchase of a single male bather by Cézanne of *c*.1876, and not vice versa, since Bonnard is not known to have been purchasing important paintings so early in his career. The Cézanne, a 'later' work in the context of this replicatory chain, intensifies the self-absorption of the male in the Bonnard of 1900, and leads to the replication of it in Bonnard's *The Earthly Paradise* of 1916–20. (For the Cézanne, *Baigneur aux bras écartés*, *c*.1876, see *Tableaux Modernes. Collection Pierre Bonnard. Vente Galerie Charpentier* [Paris 1954], lot.11; John Rewald *et al.*, *The Paintings of Paul Cézanne. A Catalogue Raisonné* [New York 1996], cat.252.)

120 Quoted in Thomson 1994 (as note 39), p.17.

121 This is where Bonnard's later art continues to bear a relationship with Vuillard's work, which 'assumes an entropy of the gaze', says Yve-Alain Bois, forcing you to slow down and concentrate. What André Gide said of Vuillard in 1905 may nearly be said of these works by Bonnard: he 'speaks almost in a hushed voice, as if confiding in someone, and [...] you have to lean over to listen to him.' See Yve-Alain Bois, 'L'aveuglement', in Dominique Fourcade and Isabelle Monod-Fontaine, *Henri Matisse, 1904–1917*, exh. cat., Centre Georges Pompidou, Paris 1993; trans. as 'On Matisse: The Blinding', *October*, no.68, Spring 1994, p.90.

122 See Hochberg 1979 (as note 2), p.25.

123 From an early moment, the optical brightness of Bonnard's art had been thought a means of improving upon life. For example, writing in 1892, Aurier said that Bonnard was 'a delightful ornamentalist, clever and ingenious like a Japanese and capable of embellishing all the ugly things in our lives with the artful and iridescent patterns suggested by his imagination.' Albert Aurier, 'Les Symbolistes', *La Revue encyclopédique*, 1 April 1892; quoted in Paris 1984 (as note 1), p.243; trans. Washington and London 1984, p.244.

124 This point is made by Clair in Paris 1984 (as note 1), p.32; trans. Washington and London 1984, p.44.

125 See Lacan 1977 (as note 46), pp.86–7, for his discussion of a 'space of light' opposite to the tactile space of perspective.

126 See note 95.

127 Posner 1980 (as note 73), p.4.

128 Michael Podro discusses the use of a painting to represent to ourselves the efforts of perception in obscure circumstances, and offers a view that Cubism 'makes our perceptual adjusting a comprehensive theme within the painting', in 'Depiction and the Golden Calf', in Norman Bryson, Michael Ann Holly and Kieth Moxley, eds., *Visual Theory. Painting and Interpretation*, Cambridge 1991, pp.175, 188. Hedonisms which install and which rescue pleasure are discussed by Clement Greenberg, *Joan Miró*, New York, rev. ed., 1950, p.42.

129 Roger Caillois, 'Mimétisme et psychasthénie légendaire', *Minotaure*, no.7, June 1935; trans. John Shepley as 'Mimicry and Legendary Psychasthenia', *October*, no.31, Winter 1984, pp.17–32. See the useful account of this in Krauss 1993 (as note 55), pp.155–6, 183–4.

130 The quotation is from Caillois 1984 (as note 129), p.30.

131 The association of the bathtub paintings with the Birth of Venus theme is made by Sylvester 1996 (as note 9), p.138. I explore Matisse's earlier subversion of the same theme in 'Moving Aphrodite: On the Genesis of *Bathers with a Turtle* by Henri Matisse', to be published by the St Louis Museum of Art in a volume devoted to this painting.

132 The three, related interpretations are suggested by the following texts, respectively, of which only the second is on Bonnard: (1) Stanley Cavell, 'The Avoidance of Love: A Reading of *King Lear*', in his *Must we Mean what we Say?*, Cambridge 1969, pp.267–353. (I should add here that the fourth part, 'Skepticism and the Problem of Others', of his *The Claim of Reason* [Oxford 1979], which ends in a study of the problem of reciprocity in *Othello*, pp.482–96, is of very certain relevance to this subject.) (2) Sylvester 1996 (as note 9), p.138. (3) Baxandall 1985 (as note 2), p.103, of a painting by Chardin.

133 See note 117.

134 Caillois 1984 (as note 129), p.31.

135 Bonnard represented a darkness filled with grotesque 'hidden' imagery in his lithograph of 1893, *Les Heurs de la nuit* (illus. Paris 1984 [as note 1], fig.39, p.37; trans. Washington and London 1984, fig.39, p.49).

136 Lacan 1977 (as note 46), pp.87–8, referring to anamorphic ghosts, not to Bonnard's paintings.

137 Bois 1994 (as note 121), pp.62–4, discusses Matisse's allusions to the sexual tautness of his own canvases upon their completion. In so far as Matisse's canvases immediately evidence the fact that they are visually rigid whereas Bonnard's only become visually rigid when viewed in a particular way, a painting by Matisse may be thought of as a representation of rigidity whereas a painting by Bonnard may be thought of as a representation of the perception of rigidity. A further, related comparison of Matisse and Bonnard is offered in the final section of this essay.

138 Lacan 1977 (as note 46), p.25.

139 Lacan 1977 (as note 46), p.76.

140 'J'espère que ma peinture tiendra, sans craquelures. Je voudrais arriver devant les jeunes peintres de l'an 2000 avec des ailes de papillon.' Diary note, 1946, quoted in Paris 1984 (as note 1), p.203; trans. Washington and London 1984, p.70.

141 'L'oeuvre d'art: un arrêt du temps.' Diary note for 16 November 1936, quoted in Paris 1984 (as note 1), p.195; trans. Washington and London 1984, p.70.

142 See Ellen Oppler, *Fauvism Reexamined*, New York 1976, pp.35–7, and Roger Benjamin, *Matisse's 'Notes of a Painter': Criticism, Theory, and Context, 1891–1908*, Ann Arbor 1987, pp.117, 128, 174, 177.

143 Among the recent texts that avoid 'Post-Impressionism', Richard Shiff, *Cézanne and the End of Impressionism*, Chicago and London 1984, offers a fine discussion of the 'end' of Impressionism, pp.3–52.

144 Cf. Baxandall 1985 (as note 2), p.45. My account varies in wanting to prise apart the three forms of fictive instantaneity.

145 Obviously, the converse is not true: a painting that sustains the belief that it can be apprehended in a moment need not necessarily be a painting intended to sustain the belief that it records a moment in time.

146 Matisse's relationship to Impressionism has been widely studied; his own account is contained in his 'Notes d'un peintre', *La Grande Revue*, vol.52, no.24, 25 December 1908, pp.731–45; trans. as 'Notes of a Painter', in Flam 1995 (as note 24), pp.37–43. Useful recent accounts of this subject include Shiff 1984 (as note 143), pp.55–69; Benjamin 1987 (as note 142), pp.171–8; Flam 1995, pp.30–7. My 'Describing Matisse', in *Henri Matisse. A Retrospective*, exh. cat., Museum of Modern Art, New York 1992, pp.13–70, describes Matisse's mnemic concept of representation.

147 See Yve-Alain Bois, 'The Semiology of Cubism', in Lynn Zelevansky, ed., *Picasso and Braque. A Symposium*, New York 1992, pp.187–8. Bois's contrast, in these pages, between the paths taken by Braque and by Picasso is a valuable one, although there is reason to question Bois's view that Picasso's Cubism took a 'semiological turn' in 1912, as is explained by Richard Wollheim, *On Formalism and its Kinds*, Barcelona 1995.

148 See Elderfield 1992 (as note 146), pp.62–3.

149 Baxandall 1985 (as note 2), p.71.

150 See note 141.

151 'The Bouquet of Roses (Angèle Lamotte, conversation with Bonnard, 1943)', *Verve* 1947 (as note 14), n.p. [pp.73, 75]; partially trans. *Verve* 1988 (as note 14), pp.170–1. Bonnard uses a variety of expressions to describe his first vision of an object, including 'mon idée initiale', 'la vision qui m'avait séduit', 'le point de départ', 'l'idée première', and 'la vision première'.

152 See Matisse, 'Notes of a Painter', as note 146.

153 See note 151.

154 Antoine Terrasse, 'Matisse and Bonnard: Forty Years of Friendship', in Terrasse 1992 (as note 50), p.24, offers a useful description of, effectively, the hare and the tortoise. Bryson 1981 (as note 29), p.3, considers the *in praesentia* image in the context of a discussion, pp.1–29, of a discursive-figural antithesis.

155 'Savor! Bonnard is in the habit of saying that, first and foremost, he seeks to paint the savor of things.' Tériade, *Verve* (American edition), vol.1, no.3, October–December 1938, p.61. Also in *Verve* 1988 (as note 14), p.78 (and 73).

156 Jacques Derrida, *Speech and Phenomena*, trans. David B. Allison (Evanston, Ill. 1973), p.65. This passage is quoted by Krauss 1993 (as note 55), p.215, in a discussion which concludes, p.217: 'But this notion of [...] the temporal as necessarily outside the visual, this idea of the separation of the senses on which modernism's logic is built, it is just this that the beat exploited by the artists of the "optical unconscious" contests. The pulse they employ is not understood to be structurally distinct from vision but to be at work from deep inside it.' Krauss's 'optical unconscious' artists are, in the main, Surrealists. What I have been arguing suggests either that the term 'optical unconscious' may be applied to Bonnard or that it is too broad a concept to distinguish the artists that Krauss discusses, or both.

157 The idea of mediating rapture is the subject of Homi K. Bhabha, 'Aura and Agora: On Negotiating Rapture and Speaking Between', in Richard Francis, ed., *Negotiating Rapture*, Chicago 1996, pp.8–17. In the same volume, Georges Didi-Huberman, 'The Supposition of the Aura: The Now, the Then, and Modernity', pp.48–63, is also relevant to the subject of this essay.

158 See note 16.

159 See Bruno Wollheim, 'Pierre Bonnard: The Obscure Object of Desire', *Modern Painters*, vol.4, no.3, Autumn 1991, pp.12–15, reporting and concurring with the views of Eric Fischl.

160 Stanley Cavell, 'The Uncanniness of the Ordinary', *In Quest of the Ordinary. Lines of Skepticism and Romanticism*, Chicago and London 1994, pp.153–78. See also the texts by Cavell cited in note 132.

Catalogue

Dates and Titles

Bonnard rarely dated his paintings after 1900. In some cases, a date can be established by an exhibition, a publication, a documented sale, or, after 1927, by sketches in his diaries. This information is given in the brief note which accompanies the work. Where no such information is available, we have followed the dating given in the *catalogue raisonné*: Jean and Henry Dauberville, *Bonnard: Catalogue raisonné de l'oeuvre peint*, Paris, vol.I, *1888–1905*, 1965; vol.II, *1906–1919*, 1968; vol.III, *1920–1939*, 1973; vol.IV, *1940–1947* and supplement *1887–1939*, 1974; and Michel and Guy-Patrice Dauberville, *Bonnard: Catalogue raisonné de l'oeuvre peint révisé et augmenté*, Paris, vol.I, *1888–1905*, 1992.

Bonnard's practice of reworking and retouching his paintings over long periods, or returning to them after an interval of several years, means that dates of completion are in many cases uncertain.

Bonnard seems not to have been very particular about titles, many of which were supplied by his dealers, or by friends and collectors, and are descriptive. As with dates, where no reliable information has emerged we have followed the *catalogue raisonné*.

Dimensions

Dimensions are given in centimetres, height before width, followed by inches in parentheses.

Short References

Bell 1994: Julian Bell, *Bonnard*, London 1994.

Cogeval 1993: Guy Cogeval, *Bonnard*, Paris 1993.

Dauberville: see Dates and Titles, left

Dejean 1988: Oscar Dejean in Pierre Mardaga (ed.), *Arcachon La Ville d'Hiver*, Institut Français d'Architecture, Liège-Bruxelles 1988.

Hayward Gallery 1994: *Bonnard at Le Bosquet*, exh. cat., The South Bank Centre, London 1994.

Hyman 1998: Timothy Hyman, *Bonnard*, London 1998.

Natanson 1951: Thadée Natanson, *Le Bonnard que je propose*, Geneva 1951.

Paris 1984: *Bonnard*, exh. cat., Musée National d'Art Moderne, Centre Georges Pompidou, Paris; The Phillips Collection, Washington DC; Dallas Museum of Art, 1984.

Terrasse 1967: Antoine Terrasse, *Pierre Bonnard*, Paris 1967 (expanded and revised 1-988).

Terrasse 1988: Michel Terrasse, *Bonnard at Le Cannet*, London 1988.

Watkins 1994: Nicholas Watkins, *Bonnard*, London 1994.

fig.18 Georges Seurat, *Vase of Flowers*
c.1878–9, oil on canvas 45.1 × 37.5
(17¾ × 14¾) *Fogg Art Museum, Harvard
University Art Museums*

Daffodils in a Green Pot c.1887

Jonquilles dans un pot vert
Oil on canvas 41 × 32 (16⅛ × 12⅝)
Private Collection
Dauberville 01696

LONDON ONLY

This painting, which Bonnard kept, is one of two very similar versions. The other is *Bouquet of Wild Flowers* (Dauberville 4).

fig.19 Pierre Bonnard in 1889
Private Collection

fig.20 *Self-Portrait* 1889, pencil and
ink on paper 11.5 × 8.5 (4½ × 3⅜)
Galerie Claude Bernard

2 **Self-Portrait** c.1889

Autoportrait
Oil on board 21.5 × 15.8 (8⅜ × 6¼)
Private Collection, Fontainebleau
Dauberville 9b (ed.1992)

Bonnard painted at least twelve self-portraits of
which this is the earliest. It seems significant that it
is the only one in which he portrays himself as a
painter since it was around this time that he gave up
the idea of pursuing a career in law or the civil
service. A letter to his father written on 7 November
1885 reveals that after leaving school he thought he
would be able to earn a living from painting, but
after a brief spell at the Ecole des Arts Décoratifs,
during which, he complains, he had been expected to
do nothing but copy from the Antique, he changed
his mind, and enrolled as a law student. None the
less, as he told his father: 'Now that I have given up
the idea of earning a living from painting, it strikes
me as the most wonderful thing. I am going to devote
all my spare time to working at it seriously, even
copying from the Antique, but I shall only do as
much of that as I choose, and no more than is useful
to me' ('Maintenant que je n'ai plus l'intention de
gagner mon pain avec l'art, cela me paraît la plus
belle des choses. Je vais consacrer tous mes loisirs à
le travailler sérieusement, voire même à faire de
l'antique, seulement j'en ferai comme bon il me
semblera et autant que cela m'est utile'. Librairie
des Argonautes, Paris, undated 'catalogue d'auto-
graphes', no.14). Only later, after working part-time
in a small civil service office (every other day from
two to four o'clock), and failing the exams, did he
take the decision to devote his time to painting.
This was probably sometime in 1890, as a letter to
his mother written on 2 December 1889 (Librairie
de l'Abbaye, Paris, catalogue no.236, 1978, no.40)
makes it clear that he was waiting to be offered an
administrative post. Both the drawing, fig.20, and
the painting, show Bonnard dressed in a wing collar
(according to Julian Bell, standard uniform for
students at the Académie Julian: see Bell 1994, p.32),
but only in the painting does he display his palette
and brushes.

3 **Intimacy** 1891

Intimité
Oil on canvas 38 × 36 (15 × 14⅛)
Musée d'Orsay, Paris
Dauberville 19

The painting is dated 1891. The two figures are
Bonnard's sister Andrée (an amateur musician and a
pupil of Francis Thomé), and her husband Claude
Terrasse (a composer and music teacher, who
acquired the picture). The hand in the foreground
holding a clay pipe is Bonnard's. The setting is
possibly the Villa Bach, Arcachon, the house where
the Terrasses were living, and where Bonnard visited
them in April 1891.

The way in which the composition is framed by a
painted line suggests that this painting is a very early
example of Bonnard's practice of working on a piece
of canvas tacked to the wall (see p.24). However, the
canvas has been relined, so that it is no longer
possible to see whether or not it bears the traces of
pin marks.

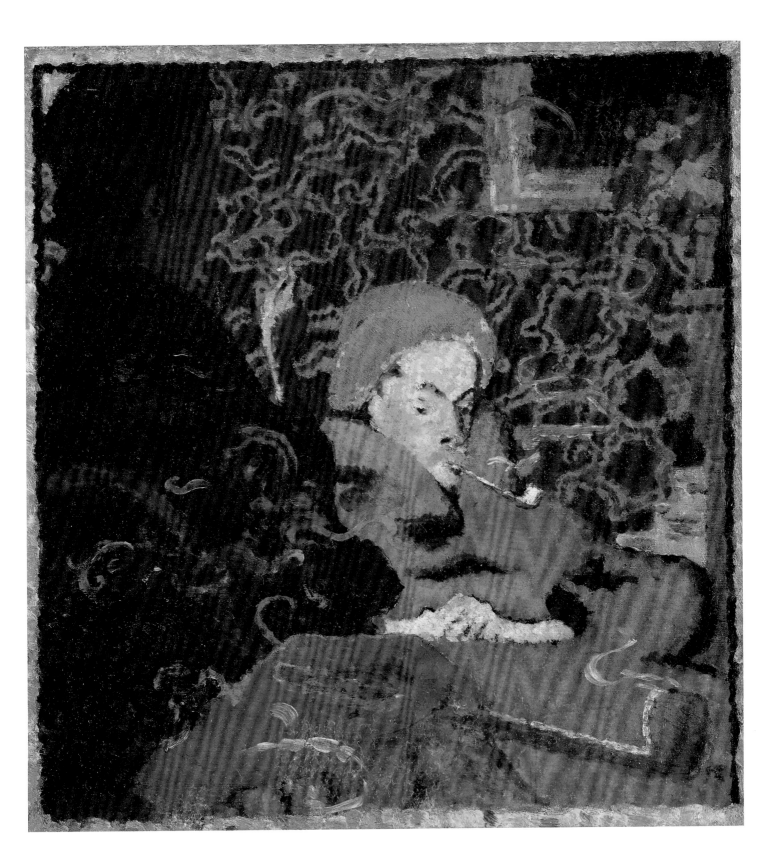

fig.21 Study for *Women in the Garden* 1891,
pencil on paper 18 × 12.6 (7⅛ × 5)
Galerie Huguette Berès, Paris

fig.22 *The Family at Le Grand-Lemps* c.1891,
pencil on paper 13.9 × 18.8 (5½ × 7⅜)
Galerie Huguette Berès, Paris

fig.23 Study for *The Croquet Game* 1892,
watercolour and pencil on paper
19 × 26 (7¾ × 10¼) *Private Collection*

4 The Croquet Game 1892

La Partie de croquet
Oil on canvas 130 × 162.5 (51¼ × 64)
*Musée d'Orsay, Paris. Don Daniel Wildenstein par
l'intermédiaire de la Société des Amis du Musée
d'Orsay*
Dauberville 38

The painting, which Bonnard kept, is signed and
dated 'Bonnard 1892'. It was completed before
March that year, when it was shown at the Salon des
Indépendants, as *Crépuscule*.

The croquet players are Bonnard's father, his
sister Andrée, her husband Claude Terrasse, and an
unidentified woman who may be Bonnard's cousin,
Berthe Schaedlin. The setting is the garden of Le
Clos, the house at Le Grand-Lemps in the Dauphiné
acquired by the artist's paternal grandfather, Michel
Bonnard. The garden, which became one of Bon-
nard's favourite themes, is also the subject of several
early decorative projects, such as *Women in the
Garden* of 1891 (Musée d'Orsay). He had conceived
that work as a screen, but when he showed it at the
Salon des Indépendants in 1891 he hung the parts
separately as *Decorative Panel 1, 2, 3 and 4* (Watkins
1994, p.29). Fig.21, almost certainly a study for
Women in the Garden, brings together figures seen
from close to and at a distance, a device which
underpins the structure of *The Croquet Game*. A
related sketch, fig.22, which is divided into panels as
though for a screen, is for a composition of figures in
a garden (members of his family) and seems to be an
intermediate stage between *Women in the Garden* and
The Croquet Game, which he began very shortly
afterwards. The highly structured composition of
The Croquet Game retains the vestiges of the polyp-
tych form.

Two related sketches are known: one is published
by Ursula Perucchi-Petri, *Die Nabis und Japan: Das
Frühwerk von Bonnard, Vuillard und Denis*, Munich,
1976, p.69; the other, fig.23, was identified as a study
for the painting by Claire Frèches-Thory in 'Pierre
Bonnard: tableaux récemment acquis par le musée
d'Orsay', *La Revue du Louvre*, no.6, 1986, p.422.
Frèches-Thory points out that *The Croquet Game*
appears in the background of *Woman with Rose* of
1909 (Dauberville 565).

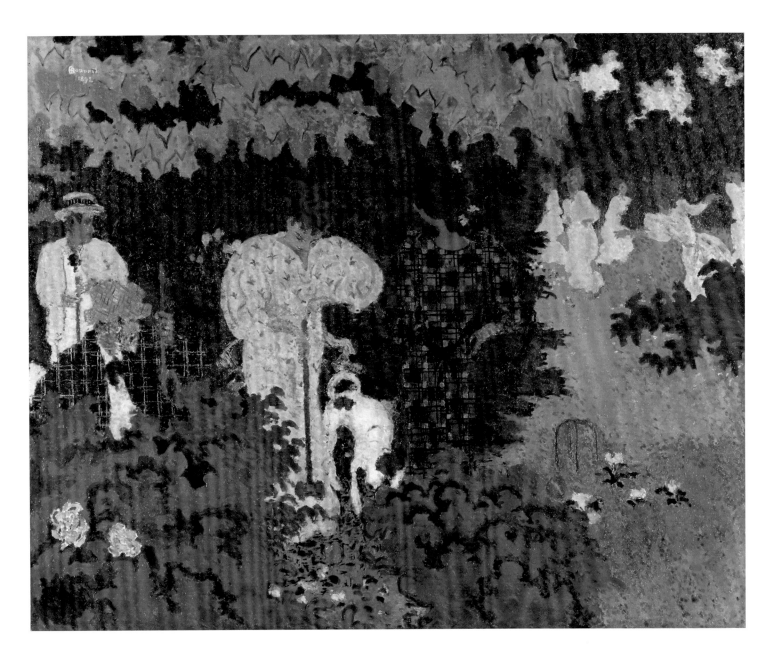

fig.24 *The House in the Courtyard* 1895,
lithograph from the album *Quelques aspects
de la vie de Paris* 1895, 35 × 26 (13¾ × 10¼)
Agnew and Sons, London

5 **Street in Eragny-sur-Oise** 1893

Rue à Eragny-sur-Oise
Oil on wood 37 × 27 (14⅝ × 10⅝)
*National Gallery of Art, Washington, Ailsa Mellon
Bruce Collection*
Dauberville 63

LONDON ONLY

Bonnard visited Eragny-sur-Oise in June 1893. This
painting was included in the Nabis exhibition at Barc
de Boutteville that year, where it was probably
acquired by Thadée Natanson, as he was the lender
when it was included in Bonnard's first one-man
show, at the Galerie Durand-Ruel, in January 1896.
The work was shown there as *Une Rue à Eragny*.

 A sketch for the composition is found in a diary of
1864 belonging to the artist's grandmother which he
was using around this time (see no.6). This minute
leather-bound book measures 6.7 × 4.6 cm.

fig.25 *Figure Studies* c.1893,
ink on paper 31.2 × 19.6 (12¼ × 7¾)
Szépművészeti Múzeum, Budapest

6 Woman Pulling on her Stockings

1893

Femme enfilant ses bas
Oil on board 35.2 × 27 (13⅞ × 10⅝)
Private Collection, courtesy the Fine Art Society plc
Dauberville 44

LONDON ONLY

Between 1893 and 1900 Bonnard made a number of
variations on the theme of a young girl pulling on a
pair of black stockings. In 1893 he met Maria
Boursin (Marthe de Méligny), and it seems very
probable that she is the model for these paintings,
and for the related drawings. A sketch for this paint-
ing is found in the small diary belonging the the
artist's grandmother which he was using as a sketch-
book around this time (see no.5). The setting is prob-
ably 65 rue de Douai, where he rented an apartment
and studio between 1893 and 1907. The painting is
signed and dated 'P. Bonnard 1893'.

fig.26 Study for *Woman Pulling on her
Stockings* 1893, ink on paper 31.4 × 20
(12⅜ × 7⅞) *Galerie Claude Bernard*

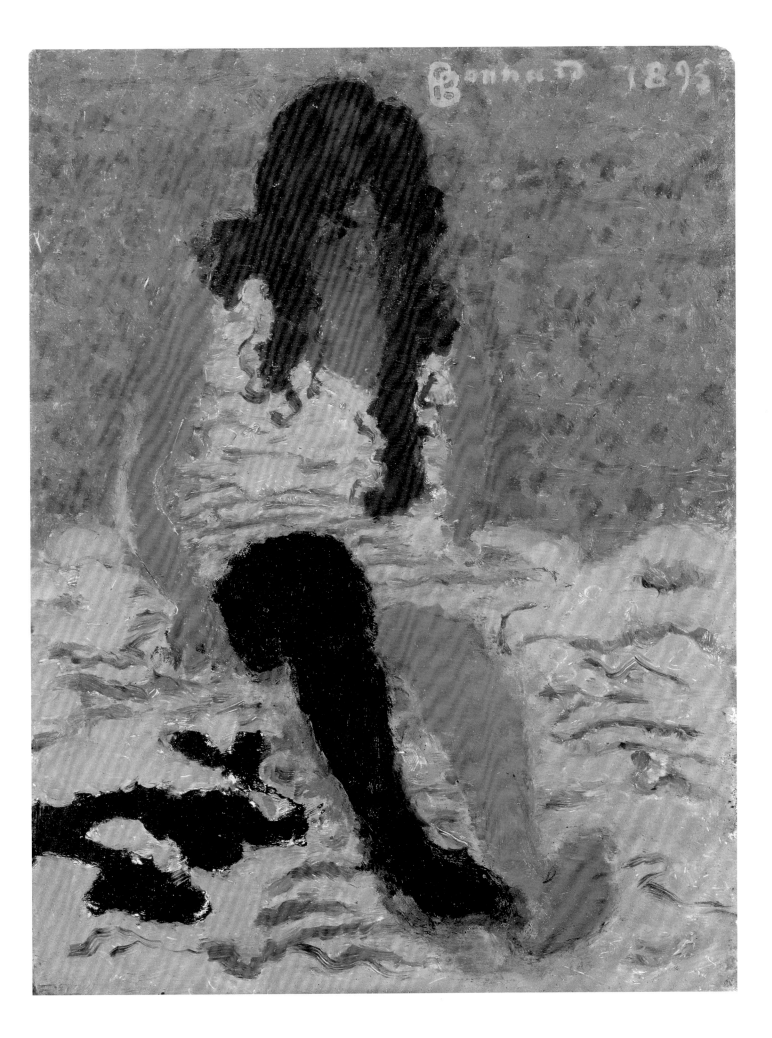

fig.27 Page from sketchbook *c.*1895
Musée d'Orsay

7 **Basket of Fruit on a Tablecloth** 1895

Corbeille de fruits sur une nappe
Oil on canvas 30 × 43 (11¾ × 16⅞)
Private Collection
Dauberville 01771

A sketch for this composition is found in a sketchbook belonging to the Musée d'Orsay (carnet RF 49922). The painting, which is signed and dated 'Bonnard 95', remained with the artist.

The vertical gaze taking in part of a table, investing a detail with the immensity of the whole, is typical of Bonnard's mature works. It is significant that when Raymond Cogniat asked him in the 1940s whether he remembered the exact moment his style crystallised, he replied: 'during a holiday I spent in about 1895 in the Dauphiné, at a house belonging to my family [Le Grand-Lemps]'. And he went on to say: 'One day all the words and theories which formed the basis of our conversations, colour, harmony, the relationship between line and tone, balance, seemed to have lost their abstract implication and became concrete. In a flash I understood what I was looking for, and how I could set about achieving it' (Raymond Cogniat, *Bonnard*, Lugano [n.d.], p.30).

A note in Bonnard's diary under 15 February 1929 is as relevant to this work as it is to the later still lifes: 'Significant forms, even in small formats' ('Les grandes formes même dans les petits formats').

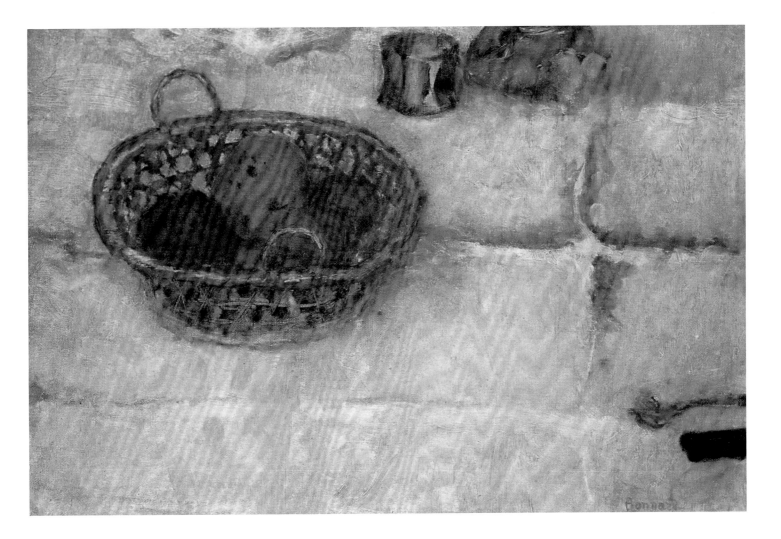

fig.28 Page from sketchbook *c.*1895
Musée d'Orsay

fig.29 Page from sketchbook *c.*1895
Musée d'Orsay

fig.30 Camille Pissarro, *L'Avenue de
L'Opéra, Sun, Winter Morning* 1898,
73 × 92 (28¼ × 36¼) *Musée de Reims*

8 **Views of Paris** *c.*1896

Aspects de Paris
Oil on board 75.5 × 104.5 (29¾ × 41⅛)
Private Collection
Dauberville 136

LONDON ONLY

The three scenes, which are set in the 18th
arrondissement where Bonnard lived and had his stu-
dio, are identified in Dauberville (from left to right)
as rue Tholozé, place Clichy, place Pigalle (or the
bottom of the boulevard Clichy). The theme of the
city had a particular relevance for Bonnard, who was
working on the album of coloured lithographs
commissioned by Ambroise Vollard in 1895 and
published four years later as *Quelques aspects de la vie
de Paris* (see fig.24).

Related sketches of street scenes conceived as pan-
els are found in a sketchbook belonging to the Musée
d'Orsay (carnet RF 49922), which, on the evidence of
a sketch for no.7, must date from around 1895. At
this period Bonnard made a number of decorative
screens and designs for several others, such as the
one seen in fig.28. The polyptych format of the
screen led to several paintings in the form of trip-
tychs (see *Races at Longchamp* 1897, Dauberville
150). *Views of Paris*, although not strictly a triptych,
is divided into three parts, each of which is signed.
In the black-and-white photograph in Dauberville it
looks as if Bonnard's slightly wavering painted lines
between each section have been covered by wooden
slats.

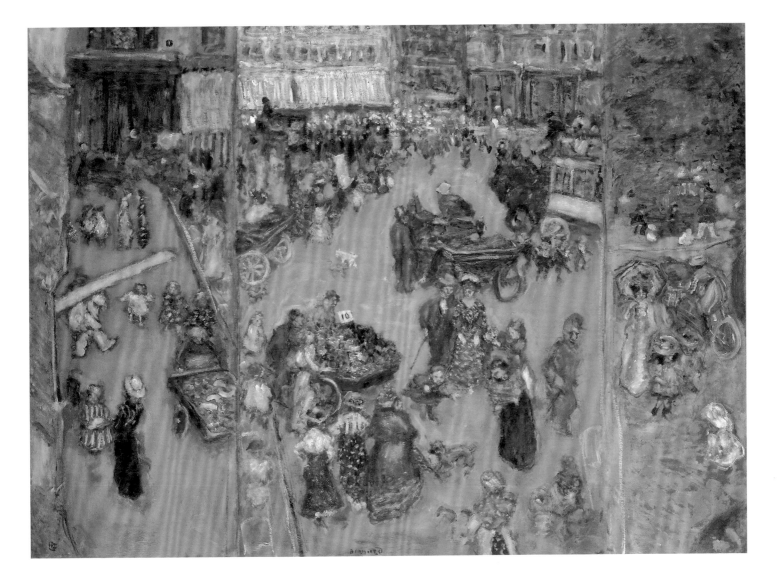

fig.31 *Grandmother and Child c.*1893,
pencil on paper 20.2 × 31.3 (8 × 12¾)
Private Collection

fig.32 *Grandmother* 1895, lithograph in
brown ink with touches of watercolour
20.2 × 23 (8 × 9) *Virginia and Ira Jackson
Collection, Houston, Texas*

fig.33 *Studies of Babies' Heads* as
reproduced in Léon Werth, *Bonnard*, 1923

9 **Grandmother and Child** 1897

Grand-mère et enfant
Oil on paper 37.5 × 37.5 (14¾ × 14¾)
Courtesy Galerie Berès, Paris
Dauberville 160

LONDON ONLY

Based on a lithograph of 1895 (fig.32), this painting
shows Bonnard's maternal grandmother, Mme
Frédéric Mertzdorff (1812–1900), seated at a table
with Andrée Terrasse's third child, Renée
(1894–1985). The emphasis on the domed shape of
the baby's cranium, which is particularly evident in
the painting, may reflect the slightly comical way
babies' heads are depicted in nineteenth-century
Japanese prints.

The painting is signed and dated '97 Bonnard'. It
belonged to Somerset Maugham for many years, and
was sold together with other paintings from his col-
lection in April 1962.

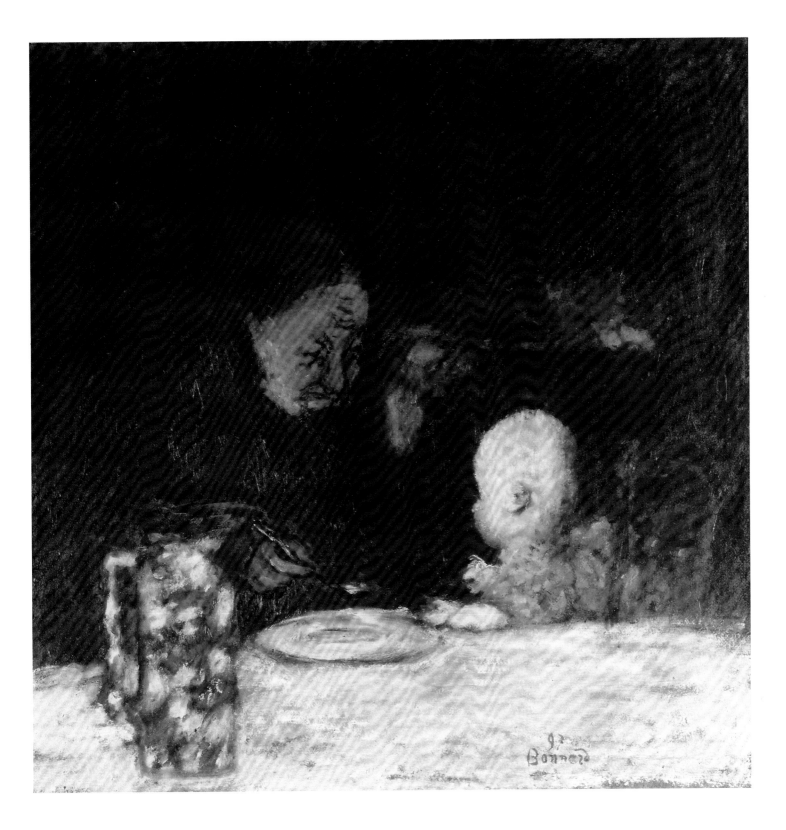

10 **The Grands Boulevards** c.1898

Les Grands Boulevards
Oil on canvas 27 × 33.7 ($10^{5}/_{8}$ × $13^{1}/_{4}$)
Sir Robert and Lady Sainsbury
Dauberville 175

Nothing is known about the history of this painting before it was acquired by Wildenstein & Co., London, in 1937. As with no.8, the subject is related to *Quelques aspects de la vie de Paris*, the album of coloured lithographs commissioned by Vollard in 1895.

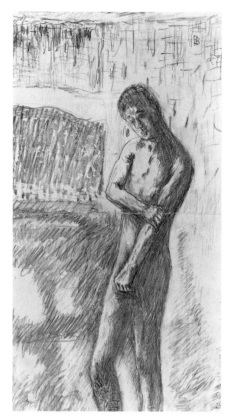

fig.34 *Study of Male Nude c.*1898,
pencil on paper, formerly
Collection P.M. Turner

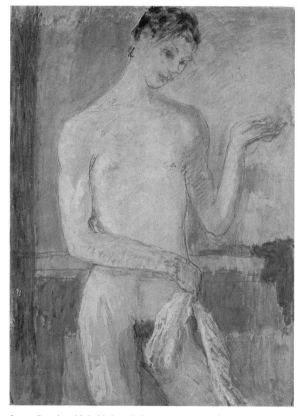

fig.35 *Standing Male Nude c.*1898,
oil on board 77 × 58 (30⅜ × 22⅞)
Private Collection

11 Man and Woman in an Interior

1898

Homme et femme dans un intérieur
Oil on board 51.5 × 34.5 (20¼ × 13⅝)
Private Collection
Dauberville 182

This small oil, which is signed and dated '98
Bonnard', is a study for no.16 and almost certainly
preceded the version seen in fig.40. A photograph of
Bonnard taken around 1897 shows him with the
same pronounced beard and moustache. The woman
on the bed is Marthe, and the interior is their bed-
room at 65 rue de Douai.

Several studies of male nudes, such as the ones
seen in figs.34 and 35, date from around this period.
They are almost certainly self-portraits, and may
represent preliminary ideas for the composition.
The gesture made by the figure in fig.35, holding his
palm out as though to accept an offering, suggests
the naked figure of Adam receiving the forbidden
fruit. Indeed, the final composition, no.16, in which
the couple are divided by a folding screen, can be
read as a play on the traditional theme of Adam and
Eve divided by the Tree of Knowledge.

Both it and the present work were acquired by
Thadée Natanson (1868–1951), one of the propri-
etors of *La Revue blanche*, and a close friend of
Bonnard's.

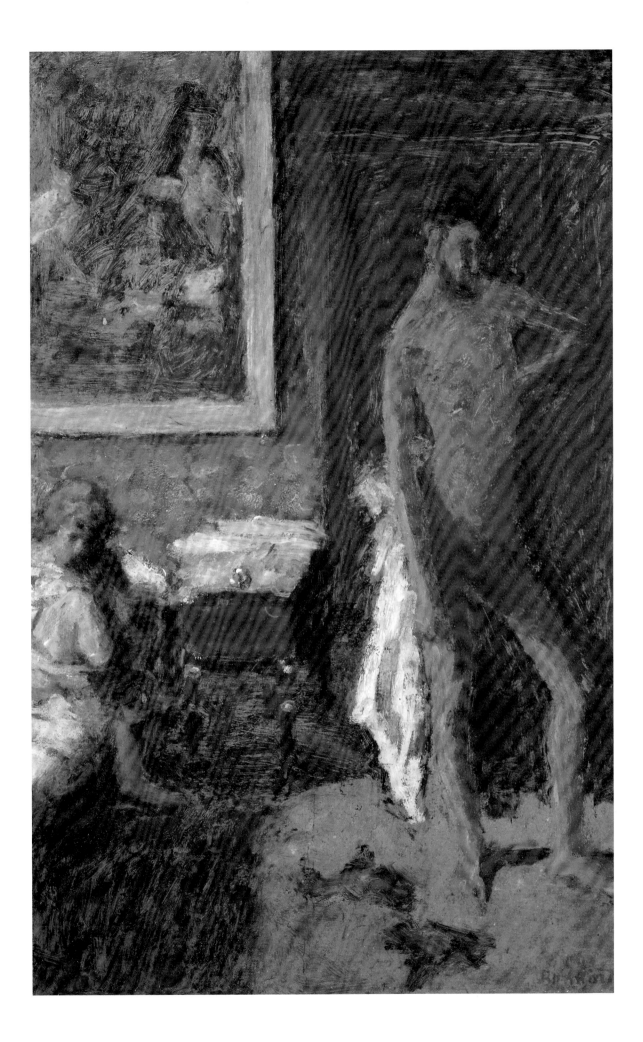

12 **The Lamp** c.1899

La Lampe
Oil on board 54 × 70.5 (21¼ × 27¾)
*The Flint Institute of Arts, Gift of The Whiting
Foundation and Mr and Mrs Donald E. Johnson*
Dauberville 210

Andrée Terrasse, Bonnard's sister, is seated at the
table with her second son, Charles (1893–1982),
and her maternal grandmother, Mme Frédéric
Mertzdorff.

13 **The Meal** 1899

Le Repas
Oil on board 32 × 40 ($12\frac{5}{8}$ × $15\frac{3}{4}$)
Private Collection
Dauberville 212

It is signed and dated 'Bonnard 99', and probably shows the dining room at Le Grand-Lemps.

14 **The Pears, or Lunch at Le Grand-Lemps** ?1899

Les Poires, ou Déjeuner au Grand-Lemps
Oil on canvas 53.5 × 61 (21⅛ × 24)
Szépmüvészeti Múzeum, Budapest
Dauberville 387

Dated *c*.1906 in Dauberville, this painting looks as if it might have been executed at about the same time as no.13, that is to say, around 1899. However, it was shown (as *Sur la nappe*) in June 1911 at the Galerie Bernheim-Jeune in an exhibition of recent works by the artist executed between 1910 and 1911, which suggests that it was an early painting which the artist kept and subsequently reworked.

The title is given in Dauberville as *Les Poires, ou Le Petit-Déjeuner au Grand-Lemps*, but as Brigitta Cifka has pointed out, the meal is far likelier to be lunch, given the bottle of wine on the table (*Budapest 1869–1914: Modernité hongroise et peinture européene*, Musée des Beaux-Arts de Dijon, July–October 1995, p.354).

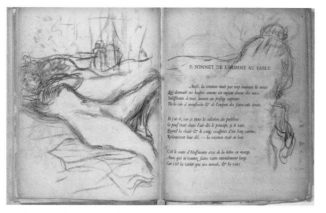

fig.36 Study for page 100 of Paul Verlaine's *Parallèlement* 1900, crayon and graphite on paper 29.5 × 24.1 (11⅝ × 9½) *Collection of Mr and Mrs Paul Mellon*

fig.37 *Séguidille* from pages 26–7 of Paul Verlaine's *Parallèlement* 1900, colour lithograph 30.5 × 25 (12 × 9⅞) *The Metropolitan Museum of Art, The Elisha Whittelsey Collection, The Elisha Whittelsey Fund 1970*

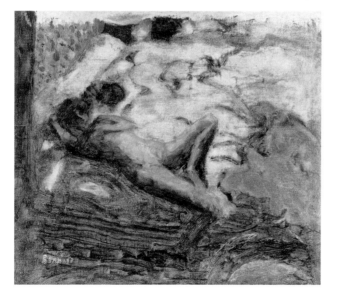

fig.38 Study for *Indolence* c.1897–8, oil on canvas 24 × 27 (9½ × 10⅝) *Private Collection*

15 **Indolence** 1898 or 1899

L'Indolente
Oil on canvas 92 × 108 (36¼ × 42½)
Private Collection
Dauberville 01803

This is generally believed to be the first of two versions Bonnard made of the image. The second version, which is in the Musée d'Orsay, is dated 1899, and was exhibited in March that year at the Galerie Durand-Ruel with the title *Farniente*. By 1908, its title had been changed to *L'Indolente*, probably by its first owner, Thadée Natanson. The present work remained with Bonnard.

The image had been found in spring 1897, the date of a series of drawings for the illustrations commissioned by Vollard for Verlaine's *Parallèlement*, which appeared in 1900. In a small version of the subject, *Blue Nude* (Dauberville 228), the pose of the nude is a mirror image of the pose in both versions of *Indolence*.

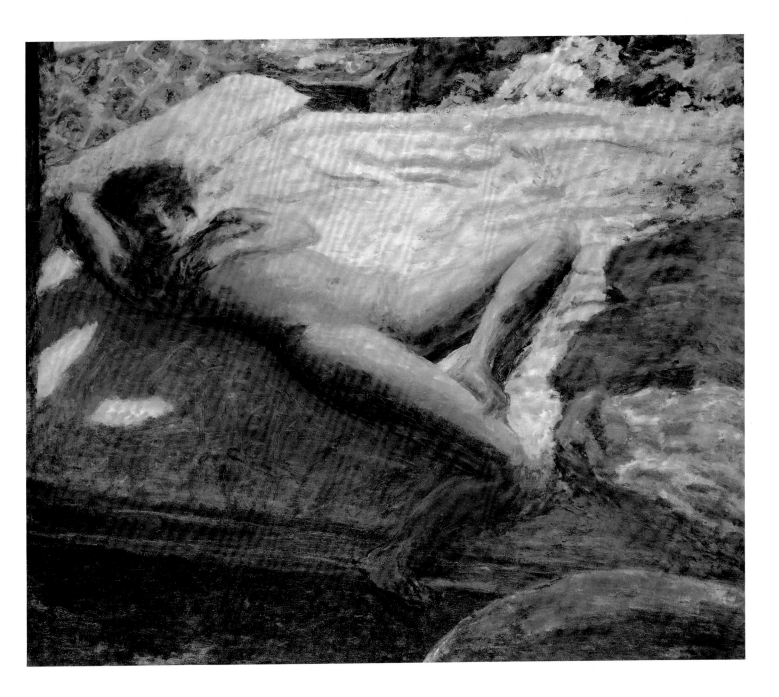

fig.39 Study for *Man and Woman* c.1899,
pencil on paper 17.2 × 10.2 (6¾ × 4⅜)
Private Collection

fig.40 *Man and Woman* c.1899,
oil on canvas 100.2 × 64.5 (39½ × 25⅜)
Private Collection

16 **Man and Woman** 1900

L'Homme et la femme
Oil on canvas 115 × 72.5 (45¼ × 28½)
Musée d'Orsay, Paris
Dauberville 224

This work, which is signed and dated 'Bonnard
1900', is the final version of a composition first
tried out in no.11. A large oil study, fig.40, which
remained in Bonnard's possession, probably
represents an intermediate stage.

The present work was acquired by Thadée
Natanson, who also owned the oil study, no.12.

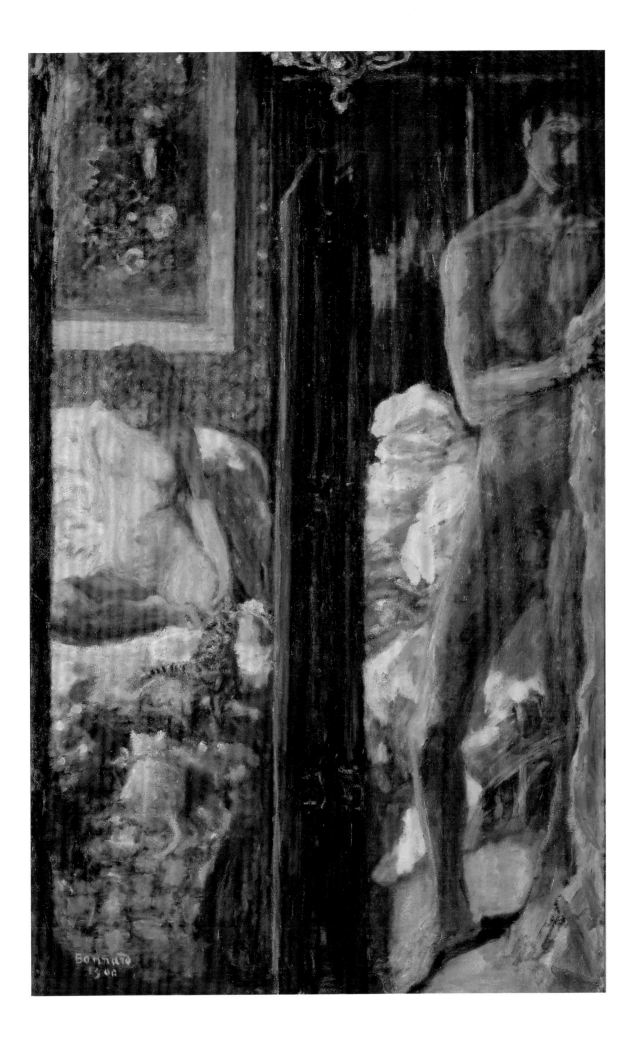

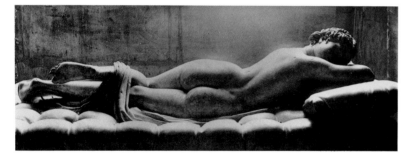

fig.41 *The Hermaphrodite*,
marble H.48 (58¼)
Musée du Louvre

17 **Siesta** 1900

La Sieste
Oil on canvas 109 × 132 (42⅞ × 52)
National Gallery of Victoria, Melbourne,
Australia, Felton Bequest 1949
Dauberville 227

This is one of the first paintings in which Bonnard
borrows a pose from a classical sculpture (see p.22).
See also no.19.

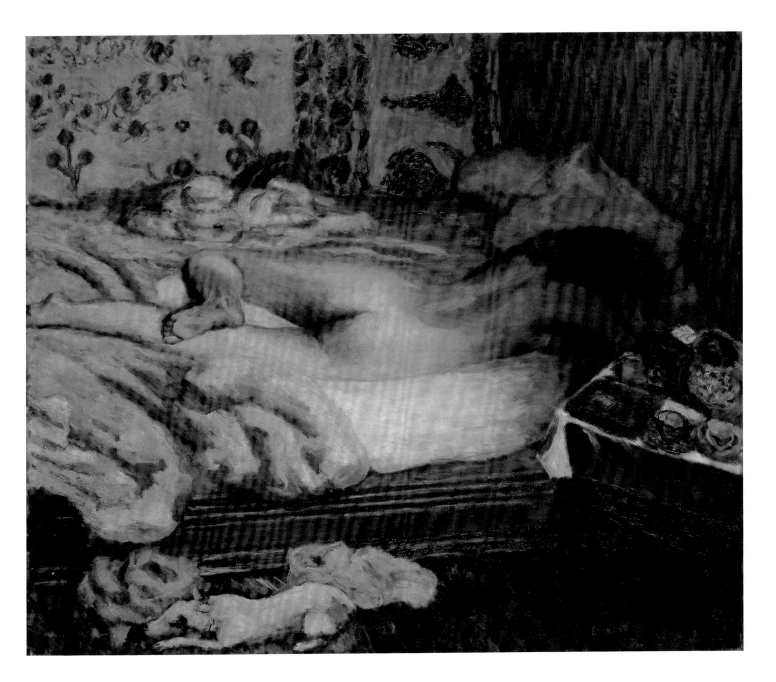

fig.42 Illustration to Peter Nansen,
Marie, Editions de la Revue blanche,
Paris 1898

18 **Nude with Black Stockings** 1900

Nu aux bas noirs
Oil on wood 59 × 43 (23¼ × 16⅞)
*Private Collection, on loan to Sheffield City Art
Galleries*
Dauberville 01829

The pose of the figure on the bed is a variation on
one Bonnard had found in 1898 when making a
series of illustrations to *Marie*, a novel by the Danish
writer Peter Nansen, which originally appeared in
serial form in *La Revue blanche* between 1 May and
15 June 1897.

The painting's first owner was Aristide Maillol, a
lifelong friend of Bonnard's.

fig.43 *Spinario*, 1st century, bronze
H.73 (28¾) *Palazzo dei Conservatori, Rome*

19 **Woman with Black Stockings** 1900

La Femme aux bas noirs
Oil on cardboard 62 × 64.2
(24⅜ × 25¼)
A. Rosengart
Dauberville 230

LONDON ONLY

The pose is close to that of the *Spinario*, a Greek bronze of a boy extracting a thorn from his foot, which became extremely well known through copies, and proved to be a popular source for artists at the end of the nineteenth century. The naturalness of the pose is reflected in Bonnard's many images of women seated in a bathroom washing or powdering their feet (for example, no.28).

Bonnard sold this painting to the Galerie Bernheim-Jeune on 25 November 1900.

20 **Woman with Black Stockings** 1900

La Femme aux bas noirs
Oil on board 78 × 58 (30¾ × 22⅞)
Private Collection, courtesy Galerie Schmit, Paris
Dauberville 226

LONDON ONLY

This picture, which takes up the pose of the woman seated on the bed in *Man and Woman* (see nos.11 and 16), was acquired by Thadée Natanson, the owner of both related works. It is signed and dated '1900 Bonnard'.

fig.44 Study for *Marthe on a Divan* 1900,
pencil on paper 23 × 30 (9 × 11¾)
Private Collection

21 **Marthe on a Divan** *c.*1900

Marthe sur un divan
Oil on cardboard 44 × 41 (17⅜ × 16⅛)
Courtesy Galerie Berès, Paris
Dauberville 225

It was acquired by Edouard Vuillard and remained in
his possession. Like many of the paintings Bonnard
gave to members of his family or to friends, it is
unsigned (see Terrasse 1988, p.304).

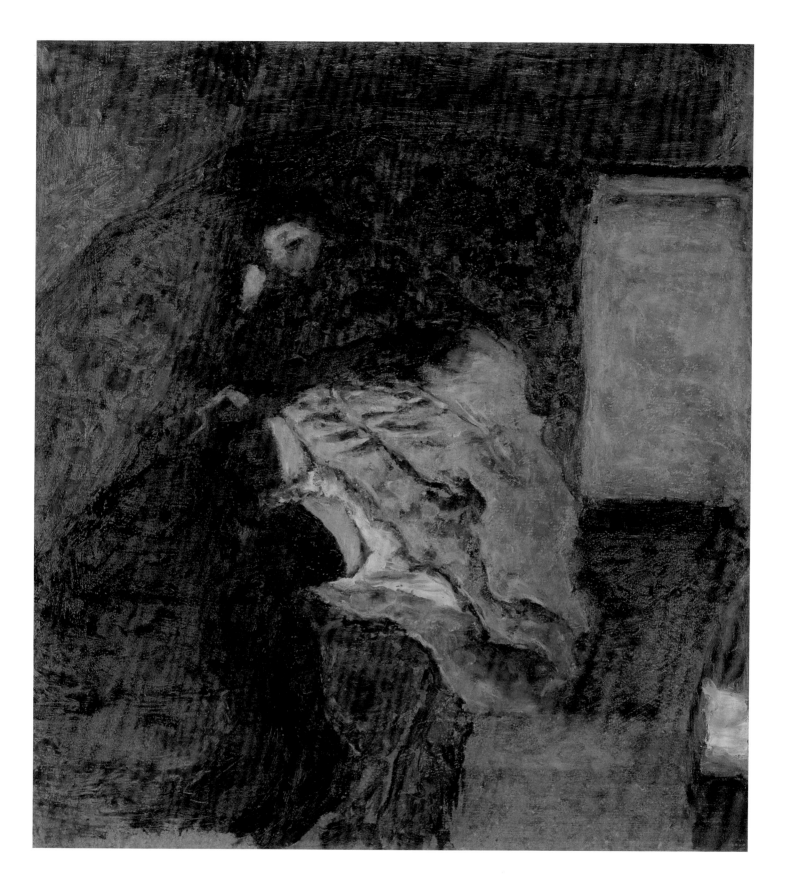

fig.45 Study for *Faun or The Rape of the Nymph*
1907, pencil on paper 44.5 × 58 (17½ × 22¾)
Private Collection, Switzerland

fig.46 Detail of a postcard belonging to
Bonnard of Porte de l'Escalier de la duchesse
d'Etampes, Palais de Fontainebleau
Private Collection

fig.47 Paul Cézanne, *The Battle of Love*
1875–6, graphite, watercolour and gouache
on paper 19 × 24.5 (7½ × 9⅝)
Private Collection

22 **Faun or The Rape of the Nymph**
1907

Faune ou La Nymphe violée
Oil on board laid down on cradled panel
66 × 70 (26 × 27)
Keisuke Watanabe
Dauberville 471

Bonnard sold this painting to the Galerie Bernheim-Jeune in 1907.

According to Antoine Terrasse, the composition was inspired by a fresco designed by Primaticcio, *Apelles Painting Campaspe and Alexander*, above the Porte de l'Escalier de la Duchesse d'Etampes in the Palais de Fontainebleau, which Bonnard visited with Vuillard in 1907. A postcard of the doorway, fig.46, was found among his papers. Terrasse suggests that in his painting Bonnard takes the place of Apelles, and, transforming himself into a faun, clasps Campaspe, who, in turn, has been turned into Marthe. He also points out that the spot from which Bonnard and Vuillard chose to make a sketch of the palace was the same Cézanne had chosen for a watercolour (note from Terrasse to the author). This is particularly interesting given that Bonnard's composition here appears to be a humorous response to Cézanne's variations on the theme of couples in a landscape locked together as though fiercely embracing or fighting.

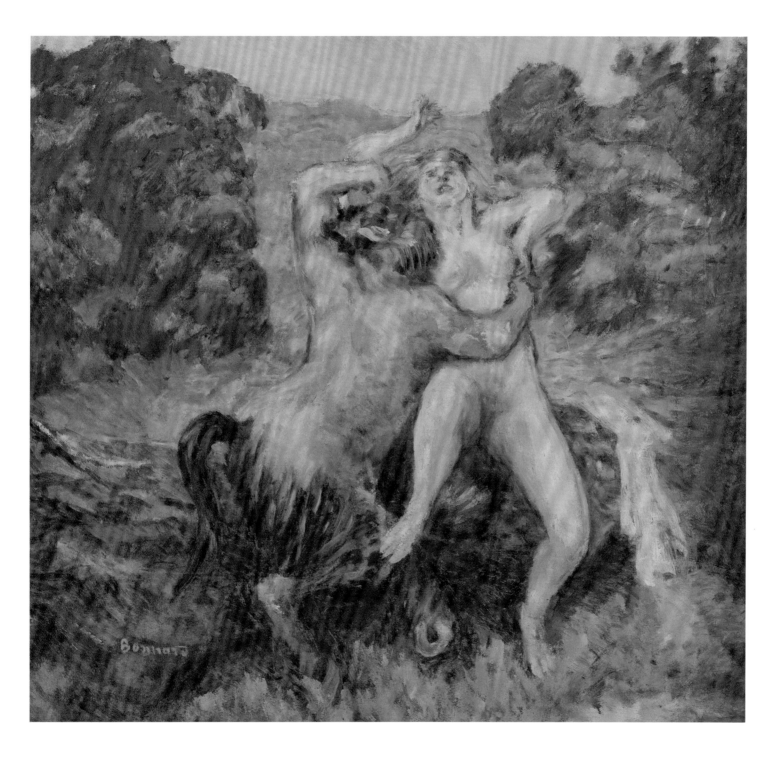

fig.48 *Reflection or The Tub* 1909,
oil on canvas 73 × 84.5 (28¾ × 33¼)
Hahnloser Collection, Villa Flora, Winterthur

23 **The Bathroom Mirror** 1908

La Glace du cabinet de toilette
Oil on panel 120 × 97 (47¼ × 38¼)
Pushkin State Museum of Fine Arts, Moscow
Dauberville 488

This was bought on 8 September 1908 by the
Galerie Bernheim-Jeune, exhibited in the Salon
d'Automne that year (no.184), and sold to the
Moscow collector Ivan Morosov on 3 October.

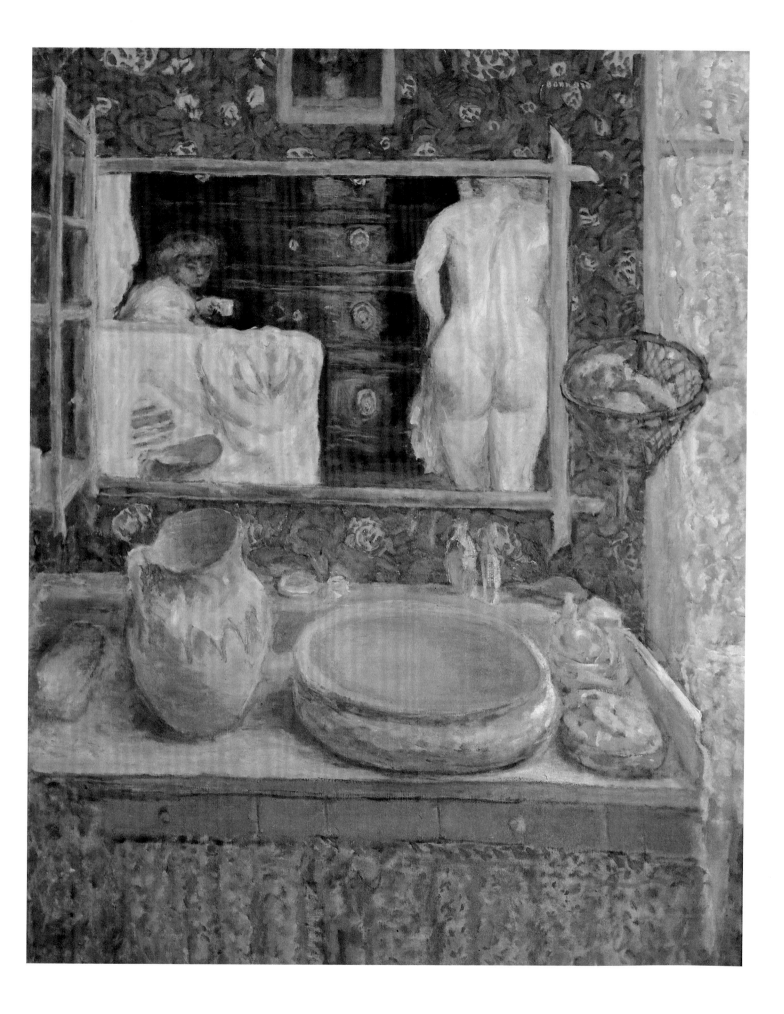

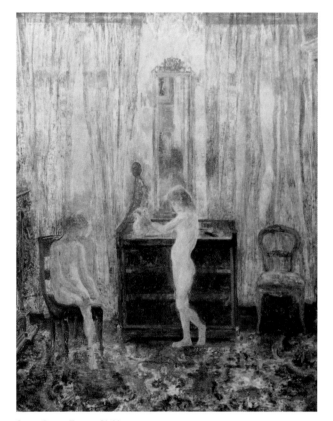

fig.49 James Ensor, *Children Dressing* 1886, oil on canvas 134.6 × 109.9 (53 × 43¼) *Private Collection*

24 **The Bathroom** 1908

Le Cabinet de toilette
Oil on canvas 124.5 × 109 (49 × 42⅞)
Musées Royaux des Beaux-Arts de Belgique, Brussels
Dauberville 481

Bought by the Galerie Bernheim-Jeune in 1908, this picture was included in Bonnard's exhibition there in February the following year. It probably shows the bathroom at 49 rue Lepic, the apartment Bonnard rented between 1908 and 1914. Although the nude can be identified as Marthe, her stance is strikingly similar to that of a professional model posing in the studio (e.g. Henri Matisse, *Nude in the Studio*, *c.*1898–9, Ishibashi Collection, Tokyo).

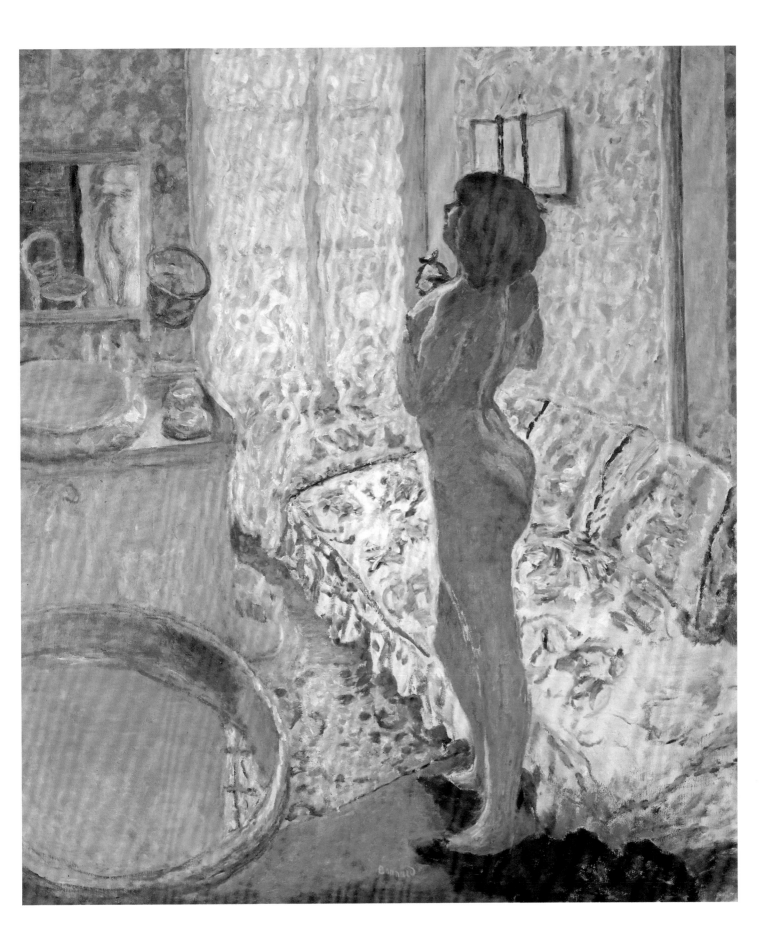

25 **Nude in the Light** 1909

Nu à la lumière
Oil on canvas 116 × 63 (45⅝ × 24¾)
Musée d'art et d'histoire de la Ville de Genève
Dauberville 534

LONDON ONLY

This painting belonged to Maurice Denis. The nude is almost certainly one of the professional models Bonnard employed at this period.

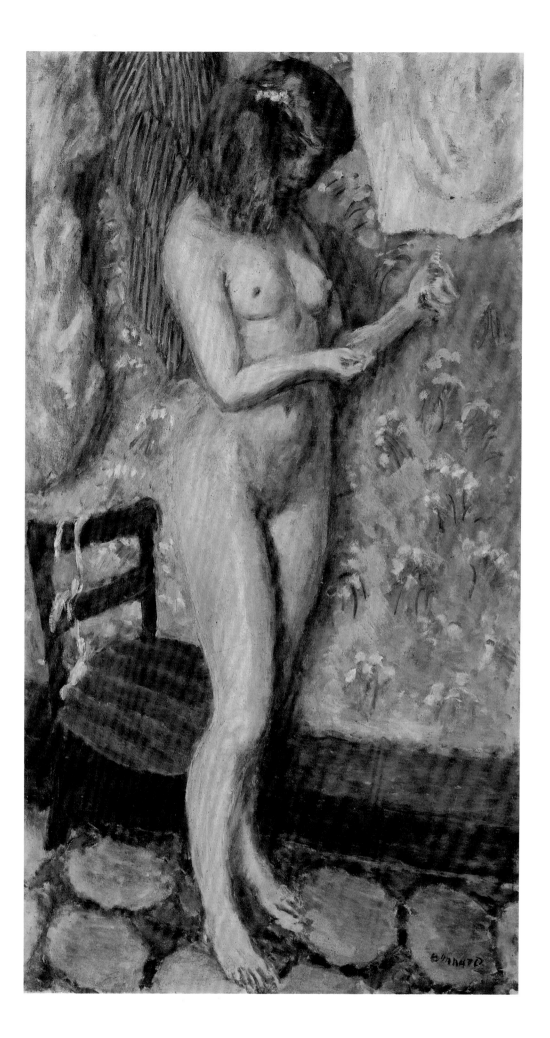

fig.50 Page from sketchbook
1913–14, *Private Collection*

26 **The Dining Room in the Country**
1913

La Salle à manger à la campagne
Oil on canvas 164.5 × 205.7 (64¾ × 81)
*The Minneapolis Institute of Arts, John R. Van
Derlip Fund*
Dauberville 763

LONDON ONLY

The setting is the dining room at 'Ma Roulotte',
the house at Vernonnet, in the Seine valley, which
Bonnard had purchased the year before. However, it
cannot be assumed that works painted after 1911, the
year he bought his first car, were painted in the place
where the subject is set. After this date, Bonnard
began to lead a more peripatetic life, moving fre-
quently between different locations in France, and
often travelling with the canvases he was working on,
rolled up.

Three preliminary studies for the composition
(which is signed and dated) are in a sketchbook of
1913–14, one of which is reproduced as fig.50.

Bonnard showed this painting, the most ambitious
he had attempted for years, at the Salon d'Automne
of 1913, where it attracted the attention of Guil-
laume Apollinaire. As Timothy Hyman points out,
'In *Dining Room in the Country*, Bonnard had at last
achieved the large-scale *décoration* implicit in his
Nabi beginnings' (Hyman 1998, p.96).

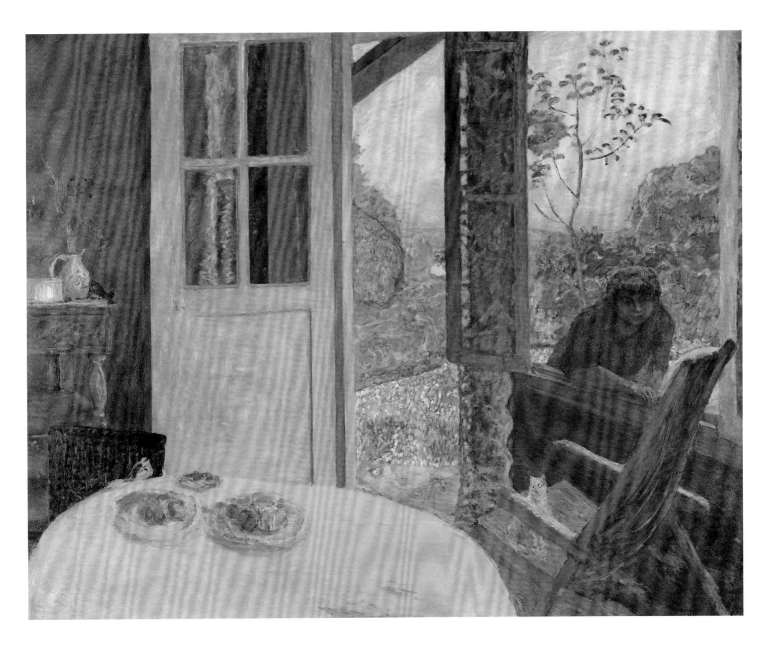

fig.51 Page from sketchbook
1913–14, *Private Collection*

27 **Resting in the Garden** c.1914

La Sieste au jardin
Oil on canvas 100.5 × 249 (39⅝ × 98)
Nasjonalgalleriet, Oslo
Dauberville 786

LONDON ONLY

The setting is very similar to a related painting,
Evening, or Resting in a Garden in the South of France,
1914 (Dauberville 787), and may show the garden of
the Villa Joséphine, Saint-Tropez, where Bonnard
stayed during January and February 1914. The
drawing reproduced as fig.51 is from the sketchbook
referred to in no.26.

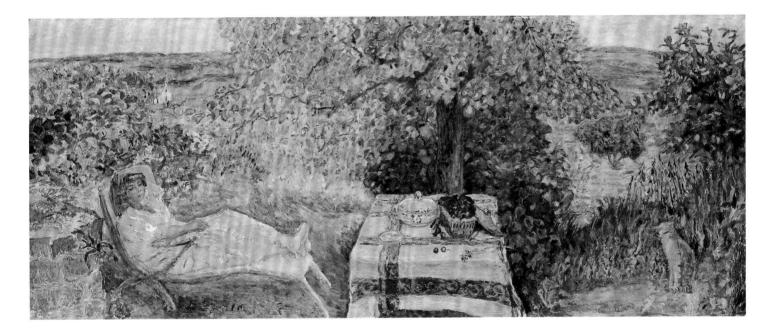

fig.52 Page from sketchbook
*c.*1913 *Private Collection*

fig.53 Page from sketchbook
*c.*1913 *Private Collection*

fig.54 *Figure Study c.*1912,
pencil on paper 11.3 × 17.2
(4½ × 6¾) *Private Collection*

28 **Woman in a Dressing Gown** 1914

Femme au peignoir
Oil on canvas 94.9 × 66.5 (37⅜ × 26¼)
Philadelphia Museum of Art, Louis E. Stern
Collection
Dauberville 810

This is a reworking of the pose first seen in no.19,
based on the antique Greek sculpture, the *Spinario*.
The painting is signed and dated 'Bonnard 1914'.

Numerous drawings of this pose, seen from differ-
ent angles, date from around this period.

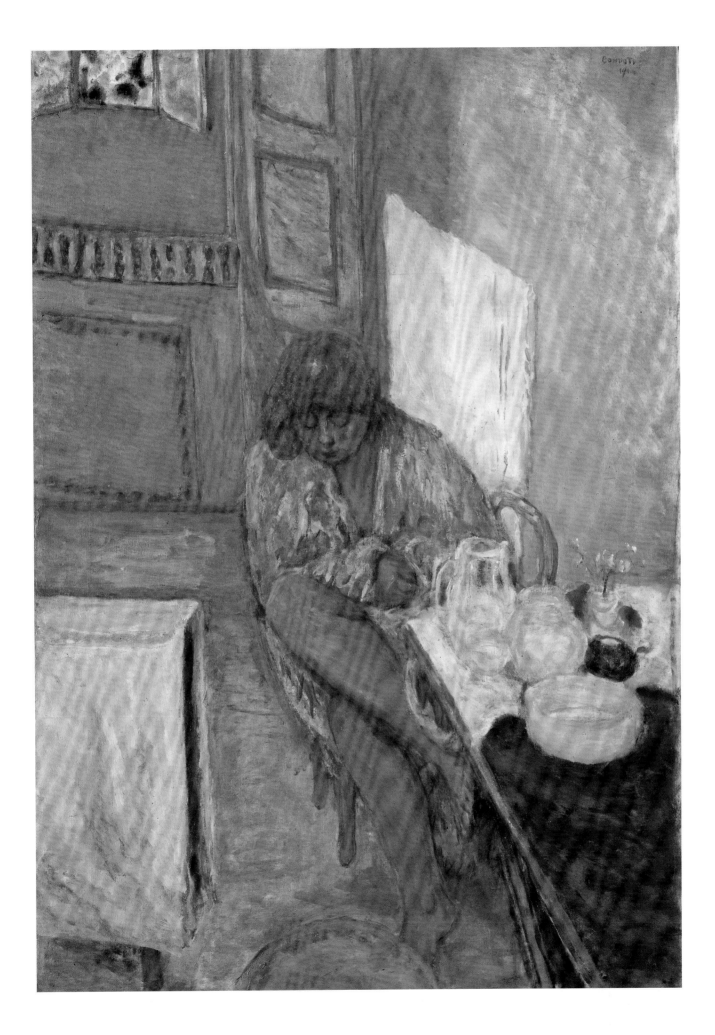

fig.55 Preparatory sketch for
Coffee 1915, pencil on paper
9.6 × 13.7 (3¾ × 5⅜) *Tate Gallery*

fig.56 Preparatory sketch for
Coffee 1915, pencil on paper
13.7 × 9.6 (5⅜ × 3¾) *Tate Gallery*

29 **Coffee** 1915

Le Café
Oil on canvas 73 × 106.4 (28¾ × 41⅞)
Tate Gallery. Presented by Sir Michael Sadler
through the National Art Collections Fund 1941

Nothing is known about the history of this painting
before it was bought by the Galerie Bernheim-Jeune
from Jos Hessel on 7 December 1923.

The three known studies are in the Tate Gallery;
two of them are reproduced here. The third is a
small sketch of Marthe and the head of the dog.

The painting was almost certainly executed
around the same time as *The Red-Checked Tablecloth*,
a work of 1915 (Dauberville 823) which shows
Marthe sitting with her dog at the same table in the
same dress, holding the same white cup. There the
view is looking down the length of the table, not
across it. The composition of *Coffee* is by far the
more complex and enigmatic of the two, locked into
place by bands and areas of colour such as the border
running down the right-hand edge of the canvas,
and the decoration on the wall behind the figures,
elements that are difficult to identify. (Timothy
Hyman interprets the decorative border on the right
as a mirror frame. See Hyman 1998, p.92). The
setting does not appear to be the dining room at 'Ma
Roulotte' (the table there was round), but it may be
the dining room in the house Bonnard rented at
Saint-Germain-en-Laye in 1915, and where he spent
a good part of the year.

Pentimenti show that the chair on the right has
been moved nearer to the centre, and the figure hold-
ing the small glass painted over it. Differences in the
green paint indicate that the right-hand side of the
figure has been extended. The composition has also
been extended by several inches along the lower edge
(as pointed out by Hyman, ibid.).

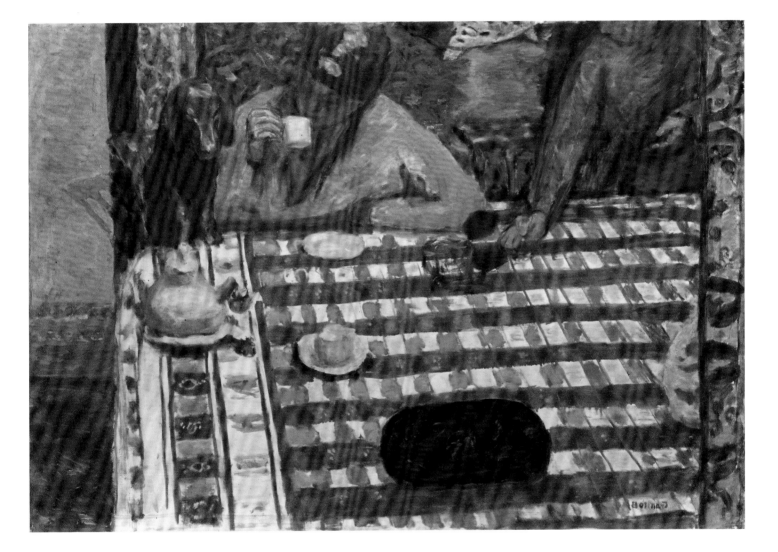

fig.57 *Nude in the Tub c.*1925,
pencil on paper 19.7 × 16.5 (7¾ × 6½)
Neffe-Degandt, London

fig.58 *Nude in the Tub*
pencil on paper
Private Collection

30 **Nude in the Tub** 1916

Nu au tub
Oil on canvas 140 × 102 (55⅛ × 40⅛)
Private Collection
Dauberville 02105

The theme of a woman washing herself in a zinc tub,
suggested no doubt by Degas' many variations on it,
was one that Bonnard returned to several times
between 1910 and 1918. Around 1916–17 he made
at least ten versions.

fig.59 *Nude in the Tub* 1912,
pencil and ink on paper 22.5 × 17.5
(8⅞ × 6⅞) *Private Collection*

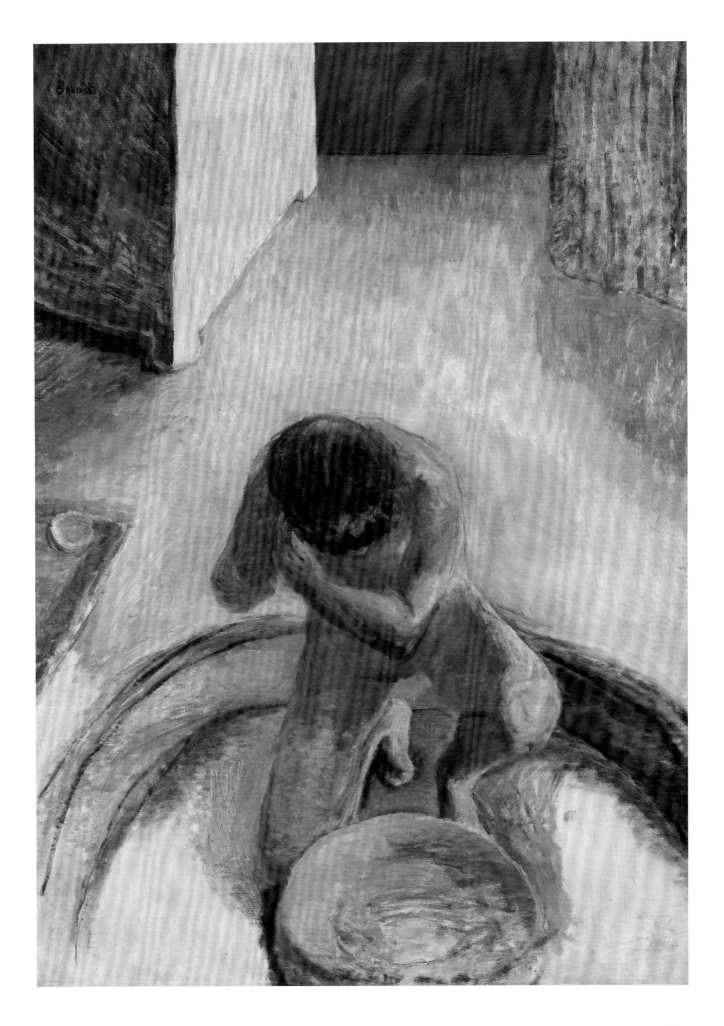

fig.60 Preparatory sketch for *The Mantlepiece* 1916, as reproduced in Léon Werth, *Bonnard*, 1923

fig.61 Maurice Denis, Study for *Décor Nahasch* 1891, charcoal on paper 47 × 62 (18½ × 24⅜) *Le Musée départemental Maurice Denis Le Prieuré, Saint-Germain-en-Laye*

fig.62 Maurice Denis, Study for *Décor Nahasch* 1891, oil on canvas or board 13.5 × 20.7 (5⅜ × 8⅛) *Private Collection*

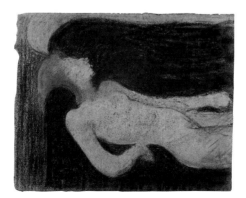

fig.63 Edouard Vuillard after Maurice Denis, *Décor Nahasch* c.1892, pastel on paper 23 × 30 (9 × 11¾) *Neffe-Degandt, London*

31 | **The Mantlepiece** 1916

La Cheminée
Oil on canvas 80.7 × 126.7 (31¾ × 49⅞)
Margoline Collection
Dauberville 884

The painting reflected in the mirror is by Maurice Denis, who showed it at the Salon des Indépendants in 1891 as *Décor 91*, and presented it to Bonnard the following year. It is listed as 'Décor Nahasch' ('nahasch' is Hebrew for serpent) in a notebook of 1892 recording gifts and sales made by Denis (information supplied by Le Musée départemental Maurice Denis Le Prieuré, Saint-Germain-en-Laye). According to Antoine Terrasse (in conversation), Bonnard eventually sold Denis' painting to a collector who had failed to persuade him to part with one of his own paintings. It has not been traced, and no photograph of it has been found. The composition is known through the drawing and oil study reproduced here, and through a Vuillard pastel in which the red sofa on which the nude is lying is a prominent feature. (This work was brought to the attention of the author by Christian Neffe).

The gesture made by the woman reflected in the mirror is based on the figure of the antique sculpture, *The Dying Niobid* (fig.69), a comparison first made by Sasha Newman (Paris 1984, p.16). The statue was excavated in 1906, in what used to be the Horti Sallustiani (the Gardens of Sallust) in Rome, and, as Newman points out (ibid., p.17), the find was much publicised. Timothy Hyman has suggested that the model adopting this classical pose is Lucienne Dupuy de Frenelle, who appears in other paintings of the period (Hyman 1998, p.111).

Bonnard made an oil study for *The Mantlepiece* (Dauberville 02109) which he kept. He sold the painting to the Galerie Bernheim-Jeune in 1916.

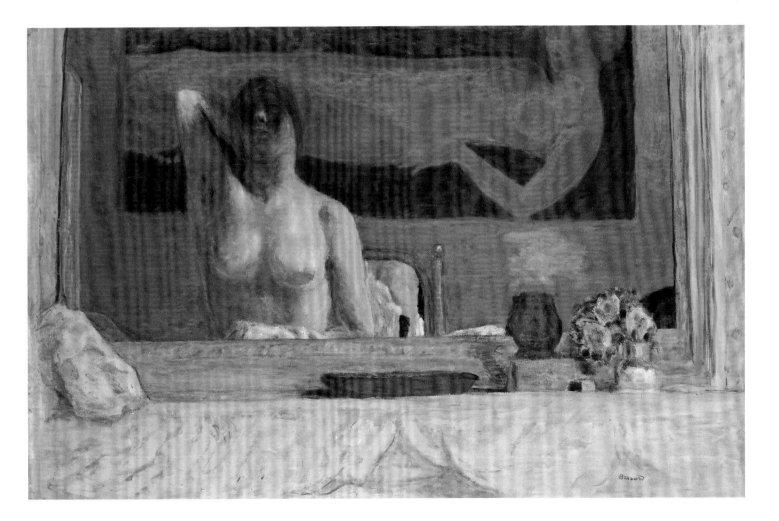

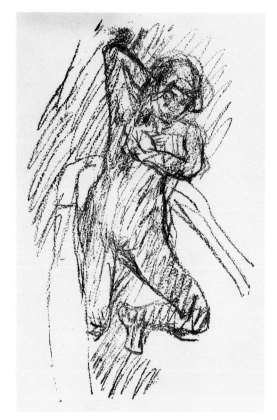

fig.64 *Nude in the Bath*, as reproduced
in Léon Werth, *Bonnard*, 1923

32 **The Spring or Nude in the Bath**
1917

La Source ou Nu dans la baignoire
Oil on canvas 85 × 50 (33½ × 19⅝)
Private Collection, Switzerland
Dauberville 890

The crouching figure of the nude seems to have
started out as a variation on the pose of *The Dying
Niobid* (see fig.69). Bonnard almost certainly began
with the idea of turning this classical figure into a
woman kneeling in a bath, but, as the drawing repro-
duced in fig.64 shows, it was a composition that
proved awkward. Instead, he seems to have turned to
another classical prototype, the *Crouching Aphrodite*
in the Louvre (see fig.122).

A related drawing measuring 21 × 12 cm was
included in a sale at the Nouveau Drouot in Paris,
17 June 1981, lot 17.

This painting was shown in an exhibition of recent
works by Bonnard at the Galerie Bernheim-Jeune
from October to November 1917.

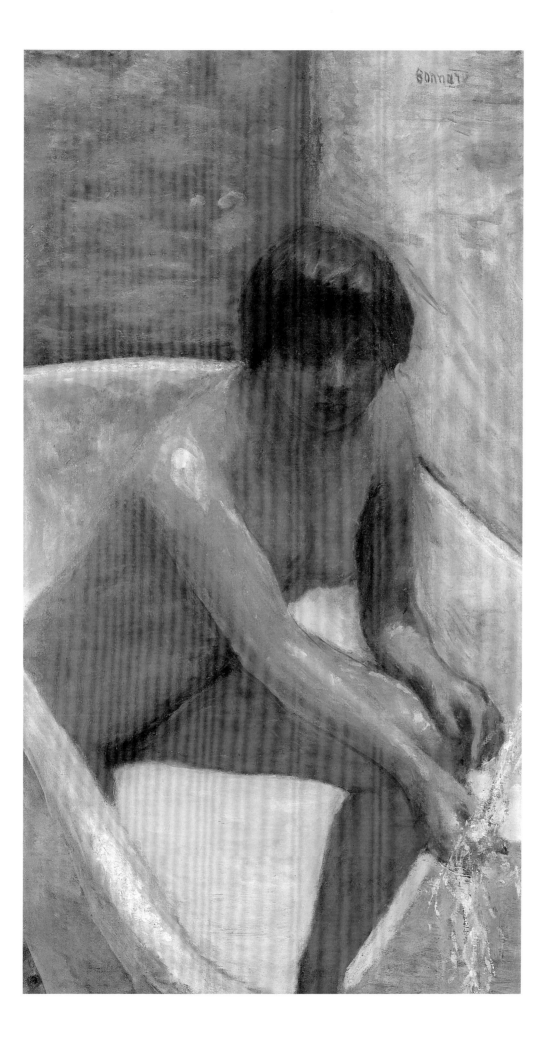

fig.65 Page from sketchbook 1918,
15.2 × 9.8 (6 × 3⅞) *Private Collection*

33 **Marthe and her Dog** 1918

Marthe et son chien
Oil on canvas 117.5 × 70 (46¼ × 27½)
Galerie Jan Krugier, Ditesheim & Cie, Geneva
Dauberville 864

The title given in Dauberville is *The Shepherd and
Dog, or The Stream*, but, according to Antoine
Terrasse (in conversation), the correct title is the one
given above. The painting shows a landscape around
the spa town of Uriage-les-Bains, near Grenoble,
which Bonnard and Marthe visited between July and
August 1918.

 It was part of a decorative series of paintings
commissioned in 1917 by Richard Bühler, a young
textile industrialist (and a cousin of Hédy Hahnloser-
Bühler), for the panelled dining room of his house in
Winterthur. Although the date of this painting given
in Dauberville is 1916, it was painted in 1918. It
is one of a number of canvases in progress which
appear in a photograph taken by George Besson of
Bonnard in his hotel room in Uriage-les-Bains (see
fig.147).

fig.66 Page from sketchbook 1918,
9.8 × 15.2 (3⅞ × 6) *Private Collection*

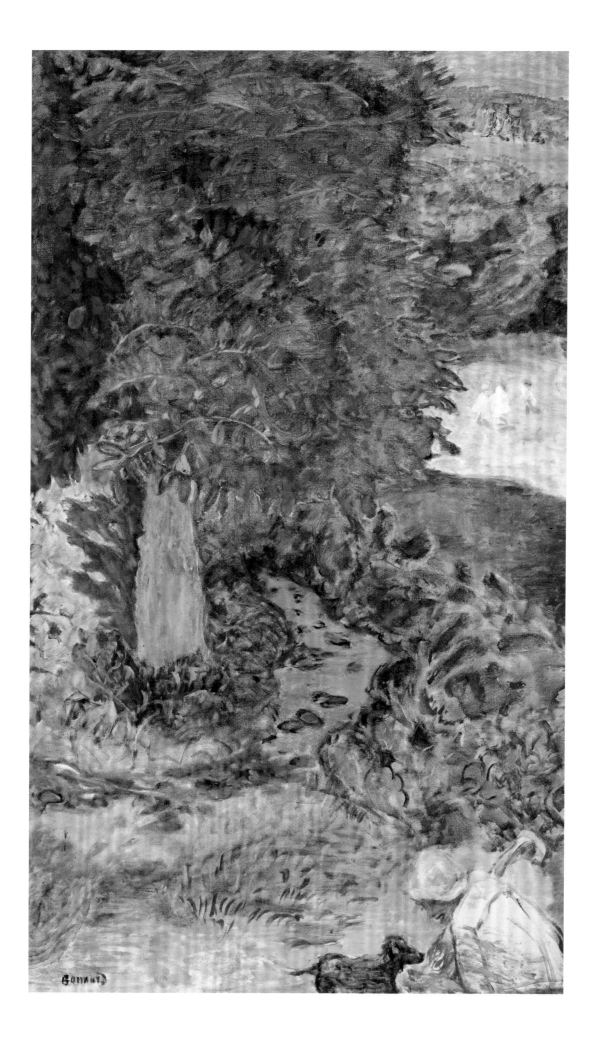

fig.67 Page from sketchbook
c.1913 *Private Collection*

fig.68 *Figure studies c.1916,*
pencil on paper 17.4 × 11 (6⅞ × 4⅜)
Private Collection

34 **Nude Crouching in the Tub** 1918

Nu accroupi dans le tub
Oil on canvas 83 × 73 (32⅝ × 28¾)
Private Collection, Paris
Dauberville 933

Once again, Bonnard borrows a pose from a classical sculpture (see no.31). Here the legs are those of *The Dying Niobid* but seen in reverse.

The painting remained in the artist's possession and was included in his estate.

fig.69 *The Dying Niobid*
5th century BC, marble from Paros,
H.149 (59) *National Museum, Rome*

fig.71 Preparatory sketch for *The Bowl of Milk c.*1919, pencil on paper 18 × 12.2 (7⅛ × 4¾) *Tate Gallery*

fig.72 Preparatory sketch for *The Bowl of Milk c.*1919, pencil on paper 18.1 × 12.2 (7⅛ × 4¾) *Tate Gallery*

fig.73 Preparatory sketch for *The Bowl of Milk c.*1919, pencil on paper 18.1 × 12.3 (7⅛ × 4⅞) *Tate Gallery*

fig.70 *Kore c.*530 BC, marble from Paros H.121 (47⅝) *Acropolis Museum, Athens*

35 **The Bowl of Milk** 1919

Le Bol de lait
Oil on canvas 116.2 × 121 (45¾ × 47⅝)
Tate Gallery. Bequeathed by Edward Le Bas 1967
Dauberville 02156

Of the nine preparatory drawings for this painting that are known, five are figure studies. One is a drawing of a woman placing (or picking up) something on the table by the window. This may have preceded three sketches showing the interior with two figures, a woman who is probably Marthe and a young girl carrying a basket. The fifth is a sketch for the figure of the woman in the oil which appears to be based on a *Kore* such as the one seen in fig.70. Her dress is virtually identical to the traditional girded Dorian peplos worn over a linen chiton with a wide selvage at the neck.

The setting is the dining room in the house Bonnard rented at Antibes in December 1918. The painting was completed in time to be shown at the Salon des Indépendants in January 1920 (as *Intérieur*), where it was bought by the Galerie Bernheim-Jeune. It was shown at the Galerie E. Druet, Paris, in April 1924 as *Intérieur à Antibes*, and at Rosenberg and Helft, London, from September to October 1937 with the English title, *The Bowl of Milk*, a title that has since been adopted.

The same interior is seen in three other oils, Dauberville 976, 978 and 980.

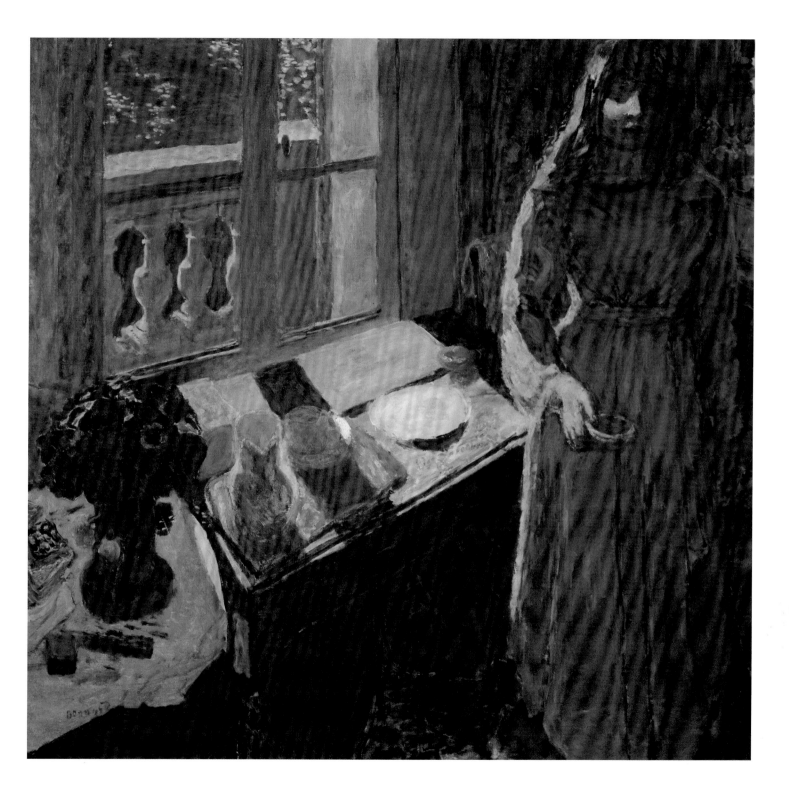

fig.74 Study for *The Earthly Paradise*
1916–20, oil on canvas 99 × 122 (39 × 48)
Private Collection

36 **The Earthly Paradise** 1916–20

Le Paradis terrestre
Oil on canvas 130 × 160 (51¼ × 63)
*The Art Institute of Chicago. Estate of Joanne
Toor Cummings; Bette and Neison Harris and
Searle Family Trust endowments; through prior
gifts of Mrs Henry C. Woods*
Dauberville 867a

This is one of four decorative paintings commissioned by the Bernheim-Jeune family between 1916 and 1920. The other three, which have the same dimensions, are *Pastoral Symphony or Countryside* (Private Collection), *Mediterranean or Monuments* (Galerie Bernheim-Jeune, Paris) and *Workers at La Grande Jatte, or The Modern City* (Museum of Modern Art, Tokyo). An oil sketch, fig.74, shows the moment when Eve, watched by the serpent, picks the forbidden fruit while an oblivious Adam rests on the ground nearby; even though the dense thicket of vegetation behind, a huge mass bearing down on the two figures, is a reminder of what is in store, the scene is one of pastoral harmony. Here, however, the mood is darker and more ambiguous. Guy Cogeval draws a comparison between this painting and no.16, 'with all the autobiographical allusions that implies' (Cogeval 1993, p.98).

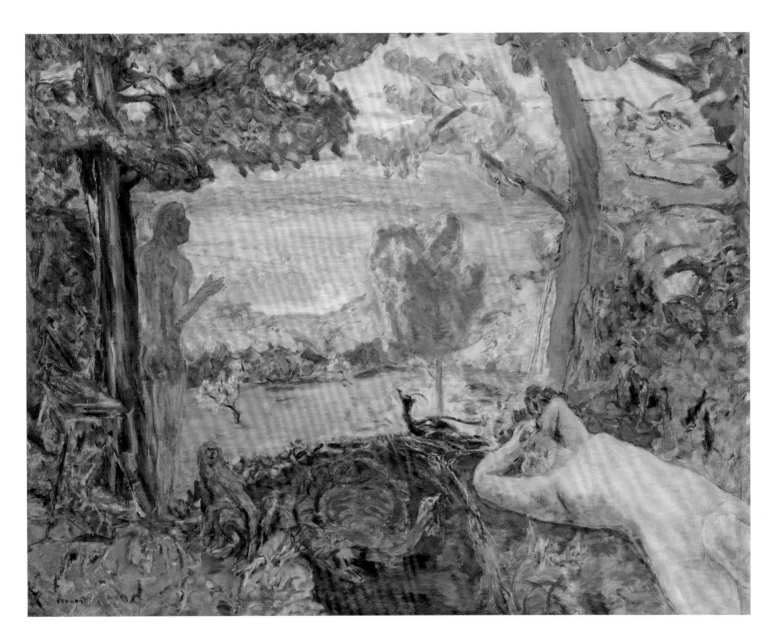

fig.75 Pierre Bonnard *c.*1920
Private Collection

fig.76 Self-Portrait *c.*1920,
pencil on paper *Private Collection*

37 **Self-Portrait with Beard** c.1920

Autoportrait à la barbe
Oil on canvas 28 × 44.5 (11 × 17½)
Private Collection
Dauberville 1025

This is identified in Dauberville as a study for a self-portrait which has not been traced (Dauberville 1026). However, when the present work was shown in Paris in 1984, Claude Laugier argued convincingly that it was the same painting as Dauberville 1026, but reworked (Paris 1984). The self-portrait appears to be based on the photograph, fig.75, although Bonnard's nakedness and the fiery background illuminating his face suggest that once again he is identifying with the primal instincts of the faun (see no.22). This painting remained with the artist and was included in his estate.

38 **Normandy Landscape** 1920

Paysage Normand
Oil on canvas 105 × 57.9 (41⅜ × 22¾)
Musée d'Unterlinden, Colmar
Dauberville 997

The date is established by its sale to the Galerie
Bernheim-Jeune in 1920.

39 **Balcony at Vernonnet** c.1920

Le Balcon à Vernonnet
Oil on canvas 100 × 78 (39⅜ × 30¾)
Musée de Brest
Dauberville 1000

LONDON ONLY

The wooden balcony was a feature of 'Ma Roulotte',
Bonnard's house at Vernonnet.

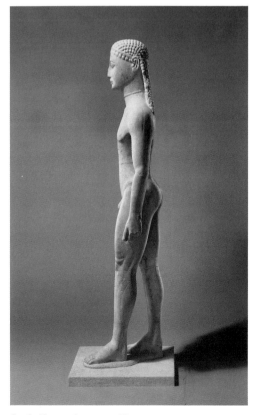

fig.77 *Standing Nude c.*1920,
pencil on paper 17.5 × 10.9
(6⅞ × 4¼) *Private Collection*

40 **Standing Nude** 1920

Nu debout
Oil on canvas 122 × 56 (48 × 22)
Private Collection
Dauberville 1043

LONDON ONLY

This was included in Bonnard's exhibition at the
Galerie Bernheim-Jeune from May to June 1921
as *Nu gris*, and was acquired by the Galerie Bern-
heim-Jeune. Another version of the composition
(Dauberville 1040) was included in the same
exhibition.

fig.78 *Kouros c.*600 BC, marble
H.149 (59) *The Metropolitan Museum
of Art, Fletcher Fund 1932.*

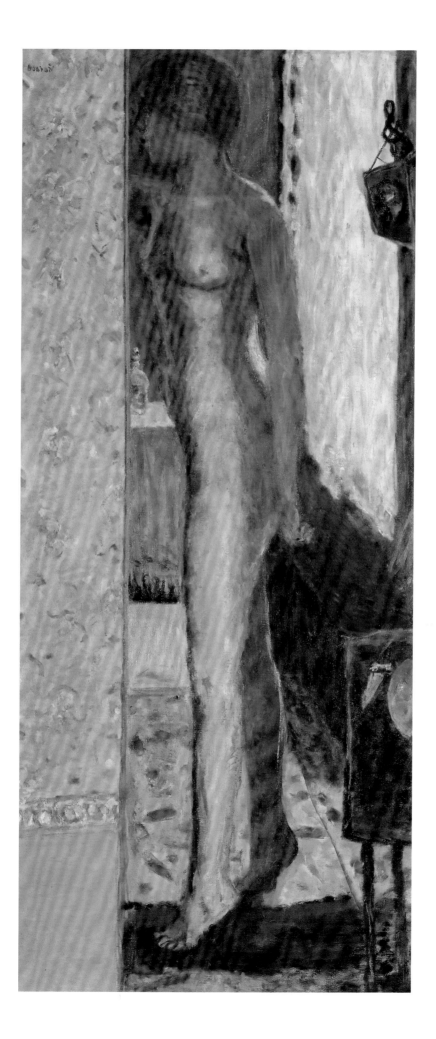

41 **The Vigil** 1921

La Veillée
Oil on canvas 96.5 × 129.5 (38 × 51)
Private Collection
Dauberville 1090

LONDON ONLY

This was included in Bonnard's exhibition at the Galerie Bernheim-Jeune, from May to June 1921. It appears as *Soirée 1920* in Léon Werth's 1923 monograph. It was bought by the Galerie Bernheim-Jeune, presumably at the time of the exhibition, and acquired from them by Etienne Vautheret, whose collection was sold at auction at the Hôtel Drouot 16 June 1933.

The woman is Marthe, and the setting is 'Ma Roulotte'.

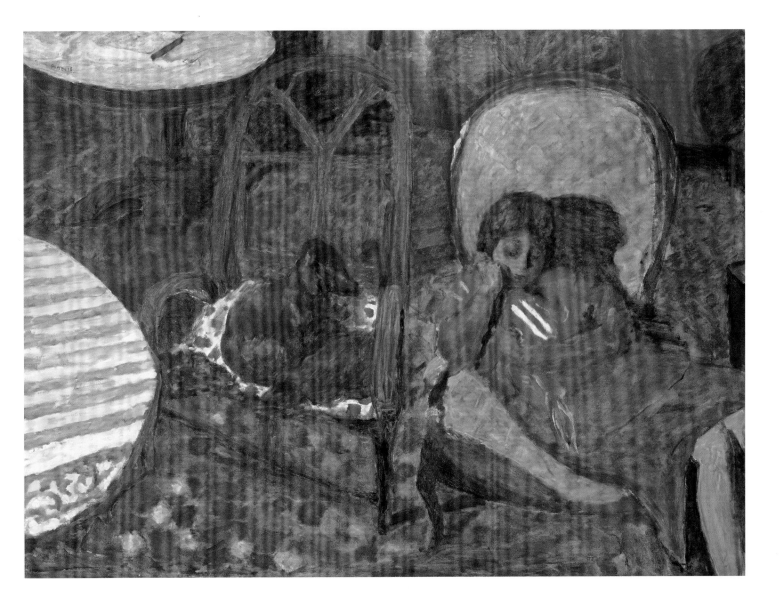

fig.79 Page from sketchbook,
1921 *Private Collection*

fig.80 Page from sketchbook,
1921 *Private Collection*

fig.81 Page from sketchbook,
1921 *Private Collection*

fig.82 Page from sketchbook,
1921 *Private Collection*

42 **The Open Window** 1921

La Fenêtre ouverte
Oil on canvas 118 × 96 (46½ × 37¾)
The Phillips Collection, Washington, DC
Acquired 1930
Dauberville 1062

The setting is the sitting room at 'Ma Roulotte'. The painting was bought by the Galerie Bernheim-Jeune in 1922. When it was reproduced in Claude Roger-Marx's pocket monograph of 1924, the title was given as *L'Eté*.

The sketch showing the interior with a standing figure, fig.79, presumably a preliminary stage, also shows a format which is square rather than upright. The study on the left of the same sheet is for the curtain seen through one of the window panes. The ink sketch of a young girl, added to fig.81, is a portrait of Renée Monchaty (see no.43).

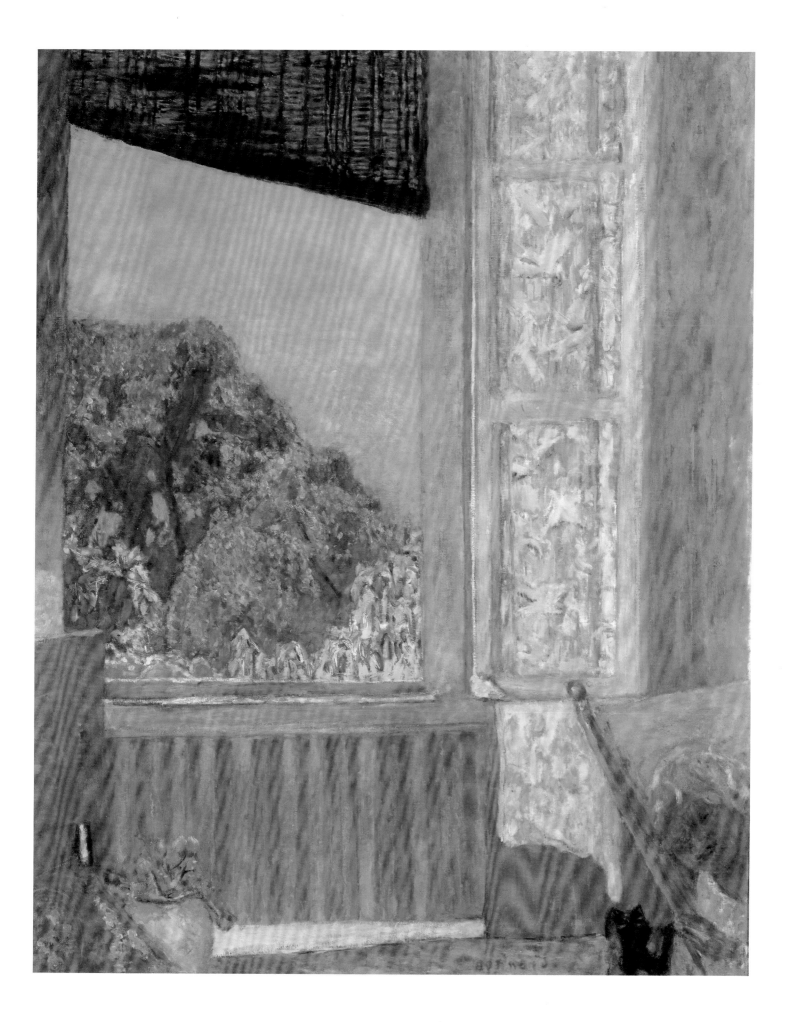

fig.83 Pen-and-ink drawing of
Renée Monchaty as reproduced in
Léon Werth, *Bonnard*, 1923

43 Young Women in the Garden (Renée Monchaty and Marthe Bonnard) 1923 (reworked 1945–6)

Jeunes femmes au jardin (Renée Monchaty
et Marthe Bonnard)
Oil on canvas 60.5 × 77 (23⅞ × 30⅜)
*Private Collection, USA, courtesy Richard L.
Feigen & Co, New York*
Dauberville 1103

Bonnard met Renée Monchaty around 1918, in
Paris, where she was living with Harry Lachman
(1886–1975), an American painter who went on to
become a film director in England and Hollywood
before returning to painting in the 1940s. According
to Antoine Terrasse, Monchaty modelled for
Bonnard, and became a friend of both his and
Marthe's (she addressed postcards to them both). By
1920, perhaps before, she and Bonnard had become
lovers, and in 1921 they spent several weeks together
in Rome. Her likeness is seen in several paintings
(e.g. Dauberville 1024, which is inscribed 'A Renée',
and Dauberville 1027), as well as in a number of
drawings of the early 1920s. Terrasse points out that
she inspired a number of Bonnard's book illustra-
tions, Vollard's *Sainte Monique* (begun in 1920),
Gide's *Prométhée mal enchaîné* (1920) and above all,
Claude Anet's *Notes sur l'amour* (1922). In the
summer of 1924 she visited Spain, announcing her
return to Paris from Toledo in October in a postcard
to Bonnard and Marthe. She killed herself in a Paris
hotel later that year. 'Bonnard was deeply distressed;
he never parted with some of the works she had
inspired, and insisted on including them unobtru-
sively in his exhibition catalogues and in anything
written on his painting' ('Bonnard, très profondé-
ment affligé, conserva toujours quelques unes des
oeuvres qu'elle lui avait inspirées, et il tint à les
inclure discrètement dans les catalogues d'exposition
ou dans les ouvrages consacrés à sa peinture'.
Written communication from Antoine Terrasse).
Bonnard reworked parts of this painting after the
death of Marthe in 1942. It was included among the
works in his estate.

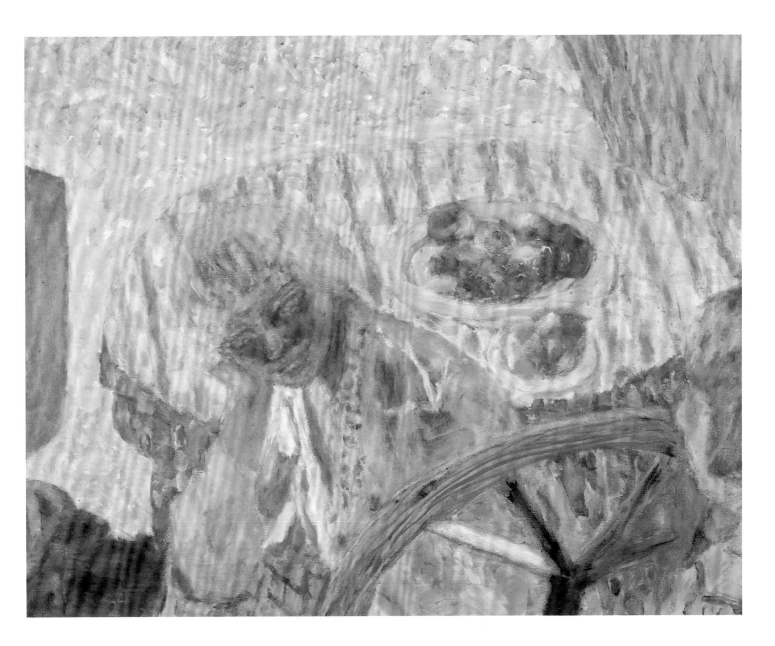

fig.84 Page from sketchbook,
*c.*1921–4 *Private Collection*

44 **Door Opening onto the Garden**
c.1924

La Porte ouverte sur le jardin
Oil on canvas 109 × 104 (42⅞ × 41)
Private Collection
Dauberville 1232

The setting is the dining room at 'Ma Roulotte'.
This painting is a slightly smaller version of one
Bonnard had painted a few years earlier, around 1921
(Dauberville 1065).

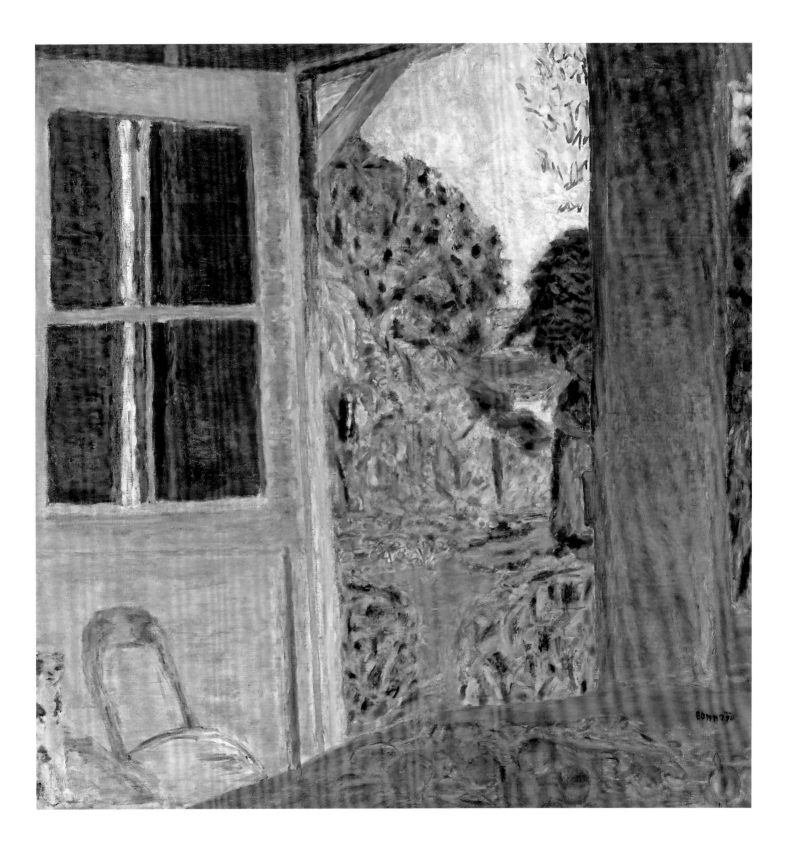

45 **Still Life with Cat** c.1924

Nature morte au chat
Oil on canvas 56 × 61 (22 × 24)
Private Collection
Dauberville 1255

There is no record of this painting prior to 1962
when it was included in *Chefs-d'oeuvre des collections
françaises* at the Galerie Charpentier, Paris between
July and September that year. However, in 1972 it
was included in an exhibition of Vollard's collection
in Tokyo, and presumably had been acquired by him
early on.

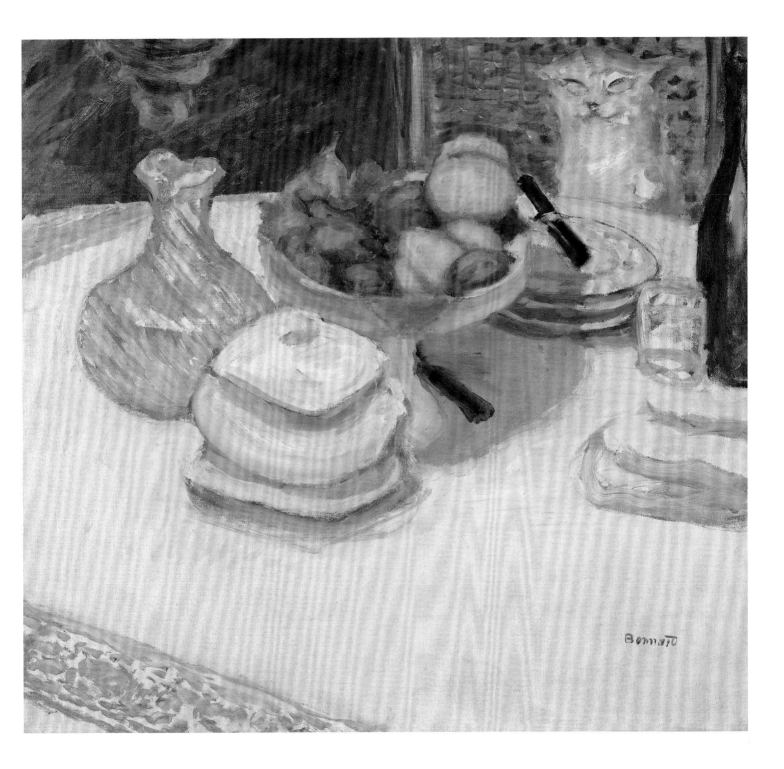

fig.85 Illustration for Jules Renard,
Histoires Naturelles, 1904

46 **Large Blue Nude** 1924

Le Grand nu bleu
Oil on canvas 101 × 73 (39¾ × 28¾)
*Private Collection, courtesy Galerie Bernheim-
Jeune, Paris*
Dauberville 1272

LONDON ONLY

The knee protruding into the picture is a return to
an image Bonnard had realised twenty years before
in one of his drawings for Jules Renard's *Histoires
Naturelles*, 1904. The book was reprinted in 1922.
The painting was included in Bonnard's exhibition
at the Galerie Bernheim-Jeune from June to July
1924, when it was bought by the gallery.

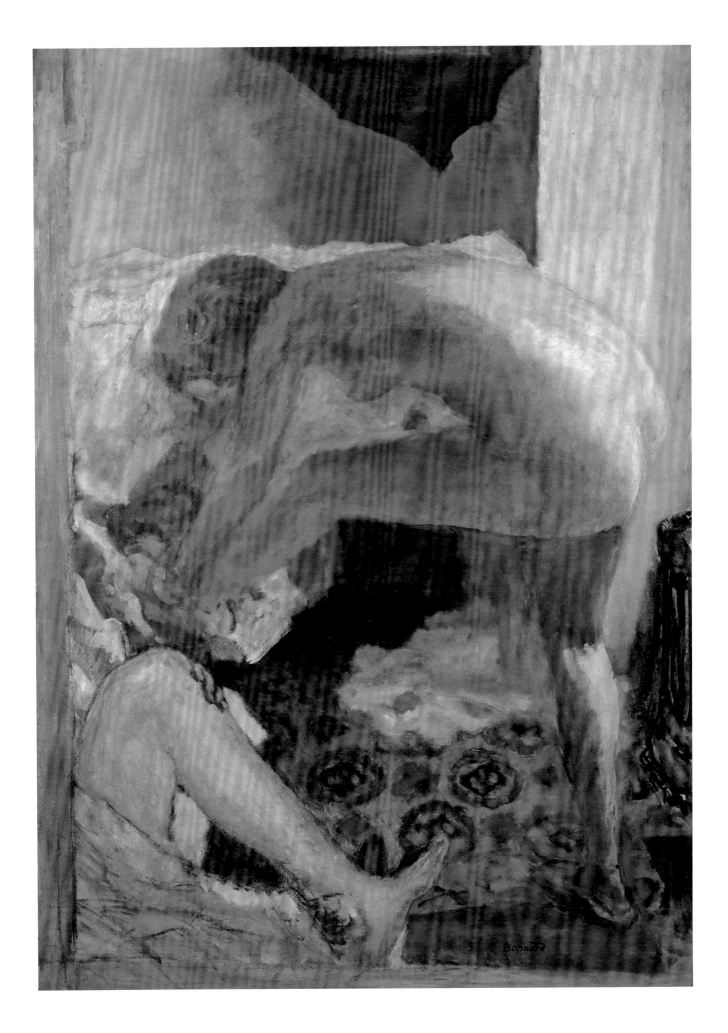

47 **Nude in the Bath** 1925

Nu dans la baignoire
Oil on canvas 103 × 64 (40½ × 25¼)
Private Collection
Dauberville 1332

LONDON ONLY

The standing figure is one of the anonymous self-portraits Bonnard liked to slip into a painting. The position of his hands, which seem to be holding a small object, suggests that he could be making a sketch of himself in the bathroom mirror.

The painting was included in Bonnard's estate.

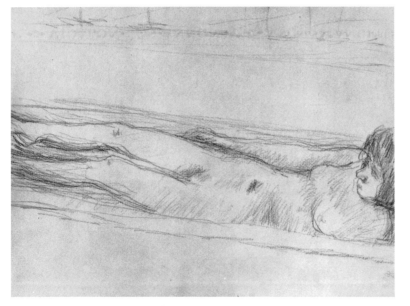

fig.86 Preparatory study for *The Bath* 1925,
pencil on paper 24.1 × 31.8 (9½ × 12½)
Private Collection

48 **The Bath** 1925

Baignoire
Oil on canvas 86 × 120 (33⅞ × 47¼)
Tate Gallery. Presented by Lord Ivor Spencer
Churchill through the Contemporary Art Society
1930
Dauberville 1334

This unsigned work was exhibited at the Salon
d'Automne of 1925 as *Baignoire*. It was bought in
October by the Galerie Bernheim-Jeune, who sold it
to Lord Ivor Spencer Churchill in 1927.

It is the first realisation of a woman lying full
length in a bath, an image that was to preoccupy
Bonnard for the next twenty years. The canvas is
unevenly shaped, which, given Bonnard's practice of
painting one or more pictures on a single piece of
canvas tacked to the wall and then cutting it up, is
not unusual.

The location of this bathroom has not been identi-
fied, although it could conceivably be 48 boulevard
des Batignolles, the apartment Bonnard and Marthe
moved to in 1924. The same division of the wall
behind the bath also appears in *Nude in the Bath*,
1924 (Dauberville 1281).

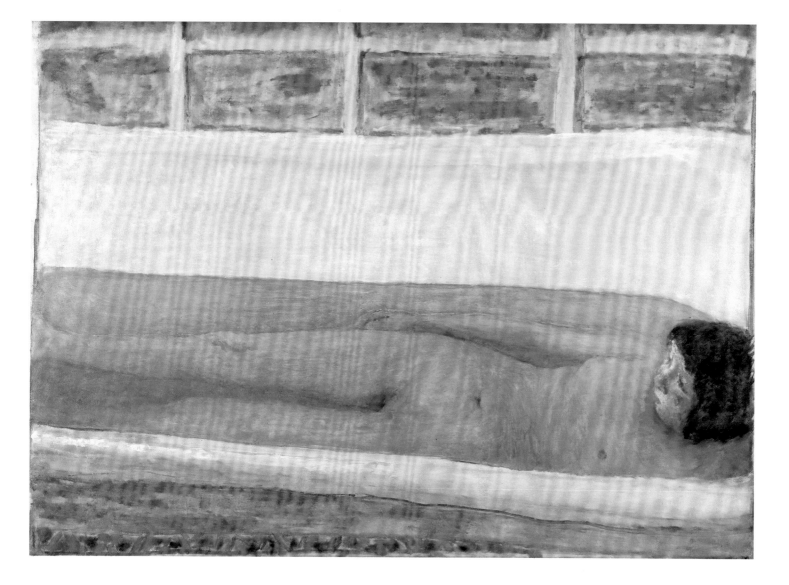

49 **Nude Dressing** 1925

Nu s'habillant
Oil on canvas 73.5 × 45 (29 × 17¾)
Jan Krugier Gallery, New York
Dauberville 1331

Nudes seen from the back are fairly rare in
Bonnard's *oeuvre*. Here, the curve of the back
suggests a mirror image of the nude in Ingres'
The Bather of Valpinçon in the Louvre.

 Nude Dressing was bought by the Galerie
Bernheim-Jeune in 1925.

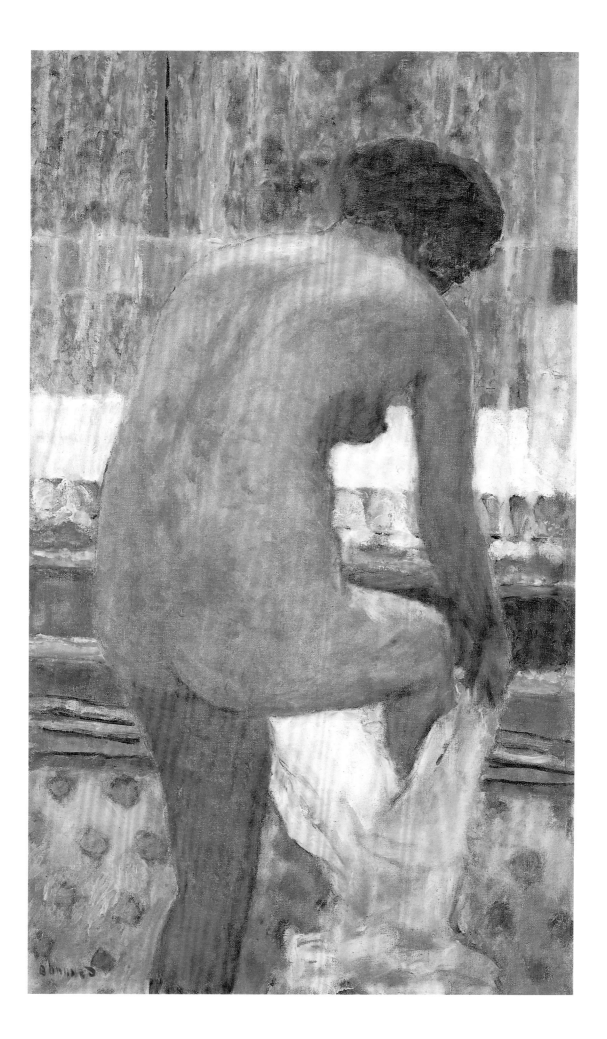

fig.87 *White Table* c.1925,
pencil on paper *Private Collection*

50 **The Table** 1925

La Table
Oil on canvas 102.9 × 74.3 (40½ × 29⅜)
*Tate Gallery. Presented by the Courtauld Fund
Trustees 1926*
Dauberville 1310

The Table left Bonnard's studio very shortly after it
was painted, and was purchased by the Tate Gallery
in 1926.

The coloured pencil drawing, fig.87, is reproduced
in Natanson 1951 as a work of 1929, but it might well
be earlier, given its close similarity with *The Table*.

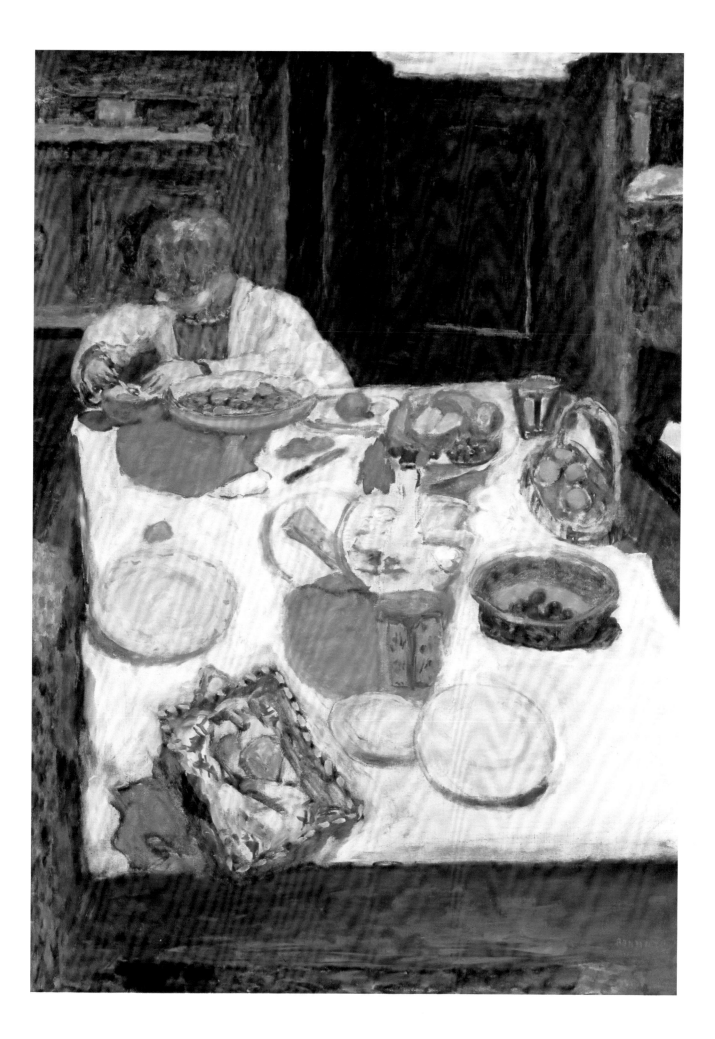

51 | **After the Meal** 1925

Après le repas
Oil on canvas 117 × 114 (46⅛ × 44⅞)
Private Collection
Dauberville 1330

It was bought by the Galerie Bernheim-Jeune in November 1925. When it was first reproduced, in Charles Terrasse, *Bonnard*, 1927, the title was given as *La Table*.

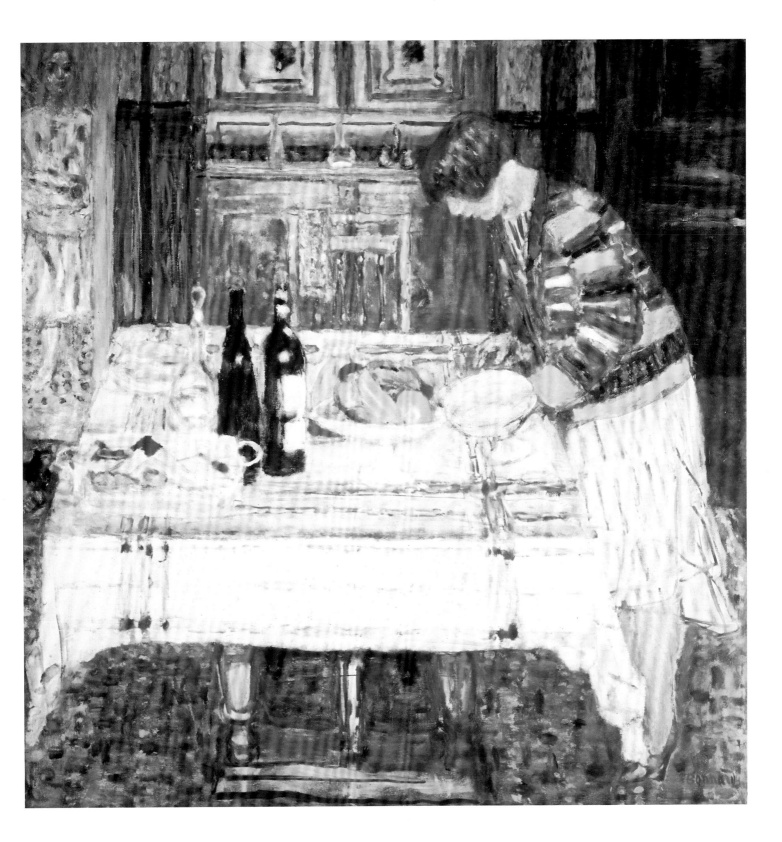

52 **The Sewing Lesson** 1926

La Leçon de couture
Oil on canvas 76 × 51 (30 × 20)
The Phillips Collection, Washington DC
Acquired 1927
Dauberville 1360

LONDON ONLY

This was bought by the Galerie Bernheim-Jeune in
1927. The figures are Marthe and a young maid who
appears in other works of the period, for example, *Le
Vestibule*, 1927 (Dauberville 1383).

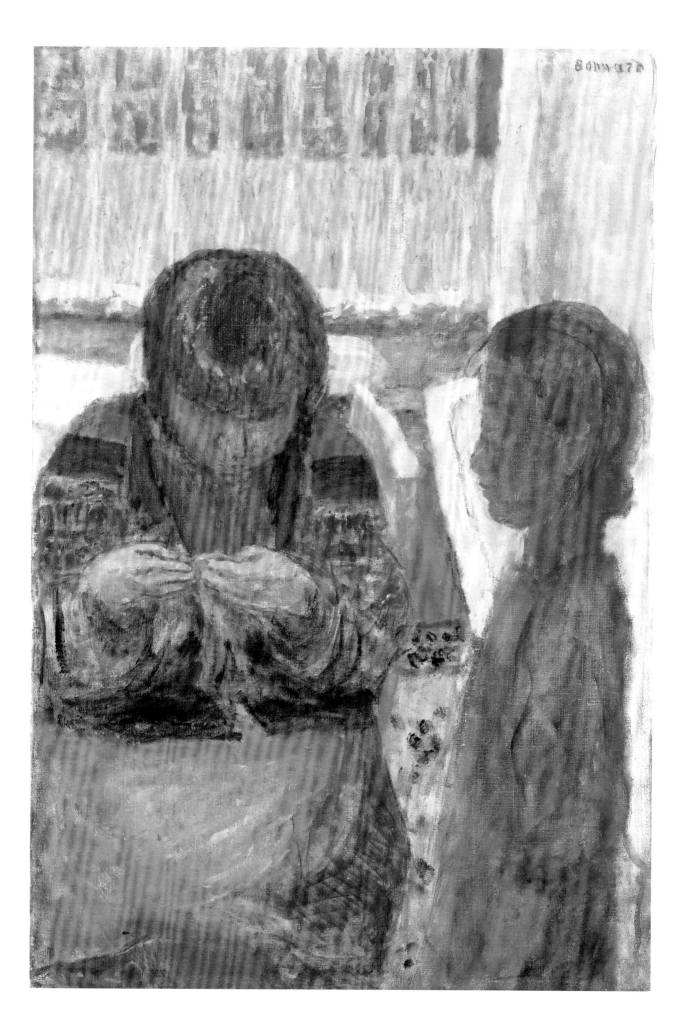

53 **The White Tablecloth** c.1926

La Nappe blanche
Oil on canvas 116.5 × 89 (46 × 35)
Private Collection

NEW YORK ONLY

This painting is not recorded in Dauberville. It was
included in an exhibition of French contemporary
art at the Musée de la Ville, The Hague, in 1936.

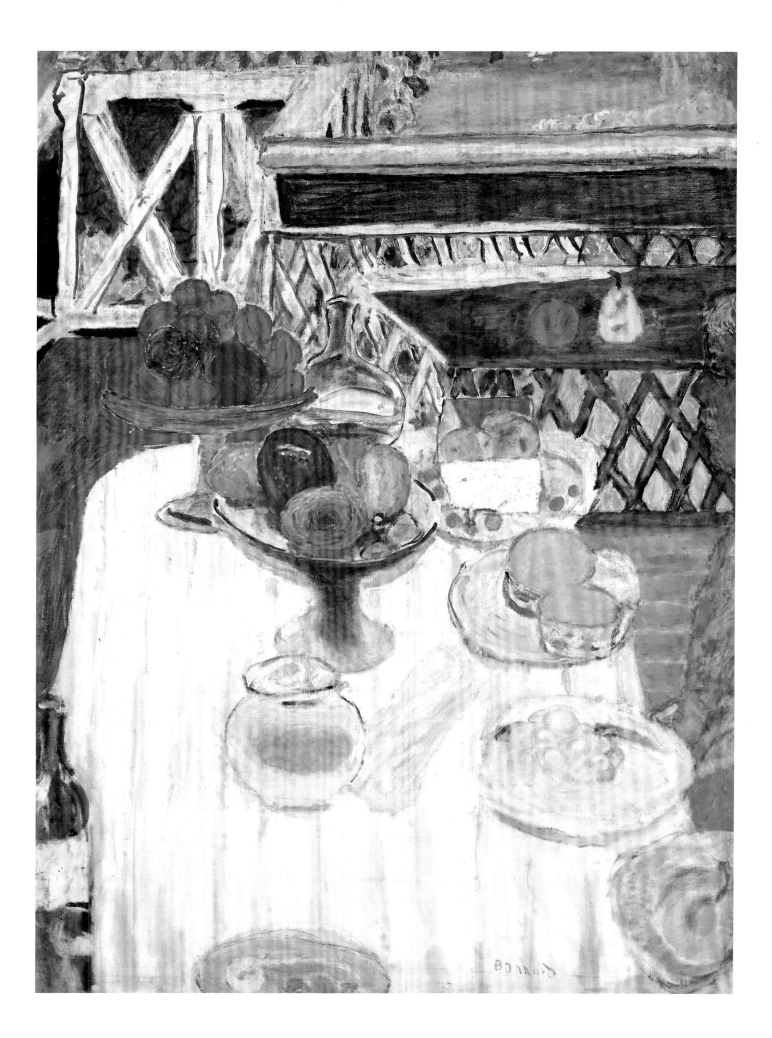

fig.88 *Boulevard des Batignolles*
*c.*1896–8, drypoint 17 × 15 (6⅝ × 5⅞)
Private Collection

fig.89 *Le Boulevard c.*1923,
pencil on paper 12 × 16 (4¾ × 6¼)
Private Collection

54 **Boulevard des Batignolles** c.1926

Boulevard des Batignolles
Oil on canvas 62.2 × 64.1 (24½ × 25¼)
Private Collection, USA
Dauberville 1351

LONDON ONLY

The composition is very close to that of a drypoint
made thirty years earlier, possibly in connection with
the album of coloured lithographs, *Quelques aspects de
la vie de Paris*, published in 1899. The present work
was reproduced in *L'Art d'Aujourd'hui*, no.15, Paris,
Autumn 1927, p.53. Bonnard sold it in June 1931.

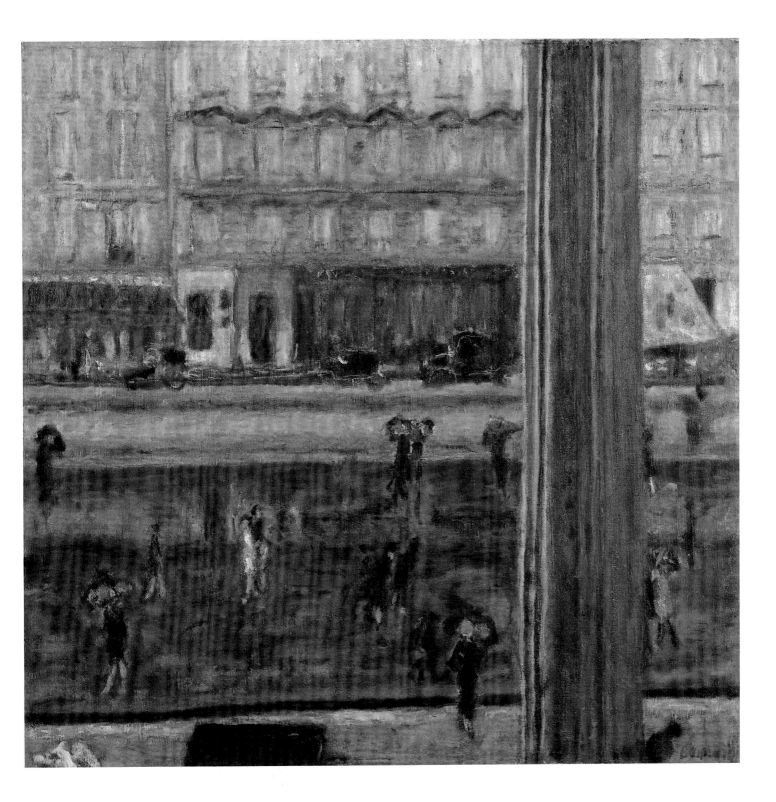

fig.90 Sketch in Bonnard's diary,
1927 *Bibliothèque Nationale, Paris*

55 **Nude with Green Slipper** 1927

Nu à la mule verte
Oil on canvas 142 × 81 (55⅞ × 31⅞)
Private Collection
Dauberville 1388

The setting is the bathroom at 'Le Bosquet', the
house at Le Cannet to which Bonnard and Marthe
moved in February 1927. Three other paintings
which show a nude in the same pose are recorded in
the catalogue raisonné as works of '*c*.1924'
(Dauberville 1277, 1278, 1283).

A note under 4 February in Bonnard's diary for
1927 suggests that he was planning a watercolour as
a preliminary study for the oil: 'watercolour facilitat-
ing generality of shades. Effect of a tone strong and
vivid-green slipper blends into ensemble of soft
yellows and turquoise-blues' ('aquarelle facilitant la
généralité des teintes. Effet d'un ton fort et coloré-
pantouffle verte fond dans un ensemble de blonds et
de bleu turquoises'). In the oil, the slipper stands out
with the startling clarity of the green satin shoe in
Watteau's *Gersaint's Shop Sign*.

Two similarly cryptic notes made in the days that
followed may also have been prompted by work on
this canvas: under 5 February he writes: 'ensemble of
broken tones enlivened by a colour within the same
range' ('ensemble de tons rompus réveillé par une
couleur dans la même gamme'); under 12 February,
'Transposition all the painting materially' ('Transpo-
sition toute la peinture matériellement').

fig.91 Study for *Nude with Green
Slipper* 1927, pencil on paper
Private Collection

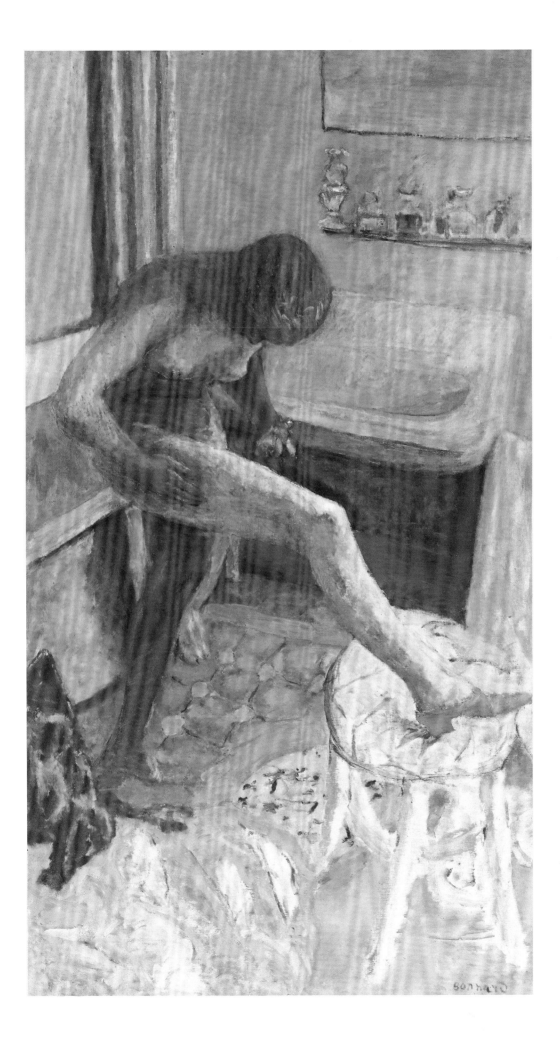

56 **Standing Nude** 1928

Nu debout
Oil on canvas 111×58 ($43\frac{3}{4} \times 22\frac{7}{8}$)
Private Collection
Dauberville 1406

Bonnard showed this at the Salon d'Automne in
1928, and it was bought shortly afterwards by the
Galerie Bernheim-Jeune.

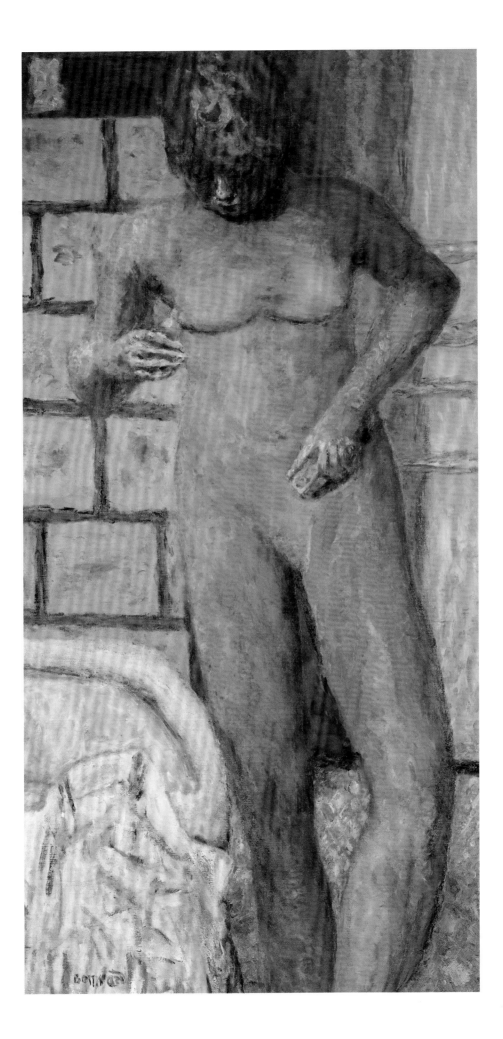

57 Café 'Au Petit Poucet' 1928

Le Café 'Au Petit Poucet'
Oil on canvas 140 × 206 (55⅛ × 81⅛)
*Musée National d'Art Moderne, Centre de
Création Industrielle, Centre Georges Pompidou,
Paris en dépôt au Musée des Beaux-Arts et
d'Archéologie de Besançon. Donation d'Adèle et de
George Besson, 1963*
Dauberville 1399

This was commissioned by Bonnard's friend
George Besson as a pendant to an earlier painting,
Place Clichy of 1912 (Musée des Beaux-Arts et
d'Archéologie de Besançon), which hung in the
dining room of his apartment on the Quai de
Grenelle. It is unsigned. On the inside of the front
cover of his diary for 1927 Bonnard noted: 'panneau
Besson 1.m. 40 × 205'. In January that year he told
Besson that he was thinking of his 'decoration': 'it
must ripen like an apple, there's no way of influenc-
ing time' ('il faut que cela mûrisse comme une
pomme, pas moyen d'agir sur le temps'; Terrasse
1988, p.281). Two related sketches are found in his
diary for 1928: a study for the composition (11 May)
and a sketch of three people seated in a café (16
May). The painting was begun in Bonnard's studio
on the rue Tourlaque and finished in Besson's apart-
ment (ibid.). The complexities of this composition,
in which real space and mirrored space are placed
side by side, bear out what George Besson remem-
bered Bonnard telling him: 'I am making every effort
to try out something a little new' ('Je fais des efforts
pour me renouveler un peu'; ibid., p.282).

The café depicted in the painting is still at 5 Place
Clichy at the corner of the rue Biot in the 18th
arrondissement. Although Bonnard shows the name
of the café printed above the window, the 1928
Annuaire Almanach du Commerce does not record
a café with that name. Under 5 Place Clichy two
establishments are listed: a 'café limonadier et tabac'
(owned by Bessière), and a 'café limonadier' known
as 'Au Muguet' (owned by Tixier).

fig.92 Sketch in Bonnard's diary,
11 May 1928 *Bibliothèque Nationale, Paris*

fig.93 Preparatory study for *Basket of
Fruit in the Dining Room at Le Cannet*
1928, chalk on paper 12.2 × 16.2
(4¾ × 6⅜) *Private Collection*

fig.94 Preparatory study for *Basket of
Fruit in the Dining Room at Le Cannet*
1928, chalk on paper 11.4 × 16.5
(4½ × 6½) *Private Collection*

58 Basket of Fruit in the Dining Room at Le Cannet 1928

La Corbeille de fruit dans la salle à manger du
Cannet
Oil on canvas 50.8 × 59.7 (20 × 23½)
Private Collection
Dauberville 1401

This was bought by the Galerie Bernheim-Jeune in
1928.

The striped wicker basket decorated with green
raffia appears in many still lifes painted from 1924
onwards (for example, no.50). The shape of the bas-
ket, and especially the wide arc created by the han-
dle, is a good example of the empty space Bonnard
said he liked to place at the centre of a composition
(see page 13).

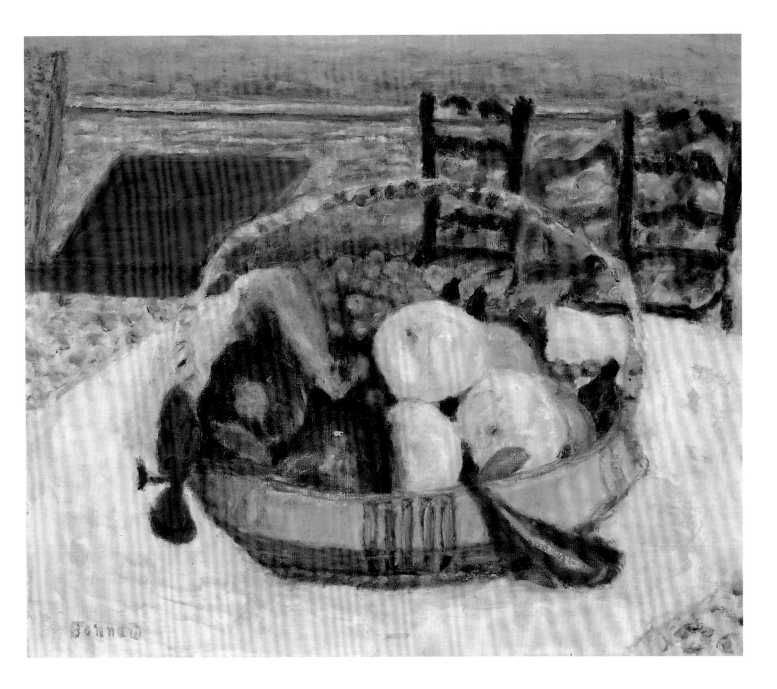

fig.95 *Basket of Fruit with Hand*
*c.*1935, pencil on paper 12.1 × 17.8
(4¾ × 7) *Private Collection*

59 **The Provençal Jug** 1930

Le Pot provençal
Oil on canvas 75.5 × 62 (29¾ × 24½)
Private Collection, Switzerland
Dauberville 1443

This was bought by the family of the present owners,
shortly after it was painted.

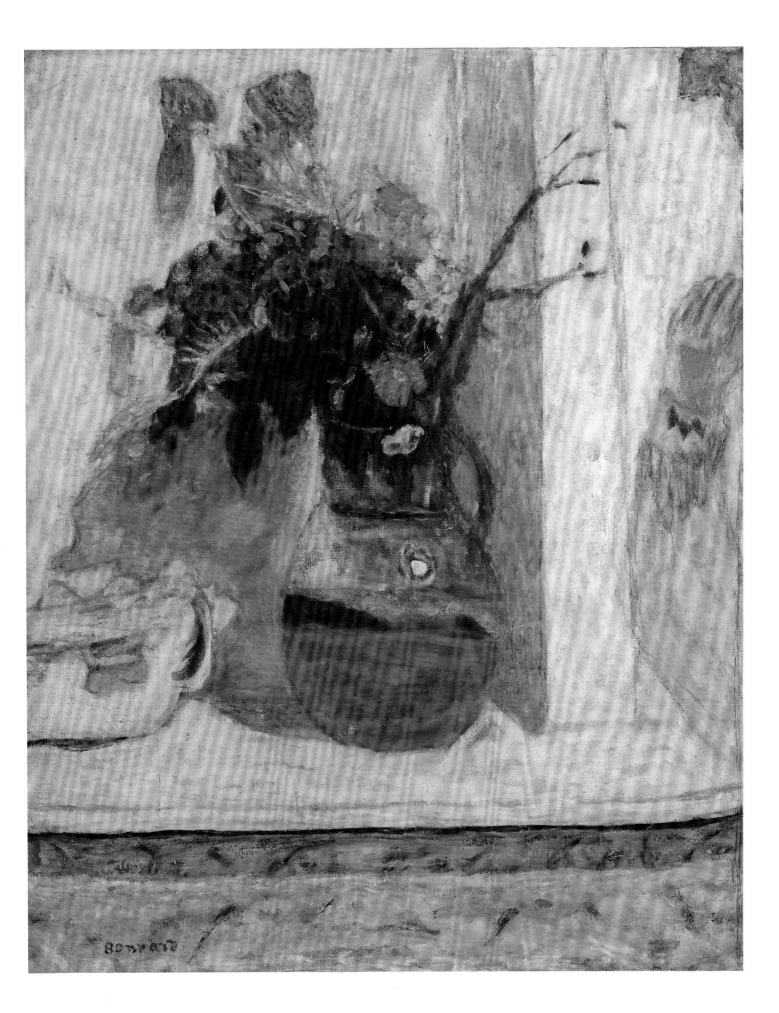

60 **Compotier and Plates of Fruit**
c.1930–2

Compotier et assiettes de fruits
Oil on canvas 60 × 70 (23⅝ × 27½)
Private Collection Chicago, Il.
Dauberville 1206

NEW YORK ONLY

When this still life was included in the exhibition in Paris in 1984 it was assigned the date given above by Antoine Terrasse (Paris 1984). The date recorded in Dauberville is '*c.*1923'. It was acquired by Jos Hessel, presumably early on.

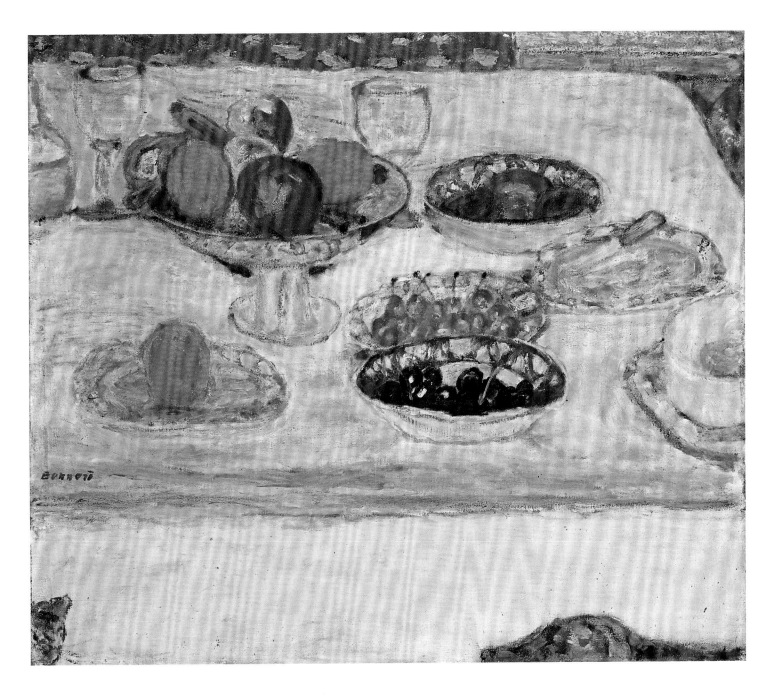

fig.96 Sketch in Bonnard's diary,
26 November 1931
Bibliothèque Nationale, Paris

fig.97 Sketch in Bonnard's diary,
30 November 1931
Bibliothèque Nationale, Paris

61 **The Boxer** 1931

Le Boxeur
Oil on canvas 53.5 × 74 (21⅛ × 29⅛)
Private Collection, Paris
Dauberville 1475

Two studies for this self-portrait are found in Bonnard's diary for 1931 (26 and 30 November). It was bought by the Galerie Bernheim-Jeune in January 1932.

fig.99 Study for *Dining Room Overlooking the Garden (The Breakfast Room)* 1930–1, pencil on paper, dimensions unknown *Private Collection*

fig.100 Study for *Dining Room Overlooking the Garden (The Breakfast Room)* 1930–1, watercolour and pencil on paper 15.2 × 11.4 (6 × 4½) *Private Collection*

fig.98 The right-hand window and balustrade of Villa Castellamare. Photographed in 1997

fig.101 Villa Castellamare, Arcachon (date unknown)

62 Dining Room Overlooking the Garden (The Breakfast Room)
1930–1

La Salle à manger sur le jardin
Oil on canvas 159.3 × 113.8 (62¾ × 44⅞)
The Museum of Modern Art, New York. Given anonymously, 1941
Dauberville 1473

The setting is the dining room of the Villa Castellamare, the house Bonnard rented for six months in the spa town of Arcachon, thirty-five miles west of Bordeaux. He and Marthe stayed there between 3 November 1930 and 15 April 1931.

Bonnard first visited Arcachon, where his friend and future brother-in-law Claude Terrasse was employed as a music teacher, in December 1889. He went back there four times between 1920 and 1929, almost certainly because of Marthe's health. The Villa Castellamare occupies a prime position in the Ville d'Hiver, between the Allée Rebsomen and the Allée Corrigan, facing the Place Turenne. The Ville d'Hiver, set back in the pine woods, was a celebrated 'ville sanatorium' which had been founded in the 1860s for the treatment of tuberculosis and other respiratory ailments (the sap from the pine trees was thought to be beneficial).

In the painting, the view through the window is the front garden of the Villa Castellamare leading down to a gate which opens on to the Place Turenne. (Today, the once-abundant garden has been reduced to a lawn and the solitary umbrella pine seen in fig.101). Along one side of the house, on the Allée Corrigan, is the Parc Mauresque, a large public park overlooking the Ville d'Eté and the Bassin d'Arcachon.

Because of Bonnard's technique of painting on canvases tacked to the wall, occasionally his paint surface extended to the very edges of the canvas, which necessitated wrapping some of the painted canvas around the stretcher in order to tack it securely. This occurred in the original stretching of this work. Owing presumably to ignorance of the artist's working methods, it was decided to make visible the additional strips of painted canvas when the painting was lined in 1963. Thus, the width of the painting increased by approximately an inch and the height increased very slightly. When the painting was lined, it was given a coating of synthetic varnish.

Since there is no evidence that Bonnard varnished his paintings, this synthetic varnish was removed in 1997 to produce a more optically subtle surface and colouration. The work has been reframed to conform to the original sight size. (Conservation note provided by The Museum of Modern Art, New York).

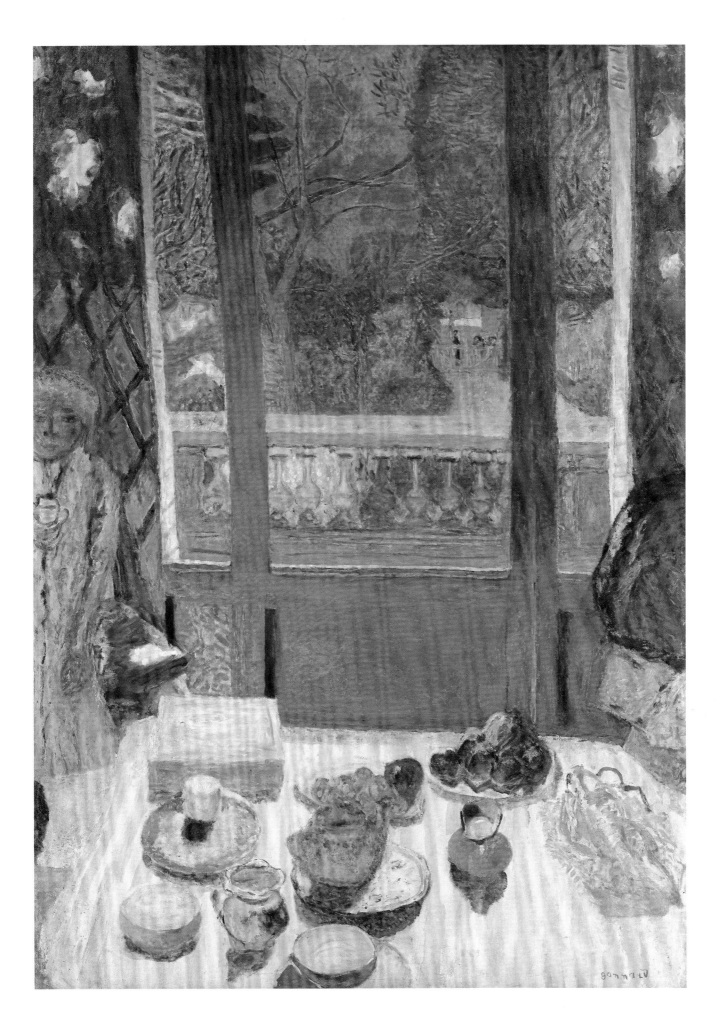

fig.102 *Still Life in Front of the Window*
1931, pencil on paper 16.2 × 12.4
(6⅜ × 4⅞) *Galerie Claude Bernard*

63 **Still Life in Front of the Window**

1931

Nature morte devant la fenêtre
Oil on canvas 75 × 57 (29½ × 22½)
*Muzeul National de Arta al Romaniei, Muzeul
K.H. Zambaccian, Bucharest*
Dauberville 1472

The setting is the same as no.62. The painting was
included in Bonnard's exhibition at the Galerie
Bernheim-Jeune in June 1933.

A study in watercolour and gouache (33 × 25 cm)
signed and dated Bonnard 1931 is reproduced in
Hommage à Bonnard, Galerie des Beaux-Arts,
Bordeaux, May–August 1986, p.153.

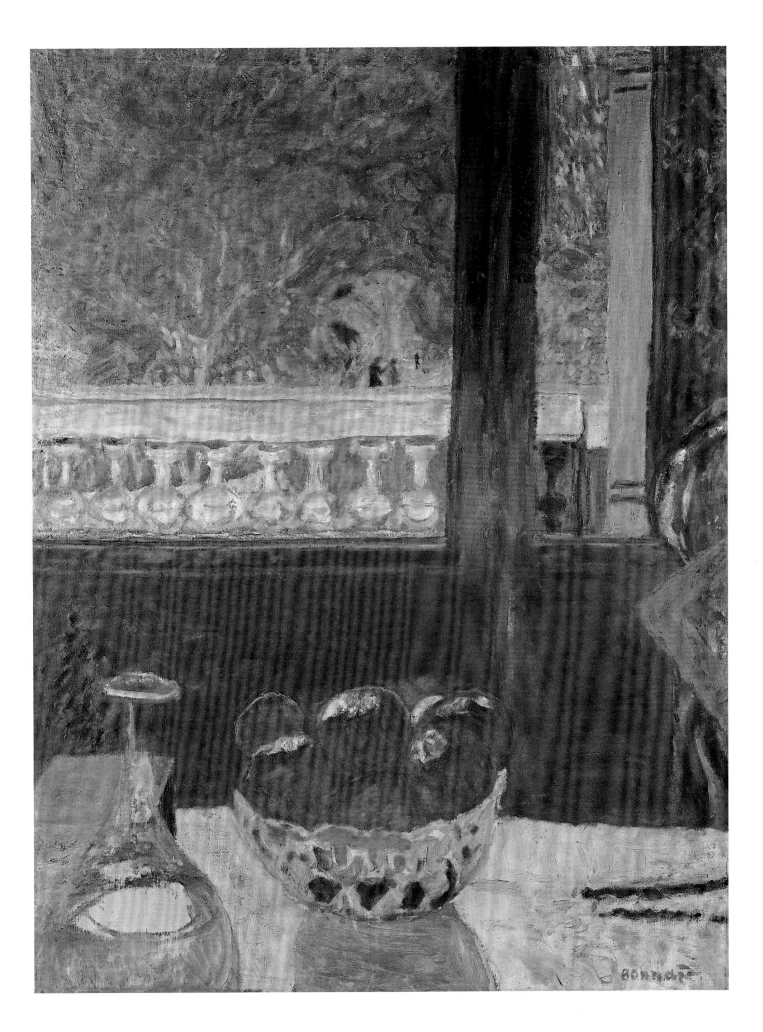

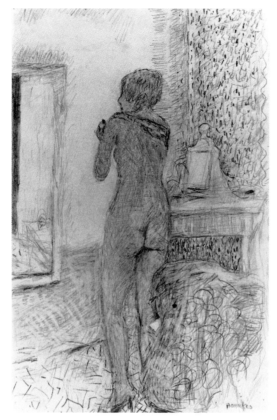

fig.103 Presumed study for *Nude in front of a Mirror* 1931, pencil on paper, dimensions unknown *Private Collection*

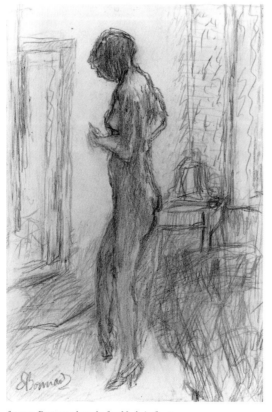

fig.104 Presumed study for *Nude in front of a Mirror* 1931, pencil on paper 26 × 17.5 (10¼ × 6¾) *Galerie Schmit, Paris*

64 **Nude in front of a Mirror** 1931

Nu au miroir
Oil on canvas 154 × 104.5 (60⅝ × 41⅛)
Galleria Internazionale d'Arte Moderna di Ca'Pesaro, Venice
Dauberville 1479

LONDON ONLY

According to Sargy Mann, the interior shown here and in no.65 is the dressing room at 'Ma Roulotte', Bonnard's house at Vernonnet. The nude is holding a friction cloth with a loop at each end; it appears in another bath painting of 1931, *Nude and Bath* (Musée National d'Art Moderne, Centre Georges Pompidou, Paris). The present work was bought from Bonnard in 1931 by Gaston Bernheim de Villers.

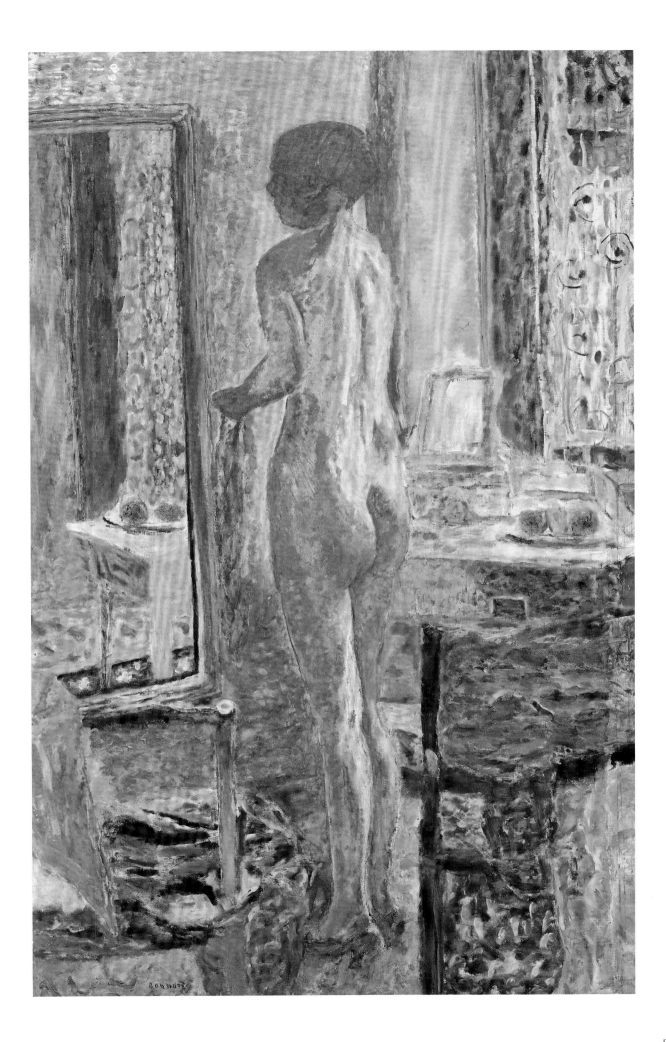

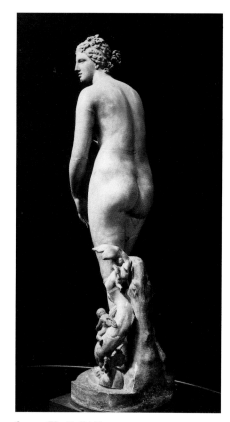

fig.105 *The Medici Venus* 1st century AD,
marble H.153 (60¼)
Galleria Uffizi, Florence

65 **Large Yellow Nude** 1931

Le Grand nu jaune
Oil on canvas 170 × 107.3 (66⅞ × 42¼)
Private Collection
Dauberville 1478

See no.64. Once again, Bonnard appears to have
borrowed the pose of a classical nude, in this case,
the Medici Venus. It may be the case that having sold
no.64 very shortly after it was finished, Bonnard
began work on another version of a nude standing in
front of a mirror. He kept this canvas, and it was
included in his estate.

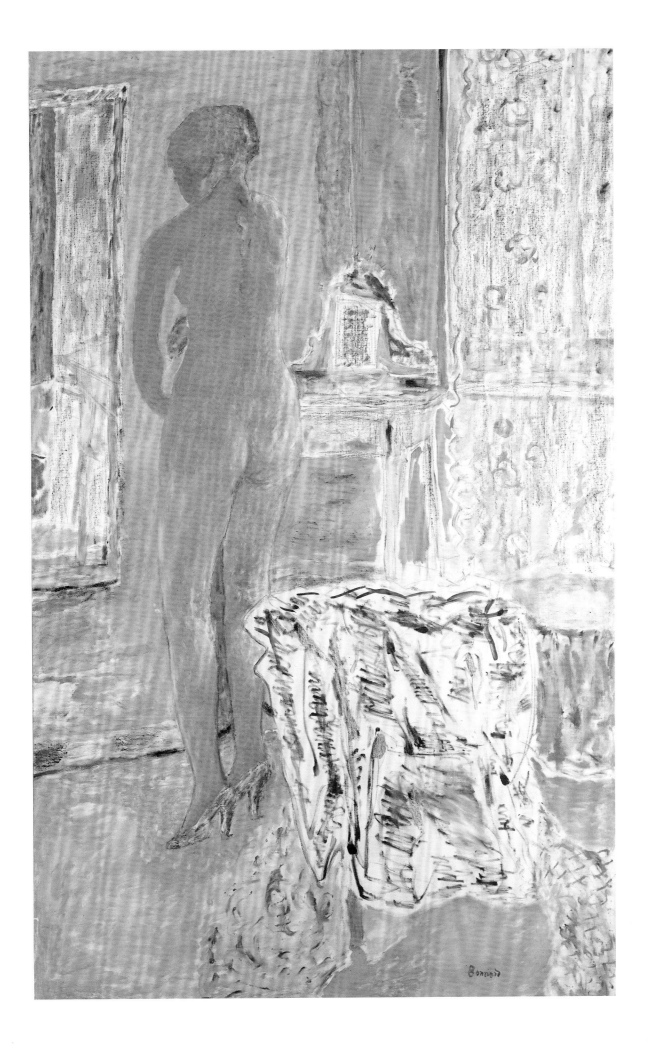

fig.106 Sketch in Bonnard's diary,
3 February 1932 *Bibliothèque Nationale, Paris*

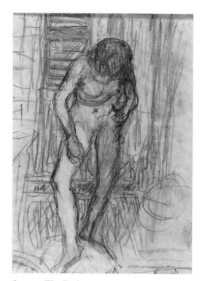

fig.107 *The Bathroom* 1932,
pencil on paper 23 × 18 (9 × 7⅛)
*Musée d'Art et d'Histoire, St Denis. Ancienne
Collection George Besson*

fig.108 Detail from a photograph
of *The Bathroom* 1932, retouched
by Bonnard in gouache and ink.
Private Collection

66 **The Bathroom** 1932

Le Cabinet de toilette
Oil on canvas 121 × 118.1 (47⅝ × 46½)
*The Museum of Modern Art, New York. Florene
May Schoenborn Bequest 1996*
Dauberville 1505

The setting is the bathroom at 'Le Bosquet', looking
from the door towards the French windows and the
hand basin on the right. The walls of the room,
which measures 2.31 × 2.08 m (91 × 82 inches),
were lined with white ceramic tiles, each with a
shallow circular depression in the centre, which
would have intensified the reflection of light. The
capping tiles along the top edge were dark green
(information supplied by Sargy Mann). The floor
was covered in linoleum printed with a blue and
white lozenge pattern.

Bonnard's diaries contain a number of related
studies, of which the earliest are under 2 and 11
February 1929. Four appear under 3, 14, 24 Febru-
ary and 25 March 1932 (while he was staying at Le
Cannet). The painting must have been completed
shortly afterwards, as it was included in *Van Gogh,
Toulouse-Lautrec, Bonnard et son époque*, organized by
George Besson at the Galerie Braun, Paris in April
1932. It was purchased from Bonnard the same year
by the Galerie Bernheim-Jeune. Sketches relating to
this composition are also found on the pages of the
1932 diary covering 8–9 December. Either Bonnard
was still thinking about the composition eight
months later or he was using pages out of sequence.

A note made on 20 April 1932 reveals concerns
that could be seen as relevant to this painting: 'the
finish – limit – line – mouldings, cornices, edges very
definite, geometrical shapes, smooth surfaces' ('le
fini – la limitation – trait – moulures, corniches,
bordures très nettes, formes géométriques surfaces
lisses'). Three other studies are known: the drawing
reproduced as fig.107; a pastel study for the nude
(24 × 12 cm) which was included in at a sale at the
Hôtel des Ventes, Rouen, 2 April 1995; and a
charcoal drawing (32 × 24.5 cm), also of the nude
(Mercury Gallery Summer Exhibition, London,
June–September 1972, no.28).

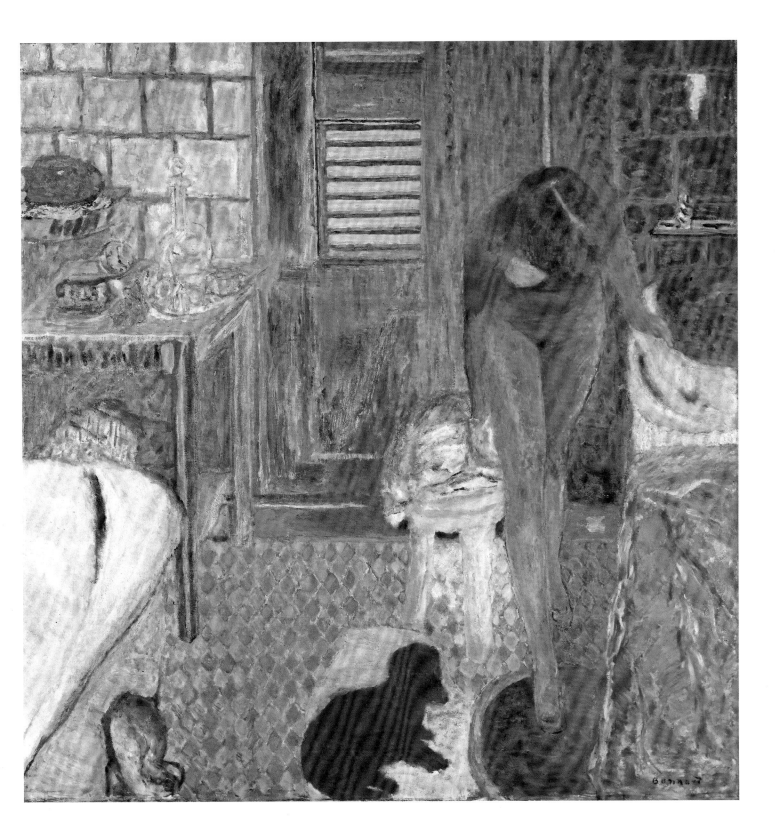

67 **The French Window** 1932

La Porte-fenêtre
Oil on canvas 86 × 112 (33⅞ × 44⅛)
Private Collection
Dauberville 1499

The setting is the small sitting room on the upper floor of 'Le Bosquet' where Bonnard and Marthe had their breakfast and lunch. The room, which measures 3.35 × 3.76 m (112 × 148 inches), was painted Naples yellow (information supplied by Sargy Mann). The small head behind Marthe is the painter's head reflected in the mirror.

As Belinda Thomson has pointed out, 'Bonnard's late addition of pencil lines over the dried paint surface to give greater definition to Marthe's hands ... is a good example of the complex reworking characteristic of Bonnard's artistic procedure (Hayward Gallery 1994, p.53).

The painting was included in Bonnard's exhibition at the Galerie Bernheim-Jeune in June 1933 as *Matinée*.

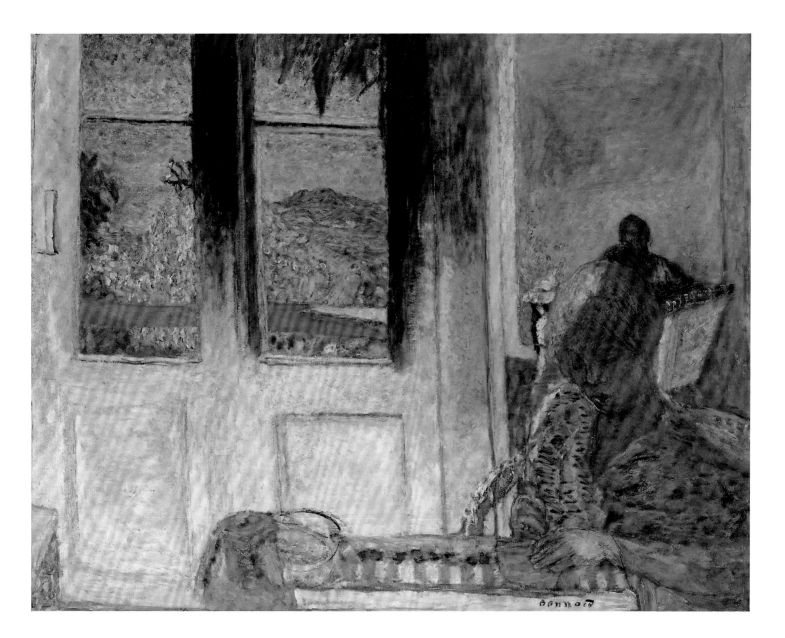

fig.109 Sketch in Bonnard's diary,
6 April 1929 *Bibliothèque Nationale, Paris*

68 **White Interior** 1932

L'Intérieur blanc
Oil on canvas 109 × 162 (42⅞ × 63¾)
Musée de Grenoble
Dauberville 1497

LONDON ONLY

The setting is the same as in no.67. The painting was
included in *Van Gogh, Toulouse-Lautrec, Bonnard et
son époque*, organized by George Besson at the
Galerie Braun, Paris in April 1932. The painting
may have evolved over a period of years given that
sketches for the composition appear in Bonnard's
diary on 29 April 1929.

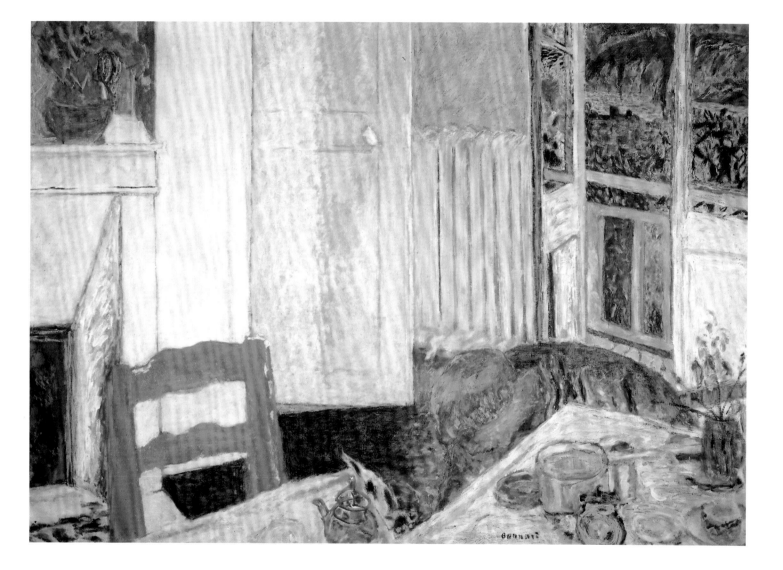

69 **Bowl of Fruit** 1933

Coupe de fruits
Oil on canvas 57.9 × 53 (22⅞ × 20⅞)
Philadelphia Museum of Art, Bequest of
Lisa Norris Elkins
Dauberville 1515

The painting was included in Bonnard's exhibition
at the Galerie Bernheim-Jeune in June 1933. As
is the case with many of the late still lifes, the
composition is lit by electric light. Sargy Mann has
pointed out that the double illumination of yellow
electric light and blue daylight was one that
particularly appealed to Bonnard (Hayward Gallery
1994, p.34).

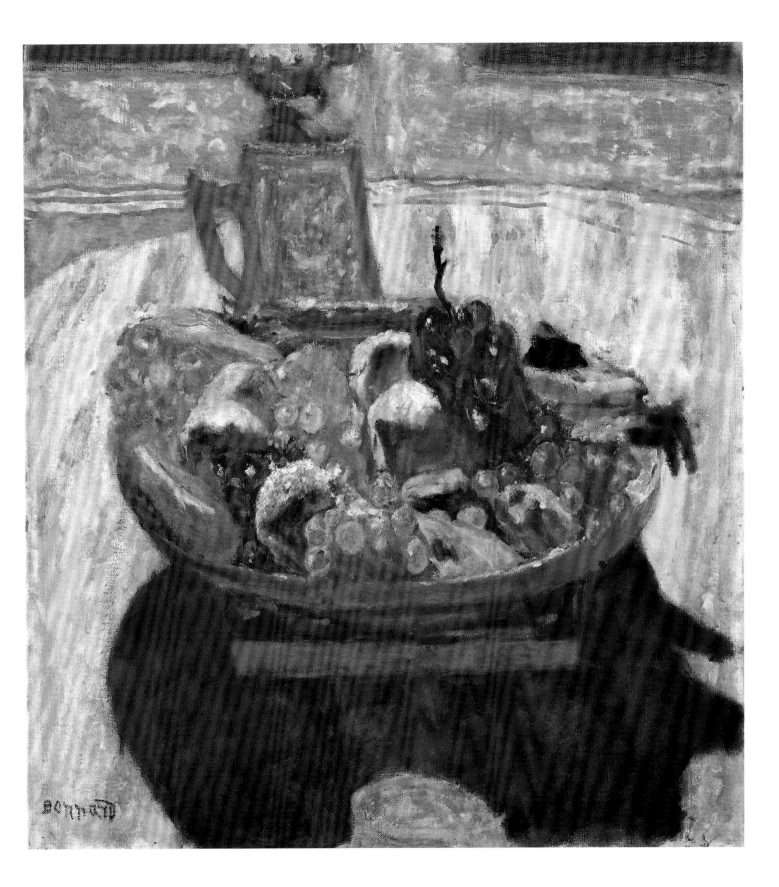

70 Large Dining Room Overlooking the Garden 1934–5

Grande salle à manger sur le jardin
Oil on canvas 126.8 × 135.3 (50 × 53¼)
Solomon R. Guggenheim Museum, New York.
Gift, Solomon R. Guggenheim, 1938
Dauberville 1524

The setting has long been identified as the dining room of the villa Bonnard rented at Bénerville-sur-Mer (known today as Blonville-Bénerville), a few kilometres from Deauville, between June and September 1934. (Bonnard's diary records his arrival there on 16 June.) However, Antoine Terrasse has recently suggested (in conversation) that this and no.71 may have been painted at La Baule, in southern Brittany, where Bonnard stayed the previous winter. As no photographs are known of either villa, the argument is inconclusive, although it is worth noting that on 19 May 1935 Bonnard recorded in his diary, 'table la Baule 25,000'. The price suggests it was an important painting, such as no.71 perhaps.

The present work was shown at the Salon d'Automne, 1935, as *Salle à manger de campagne*, and was purchased the same year by the Galerie Bernheim-Jeune.

A related study (pencil on paper 17.4 × 12.5 cm) is reproduced in Angelica Zander Rudenstine, *The Guggenheim Museum Collection: Paintings 1880–1945*, New York 1976, p.40. As Rudenstine has observed, the vertical format of the drawing, which cuts off the scene on either side of the window, brings it into closer relationship with no.71. In any case, as Rudenstine says, 'It is difficult to establish which of the two paintings came first. The drawing and the two paintings probably date from approximately the same time, and the drawing, while strictly speaking more readily identifiable as a sketch for [no.71], was also clearly involved in the development of the Guggenheim work'.

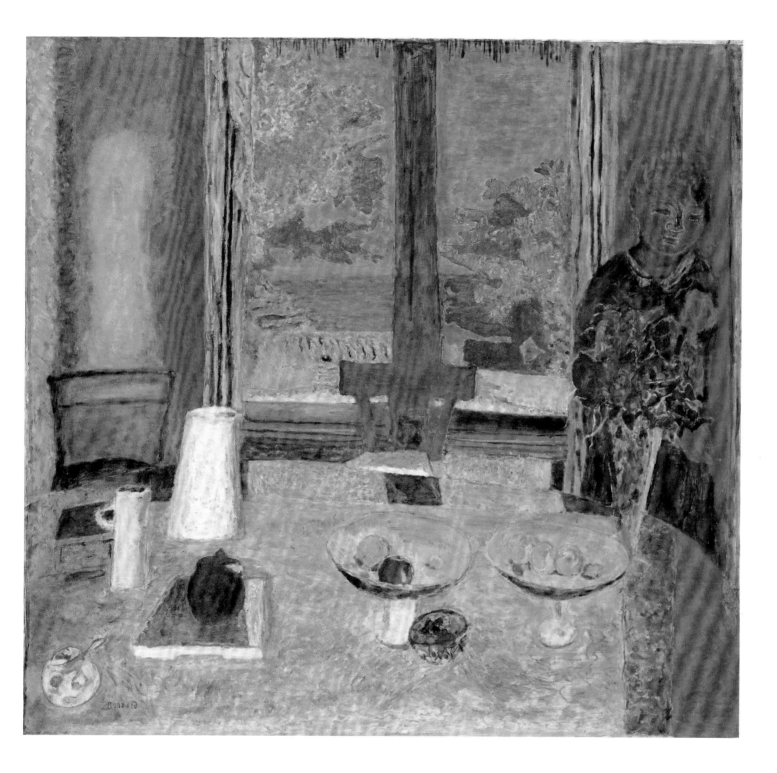

71 Table in Front of the Window

1934–5

La Table devant la fenêtre
Oil on canvas 101.5 × 72.5 (40 × 28½)
Private Collection
Dauberville 1525

The room is clearly the same as the one seen in
no.70, although the view out of the window is not.
In no.70, the window looks over a garden and the sea
beyond (the villas at Bénerville were situated on top
of a cliff), but here the window appears to look out
over a river, with its far bank clearly visible.

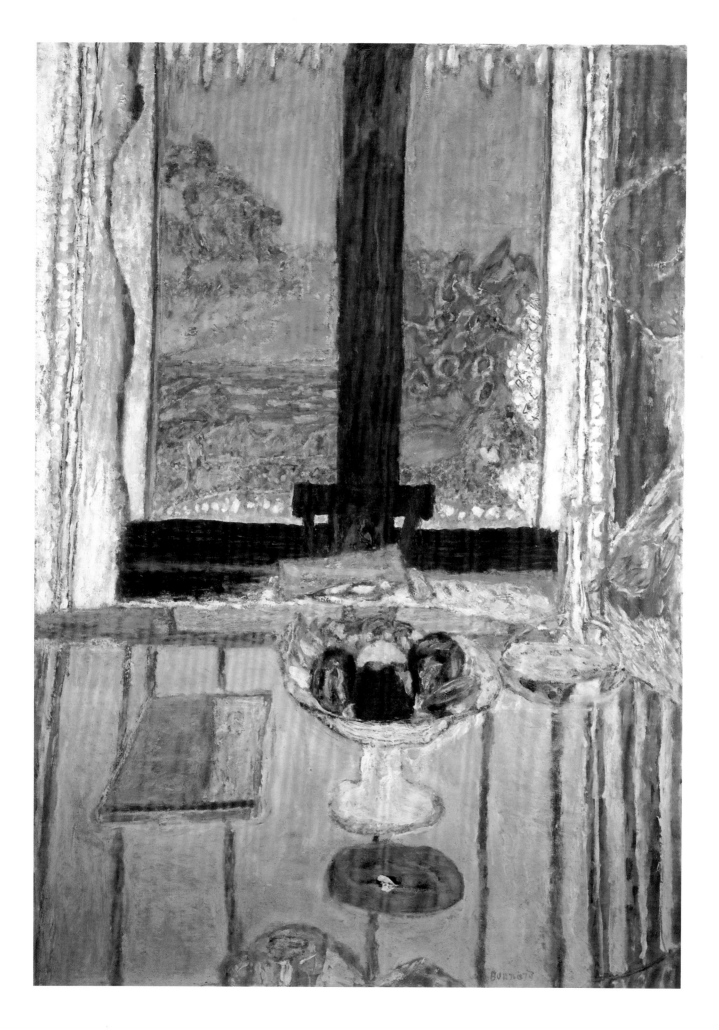

fig.110 Sketch in Bonnard's diary,
28 October 1934 *Bibliothèque Nationale, Paris*

72 **Corner of a Table** c.1935

Coin de table
Oil on canvas 67 × 63.5 (26⅜ × 25)
*Musée National d'Art Moderne, Centre de
Création Industrielle, Centre Georges Pompidou,
Paris. Dépôt du Département des Peintures du
Louvre*
Dauberville 1534

The setting is the dining room at 'Le Bosquet'. The
table was covered with a piece of red felt over which
a white tablecloth was laid at meal times.

A sketch for the composition is found in Bon-
nard's diary, 28 October 1934. The painting was
shown at the Salon des Indépendants, 1936, where it
was acquired by the French State.

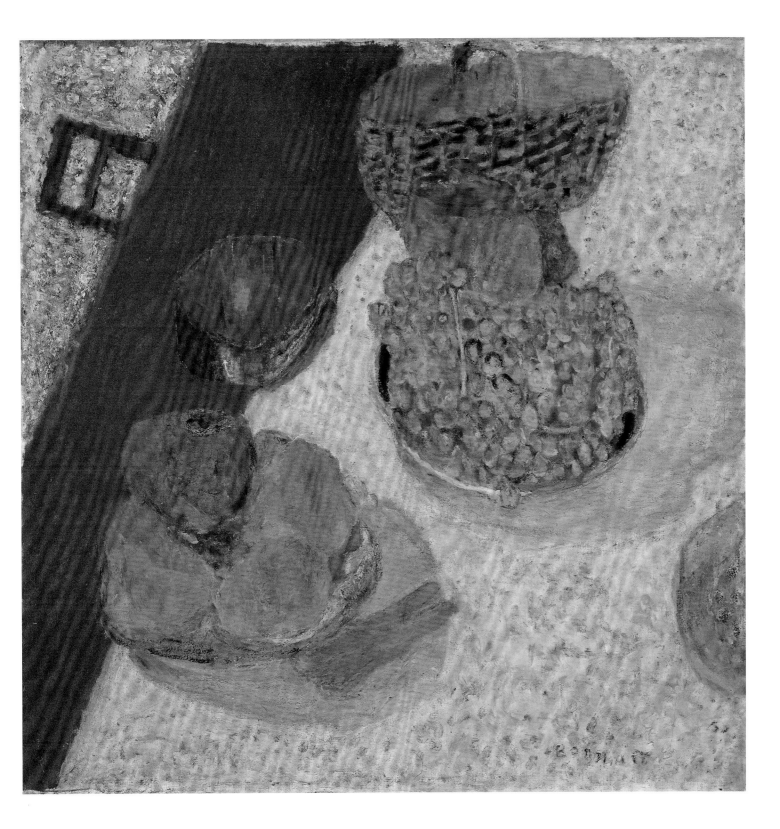

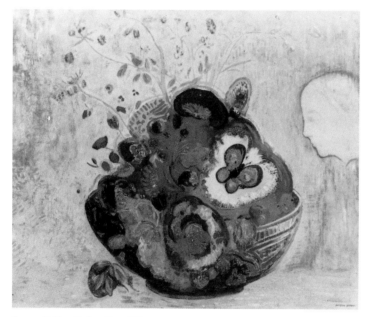

fig.111 Odilon Redon *Vase of Flowers and Profile* c.1899, oil on canvas 65 × 81 (25⅝ × 31⅞) *Private Collection*

73 **The Breakfast Table** 1936

Le Petit déjeuner
Oil on canvas 63.8 × 95.3 (25⅛ × 37½)
Private Collection
Dauberville 1549

NEW YORK ONLY

The setting is the small sitting room on the upper floor of 'Le Bosquet'. As in an earlier painting set in the same interior, no.67, Bonnard's reflection is seen in the mirror hanging to the right of the French windows.

Bonnard believed that 'a figure should be part of the background against which it is placed'. The transparent, almost ghostly appearance of those placed in many of the interiors evokes the wraith-like figures of Odilon Redon. Here, the debt to Redon, who had been a pivotal figure for Bonnard and his fellow 'Nabis', is made more explicit by the juxtaposition of a luminous profile with a still life.

It was included in the Carnegie International Exhibition, Pittsburgh, October to December 1936.

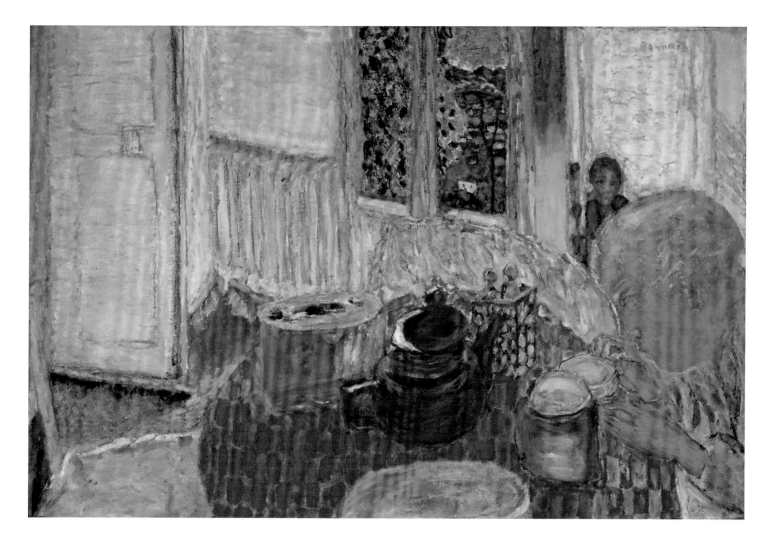

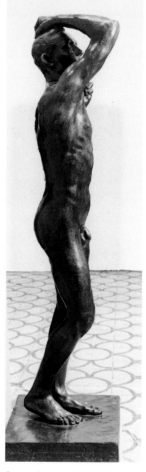

fig.112 Auguste Rodin *The Age
of Bronze* 1875–6, bronze
170.2 × 60 × 60 (67 × 23⅝ × 23⅝)
*The Board of Trustees of the
Victoria and Albert Museum*

74 **Grey Nude in Profile** 1936

Nu gris de profil
Oil on canvas 114 × 61 (44⅞ × 24)
Private Collection, Principality of Liechtenstein
Dauberville 1548

NEW YORK ONLY

The date is given in Dauberville as '1936 (later
reworked)'. As the painting remained in Bonnard's
studio, the reworking could have been done at any
time in the ten year period before his death.

The pose of the nude is close to that of Rodin's
sculpture, *The Age of Bronze*, a reminder of
Bonnard's admiration for the older artist, whom
he may have met early in his career, as his name is
noted in an address book Bonnard kept between 1886
and 1893. In 1914, at Félix Fénéon's request, Rodin
had agreed to pose for a drawing by Bonnard (see
Chronology). There is also a photograph of Rodin
at work on his bust of Falguière which was found
amongst Bonnard's photographs, and which is
thought to have been taken by him (Cabinet des Arts
Graphiques, Musée d'Orsay, Paris).

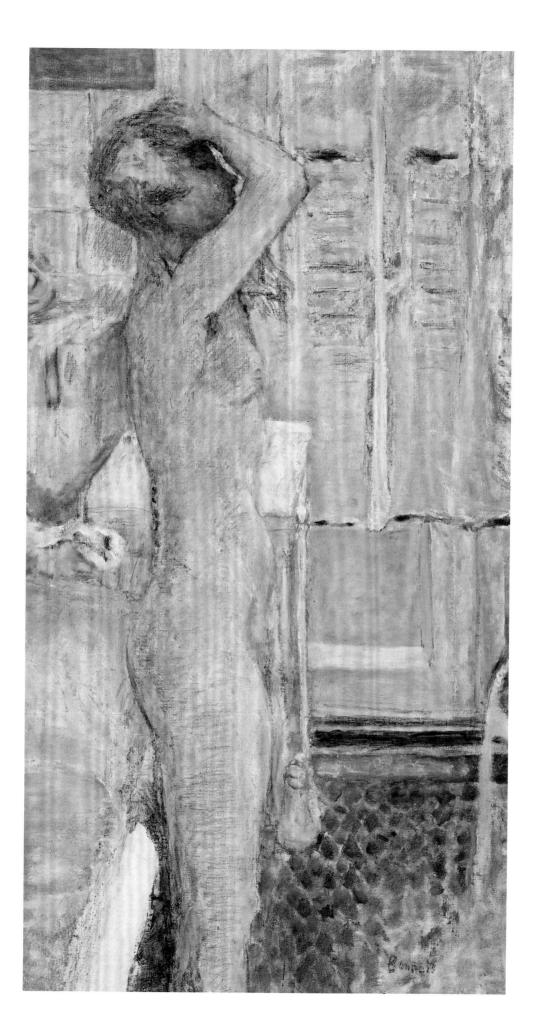

fig.113 *Page of Studies* 1927, pencil on paper
27.5 × 19.5 (10⅞ × 7⅝) *Private Collection*

fig.114 *Nude in a Bath*, pencil on paper
Private Collection

75 **Nude in the Bath** 1936

Nu dans le bain
Oil on canvas 93 × 147 (36⅝ × 57⅞)
Musée d'Art Moderne de la Ville de Paris
Dauberville 1558

The dating of this painting is established by a letter
of 4 August 1936 from Raymond Escholier, Director
of the Petit Palais, informing Bonnard that the
'Ville de Paris Committee for the allocation of special
funds to artists on the occasion of the 1937
exhibition' had decided to buy this painting, and
no.76, for the 'Musée Moderne de la Ville de Paris –
quai de Tokyo'. In a second letter, dated 23 May
1939, Escholier agreed to a request from Bonnard
for the painting to be temporarily returned to him.
As Antoine Terrasse has suggested, this was so that
Bonnard could have it by him while working on
another major bath painting, no.80. (The documents
cited above were made available by Antoine
Terrasse.)

The subject of the nude lying in the bath had con-
tinued to preoccupy Bonnard long after he finished
no.49. The drawing in fig.113 is on the back of a bill
from a tradesman at Le Cannet sent in April 1927. It
must date from around the same time as one of the
other sketches is for a painting of 1928, and the third
for a newel post for the staircase at 'Le Bosquet'.
Over twenty studies of nudes lying full-length in a
bath are found in Bonnard's diaries between 1927
and 1936. At least half of these are in the diary for
1928.

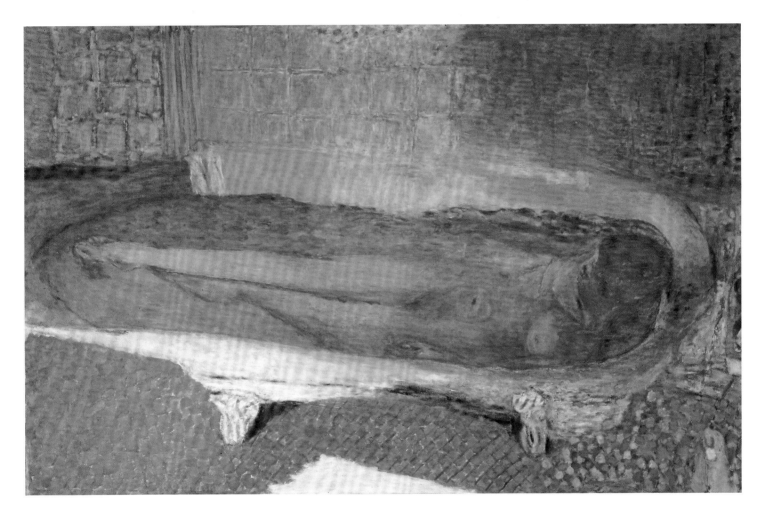

76 **The Garden** 1936

Le Jardin
Oil on canvas 127 × 100 (50 × 39⅜)
Musée d'Art Moderne de la Ville de Paris
Dauberville 1556

Like no.75, this painting was acquired for the new
Musée Moderne de la Ville de Paris on the Quai de
Tokyo (as it was then known). It must be the work
referred to as *Paysage de Provence* in Escholier's
letter of August 1936 cited under no.75, and can
therefore be ascribed to 1936.

The garden at 'Le Bosquet', which Bonnard
allowed to grow wild, was described by James Thrall
Soby as 'dense and thick; patterns of trees, shrubs,
flowers, bushes intermingled, pierced with window-
like openings through which the eye escaped into a
panorama of sky, mountains, sea and distant Cannes'
('Bonnard', in Alexander Liberman, *The Artist in his
Studio*, New York 1960, p.18). It was planted with
jasmine, wisteria, honeysuckle and mimosa, fig, pear
and citrus trees, as well as the almond tree seen in
no.97. Writing about this painting, Belinda Thomson
observes, 'Bonnard's viewpoint incorporates the wall
and projecting roof to the upper right; he seems to
have been standing outside the kitchen, looking
down towards the garden gate' (Hayward Gallery
1994, p.72).

fig.115 *Self-Portrait* 1938,
pencil on paper 12.5 × 16
(4⅞ × 6¼) *Private Collection*

77 **Self-Portrait in a Mirror** 1938

Autoportrait dans la glace
Oil on canvas 56 × 68.5 (22 × 27)
Private Collection
Dauberville 1565

The mirror is the one that hung above the wash-basin in Bonnard's bedroom at 'Le Bosquet'. Sargy Mann has pointed out that the picture on the wall is a Piranesi print (Hayward Gallery 1994, p.76).

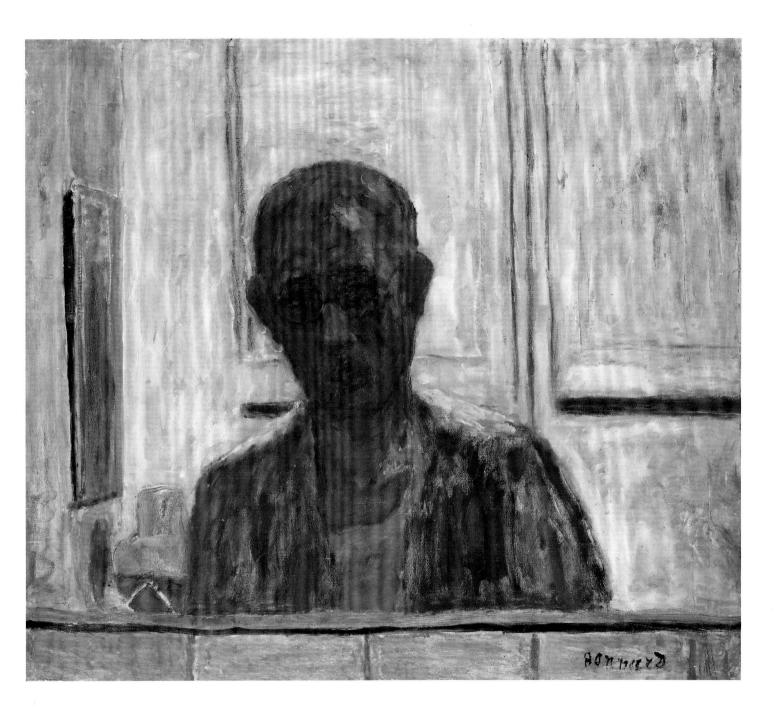

78 **Self-Portrait** c.1938–40

Autoportrait
Oil on canvas 76.2 × 61 (30 × 24)
*The Art Gallery of New South Wales. Purchased
1972*
Dauberville 1599

On 19 October 1938 Bonnard noted in his diary:
'portrait – do one of a man who looks like Mr
so-and-so' ('portrait – faire un homme qui ressemble
à Mr un tel'). Whether or not he was thinking of a
self-portrait when he wrote that, it is in keeping with
his practice when painting himself of avoiding any
reference to his profession as a painter. This work
remained with Bonnard, and was included in his
estate.

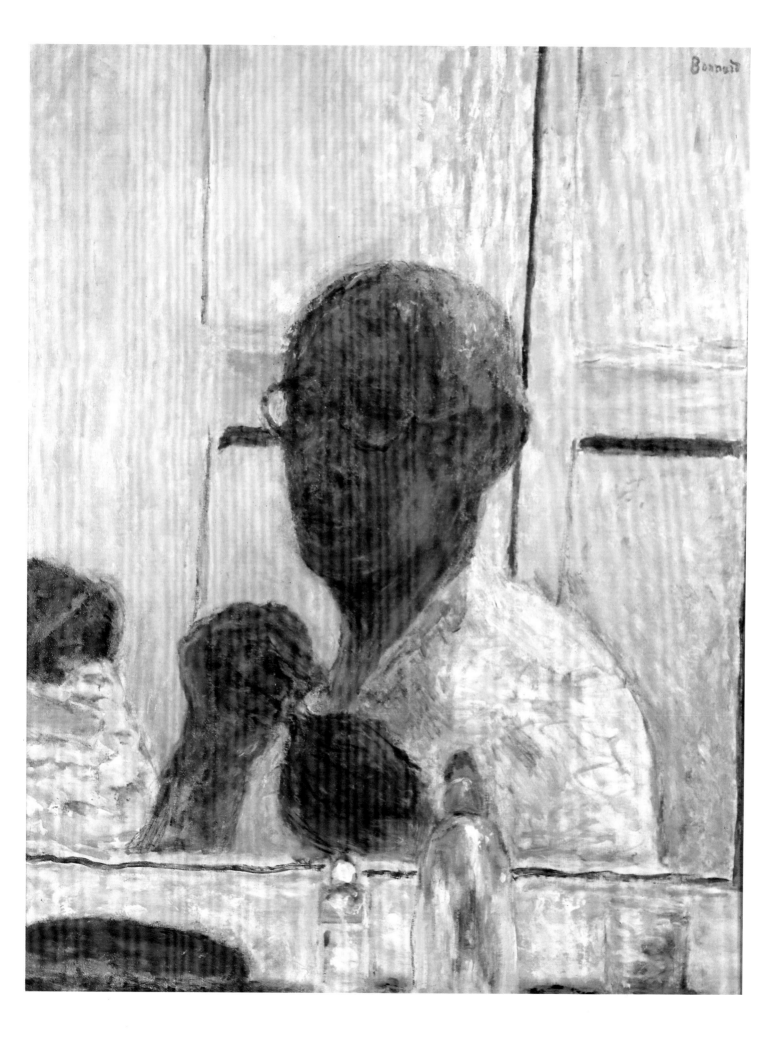

fig.116 Pages in Bonnard's diary,
31 July – 3 August 1936
Bibliothèque Nationale, Paris

79 Nude with Chair c.1935–8

Nu à la chaise
Oil on canvas 127 × 97 (50 × 38¼)
Fernando Botero
Dauberville 1338

Thirteen studies for this composition are found in Bonnard's diaries between 1935 and 1938. Six appear in the 1935 diary (12 June; 13, 22, 27 July; 2, 13 August); six in the 1936 diary (31 July to 3 August; 3, 6, 7, 8 September); one in 1937 (17 June), and one in 1938 (4 February). A cryptic note made on 3 July 1935 is relevant, not only to this painting but to all Bonnard's nudes: 'the model under our eyes and the model in our imagination' ('le modèle qu'on a sous les yeux et le modèle qu'on a dans la tête'). Sargy Mann has pointed out (in conversation) that at least some of these drawings were probably made while Bonnard was working on the painting.

The setting could possibly be the bathroom of the Villa Castellamare, the house in Arcachon Bonnard rented in the winter of 1930–1 (see no.63). The tiles are very similar to those seen in *Nude and Bath* of 1931 (Musée National d'Art Moderne, Centre Georges Pompidou, Paris), a work that, according to Antoine Terrasse (in conversation), was painted at Arcachon.

The painting remained with Bonnard, and was included in his estate.

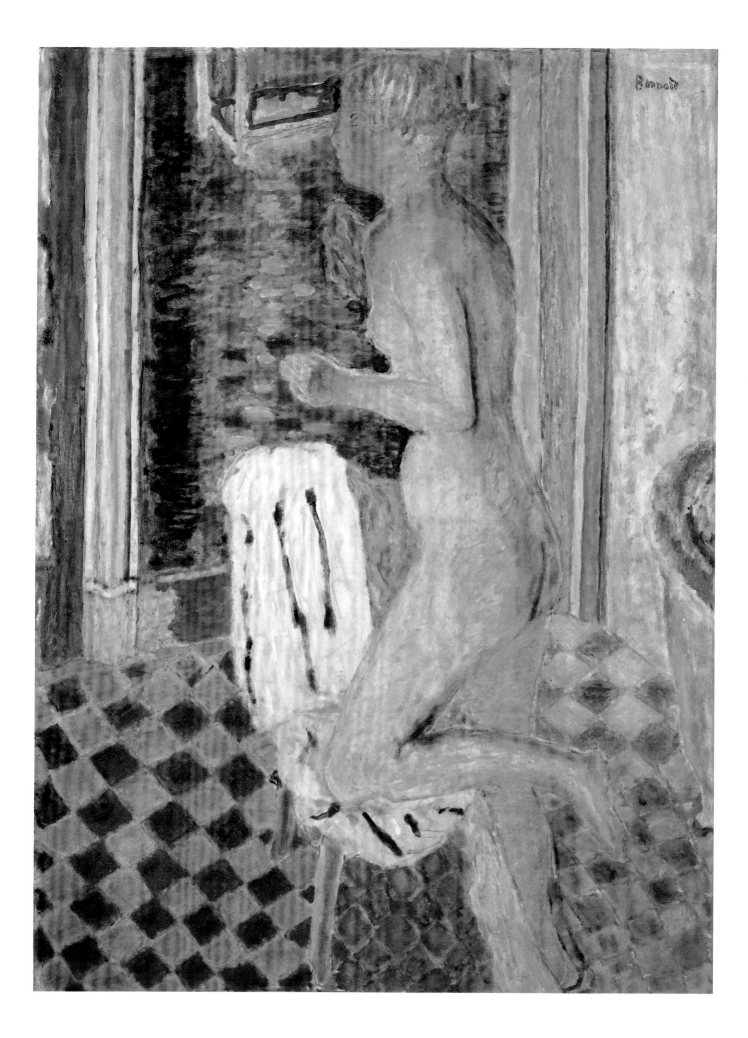

fig.117 Page in Bonnard's diary,
June 1937 *Bibliothèque Nationale, Paris*

fig.118 Pages in Bonnard's diary,
February 1938 *Bibliothèque Nationale, Paris*

fig.119 Pages in Bonnard's diary,
February 1938 *Bibliothèque Nationale, Paris*

80 **The Large Bath, Nude** 1937–9

La Grande baignoire, nu
Oil on canvas 94 × 144 (37 × 56¾)
Private Collection
Dauberville 1566

Bonnard worked on this version over a number of
years, perhaps starting it shortly after he had
completed no.75. A first state is reproduced in the
photograph taken in Bonnard's hotel bedroom in
Deauville by Rogi André for the article written by
Ingrid Rydbeck, *Hos Bonnard I Deauville*, published
in *Konstrevy*, Stockholm, 1937 (see Chronology,
fig.154).

 In May 1939, when the painting was still unfin-
ished, Bonnard asked Raymond Escholier, Director
of the Petit Palais, to allow him to borrow back the
bath painting of 1936, no.75. Escholier replied, 'I
have been told of your wish to take back your
Baigneuse – which I might add I find magnificent –
but your wish is my command, and I see no reason
why I should not let you have back this splendid
painting' ('On me transmets votre désir de reprendre
votre Baigneuse que je trouve d'ailleurs magnifique,
mais vos désirs sont des ordres et je ne vois aucun
inconvénient à vous confier cette toile splendide').
Bonnard probably had the two works together in the
studio until October, the date Escholier set for the
return of no.75.

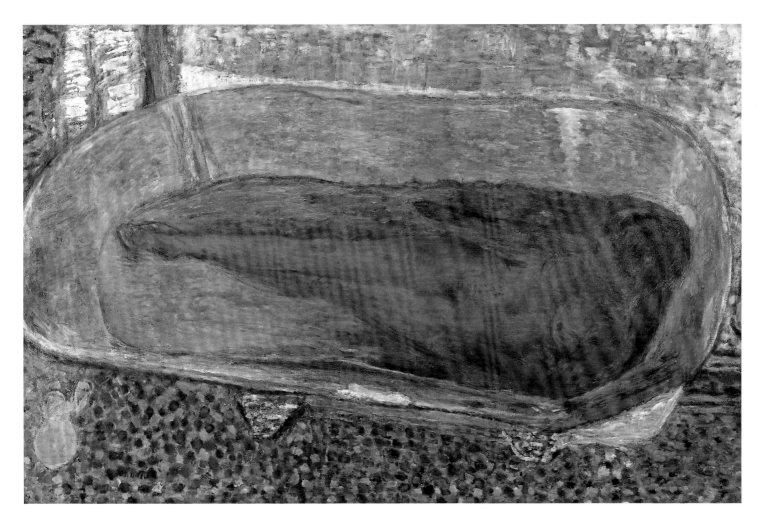

fig.120 *Nude Crouching in the Bath* 1938,
pencil on paper 11.4 × 15.2 (4½ × 6)
Private Collection

fig.121 Page in Bonnard's diary,
October 1938 *Bibliothèque Nationale,
Paris*

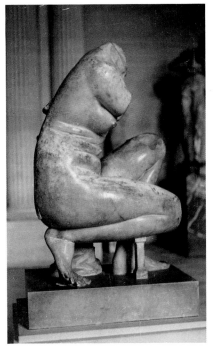

fig.122 *Crouching Aphrodite*,
H.98 (38⅝) *Musée du Louvre*

81 **Nude Crouching in the Bath** 1940

Nu accroupi dans la baignoire
Oil on canvas 67 × 85 (26⅜ × 33½)
Private Collection
Dauberville 1602

Bonnard made a sketch of a very similar nude in his
diary for 1938 (22 October). No.107 can be identified
as a preliminary study. The pose is based on that of
the *Crouching Aphrodite* in the Louvre.

This painting was included in Bonnard's estate.

fig.123 Study for a landscape
at Le Cannet, pencil on paper
Private Collection

fig.124 *View from Bonnard's house
at Le Cannet* c.1941, pencil on
paper 12.4 × 16.5 (4⅞ × 6½)
Private Collection

82 **Red Roofs at Le Cannet** 1941

Toits rouges au Cannet
Oil on canvas 57 × 93.5 (22½ × 36¾)
Private Collection
Dauberville 1605

This view from 'Le Bosquet', Bonnard's house at Le
Cannet, was included in his estate.

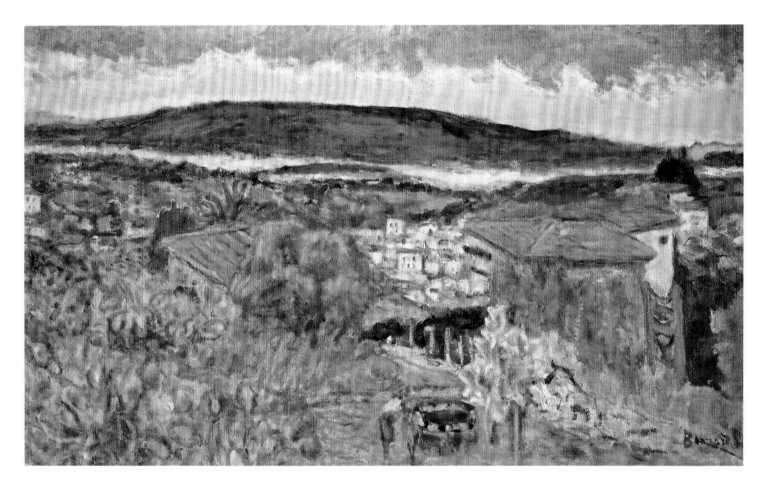

fig.125 *Landscape, Le Cannet*
*c.*1941, pencil on paper
12.7 × 20.3 (5 × 8)
Neffe-Degandt, London

83 **Panoramic View of Le Cannet**
1941

Vue panoramique du Cannet
Oil on canvas 80 × 104 (31½ × 41)
Private Collection
Dauberville 1606

As this was included in Bonnard's estate, the date of completion is uncertain.

84 **Still Life with Melon** 1941

Nature morte au melon
Oil on canvas 51 × 62 (20⅛ × 24½)
Private Collection
Dauberville 1629

In André Lhote's *Bonnard: Seize Peintures 1939–43*, the date for this painting is given as 1941, and the title as *Still life with Lemon* (*Nature morte au citron*). The error in the title almost certainly arose from Lhote's misreading of the colour photograph, since in reproduction the disparity in size between the purple fig and the melon is not so apparent. The painting was bought from Bonnard by the Paris art dealer, Pierre Colle.

fig.126 Page in Bonnard's diary,
26 February 1939
Bibliothèque Nationale, Paris

85 Still Life with Bottle of Red Wine

1942

Nature morte à la bouteille de vin rouge
Oil on canvas 65 × 54 (25⅝ × 21¼)
Mrs Wendell Cherry
Dauberville 1621

A study for a similar composition in Bonnard's
diary, 26 February 1939, while he was staying at
'Le Bosquet', may relate to this and no.86. Another,
larger sketch for a variation on the composition is
found in Bonnard's diary for 1944, on the pages
covering 19–20 October.

fig.127 Pages in Bonnard's diary,
19–20 October 1944
Bibliothèque Nationale, Paris

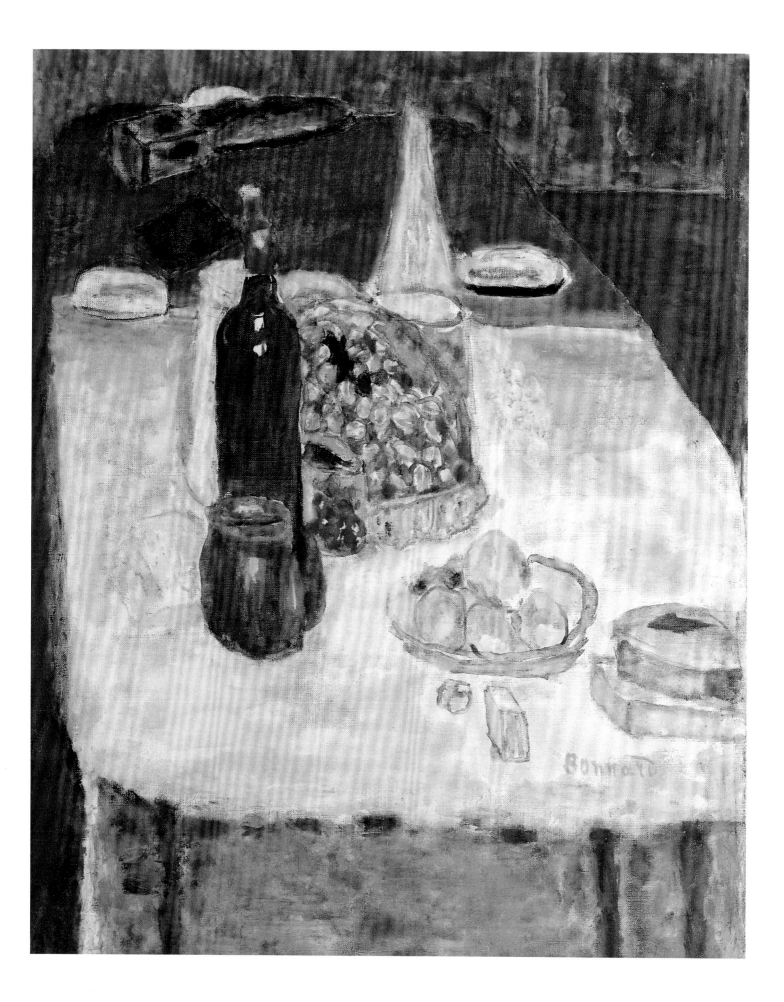

86 **Still Life with Bottle of Red Wine**
1942

Nature morte à la bouteille de vin rouge
Oil on canvas 66 × 61 (26 × 24)
Private Collection
Dauberville 1620

Bonnard occasionally made several versions of the same subject. It was a practice that can be seen as early as 1898–1900 when he made two very similar versions of *Indolence*, of which no. 15 is one . This version of *Still Life with Bottle of Red Wine* is dated 1942. It remained with Bonnard, and in April 1946 he lent it to the exhibition, *Les Grands peintres contemporains*, in Nice.

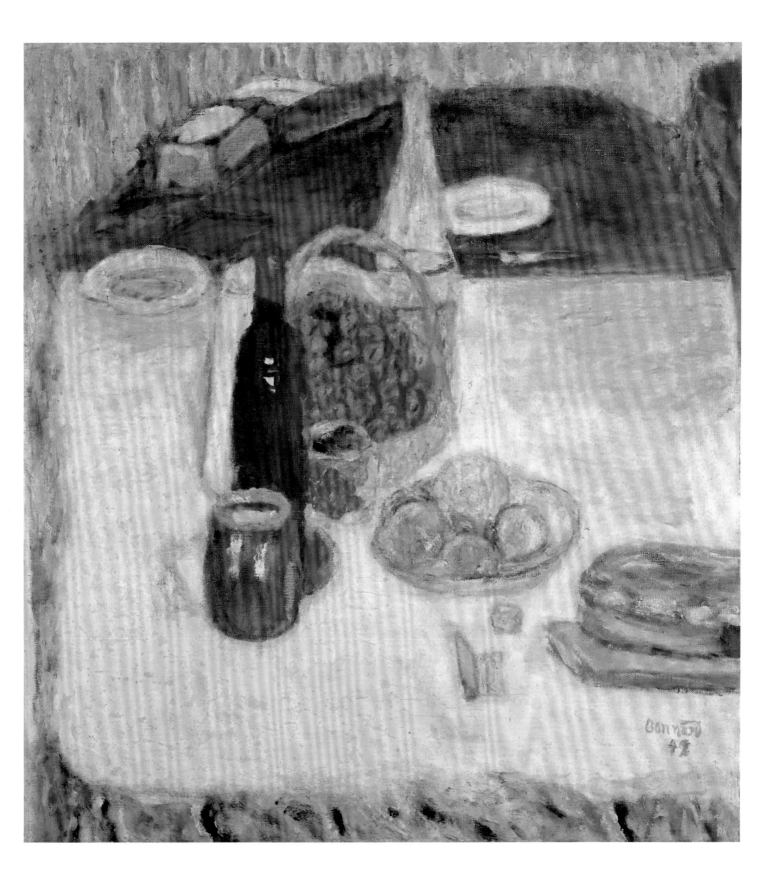

87 **The Bath Mitten** 1942

Le Gant de crin
Oil on canvas 130 × 59 (51⅛ × 23¼)
Private Collection
Dauberville 1623

As this was included in Bonnard's estate, the date of completion is uncertain. Once again, the interior is the bathroom at 'Le Bosquet'.

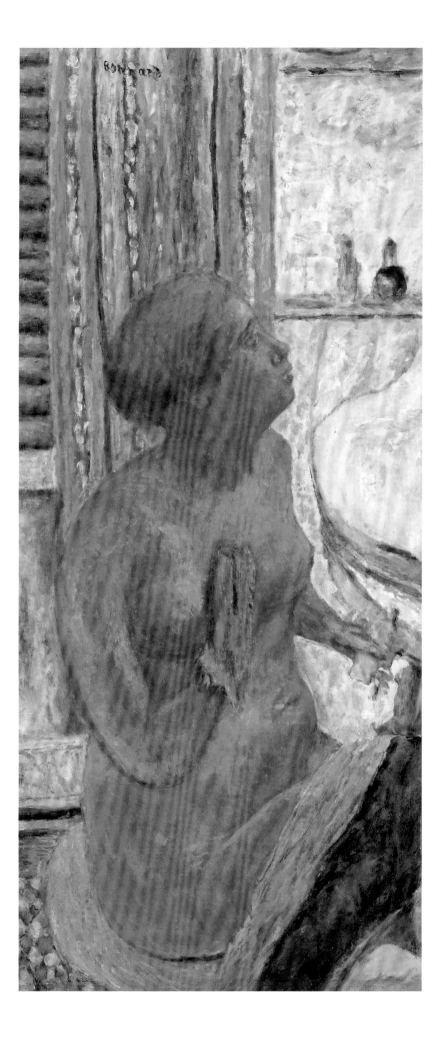

88 **Portrait of the Painter in a Red Dressing Gown** 1943

Portrait du peintre à la robe de chambre rouge
Oil on canvas 65 × 47 (25⅝ × 18½)
Private Collection
Dauberville 1662

As this was included in Bonnard's estate, the date of completion is uncertain.

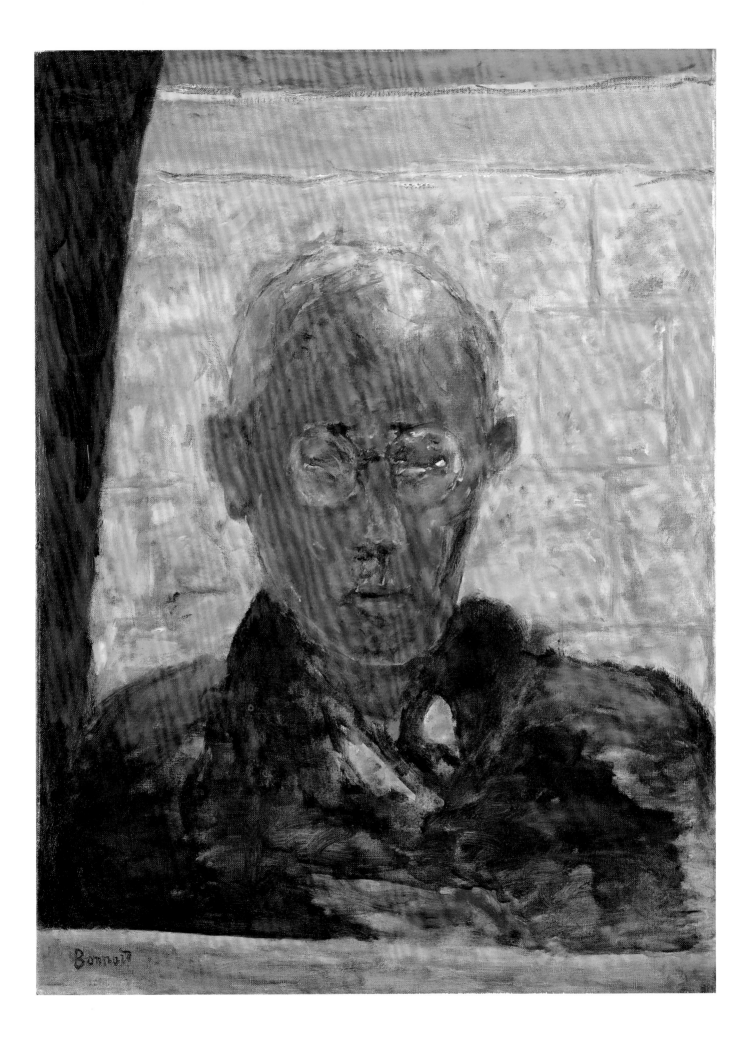

89 Peaches and Grapes on a Red Tablecloth 1943

Pêches et raisins sur une nappe rouge
Oil on canvas 65 × 47 (25⅝ × 18½)
Private Collection
Dauberville 1631

As this was included in Bonnard's estate, the date of completion is uncertain.

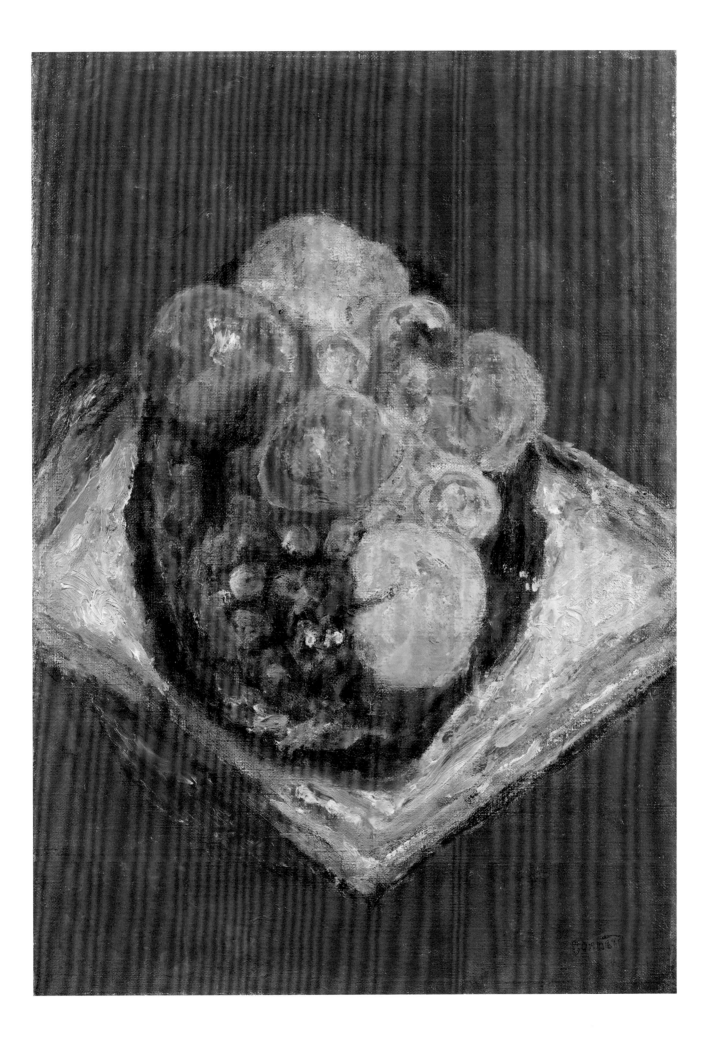

90 **Basket of Fruit on a Table in
the Garden at Le Cannet** *c.*1944

Corbeille de fruits sur une table dans le
jardin au Cannet
Oil on canvas 67.5 × 54.5 (26⅝ × 21½)
Private Collection
Dauberville 1644

As this was included in Bonnard's estate, the date of
completion is uncertain.

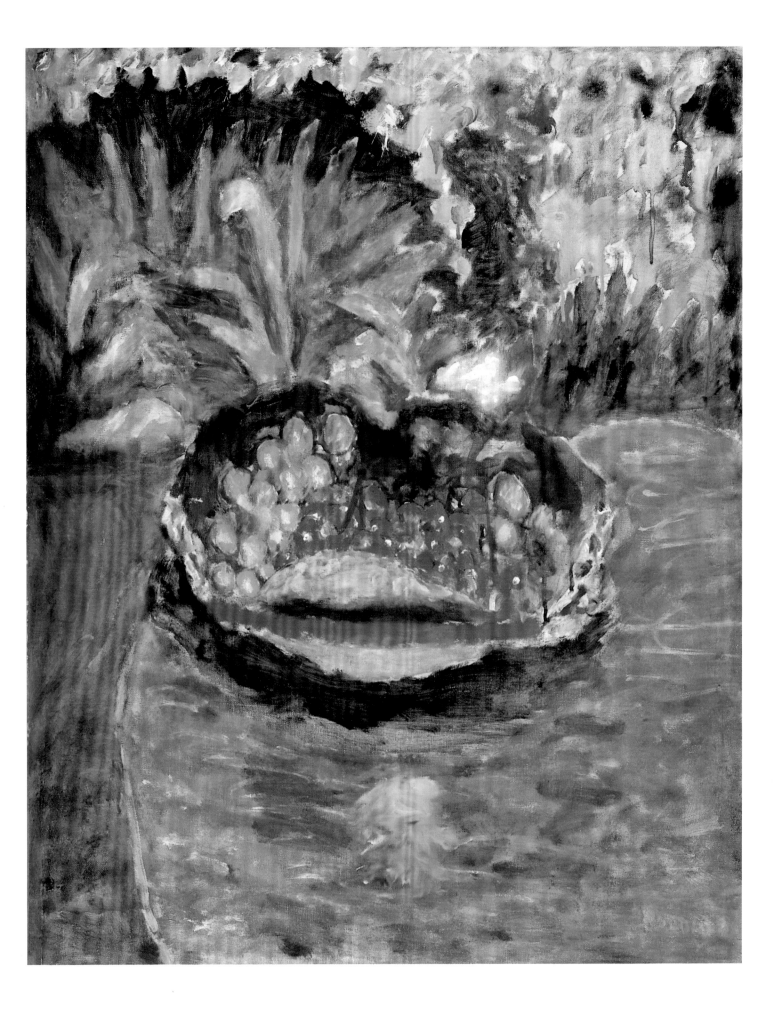

fig.128 Page in Bonnard's diary,
27 July 1939 *Bibliothèque Nationale, Paris*

91 **Basket of Fruit Reflected in a
Mirror** 1944–6

Corbeille de fruits se reflétant dans une
glace de buffet
Oil on canvas 47.3 × 71.4 (18⅝ × 28⅛)
*The Museum of Modern Art, New York. Gift of
David and Peggy Rockefeller, 1994*
Dauberville 1681

A related sketch for this composition is found in
Bonnard's diary, 27 July 1939. The painting is one of
four canvases pinned to the studio wall seen in one of
the photographs taken by Brassaï in August 1946
(Terrasse 1967, p.186). It was included in the artist's
estate.

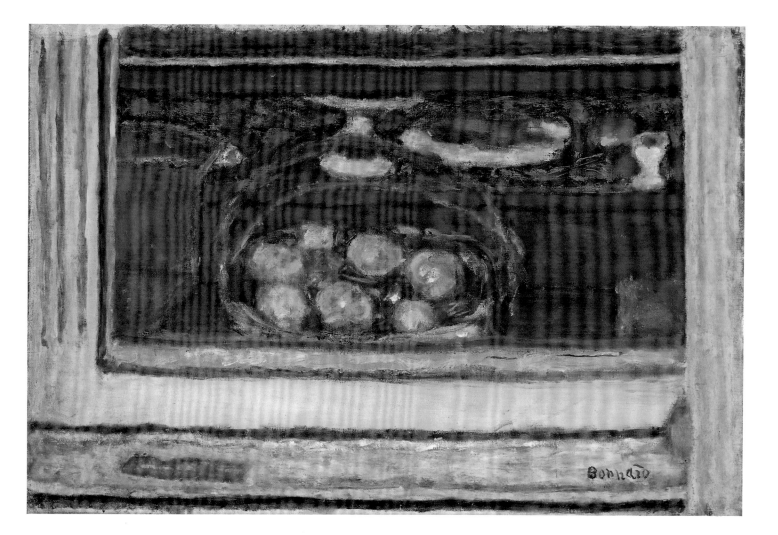

92 Large Landscape, South of France (Le Cannet) 1945

Grand paysage du Midi (Le Cannet)
Oil on canvas 95.3 × 125.7 (37½ × 49½)
Milwaukee Art Museum, Gift of Mr and Mrs
Harry Lynde Bradley
Dauberville 1652

This was reproduced in *Cahiers d'Art*, 1945–6, p.80. Sargy Mann has suggested (in conversation) that the view is of the hill behind 'Le Bosquet', with the small irrigation canal 'La Bocca' to the left, and the path along which Bonnard took his daily walk in the centre.

93 **Landscape with Red Roof** 1945–6

Paysage au toit rouge
Oil on canvas 64 × 57 (25¼ × 22½)
Private Collection
Dauberville 1667

Sargy Mann has identified this view as looking along the south-east face of 'Le Bosquet' from the balcony outside the French windows in the bathroom: 'Bonnard is looking over the projecting lavatory roof – the orange at the bottom of the painting – past his bedroom window to the figure leaning out of the spare room window' (Hayward Gallery 1994, p.106). The painting appears in several of the photographs taken by Brassaï in August 1946 in the studio at Le Cannet. One of these shows Bonnard working on the canvas, which is pinned to the wall next to no.91. It was included in the artist's estate.

fig.129 *Nude in the Bath* 1940,
?oil on canvas 22 × 27 (8⅝ × 10⅝)
Private Collection

fig.130 Pages in Bonnard's diary,
15–18 February 1940
Bibliothèque Nationale, Paris

fig.131 Page in Bonnard's diary,
27 April 1940 *Bibliothèque Nationale, Paris*

94 Nude in the Bath and Small Dog

1941–6

Nu dans le bain au petit chien
Oil on canvas 121.9 × 151.1 (48 × 59½)
*Carnegie Museum of Art, Pittsburgh. Acquired
through the generosity of the Sarah Mellon Scaife
Family, 1970*
Dauberville 1687

Although this painting is usually dated 1941–6,
Bonnard may have started work on it the previous
year as a particularly fine study for the composition
is spread across two pages in his diary for 1940
(15–18 February). Furthermore, a small painting (or
a gouache), fig.129, which is reproduced as a work of
1940 in André Lhote's *Bonnard: Seize Peintures
1939–43*, published in January 1944, may well be a
preliminary study. Among the many studies for
nudes lying, sitting or crouching in a bath which
appear in the diary of 1940, one of an empty bath
(April 16) and a bath with a recumbent nude, a mat
and a dark patch indicating the presence of a dog
(27 April, fig.131) seem particularly relevant. Studies
of the bath in which only the legs are visible are
found in the 1941 diary (27 April, 3 May). Sargy
Mann has pointed out that an earlier state of the oil
is reproduced in F.J. Beer's *Pierre Bonnard*, Mar-
seilles 1947, p.132 (Hayward Gallery 1994, p.104). It
is also seen in a photograph taken at Le Cannet in
1945 or 1946 by André Ostier, which shows Bonnard
using one length of canvas for this and one other
painting (Dauberville 1665).

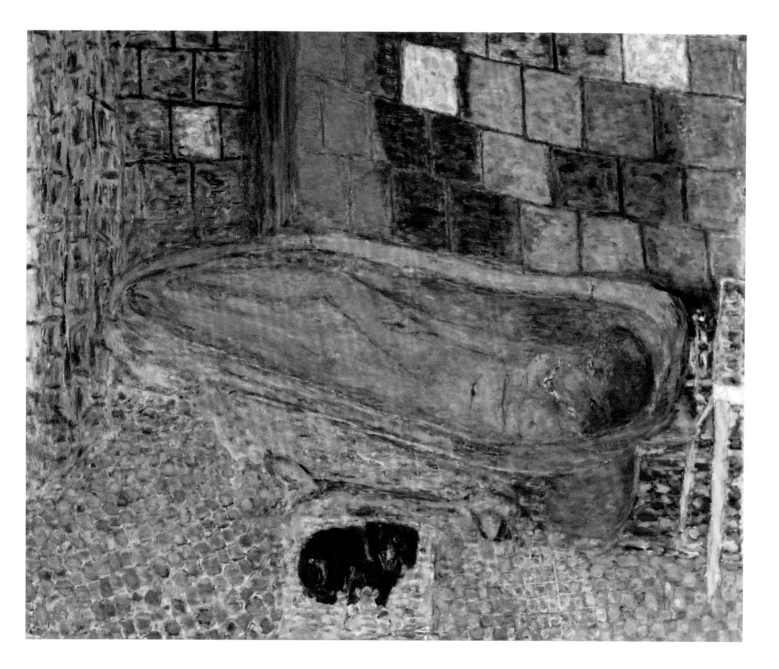

95 **Self-Portrait** 1945

Portrait du peintre par lui-même
Oil on canvas 54 × 44 (21¼ × 17⅜)
Fondation Bemberg
Dauberville 1663

This was exhibited twice in Bonnard's lifetime: in
1945 in an exhibition in Nice entitled *Portrait de
Bonnard*, and in December 1946 at the Galerie
Maeght in Paris. It was acquired by Sam Salz, New
York, and sold by him to Donald Stralem on 3 May
1949.

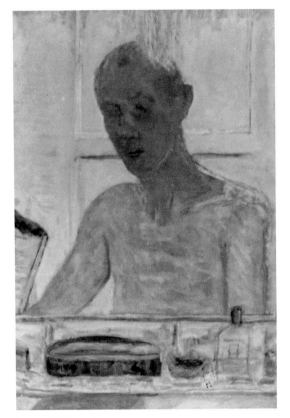

fig.132 *Self-Portrait in the
Bathroom Mirror* 1943 (first state)

96 **Self-Portrait in the Bathroom Mirror** 1943–6

Autoportrait dans la glace du cabinet de toilette
Oil on canvas 73 × 51 (28¾ × 20⅛)
*Musée National d'Art Moderne, Centre de
Création Industrielle, Centre Georges Pompidou,
Paris. Dation (Ancienne Collection Florence
Gould) 1984*
Dauberville 1664

This was one of the sixteen paintings included in
André Lhote *Bonnard: Seize Peintures 1939–43*
published in January 1944. A number of the works
reproduced are unsigned, and some of those were
subsequently reworked, including this self-portrait.
The date of the first state is given as 1943.

There has been some speculation concerning the
relationship between this image and the harrowing
photographs taken of concentration camp inmates
following the liberation of Majdanek (January 1944),
Auschwitz (July 1944) and Bergen-Belsen (April
1945). However, as the reproduction in Lhote's book
demonstrates, the portrait had taken shape months
before Russian troops entered Majdanek, the first
camp to be liberated.

The painting remained with the artist, and was
included in his estate.

97 **Almond Tree in Blossom** 1946–7

L'Amandier en fleur
Oil on canvas 55 × 37.5 (21⅝ × 14¾)
Musée National d'Art Moderne, Centre de
Création Industrielle, Centre Georges Pompidou,
Paris. Dépôt du Département des Peintures du
Louvre249
Dauberville 1692

The almond tree grew on the plot of land Bonnard
had acquired in May 1927 in order to enlarge the
garden of 'Le Bosquet', and was visible from his bed-
room window. The painting was in progress by 1946,
and may have been begun, as Belinda Thomson
suggests, in 1945 (Hayward Gallery 1994, p.118). In
January 1947, Bonnard, weak and close to death,
instructed his nephew Charles Terrasse to change
the colour of the patch of grass in the left foreground
from green to yellow.

98 Still Life with Fruit and Bottles

*c.*1925

Nature morte aux fruits et aux bouteilles
Watercolour and gouache on paper
50 × 65.5 (19¾ × 25¾)
Private Collection

A pencil drawing for this still life is published in a catalogue of Bonnard drawings, Galerie Claude Bernard, Paris 1972, p.111. The dimensions are recorded there as 13.5 × 10.5 cm.

99 Fruit, Harmony in the Light *c.*1930

Fruits, harmonie claire
Gouache and watercolour on paper
34 × 32 (13⅜ × 12⅝)
*Musée du Louvre, Département des Arts
Graphiques, Fonds Orsay*

LONDON ONLY

This and no.100 belonged to Bonnard's friend and biographer, the critic Claude Roger-Marx. They were clearly conceived as a pair.

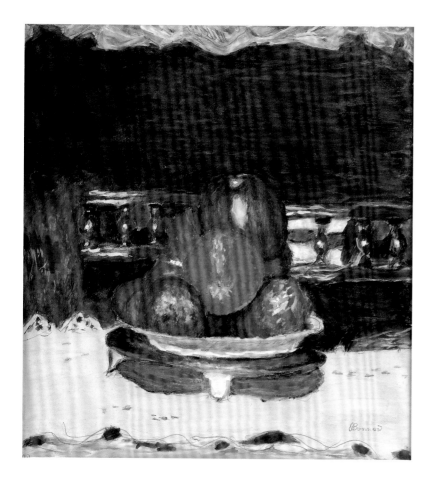

100 **Fruit, Harmony in the Dark** c.1930

Fruits, harmonie foncée
Watercolour and gouache on paper
35 × 32 (13¾ × 12⅝)
*Musée du Louvre, Département des Arts
Graphiques, Fonds Orsay*

LONDON ONLY

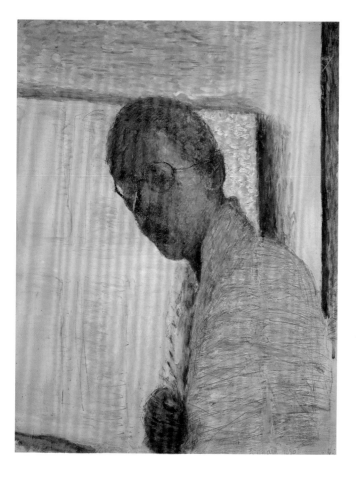

101 **Self-Portrait** 1930

Autoportrait
Watercolour, gouache and pencil on paper
65 × 50 (25⅝ × 19¾)
Private Collection

Unusually, this gouache is inscribed with the date.
On 17 October 1929, Bonnard visited the Chardin
exhibition at the Théâtre Pigalle in Paris, where he
saw the well-known portrait of the artist (now in the
Louvre) standing at his easel wearing a pince-nez
with large round lenses. As Antoine Terrasse has
pointed out, this self-portrait is a homage to an artist
whom Bonnard especially admired (Paris 1984,
p.188).

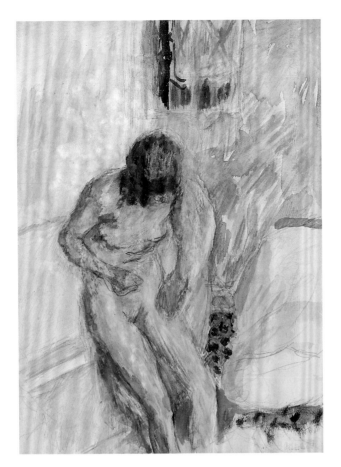

102 **Nude and Bath** 1931

Nu à la baignoire
Gouache on paper 32.5 × 25 (12¾ × 9⅞)
Private Collection

LONDON ONLY

This and no.103 are studies for *Nude and Bath*, 1931
(fig.5, p.14) (Musée National d'Art Moderne, Centre
Georges Pompidou, Paris).

fig.133 Study for *Nude
and Bath c.*1931, pencil on
paper 15.2 × 9.5 (6 × 3¾)
Private Collection

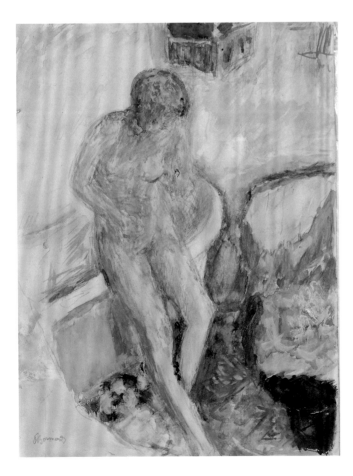

103 **Nude and Bath** 1931

Nu à la baignoire
Gouache and crayon on paper
32.5 × 25 (12¾ × 9⅞)
*Private Collection, courtesy Galerie Schmit,
Paris*

LONDON ONLY

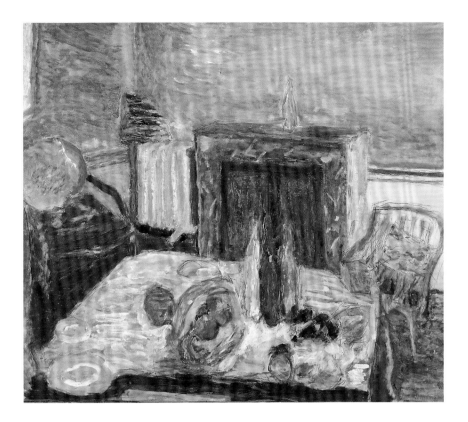

104 **The Dining Room at Le Cannet**
1935

La Salle à manger au Cannet
Gouache on paper 56 × 59 (22 × 23¼)
Private Collection

LONDON ONLY

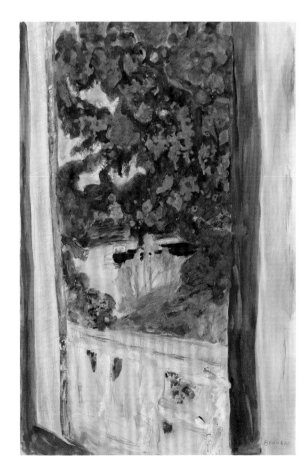

105 **Tug on the Seine at Vernon** c.1935

Remorqueur sur la Seine à Vernon
Watercolour, gouache and pencil on paper
49.9 × 32.7 (19⅝ × 12⅞)
Private Collection, courtesy James Roundell Ltd

LONDON ONLY

106 **Clouds over the Sea** c.1935

Nuages sur la mer
Gouache on paper 29.5 × 38.5 ($11\frac{5}{8}$ × $15\frac{1}{8}$)
Private Collection

LONDON ONLY

107 **Crouching Nude** 1938–40

Nu accroupi
Gouache on paper 19 × 24.5 ($7\frac{1}{2}$ × $9\frac{5}{8}$)
Private Collection

This is a study for no.81.

108 The Dining Room: Le Bosquet

c.1940

La Salle à manger: Le Bosquet
Watercolour, gouache and pencil on paper
46.5 × 48.7 (18¼ × 19⅜)
Trustees of the British Museum

LONDON ONLY

A similar composition in gouache and watercolour,
Still Life: Preparation for Lunch, c.1940, belongs
to The Art Institute of Chicago. Both are almost
certainly studies for *The Dining Room*, 1942–6
(Private Collection).

109 The Sea c.1944

La Mer
Watercolour and gouache on paper laid on
canvas 27.5 × 25.5 (10⅞ × 10)
*Private Collection, courtesy Galerie Jan Krugier,
Ditesheim & Cie, Geneva*

LONDON ONLY

110 **The Bath** 1942

La Baignoire
Gouache and pastel on paper
50 × 65 (19¾ × 25⅝)
Mr J. Dellal
Dauberville 1623

LONDON ONLY

The Bath is one of the eleven gouaches commissioned in 1942 by Louis Carré for a set of lithographs put onto stone by Jacques Villon between 1942 and 1946. As Sargy Mann has pointed out, 'this is an exceptional work in Bonnard's *oeuvre*; a gouache completely reworked in pastel' (Hayward Gallery 1994, p.93).

fig.134 Study for *The Bath* 1942, pencil on paper
11 × 12.5 (4¼ × 4⅞)
Private Collection

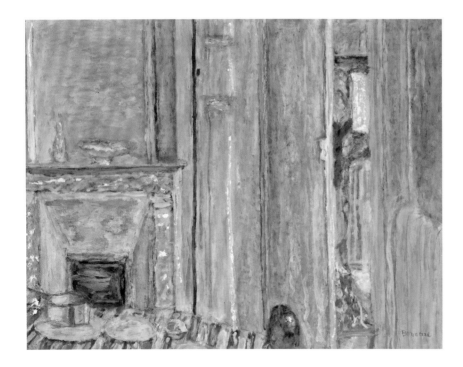

111 **The Mantlepiece** c.1942

La Cheminée
Gouache on paper 48 × 63.5 (18⅞ × 25)
Private Collection

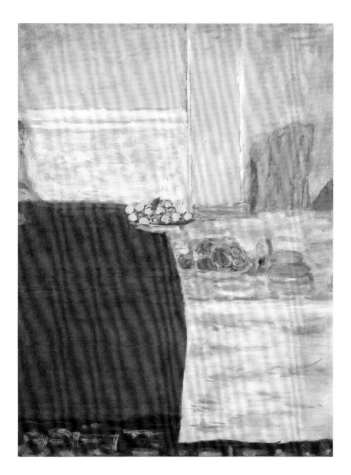

112 Fruit on Red Cloth 1943

Fruits sur le tapis rouge
Watercolour and gouache on paper laid
on canvas 64.8 × 50.2 (25½ × 19¾)
Private Collection

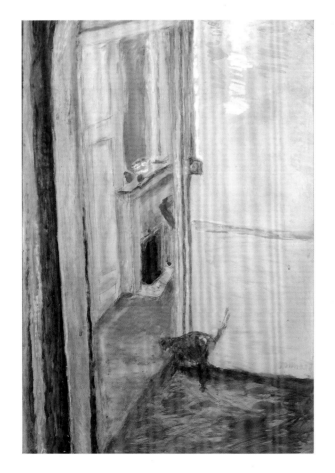

113 Open Door at Le Cannet c.1943

La Porte ouverte, maison du Cannet
Watercolour on paper
75.3 × 52.7 (29⅝ × 20¾)
Private Collection, Paris

LONDON ONLY

Chronology

1867

3 October: Pierre Eugène Frédéric Bonnard born at Fontenay-aux-Roses, a Paris suburb, the second child of François Eugène Bonnard and Elizabeth Lélia Mertzdorff. Their first child, Charles, was born in 1864. Eugène Bonnard, a civil servant employed in the Ministry of War, came from the Dauphiné, and his family spent their holidays there, at the grandfather's house in the hamlet of Le Grand-Lemps. Bonnard had a studio there and continued to visit regularly until *c.*1925. The property was sold in 1928.

1872

Birth of Bonnard's sister Andrée.

1875–

Educated at the Lycée at Vanves, and then at the Paris Lycées Louis-le-Grand and Charlemagne. He passes his baccalaureate in 1885.

1885

7 November: in a letter to his father, Bonnard tells him that after a brief period at the Ecole des Arts Décoratifs in Paris, where he did little else except copy from the Antique, he has decided to give up the idea of earning a living from painting and to enrol in the 'Ecole de Droit'. He also tells his father that he intends to devote his free time to the serious study of painting (see no.2).

1886

5 June: a letter to his mother shows that he is living with his grandmother, 8 rue de Parme, near the rue de Clichy. He tells her he is planning to paint outdoors at Chatou and Bougival.

1887

Enrols at the Académie Julian in Paris where he meets Paul Sérusier, Henri-Gabriel Ibels, Paul Ranson and Maurice Denis.
14 February: applies for admission to the painting school ('section peinture') of the Ecole des Beaux-Arts and is admitted on 11 March.

1888

Gains his 'licence en droit'.
February: a letter to his mother shows that he is working part-time in a 'bureau d'enregistrement' (record office), without much hope of advancement. Refers to his 'chères études', presumably his classes at the Ecole des Beaux-Arts.
May: opening of *Exposition historique de l'art de la gravure au Japon* organised by Samuel Bing, 22 rue de Provence.

fig.135 Mme Frédéric Mertzdorff, Bonnard's maternal grandmother, *c.*1888, ink and pencil on paper 25.5 × 23 (10 × 9) *Galerie Claude Bernard*

fig.136 Mme Eugène Bonnard, the artist's mother, *c.*1889, watercolour and pencil on paper 12.8 × 8 (5 × 3¼) *Galerie Claude Bernard*

fig.137 Pierre Bonnard, *c.*1889 *Annette Vaillant Archive*

Paul Sérusier meets Gauguin at the Pension Gloanec at Pont-Aven in Brittany and under his direction paints a small landscape constructed of flat areas of pure colour. He shows it to his friends at the Académie Julian and together they form a group calling themselves 'Nabis' (the Hebrew word for prophets). Sérusier's painting becomes known as *The Talisman*.
Paints landscapes in the countryside around Le Grand-Lemps.

1889

June: exhibition of the 'Impressionist and Synthetist Group' organised by Gauguin at the Café Volpini in the Champ-de-Mars, the site of the Exposition Universelle.
The bi-monthly magazine *La Revue blanche* is founded in Liège by Auguste Jeune-Homme and Paul Leclerc.
Rents a studio in rue Le Chapelais, off the Avenue de Clichy.
Competes unsuccessfully for the Prix de Rome (the theme was *Le Triomphe de Mardochée*).
Around this time he meets Ker-Xavier Roussel and Edouard Vuillard.
2 December: Bonnard writes to his mother that he is still waiting to be appointed to a post in the civil service. It must have been after this date that he fails his exam.
Wins first prize in a poster competition.

1890

8 April–24 May: called up for military service, Bonnard serves in the 52ème Régiment d'infanterie de Bourgoin as 'soldat de deuxième classe'.

April–May: *Exposition de la Gravure japonaise* at the Ecole des Beaux-Arts includes 725 *ukiyo-e* woodcuts and 421 illustrated books.

April: *La Revue blanche* moves to Paris where it is edited by Alexandre and Thadée Natanson. Rents a studio at 28, rue Pigalle which he shares with Edouard Vuillard, Maurice Denis and the actor Aurélien Lugné-Poe. Meets André Antoine, founder of the Théâtre Libre, and Paul Fort, founder of the short-lived Théâtre d'Art.

August: *Art et critique* publishes an article by Maurice Denis in which he makes his celebrated statement: 'We should remember that a picture, before it is a battle horse or a naked woman or some sort of narrative, is basically a flat surface covered with paints put together in a certain order.'

25 September: Andrée Bonnard marries the composer Claude Terrasse at Le Grand-Lemps.

1891

March–April: participates for the first time in the Salon des Indépendants where he shows five paintings and four decorative panels, *Women in the Garden*.

At the end of March his prize-winning poster of 1889, *France-Champagne,* is distributed, and attracts the attention of Toulouse-Lautrec whom Bonnard introduces to his printer Edward Ancourt.

With Ibels designs the décor for *Geste du roy Fierabras* at the Théâtre Moderne.

August: exhibits one painting at an exhibition at the château at Saint-Germain-en-Laye.

December: participates in *Peintres impressionistes et symbolistes*, the first of fifteen exhibitions of that title organised over the next five years by Louis-Léon Le Barc de Boutteville at his gallery, 47 rue Le Peletier. It is the first group showing of the Nabis. Albert Aurier, writing in the *Mercure de France,* calls them 'les vrais maîtres de demain' ('the true artists of tomorrow').

28 December: Bonnard is one of the painters quoted in a series of articles by Jacques Daurelle entitled 'Chez les jeunes peintres' published in *Echo de Paris*.

Begins work on the illustrations for Claude Terrasse's *Petit solfège illustré.*

1892

Early in the year competes unsuccessfully for an interior design project.

March–April: shows seven paintings at the Salon des Indépendants, including *The Croquet Game* (listed as *Crépuscule*).

Bonnard attracts the notice of several critics, one of whom describes him as 'le plus japonais de tous les peintres français' ('The most Japanese of all French painters').

April: G. Albert-Aurier's article 'Les symbolistes' is published in *La Revue encyclopédique:* among the illustrations is a drawing by Bonnard.

fig.138 Marthe (Maria Boursin), photographed by Bonnard in their Paris apartment, 1899–1900
Musée d'Orsay, Paris

May: invited to exhibit in Antwerp by 'L'Association pour l'Art'.

August–September: stays at Le Grand-Lemps.

September: writes to Vuillard: 'Painting, especially in oils, has kept me very busy, it's going slowly, very hesitantly, but I believe I am on the right track' ('La peinture à l'huile entre autres m'a beaucoup occupé, cela va doucement, bien timidement mais je crois être sur la bonne voie').

November: Albert Besnard and Henri Lerolle, both well-known painters of the day, each buy a decorative panel by Bonnard from the *3ème exposition des peintres impressionistes et symbolistes* at Le Barc de Boutteville.

Paints a portrait of his cousin Berthe Schaedlin who, around this time, turns down his offer of marriage.

1893

March–April: shows four paintings at the Salon des Indépendants.

May: Aurélien Lugné-Poe, with Vuillard and Camille Mauclair, opens a workshop theatre, the Théâtre de l'Oeuvre, with a performance of Maurice Maeterlinck's *Pelléas et Mélisande.*

Publication of an album of music by Claude Terrasse, *Petites scènes familières,* illustrated with twenty lithographs by Bonnard.

Exhibition of Utamaro and Hiroshige at the Galerie Durand-Ruel.

April: marriage of Thadée Natanson and Misia (Marie) Godebska.

Bonnard paints several portraits of Misia, and her likeness appears in other paintings.

June: visits Eragny-sur-Oise.

Meets Maria Boursin (1869–1942) who calls herself Marthe de Méligny. She becomes his lifelong companion. Her likeness appears in around 384 paintings.

Meets Ambroise Vollard through Maurice Denis.

Moves to a new studio at 65 rue de Douai, near the Place Pigalle (a few years earlier, in 1890, he had described the area to his mother as 'a rather seedy district' ('quartier en général assez mal habité').

1894

Designs poster for *La Revue blanche.*

Meets Odilon Redon, probably around the time of Redon's exhibition at Durand-Ruel in March–April.

May: participates in the Nabis exhibition in the Paris offices of *La Dépêche de Toulouse.*

Summer: Thadée and Misia Natanson accompanied by Lugné-Poe travel to Christiania (Oslo) to meet Ibsen.

1895

Tiffany show a number of stained glass windows at the Salon including one by Bonnard, *Maternité.*

April–May: with Denis, Ibels, Vallotton and Vuillard exhibits at the Galerie Laffitte.

October: Thadée Natanson visits the Munch exhibition at the Galerie Blomquist in Christiania (Oslo), and in December writes about it for the *La Revue blanche.*

22 November: death of Bonnard's father.

November–December: Vollard commissions sets of lithographs from Bonnard, Vuillard, Denis and Roussel.

Takes part in a competition for dining room furniture organised by the Union des Arts Décoratifs.

1896

January: shows fifty-six works at the Galerie Durand-Ruel. It is his first one-man show and provokes a strong reaction from Camille Pissarro: 'One more Symbolist who is a total failure' ('Encore un symboliste qui fait fiasco'). Pissarro claims that Puvis de Chavannes, Degas, Renoir and Monet are unanimous in finding the exhibition 'hideous'. Camille Mauclair writes a critical review in the March issue of the *Mercure de France.*

February: exhibits at the Salon de la Libre Esthétique in Brussels.

June–July: participates in *Les Peintres graveurs* at Vollard's gallery for which he designs the poster. Claude Terrasse is appointed organist at the Trinité church in Paris, and the family return from Arcachon.

August–September: participates in the twenty-third group exhibition of *Le Salon des Cent* for which he designs the poster.

Paints *Le Jardin de Paris*, 119 × 192 cm, his most ambitious painting to date, which is bought by Vollard.

10 December: Alfred Jarry's play *Ubu Roi* is given its first performance in the Salle du Nouveau Théâtre, 15 rue Blanche. The production is by the Théâtre de l'Oeuvre, and Bonnard collaborates with Sérusier, Toulouse-Lautrec, Vuillard, Ranson and Jarry on the scenery and masks; the music is by Claude Terrasse.

Production of Bonnard's colour lithograph screen with four panels, *Nurses Taking a Walk, Frieze of Cabs.* The edition of 110 is published by M. Moline, Director of the Galerie Laffitte.

The Nabis show with Le Barc de Boutteville for the last time. His death deprives them of one of their most active supporters.

At some point in the year rents another studio in the Batignolles district.

1897

April–May: group show of the Nabis at Vollard's gallery.

May–June: illustrations for *Marie*, a novel by the Danish writer Peter Nansen, appear in four issues of *La Revue blanche*. They attract the attention of Renoir who sends Bonnard a letter care of Vollard saying: 'I find your drawings in the revue blanche quite exquisite. They are really you; don't lose this art' ('je trouve vos dessins de la revue blanche tout ce qu'il y a de plus exquis. C'est bien vous, gardez cet art'). The book was published the following year.

1898

January: Bonnard collaborates on making puppets for the short-lived Théâtre des Pantins founded by Alfred Jarry, Franc-Nohain and Claude Terrasse, and located in an apartment owned by Terrasse in 6 rue Ballu. On 20 January they give a performance of Jarry's *Ubu Roi*.

April: group show of the Nabis at Vollard's gallery.

Paints the first of two oil studies for *Man and Woman* (no.16), thus initiating a number of major paintings on the theme of the nude.

10 September: attends the funeral of Stéphane Mallarmé.

1899

Publication of Alfred Jarry's *Petit Almanach du père Ubu* illustrated by Bonnard.

March: *L'Ecole moderne*, an exhibition of contemporary art organised by Signac in homage to Redon opens at the Galerie Durand-Ruel; it includes ten works by Bonnard.

April: exhibition of lithographs by Bonnard, Vuillard, Denis and Redon at Vollard's gallery. Visits Venice and Milan with Vuillard and Roussel.

Publication of a suite of twelve lithographs commissioned by Vollard, *Quelques aspects de la vie de Paris*.

Autumn: rents a studio and apartment at 65 rue de Douai overlooking the garden of a neighbouring convent.

1900

June: exhibits with the Nabis at the Galerie Bernheim-Jeune.

September: Vollard publishes an edition of Paul Verlaine's erotic poems *Parallèlement* illustrated by Bonnard with 109 lithographs in pink sanguine and nine woodcuts (cut after drawings by Bonnard). Although these lithographs were largely ignored by the critics and the public, Alfred Jarry hailed them as: 'the first illustrations anyone has published that are perfectly suited to a book of verse' ('la première illustration que l'on publie qui soit tout à fait adaptée à un livre de vers'). They also attract the attention of Cézanne. Paints a large family group, *A Family Afternoon*, 139 × 212 cm, the first of his paintings to be bought by the Galerie Bernheim-Jeune. The gallery, run by the brothers Joseph ('Josse') and Gaston Bernheim-Jeune, represents Bonnard regularly from now on.

[258]

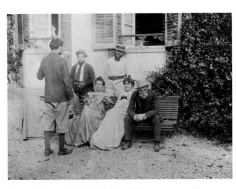

fig.139 Bonnard at Le Relais, Villeneuve-sur-Yonne, 11 September 1898, the day after the funeral of Stéphane Mallarmé. Seated in front of Bonnard: Ida (wife of Cipa Natanson), Misia (wife of Thadée Natanson) and Auguste Renoir; standing: Cipa and Thadée Natanson *Annette Vaillant Archive*

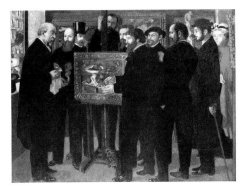

fig.140 Maurice Denis, *Homage to Cézanne* 1900, oil on canvas 180 × 240 (70⅞ × 94½) *Musée d'Orsay, Paris*

fig.141 Bonnard in his garden, photographed by Vuillard, 1900 *Musée d'Orsay, Paris*

fig.142 Bonnard and his niece Renée, photographed by Vuillard, 1900 *Musée d'Orsay, Paris*

Rents a house at Montval, near Marly-le-Roi. Portrayed by Maurice Denis in his large group portrait *Hommage to Cézanne*.

1901

January: publication by Vollard of Alfred Jarry's *Almanach illustré du père Ubu* with seventy-nine lithographic drawings by Bonnard.

Visits Spain with Vuillard and Antoine and Emmanuel Bibesco.

Shows nine paintings at the Salon des Indépendants.

1902

Visits Holland with his dealer Jos Hessel and his wife Lucie, Vuillard and Roussel.

July: stays at Colleville, near Vierville-sur-Mer, in the Calvados.

November: Vollard publishes an edition of *Daphnis et Chloé* by Longus illustrated by 156 lithographs by Bonnard.

1903

March: Exhibits six paintings at the Salon des Indépendants, of which he is now a committee member, and three at the newly founded Salon d'Automne.

April: *La Revue blanche* closes.

Exhibits at the Vienna Secession.

1904

February–March: takes part in a major Impressionist exhibition at the Salon de la Libre Esthétique in Brussels.

Spring: works at L'Etang-la-Ville, where Roussel settled in 1899.

With Vuillard visits Roussel in Saint-Tropez where he meets Signac and Valtat.

July: stays at Varengeville, on the Normandy coast.

Publication of Jules Renard's *Histoires naturelles* with sixty-seven drawings by Bonnard.

1905

June–July: with Pierre Laprade and Maurice Ravel visits Belgium and Holland on the yacht belonging to Misia and Alfred Edwards (who were married in February this year). Edwards was the owner of the newspaper *Le Matin*.

Visits Berlin in order to paint the portrait of Sophie Herrmann, wife of the painter Curt Herrmann.

December: Rents two large rooms at 60 rue de Douai (formerly the convent Bonnard could see from his old studio). By now he is painting regularly from life using professional models, a practice he follows regularly for the next few years, although he never abandons it altogether.

1906

February: visits the South of France where he stays briefly with Maillol at Banyuls.

April: one-man show at Amboise Vollard's gallery which includes a table centre piece in bronze, one of a number of bronzes Bonnard made around this time.

Spring: works at L'Etang-la-Ville.

July: visits Belgium and Holland with Misia Edwards and her husband on their yacht, *Aimée*.
August: visits Wimereux, near Boulogne-sur-Mer.
Begins work on four decorative panels for Misia Edwards: *Landscape with Bathers*, *After the Flood*, *Pleasure* and *Fountains or The Voyage (*completed by 1910).
November: Shows forty-one works in his first one-man exhibition in the new premises of the Galerie Bernheim-Jeune at 25 Boulevard de la Madeleine.

1907

Spring: works at Vernouillet.
June: participates in group show at the Galerie Bernheim-Jeune.
Moves to new studio at 60 rue de Douai.

1908

Visits London with Vuillard.
February: travels to Algeria and Tunisia.
12–13 June: Vente Thadée Natanson at the Hotel Drouot. The sale, which includes nineteen paintings by Bonnard, is shown at the Galerie Bernheim-Jeune from 10 to 11 June. His portrait of Thadée Natanson (Dauberville 144) is bought by Vuillard.
Illustrations for Octave Mirbeau's account of a car journey through the low countries, *La 628-E8*.
August: stays at Quiberon.
14 December: major exhibition of Seurat opens at the Galerie Bernheim-Jeune. Listed in the catalogue are 205 items including eighty-three oils. Every major work is included, with the exception of the large *Models* and *Bathers, Asnières*.
Moves to new apartment at 49 rue Lepic, keeping his studio at 60 rue de Douai.

1909

February: exhibits thirty-six recent paintings at the Galerie Bernheim-Jeune.
June: visits Saint-Tropez where he stays with Manguin. From now on he makes annual visits to the South of France, renting villas at Saint-Tropez, Grasse, Antibes, and at Le Cannet, where he eventually buys a house in 1926.
Meets George Besson (1882–1971), an art critic, writer and publisher, who becomes a close friend.
Death of Paul Ranson.
Bonnard makes a will leaving everything to Marthe de Méligny.

1910

January: the Moscow collector Ivan Morosov commissions two paintings: *Morning in Paris* and *Evening in Paris*. By this date Bonnard owns a small Cézanne oil of a male nude (fig.9). It is listed as no.12 in the Cézanne exhibition at the Galerie Bernheim-Jeune, 10–22 January.
February: acquires a drawing by Rodin.
March: Shows thirty-four paintings at the Galerie Bernheim-Jeune.
Moves to new studio 21 quai Voltaire.
September: stays at Saint-Tropez.

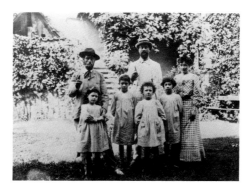

fig.143 Bonnard with his sister and brother-in-law, Andrée and Claude Terrasse, and their children *Private Collection*

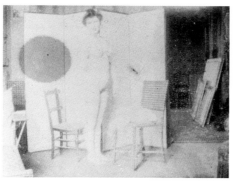

fig.144 Model posing in Bonnard's studio, 65 rue de Douai, *c*.1905 *Musée d'Orsay*

fig.145 Bonnard, *c*.1907 *Private Collection*

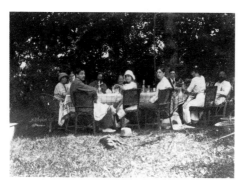

fig.146 Bonnard (far side of table) and Marthe (seated left) with the Terrasse family at Le Grand-Lemps, *c*.1913 *Private Collection*

Exhibits the four decorative panels commissioned by Misia Edwards at the Salon d'Automne.

1911

March: stays at Saint-Tropez, the first of three visits he makes this year.
May–June: Shows twenty-eight recent paintings at the Galerie Bernheim-Jeune.
Rents a studio at 22 rue Tourlaque, near to his apartment in the rue Lepic. He buys his first car, a 11CV Renault.
July: spends the summer at Saint-Tropez, with Paul Signac.
Realises a large triptych, *Méditerranée*, for the house of the Moscow collector Ivan Morosov. It is exhibited at the Salon de l'Automne where it is described by Apollinaire as 'a savoury ragout of colours'.
Paints *La Place Clichy* for the dining room of George Besson.

1912

January–April: Grasse, where he rents the Villa Antoinette.
May–June: shows thirty-one paintings at the Galerie Bernheim-Jeune.
August: buys a small house, 'Ma Roulotte', at Vernonnet, near Vernon in the Eure. It is also near Giverny where Monet had been living since 1883.
Bonnard is offered the Légion d'Honneur which he declines (Vuillard, Roussel and Vallotton also decline).
First major articles on his work appear: a profile by Thadée Natanson, and a critical appreciation by Lucie Cousturier.
Ivan Morosov commissions two large decorative panels, *Spring* and *Autumn* for his Moscow house.
Rents a house in Saint Germain-en-Laye (40 rue Voltaire), where he spends most of the First World War.

1913

May–June: with Vuillard he is invited to visit Hamburg by the mayor Alfred Lichtwark.
Shows twenty-one recent works at the Galerie Bernheim-Jeune.
November: shows *The Dining Room in the Country* at the Salon d'Automne. According to Apollinaire, it is one of the two most widely admired works there, the other being Matisse's portrait of his wife (which Apollinaire greatly prefers).
Represented by one painting in the Armory show in New York.

1914

January–February: Saint-Tropez, where he rents the Villa Joséphine.
May: designs poster for the Ballets Russes.
13 June: Félix Fénéon asks him to make a drawing of Rodin for an album dedicated to the sculptor, who has agreed to sit to Bonnard.
15 June: text on Bonnard by Pierre Laprade appears in *Les Marges* with four ink drawings by Bonnard.

1915

Works mostly in Saint Germain-en-Laye and Vernonnet.

Contributes a drawing to the *Album national de la guerre* published by the Comité de la fraternité des artistes (other contributors include Degas, Monet, Renoir, Signac and Vuillard).

1916

Begins works on four panels for the Bernheim-Jeune family (completed in 1920): *Pastoral Symphony or Countryside*, *Mediterranean or Monuments*, *Earthly Paradise*, and *Workers at the Grande Jatte or The Modern City*.

Around this time makes an etching of Renoir from a photograph thought to have been taken by Monet.

August: visits Saint-Nectaire.

October: moves to new apartment at 56 rue Molitor, Auteuil.

November: Visits Winterthur, where fifteen of his paintings are included in an exhibition of French art. He is the guest of the Swiss collectors, Dr Arthur Hahnloser, an ophthalmologist, and his wife, Hédy Hahnloser-Bühler, a painter and designer.

1917

January–April: works at Cannes.

The Hahnlosers commission a large decorative canvas, *Summer*, for the salon of their house in Winterthur, but Bonnard mistakes the dimensions, and the picture is eventually exchanged for a smaller painting, *The Fauns*, of 1905. Hédy Hahnloser's cousin, Richard Bühler, commissions a number of paintings as a decoration for his panelled dining-room in Winterthur. The paintings were split up in 1935 when Bühler sold his collection.

October–November: shows two decorations and nine recent paintings at the Galerie Bernheim-Jeune.

1918

Paints *The Terrace*, the first of three large-scale panoramic landscapes based on the view from the terrace of 'Ma Roulotte'. The other two are *The Terrace at Vernon*, 1928 and *Decoration, Vernon*, 1920–39.

July–August: visits the spa town of Uriage, in the Isère.

December: stays in Antibes, where Matisse visits him.

Bonnard and Renoir are chosen as Honorary Presidents by Le Groupement de la Jeune Peinture Française.

Around this time meets Renée Monchaty who models for him.

1919

Publication of two monographs: François Fosca, *Bonnard* (Geneva) and Léon Werth, *Bonnard* (Paris).

16 March: death of Bonnard's mother.

September: stays at Luxeuil.

Exhibits three paintings, including *The Terrace*, at the Salon d'Automne.

fig.147 Bonnard photographed by George Besson in his hotel room at Uriage-les-Bains, 1918 *Private Collection*

fig.148 Renée Monchaty, *c.*1921 *Private Collection*

fig.149 *Self-Portrait* 1923, ink and pencil on paper 12.7 × 16.8 (5 × 6⅝) *Virginia and Ira Jackson Collection, Houston, Texas*

1920

February–April: Visits the spa town of Arcachon in south-west France.

Shows one painting at the Salon des Indépendants.

June: visits Saint-Honoré-les-Bains.

August: publication of André Gide's *Prométhée mal enchaîné* with thirty illustrations by Bonnard.

October: designs sets for a production by the Swedish Ballet Company of *Jeux*, danced by Nijinsky, with music by Claude Debussy, choreography by Jean Borlin, and costumes by Jeanne Lanvin.

Contributes to the purchase by the Louvre of Courbet's *The Painter's Studio*.

December: Spends three months with Manguin in Saint-Tropez.

1921

March: spends two weeks in Rome with Renée Monchaty.

May–June: shows twenty-four paintings at the Galerie Bernheim-Jeune including the four panels for the Bernheim-Jeune family.

June: works at Saint-Honoré-les-Bains.

September: visits Luxeuil and Saint-Gervais-les-Bains.

1922

February: visits Cannes.

April: visits Le Cannet.

August–September: stays at Arcachon.

Publication of Claude Anet's *Notes sur l'amour* with fourteen ink drawings by Bonnard engraved on wood by Yvonne Maillez.

Publication of Gustave Coquiot's book on Bonnard with cover design and seven vignettes by the artist.

Represented at the Venice Biennale.

Falls ill with pneumonia.

Around this time abandons photography.

1923

January: works at Le Cannet and Vernon.

Awarded third prize and $500 at Carnegie International Exhibition, Pittsburgh.

June: death of his brother-in-law, Claude Terrasse, and shortly afterwards of his sister Andrée.

November: shows three paintings at the Salon d'Automne including *The Terrace at Vernon*.

1924

April: retrospective at the Galerie E. Druet which includes sixty-eight paintings from 1891 to 1922.

June: Marthe, who had been taking drawing lessons from Louise Hervieu, exhibits with Lebasque at the Galerie E. Druet. She signs her drawings and pastels Marthe Solange (fig.150).

Publication of Claude Roger-Marx's small monograph on Bonnard.

Makes fifty-five etchings as illustrations to Octave Mirbeau's book, *Dingo*.

Suicide of Renée Monchaty.

December: rents Villa Le Rêve at Le Cannet where he spends much of 1925.

Moves to a new Paris apartment at 48 boulevard des Batignolles.

fig.150 Marthe Solange, *Still-Life* 1924, pastel on paper 73 × 51 (28¾ × 20⅛) *Private Collection*

fig.151 *Self-Portrait* 1926, ink on paper 13 × 12 (5⅛ × 4¾) *Galerie Claude Bernard*

1925

13 August: Bonnard marries Marthe at the town hall in the XVIII arrondissement. The only people present at the ceremony are the two witnesses, Louisa Poilard, their concierge, and her husband, Joseph Tanson, a bank employee. Bonnard does not inform his family of the marriage.

1926

February: buys a hillside villa, which he names 'Le Bosquet', at Le Cannet, above Cannes, and undertakes extensive renovations.
Visits USA as member of the Carnegie International Jury. There he meets Duncan Phillips who becomes his most important American collector.
November–December: shows twenty recent paintings at the Galerie Bernheim-Jeune.

1927

At Arcachon until 9 January, when he leaves for Cannes.
8–15 February: brief stay in Paris before returning to Cannes. A note in his diary on 3 April to turn off the central heating indicates that he was already installed at 'Le Bosquet'.
Publication of an important monograph by Bonnard's nephew, Charles Terrasse, with a cover design by the artist. The book is the result of numerous conversations between the painter and author.
May: acquires a piece of land adjoining 'Le Bosquet'.
25 June–4 July: Uriage-les-Bains.
October–November: exhibits at Galerie Bernheim-Jeune.
20 November: leaves Paris for Le Cannet, where he arrives a week later.

1928

April: one-man show at the de Hauke Gallery, New York, Bonnard's first solo exhibition outside France. The catalogue preface is by Claude Anet.
16 May: sale of the collection of Alexandre Natanson.
Paints a second canvas for George Besson's dining room, *Café 'Au Petit Poucet'*. The first was *La Place Clichy*, 1911.
September–November: moves between Arcachon, Paris, Vernon and Vichy.
November–December: his exhibition at Galerie Bernheim-Jeune prompts André Lhote to write in La Nouvelle Revue française (1 January 1929): 'Becoming more and more out of sympathy with the impressionistic fragmentation of objects, Bonnard tries to integrate them into the architectural forms that normally surround them' ('Dédaignant de plus en plus le morcellement impressioniste des objets, Bonnard s'efforce de les rendre solidaires des formes architecturales qui leur font un cadre quotidien').
Participates in an exhibition of drawings and watercolours at Jacques Rodrigues-Henriques.

1929

January–February: stays at Arcachon.
April–May: participates in exhibition of French painting at the Palais des Beaux-Arts in Brussels.
October: visits the Chardin exhibition at the Galerie du Théâtre Pigalle.

1930

January–March: 7 paintings included in *Paintings in Paris From American Collections* at the Museum of Modern Art, New York.
Death of his nephew Jean Terrasse.
At the suggestion of Dr Arthur Hahnloser begins working in watercolour and gouache while recovering in a clinic from an outbreak of boils.
Publication of Vollard's *Sainte Monique* for which Bonnard made twenty-nine drawings (transferred onto stone), seventeen etchings and 178 woodblocks.
November: rents the Villa Castellamare in the Ville d'Hiver at Arcachon. During his six month stay there he paints *Dining Room Overlooking the Garden (The Breakfast Room)*.

1931

At Arcachon until 15 April.
April–June: stays in Paris.
Summer: works at Vernon.
Autumn: moves to Le Cannet.

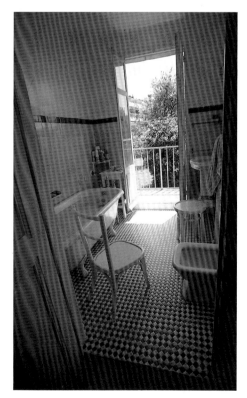

fig.152 The Bathroom at Le Bosquet, 1983

1932

January–April: works at Le Cannet.
April: six paintings in the exhibition *Van Gogh, Toulouse-Lautrec, Bonnard et son époque*, organised by George Besson at the Galerie Braun, Paris.
May–August: works at Vernon.
September: moves to Le Cannet.

1933

End of April: spends ten days at Arcachon.
June: after seeing Bonnard's exhibition at the Galerie Bernheim-Jeune, which included twenty-six recent works, Signac writes him a note of congratulations.
November–December: works at La Baule, in Brittany.
Moves to a new Paris apartment, 16bis, rue Caulincourt.

1934

March: exhibition of forty-four works at the Wildenstein Gallery, New York.
16 June: rents a villa at Bénerville, on the Normandy coast.
From now until the outbreak of war in September 1939 Bonnard makes regular visits to the Normandy coast, most frequently to Trouville.
November: moves to Le Cannet.

1935

February: participates in *Artistes de Paris*, Palais des Beaux-Arts, Brussels.
April: leaves Le Cannet and drives to Trouville, by way of Lyon, Nevers, and Chartres.
20–1 May: rapid visit to London to see his exhibition at the Reid & Lefevre Gallery.
June: stays at Trouville and Bénerville.
July: Vernon.
October: Deauville
November: Vernon.
25 December: Deauville.

1936

Works at Deauville for most of the year. Paints *Nude in the Bath*, about which he says: 'I shall never dare to embark on such a difficult subject again.' It is the first of three major late paintings on this theme; the other two are *The Large Bath, Nude*, c.1937–43 and *Nude in the Bath and Small Dog*, 1941–6.
May: one-man exhibition at Reid and Lefevre Gallery, London.
June: Paris: exhibition *Portraits by Bonnard* at Galerie Braun & Co.
The French State buys *Corner of the Table* from the Salon des Indépendants.
19 July: Deauville.
Begins work on *The Circus Horse* (completed 1946)
Awarded second prize at the Carnegie International Exhibition in Pittsburgh.
Together with Vuillard and Roussel, Bonnard is invited to contribute a mural decoration for the theatre in the new Palais de Chaillot.

fig.153 Pierre Bonnard, 1937 *Private Collection*

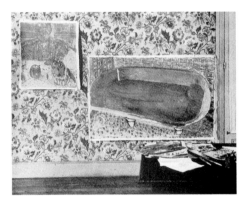

fig.154 The wall of Bonnard's hotel bedroom at Deauville, 1937. The painting on the right is *The Large Bath, Nude*, (no.80, unfinished state) *Private Collection*

fig.155 Pierre Bonnard, 1942 *Private Collection*

September: drives to Le Cannet stopping at Dijon, Lyon, and Aix on the way.
December: represented by nineteen paintings in exhibition shared with Vuillard at Galerie Paul Rosenberg, Paris.
12 December: leaves Le Cannet.

1937

Spends most of the year in Deauville, making brief visits to Paris.
Important interview by Ingrid Rydbeck, which took place in Deauville, is published in *Konstrevy*, no.4, Stockholm. She was accompanied by the photographer Rogi André.
June–October: represented by a large group of works in *Les Maîtres de l'art indépendant 1895–1937*, at the Petit Palais.

1938

February–mid-May: Stays at Le Cannet.
May–September: works at Deauville.
Sale of 'Ma Roulotte', Bonnard's house at Vernonnet.
Designs cover for the third issue of *Verve*, the arts magazine founded in 1937 by Tériade.
December: loan exhibition of paintings and prints by Bonnard and Vuillard at the Art Institute of Chicago

1939

February–April: represented in *Parijsche Schilders* at the Municipal Museum, Amsterdam
2 March: leaves Le Cannet for Paris where he moves into a new apartment at 2 place de la Porte-des-Ternes on 24 March.
March: fifty-one paintings included in retrospective at Svensk-Franska Konstgalleriet, Stockholm.
Begins work on *The Studio with Mimosa*, his last major interior (completed 1946).
September: leaves Paris for Le Cannet.

1940

April: elected Honorary Academician by the Royal Academy of Arts, London (nominated by Augustus John).
21 June: death of Edouard Vuillard at La Baule.

1941

March: death in Algeria of his brother Charles Bonnard.
The same month sits for a portrait by a young painter, Kostia Terechkovitch, who later publishes an account of his visits to 'Le Bosquet'.
Paints *Dark Nude*. The sitter is Dina Vierny, the favorite model of Maillol, who had introduced her to Bonnard.
August: in a letter to George Besson, Bonnard writes from Le Cannet of his longing for new horizons (J'aurais bien besoin aussi de voir d'autres horizons'), and of the monotony of the light and the objects ('la lumière et les objets se monotonisent beaucoup').
18 October: Bonnard's *Souvenirs sur Renoir* are published in *Comoedia*.
Sale of part of Félix Fénéon's collection including six paintings by Bonnard.

1942

26 January: death of Marthe Bonnard.
29 June: after this date Bonnard ceases his daily habit of recording the weather in his diary.
The Paris dealer Louis Carré commissions eleven gouaches from which Jacques Villon will make lithographs. Bonnard oversees the project at every stage.

1943

Special edition of *Le Point* devoted to Bonnard.
2 November: death of Maurice Denis.
Bonnard is admitted to hospital suffering from severe congestion of the lungs.
A number of fakes having appeared on the market, Bonnard agrees to a suggestion put to him by Jean and Henry Dauberville that they should compile a *catalogue raisonné* of the oils.

1944

January: publication of *Bonnard: Seize Peintures 1939–1943* by André Lhote. More than half the plates are of unsigned paintings, a number of which were later substantially reworked.
Publication by Tériade of *Correspondances*, a series of fictional letters from the artist's youth illustrated with twenty-eight pencil and pen drawings.
Publication of Sacha Guitry's *De Jeanne d'Arc à Philippe Pétain* which includes as one of the illustrations a gouache Bonnard had made for the book in 1942.
June: death of Ker-Xavier Roussel.
24 September: death of Aristide Maillol.

1945

July: visits Paris for the first time since 1939.

1946

Visits Fontainebleau and Paris.
Paints *The Fruit Picking,* six decorative paintings commissioned by Louis Carré for his dining room.
June–July: shows thirty-six major works at the Galerie Bernheim-Jeune.
August: Brassaï visits Bonnard at Le Cannet, and photographs the studio.
October: last visit to the Louvre with the Director Georges Salles, and Jean Leymarie.
Agrees to a large retrospective in 1947 to be organised by the Museum of Modern Art, New York, in celebration of his eightieth birthday. The retrospective takes place in Cleveland and New York between March and September 1948.

1947

23 January: Bonnard dies at Le Cannet. The funeral service is held at Sainte-Philomène-du Cannet.
August: publication of special edition of *Verve* devoted to Bonnard for which he had designed the cover and frontispiece. He also chose the decorative designs and selected the extracts from his diaries.

fig.156 Pierre Bonnard, photographed by Cartier-Bresson in 1944.

fig.157 Pierre Bonnard, photographed by André Ostier in 1945 or 1946 *Private Collection*

fig.158 The studio at Le Bosquet, photographed by Alexander Liberman in 1955.

Select Bibliography

The most inclusive bibliography is to be found in *Bonnard*, published on the occasion of the exhibition *Bonnard: The Late Paintings*, co-curated by the Centre Georges Pompidou, Paris, The Phillips Collection, Washington and the Dallas Museum of Art in 1984. It was compiled by Jan Lancaster and Sarah Martin, and comprises approximately 1,400 items. Their work was aided by Claude Laugier and Laure de Buzon-Vallet who had prepared the bibliography for the French edition of the catalogue.

Catalogue raisonné

Jean and Henry Dauberville, *Bonnard: Catalogue raisonné de l'oeuvre peint*, Paris, vol.I, *1888–1905*, 1965 (revised edition 1992); vol.II, *1906–1919*, 1968; vol.III, *1920–1939*, 1973; vol.IV, *1940–1947* and supplement *1887–1939*, 1974.

Monographs

The first monograph of consequence is Charles Terrasse, *Bonnard*, Paris 1927. It was written by Bonnard's nephew with the help and encouragement of the artist and remains essential reading. Thadée Natanson, one of the editors of *La Revue blanche* and a close friend of Bonnard's, is the author of a substantial memoir, *Le Bonnard que je propose*, Geneva 1951. Later, Natanson's niece, Annette Vaillant published *Bonnard ou Le Bonheur de Voir, Editions Ides et Calendes*, Neuchâtel 1965 (English edition London 1966), for many years one of the few texts available in English.

Major contributions have also been made by Bonnard's great-nephews. Antoine Terrasse is the author of an authoritative monograph: *Pierre Bonnard*, Paris 1967 (expanded and revised in 1988). He is also the author of *Bonnard: Nus*, Petite Encyclopédie de l'art, no.97, Paris 1970, and *Pierre Bonnard, Illustrator*, London 1989. Michel Terrasse is the author of *Bonnard at Le Cannet*, London 1988, and more recently, of *Bonnard: du dessin au tableau*, Paris 1996, in which the connections between the drawings and paintings are closely examined.

There are a number of picture books, that is to say, books which consist of coloured plates accompanied by short texts and/or notes. Of these, the following are recommended: André Fermigier, *Pierre Bonnard*, Paris 1969 (second edition 1992), English edition New York 1987; Guy Cogeval, *Bonnard*, Paris 1993; Julian Bell, *Bonnard*, London 1994.

Three recent monographs in English have made Bonnard accessible to a wider public: Nicholas Watkins, *Bonnard*, London 1994, and *Bonnard: Colour and Light*, London and New York 1998; Timothy Hyman, *Bonnard*, London 1998.

Writings and interviews

Bonnard made a selection of his own observations about painting taken from the diaries he kept between 1927 and 1946. These appeared in a special number of *Verve*, 'Couleur de Bonnard', vol.V, no.17–18, Paris 1947. Antoine Terrasse published extracts from the diaries, together with photographs of many of the pages containing sketches, in the catalogue of *Bonnard*, Musée National d'Art Moderne, Centre Georges Pompidou, Paris 1984, and in English translation in *Bonnard: The Late Paintings*, 1984, pp.53–70 (see under 'Exhibition catalogues').

Of interest too is Bonnard's contribution to the debate 'Pour et Contre l'Art Abstrait', which appeared in *Cahier des Amis de l'Art*, no.11, Paris 1947.

Very few of Bonnard's letters have been published. The exception are those he wrote to Matisse which are collected in *Bonnard-Matisse Correspondance*, presented by Jean Clair and Antoine Terrasse, Paris 1991. The English edition is *Bonnard/Matisse: Letters Between Friends*, New York 1992.

Most of the interviews by Bonnard date from the last ten years. The most substantial are listed in date order below:

Courthion, Pierre, 'Impromptus – Pierre Bonnard', *Les Nouvelles littéraires*, Paris, 24 June 1933.

Bouvier, Marguerite, 'Bonnard revient à la litho …', *Comoedia*, 23 January 1943.

Angèle Lamotte, 'Le Bouquet de roses: propos de Pierre Bonnard recueillis en 1943', *Verve*, special issue 'Couleur de Bonnard', Paris, vol.V, nos.17–18, August 1947. The English edition, 'The Bouquet of Roses', is in Michael Anthonioz (ed.), *Verve: The Ultimate Review of Art and Literature (1937–1960)*, New York 1988, pp.170–1, 178.

Rydbeck, Ingrid, 'Hos Bonnard I Deauville', *Konstrevy*, Stockholm 1937. Reprinted in *Louisiana Revy*, Humlebaek, no.1, September 1967.

The following publication does not fall into this category, but is included here as it does not appear in any other Bonnard bibliography: *Le Procès de la Succession Bonnard et Le droit des artistes. Plaidoyer de Maurice Garçon, Avocat à la Cours de Paris*, 10 November 1952. Copies of this privately printed book were deposited in various libraries, including The Ryerson Library, Chicago, The Courtauld Institute of Art Library, London, the Archives of the Musée National d'Art Moderne, Centre Georges Pompidou, Paris, the Frick Art Reference Library, New York and the library of the Museum of Modern Art, New York.

Exhibition catalogues

Bonnard and his Environment, with texts by James Thrall Soby, James Elliott and Monroe Wheeler, The Museum of Modern Art, New York 1964.

Pierre Bonnard 1867–1947, with text by Denys Sutton, Royal Academy of Arts, London 1966.

Bonnard, with texts by Sasha Newman, Steven A. Nash, Jean Clair, Antoine Terrasse, Margrit Hahnloser-Ingold, Jean-François Chevrier, Musée National d'Art Moderne, Centre Georges Pompidou, Paris; The Phillips Collection, Washington; Museum of Art, Dallas, 1984. The English edition with an introduction by John Russell was edited by Sasha Newman.

Drawings by Bonnard, with an introduction by Sargy Mann, Arts Council of Great Britain, London 1984.

Hommage à Bonnard, with texts by Philippe Le Leyzour and Claire Frèches-Thory, Galerie des Beaux-Arts, Bordeaux 1986.

Bonnard: The Graphic Art, with texts by Colta Ives, Helen Giambruni, Sasha Newman, The Metropolitan Museum of Art, New York; Museum of Fine Arts, Houston; Museum of Fine Arts, Boston 1989–90.

Bonnard at Le Bosquet, with texts by Belinda Thomson and Sargy Mann, The South Bank Centre, London 1994.

Articles

Some of the most informative writings on Bonnard, including several by painters, were written for ephemeral publications such as magazines, newspapers, or dealers' catalogues. The essay by James Thrall Soby does not fall into this category, but the book in which it appears is not easy to find in this country.

Credits

Jean-Michel Alberola, Avigdor Arikha, Miquel Barcelo and François Rouan, 'Face à Bonnard quatres peintres', *Petit Journal de l'Exposition Bonnard*, Musée National d'Art Moderne, Centre Georges Pompidou, Paris 1984, pp.10–11.

Patrick Heron, 'Bonnard and Abstraction' in *The Changing Forms of Art*, London 1955; *Colour and Abstraction in the Drawings of Bonnard*, Waddington Galleries, London 1972.

Merlin Ingli James, 'London and Newcastle Bonnard', *The Burlington Magazine*, September 1994, pp.633–4.

Max Kozloff, 'Bonnard: Expressionist of Pleasure', *The Nation*, New York, 26 October 1964.

Bernice Rose, 'Colour and Light', in *Bonnard and Rothko*, Pace Wildenstein Gallery, New York 1997.

James Thrall Soby, 'Bonnard', in Alexander Liberman (ed.), *The Artist in his Studio*, New York 1960. Certain of Liberman's photographs taken at Le Bosquet do not appear in subsequent editions.

David Sylvester, 'Bonnard's *The Table*', first published in *The Listener*, 15 March 1962, reprinted in *About Modern Art: Critical Essays 1948–97*, Chatto and Windus, London 1997, pp.104–10; 'Bonnard' (appeared in the *Sunday Times Colour Magazine* on 6 February 1966 under the title 'A Nude about the House'), reprinted in *About Modern Art*, pp.136–9; 'A kind of Informality: D. Sylvester, M. Podro and A. Forge Talking about Bonnard', *Studio International*, no.171, London, February 1966, pp.48–55.

Antoine Terrasse, 'Le Dessin de Bonnard', *L'Oeil*, no.167, Paris, November 1968, pp.10–17.

Graphic art

Francis Bouvet, *Bonnard: The Complete Graphic Work*, translated from the French by Jane Brenton, New York and London 1981 (French edition Paris 1981).

Antoine Terrasse, *Pierre Bonnard Illustrator: A Catalogue Raisonné*, translated from the French by Jean-Marie Clarke, London 1989 (French edition Paris 1988).

Photography

Françoise Heilbrun and Philippe Néagu, *Pierre Bonnard Photographe*, Philippe Sers, Réunion des Musées Nationaux, Paris 1987.

Copyright Credits

All works by Bonnard are © ADAGP, Paris and DACS, London 1998 *except in USA*

Maurice Denis © ADAGP, Paris and DACS, London 1988 *except in USA*

James Ensor © DACS 1998

Henri Matisse © Succession Matisse/DACS 1988

Photographic Credits

The publishers have made every effort to trace all the relevant copyright holders and apologise for any omissions that may have been made.

Figure illustrations
Acropolis Museum, Athens (Kostas Kontos, Athens) 70; Agnew and Sons, London (Bridgeman Art Library, London) 24; Bibliothèque Nationale, Paris 90, 92, 96–7, 106, 109–10, 116–19, 121, 126–8, 130–1; Cartier-Bresson H./Magnum Photos 3, 156; Courtesy of the Fogg Art Museum, Harvard University Art Museums, Bequest from the Collection of Maurice Wertheim, Class of 1906 © President and Fellows, Harvard College, Harvard University Art Museums 18; Galerie Huguette Berès, Paris 21–2; Galerie Claude Bernard, Paris 20, 26, 59, 102, 135–6, 151; Galerie Schmit, Paris 104; Galleria Uffizi, Florence (Fratelli Alinari) 105; Hannloser Collection, Villa Flora, Winterthur 48; Virginia & Ira Jackson Collection, Houston, Texas (Rick Gardner Photography, Houston, Texas) 32; © Alexander Liberman 16, 158; Photo: Sargy Mann, © Mann/Espley 152; Collection of Mr and Mrs Paul Mellon, Upperville, Virginia 36; The Metropolitan Museum of Art, The Elisha Whittelsey Collection, The Elisha Whittelsey Fund 1970 37; The Metropolitan Museum of Art, Fletcher Fund 1932 78; Collection Mnam/Cci/Centre Georges Pompidou, Paris (Photothèque des collection du Mnam-Cci, Centre Georges Pompidou, Paris) 5; Musée d'Art et d'Histoire, St Denis 107; Le Musée Départmental Maurice Denis, Saint-Germain-en-Laye (SPADEM and ADAGP) 61; Musée Guimet, Paris (Réunion des Musées Nationaux) 13; Musée de Grenoble (The Bridgeman Art Library, London) 14; Musée d'Orsay, Paris (Réunion des Musées Nationaux) 6, 12, 27–9, 138, 140–2, 144; Musée de Rheims (Giraudon/Bridgeman Art Library) 30; Musée du Louvre, Paris (Giraudon) 41; Musée du Louvre (Conway Library) 122; The Museum of Fine Arts, Houston, The John A. and Audrey Jonas Beck Collection (Photo: A. Mewbourn) 7; Photo: Thadée Natanson, courtesy of the

Annette Vaillant Archive 137; Photo: René-Thadée Natanson, courtesy Annette Vaillant Archive 15; National Gallery of Scotland 2; National Museum, Rome (Fratelli Alinari) 69; Neffe-Degandt, London 57, 63, 125; Ny Carlsberg Glyptothek, Copenhagen 4; Palazzo dei Conservatori, Rome (Fratelli Alinari, Florence) 43; Private Collection 1, 8, 9, 11, 17, 23, 31, 34–5, 38–9, 42, 49, 62, 75–6, 82, 85, 87–8, 101, 103, 108, 111, 115, 123–4, 129, 132, 143, 145–6, 148, 150, 155; Private Collection (Photo: George Besson) 147; Private Collection (Galerie Philippe Cazeau, Paris, Photo: Jean-Claude Bloch) 54, 58, 86, 91, 94–5, 99, 114, 120, 133; Private Collection (Christie's, London) 44; Private Collection (Fujikawa Galleries Inc.) 74; Private Collection (Hazlitt, Gooden & Fox) 93; Private Collection (Photo: Josse) 19, 46, 50–3, 65–7, 79–81, 84, 100, 113; Private Collection (Photo: André Ostier) 157; Private Collection (Photo: Rogi-André) 154; Private Collection (Photo: Schweizer) 47; Private Collection (Sotheby's London) 10, 40, 89, 134; Private Collection, Switzerland (Gerhard Howald, Bern) 45; Photo: Roger-Viollet, © Harlingue-Viollet 153; Szépmüvészeti Múzeum, Budapest 25; Tate Gallery Photographic Department 55–6, 71–3; Annette Vaillant Archive 139; The Board of Trustees of the Victoria and Albert Museum, London 112; Sarah Whitfield 98; Wolseley Fine Art, London 33, 60, 64, 68, 77, 83, 149.

Catalogue illustrations
David Allison
Fondation Bemberg, Toulouse
Galerie Berès
Galerie Claude Bernard, Photo: Walch
Galerie Bernheim-Jeune
Musée des Beaux-Arts et d'Archéologie de Besançon
Musée de Brest
British Museum, London
Musées Royaux des Beaux-Arts de Belgique, Brussels
Muzeul K.H. Zambaccian, Bucharest
Szépmüvészeti Múzeum, Budapest
Achim Bunz
Carnegie Museum of Art, Pittsburgh,
The Art Institute of Chicago, Photo: Greg Williams
Musée d'Unterlinden, Colmar, Photo: O. Zimmermann
Christies, New York
E.T. Archive
Richard L. Feigen & Co
The Fine Art Society plc
The Flint Institute of Arts
Musée d'art et d'histoire, Geneva

Lenders

Musée de Grenoble
The Solomon R.Guggenheim Foundation,
 New York, Photo: David Heald
Peter Harholdt
G. Howald
J. Hyde
Galerie Jan Krugier, Ditesheim & Cie, Geneva
Jan Krugier Gallery, New York
Bill Jacobson
Jean-Louis Josse
Jacques Lathion
Marcella Leith
Marcus Leith
Trustees of the National Gallery, London
National Gallery of Victoria, Melbourne
Milwaukee Art Museum
The Minneapolis Institute of Arts
Mitchell-Innes & Nash
Pushkin State Museum of Fine Arts, Moscow
Neffe-Degandt Ltd
The Museum of Modern Art, New York
Nasjonalgalleriet, Oslo, Photo: Jacques Lathion
Philadelphia Museum of Art
The Phillips Collection, Washington
Photothèque des Musées de la Ville de Paris
Musée National d'Art Moderne, Centre Georges
 Pompidou, Paris, Photo: Jacques Faujour
Heinz Preute
Réunion des Musées Nationaux, Paris,
 Photos: Arnaudet, Gérard Blot and Hervé
 Lewandowski
Romerhof
James Roundell
Sheffield City Art Galleries
Peter Schibli
Galerie Schmit
Schweizer
Sotheby's Geneva
Sotheby's Paris
Sydney, The Art Gallery of New South Wales
Tate Gallery, London
Richard Trigg
Malcom Varon
Galleria Internazionale d'Arte Moderna di
 Ca'Pesaro, Venice, Photo: Foto flash
Board of Trustees of the National Gallery of Art,
 Washington, Photo: Bob Grove
Rolf Willimann

Numbers refer to catalogue entries

Private Collections

Fernando Botero 79
Mrs Wendell Cherry 85
Mr J. Dellal 110
Galerie Jan Krugier, Ditesheim & Cie, Geneva
 33
Jan Krugier Gallery, New York 49
Margoline Collection 31
A. Rosengart 19
Sir Robert and Lady Sainsbury 10
Keisuke Watanabe 22
Private Collection 1, 2, 6–9, 11, 13, 15, 18, 20,
 21, 30, 32, 34, 37, 40, 41, 43–7, 51, 53–6,
 58–61, 65, 67, 71, 73, 74, 77, 80–4, 86–90, 93,
 98, 101–7, 109, 111–13

Public Collections

Musée des Beaux-Arts et d'Archéologie de
 Besançon 57
Musée de Brest 39
Brussels, Musées Royaux des Beaux-Arts de
 Belgique 24
Bucharest, Muzeul K.H. Zambaccian 63
Budapest, Szépmüvészeti Múzeum 14
The Art Institute of Chicago 36
Colmar, Musée d'Unterlinden 38
The Flint Institute of Arts 12
Geneva, Musée d'art et d'histoire 25
Musée de Grenoble 68
London, British Museum 108
London, Tate Gallery 29, 35, 48, 50
Melbourne, National Gallery of Victoria 17
Milwaukee Art Museum 92
The Minneapolis Institute of Arts 26
Moscow, Pushkin State Museum of Fine Arts 23
New York, The Museum of Modern Art 62, 66,
 91
New York, Solomon R. Guggenheim Museum
 70
Oslo, Nasjonalgalleriet 27
Paris, Musée d'Art Moderne de la Ville de Paris
 75, 76
Paris, Musée du Louvre 99–100
Paris, Musée National d'Art Moderne 72, 96, 97
Paris, Musée d'Orsay 3–4, 16
Philadelphia Museum of Art 28, 69
Pittsburgh, Carnegie Museum of Art 94
Sydney, The Art Gallery of New South Wales 78
Toulouse, Fondation Bemberg 95
Venice, Galleria Internazionale d'Arte Moderna
 di Ca'Pesaro 64
Washington, National Gallery of Art 5
Washington, The Phillips Collection 42, 52

The Tate Gallery Exhibition Team

Head of Exhibitions
Ruth Rattenbury

Exhibitions Assistant
Emmanuelle Lepic
Exhibitions Graphics
Philip Miles

Exhibitions Registrar
Sionaigh Durrant

Head of Art Handling
Jim Grundy
Senior Art Handler
Adrian Lawrence

Head of Conservation
Roy Perry
Paintings Conservator
Tim Green

*Translations from French in
texts by Sarah Whitfield*
Barbara Wright
*Translations from French in
texts by John Elderfield*
Christel Hollevoet-Force

Index